THE
DEVIL'S
ADVOCATE

THE DEVIL'S ADVOCATE

AN AMBROSE BIERCE READER

EDITED BY BRIAN ST. PIERRE

CHRONICLE BOOKS SAN FRANCISCO

Printed in the United States of America
by R. R. Donnelley & Sons.

Library of Congress Cataloging in Publication Data

Bierce, Ambrose, 1842-1914?
The Devil's advocate.

Contents: Stories of the Civil War—Californians—
Journalism, by and large—[etc.]
I. St. Pierre, Brian. II. Title. III. Title:
Ambrose Bierce reader.
PS1097 .A6 1987 813'.4 87-24249
ISBN 0-87701-401-9
ISBN 0-87701-476-0 (pbk.)

Book and cover design: Fearn Cutler
Composition: G & S Typesetters, Texas

Cover: Courtesy of The Henry E. Huntington
Library and Art Gallery.

Distributed in Canada by
Raincoast Books
112 East 3rd Avenue
Vancouver, B.C.
V5T 1C8

10 9 8 7 6 5 4 3 2 1
Chronicle Books
San Francisco, California

CONTENTS

INTRODUCTION

Ambrose Bierce had a carefully cultivated talent for making enemies. When they were not found immediately to hand, he went looking for candidates, browsing through churches, courtrooms, books, legislatures, and newspapers for the fools and foolishness that delighted him. He was a connoisseur of cant who expected the worst of humanity and derived great satisfaction at the fulfillment it rarely failed to provide.

Some years after Bierce's death, H.L. Mencken, another great newspaper columnist and, in some ways, Bierce's spiritual heir, wrote, "Out of the spectacle of life about him he got an unflagging and Gargantuan joy . . . He was the first American to lay about him with complete gusto. Such beserk men have been rare in our history; the normal Americano, even when he runs amok, shows a considerable discretion. But there was no more discretion in Bierce than you would find in a runaway locomotive."

Over a span of thirty years, Bierce wrote columns for three San Francisco weeklies, the *News Letter, Argonaut,* and *Wasp,* and a weekly column for the *San Francisco Examiner,* all of which earned him a variety of epithets—"the wickedest man in San Francisco," "Bitter Bierce," "Almighty God Bierce," "the best-hated and best-loved man in California" among them. He also wrote satirical fables, verse, essays, and short stories and was marked for literary immortality by several leading critics of his day.

They were wrong. His reputation faded in his own lifetime. Not long after Bierce's death, Mencken wrote, "Had he been a more cautious man, the professors of literature would be politer to him today." That may be true, but there is also a good possibility that, had he been a more cautious man, he would have been forgotten, and we, still needing ammunition against the same sort of fools and foolishness he reveled in reviling, would be very much the poorer for it.

The tenth of thirteen children, Ambrose Gwinett Bierce was born into poverty and puritanism on June 24, 1842, in the backwoods of southeastern Ohio near the West Virginia border. His father was a bookish, failed farmer, his mother a shrewish, dogmatically pious and disappointed farmer's wife. It was typical of their miserable lot that when the family moved to what promised to be better circumstances in Indiana four years after Ambrose's birth, his baby brother died on the journey.

His father, Marcus Aurelius Bierce, was named for the Stoic

philosopher, and his name fit him like a soft glove. One of his several peculiarities was to give all his children names beginning with the letter A. Both sides of the family traced their history back to the earliest days of Puritan America (on his mother's side, to the *Mayflower*), and, for the most part, the strain of religiosity had remained undiluted. The exception was Marcus' minor vice, a love of reading eclectic enough to include Byron and Poe.

Ambrose's life as a child was one of nearly unrelenting duty— to parents, church, and never-ending farm chores (he later wrote: "ah, duty is as cruel as death!"). By all accounts, he was a solitary, introverted, touchy, and rebellious boy who took no part in sports or social activities other than pranks and practical jokes (in *The Devil's Dictionary* he defines disobedience as "the silver lining to the cloud of servitude").

He was, however, a voracious reader; between his father's collection and the local library, he grounded himself well in literature. His first job, at fifteen, was as a printer's devil, and he lived far enough from home to become a boarder. At seventeen, he attended Kentucky Military Institute and a year later was working as a waiter-bartender in a saloon in Elkhart, Indiana.

When the Civil War began in 1861, Ambrose Bierce was the second man in his county to join the Union Army. His family was fiercely anti-slavery, but most likely the war represented, at last, deliverance from the bleakness of rural life.

Terms of enlistment were three months, but for Bierce reenlistment was automatic—he had, as army men say, found a home. He was a sergeant by his second term and distinguished himself several times for bravery bordering on recklessness in some of the worst battles of the war at Shiloh, Kennesaw Mountain, and Chickamauga. Finally, perhaps inevitably, he was seriously wounded by a bullet to the head.

He returned home on medical leave, a twenty-one-year-old first lieutenant, mustachioed, distinguished, and a hero. After his high-school sweetheart and he quarreled and broke their tenative engagement, Bierce quickly resumed the business of soldiering. Perhaps because he had returned prematurely, still weak, he foolishly allowed himself to be captured by the enemy; he escaped soon after, barefoot and underclothed, and lived off the land as he worked his way back to his brigade. He wasn't fully recovered when the war ended the following year.

The great adventure had ended, and though he had grown to detest the generals who wasted the lives of their troops through political ambition or stupidity—he had seen the feckless Sheridan, barbaric Sherman, and inefficient Grant at first hand—he had grown to love the game and never forgot it. Years later he wrote: "It was once my fortune

to command a company of soldiers—real soldiers. Not professional life-long fighters, the product of European militarism—just plain, ordinary, American, volunteer soldiers, who loved their country and fought for it with never a thought of grabbing it for themselves; that is a trick which the survivors were taught later by gentlemen desiring their votes."

He was mustered out in Alabama and seems never to have thought of going back to Indiana; from then on, home was wherever he hung his hat. He got a job with the U.S. Treasury Department, confiscating enemy property—a punitive form of war reparations—in Selma, Alabama. The city had been savagely devastated near the end of the war and was not a comfortable place to be a carpetbagger, nor, given his occupation, a safe one. The job was available because his predecessor was filling a vacancy in the soil of Selma's graveyard.

Bierce found the job "exceedingly disagreeable." Despite the fun of being shot at again, he couldn't stomach the brutal excesses of Reconstruction and jumped at the chance for a better sort of adventure when his former commanding officer offered him a job with an expedition to explore and survey the country between Nebraska and California.

While waiting for his separation from the Treasury Department and reattachment to the army, Bierce took a cruise to Panama. His account of the trip is distinguished mostly by misspellings and scrambled syntax, an astonishing contrast to the careful writing he produced only a few years later.

The small party that set out across the plains in July 1866 consisted of four brave men—the two officers, a cook, and a teamster. Indians were active and hostile much of the way, and the land itself wasn't always hospitable either. Bierce, however, was enchanted by the new landscape and open spaces. "It was a revelation and a dream," he wrote.

Late in the year, they arrived in San Franciso and reported in to the Presidio. Whatever delights the city and its civilization presented were immediately eclipsed by the bad news that Bierce, who had arrived as a brevet major, could only stay in the army if he accepted a demotion to second lieutenant—the postwar army was simply overstocked with officers.

Stung, hurt, and proud, he resigned; the army had made him an officer and something of a gentleman, and he couldn't accept a junior station again: "If I had served long enough I might have become a captain. In time, if I lived, I should naturally have become the senior captain of the Army; and then if there were another war and any of the field officers did me a favor to paunch a bullet I should become a junior major, certain of another step upward as soon as a number of my super-

iors equal to the whole number of majors should be killed, resign or die of old age—enchanting prospect!"

The San Francisco Bierce found himself stranded in was already nearly legendary in much of the world, an instant city that had grown in less than two decades from a squalid encampment of three hundred people to a thriving metropolis of over sixty thousand. As one of the few who had not come to San Francisco to seek his fortune, Bierce was something of an odd duck right from the start.

It was a city mostly of men, only half of whom were Americans. They were generally quite literate (Bancroft's bookstore was the largest west of Chicago, and there were six daily newspapers) and already sentimentalizing and tidying up the story of San Francisco's rowdy beginnings. Much of its polyglot citizenry was still not committed to the place (hotels and restaurants were all out of proportion to the population of most cities), and, outside of New Orleans, it was perhaps the most festive city in America. "Home is less and the street more for the San Franciscans than for the citizens of New York or Charleston," wrote John S. Hittell, one of the first historians of California. "Many of the influences potent against housekeeping twenty years ago continue nearly as powerful as ever."

Bierce went back to work for the Treasury—as night watchman at the U.S. Mint. The undemanding job allowed him plenty of time to read, which he did with a new passion and with a plan: He would become a writer. He methodically devoured the works of Gibbon, Burke, Spencer, and Pope. Within a year he had taught himself enough to become a published writer, first of verse, then of articles and essays for the *Californian, Alta California,* and the *Golden Era.*

Later, he contributed some items to the *News Letter,* which published a page of his tart paragraphs about the pomposities and foolishness of the local citizenry. Called in for an interview, he was hired on the spot and groomed by the paper's brilliant editor, James Watkins, to take over the page known as the "Town Crier." Watkins added Swift, Voltaire, Thackeray, and Shakespeare to Bierce's reading list and taught him how to write well. From Watkins came the detestation of slang and vulgarity Bierce held all his life, as well as the appreciation of wit instead of the broad humor most Westerners favored. Bierce joined the staff in the summer of 1868 and was managing editor and sole writer of "Town Crier" by December. He was twenty-six years old.

Not long afterward, the pungency of his prose was being noted and quoted in New York and London magazines. One writer said Bierce possessed "a Rabelaisian audacity which stands abashed at but very few things indeed," while another observed that he was the "most impudent and most irreverential person on the Pacific Coast."

Bierce also introduced a new feature on the "Town Crier" page called "Telegraphic Dottings," very brief items separated by ellipses: "An insurance company was robbed. Tit for tat . . . Frightful atrocities of the Chinese. Theft and murder of a hen . . . Mr. Bancroft [the famous bibliophile, whom Bierce detested] is about to build a new sty on Market Street . . . French priest has abandoned the errors of the Romish for those of the Protestant church. . . ." Generally, however, the column consisted of longer items, such as, "One day last week a woman at the Brooklyn Hotel attempted to refute some imputations against her character by passing through an ordeal of arsenic. She was speedily pumped dry by a meddling medico, and her chastity is still a bone of contention."

Another time a scandal occurred when a candidate running for the Board of Education was accused of consorting with prostitutes; Bierce urged his election as a potential victory for morality, as "No respectable harlot who cares for her reputation would continue her acquaintance with a man who had been elected to the Board of Education."

In those days there was no standard like today's "absence of malice," intended to balance newsworthiness against the possibilities of slander. The notion would have been thought ludicrous by Bierce and his fellow journalists, for whom the possibilities of slander were a fine reason to get out of bed in the morning. The very sensible recourse for those so injured was to shoot at editors and pummel writers. If the writers happened to be strapping, six-foot war veterans like Bierce who carried a gun, their targets could only seethe. Bierce was sued for libel only once, and his response—a salvo of savage columns, each making his enemy look more and more foolish—led to the suit being dropped altogether. Some of his colleagues fenced with him in print, but not for long; he was a better hater and a sharper wit.

He had also become quite a man about town. Always more comfortable in saloons than salons, he was a familiar and genial sight. With other journalists and writers like Charles Warren Stoddard and Jimmy Bowman, he was often in the bars along Market Street and the lower edge of the Barbary Coast.

Somehow, Bierce met an attractive and respectable young woman named Mollie Day. Her father, a mining engineer, was quite prosperous, but in San Francisco's already rigid caste system, he was far down in the pecking order. Her mother was a socially ambitious dragon who, of course, thoroughly disapproved of Bierce. Had he known that she was to become part of the package he was buying, he would undoubtedly have fled.

After a courtship of about a year, Bierce and Mollie were wed

on Christmas Day, 1871. Mr. Day came down from Utah, where he wisely spent all his time, to give his daughter away and to present the couple with the money for an extended stay in England. (He probably felt, with the wisdom of age and certainly experience, that it would be good to put distance between the couple and Mrs. Day.)

It was an odd, stagnant time in California anyway. Most of the great mining fortunes had been made and now fueled a relentless and often ruthless commerce. Real-estate deals were manipulated for the benefit of what would come to be called agribusiness—notably, large wheat and cotton farms. The bankers exploited the overheated financial climate, and the railroads and farms exploited labor. Homesteaders were suddenly turned into squatters when their land was sold out from under them, and the tolerance for which San Francisco was noted was disappearing. Mark Twain, Bret Harte, and other literary lights who had enlivened the scene had left. Bierce, for whom San Francisco had never been a destination anyway, found it quite easy to decamp. After all, there was no shortage of fools and foolishness elsewhere in the world.

Bierce took to London immediately, and the journalists and publicans of the city returned the favor. As he had been published, quoted, and commented upon in England, he had no difficulty finding writing work; London has always had a tradition of irreverent and satirical newspapers and magazines, and Bierce fit right into the scene.

He began producing satirical fables for *Fun* magazine, run by the legendary toper and wit Tom Hood, and wrote a column in *Figaro* magazine along the lines of his San Francisco work. In less than a year, he had published his first book, a collection of sketches drawn primarily from the *News Letter*. Entitled *The Fiend's Delight*, it was well received but made him little money. The same was true of another collection the following year, *Nuggets and Dust*, also a recycling mostly of his San Francisco work. *Cobwebs from an Empty Skull*, a collection of his British work, came in the third year, from his third publisher, and advanced his fortunes not at all.

Mr. Day's wedding gift had long ago run out, and Bierce was experiencing not only the fate of writing for his life, but also of parenthood and son-in-lawdom. The writing grind and London fog had exacerbated his asthma, so Mollie and he had shifted homes from Bristol to Bath to Hampstead Heath, acquiring along the way two sons and Mrs. Day. Bierce spent more and more time endangering his health roistering with his friends in London, and his family finally left him to return to America. After a few months, Mollie sent Bierce word that she was again pregnant; his existence had grown somewhat precarious

anyway, and tired of "lack of sleep, hard work and unchristian cooking," he returned home immediately.

San Francisco in 1875 was a town fallen upon hard times—William Ralston's Bank of California had just failed, the value of shares in the Comstock Lode mines had dropped $42 million in a week, and thousands of men were out of work. The seeds of speculation and money-churning had come to bitter fruition.

There was no work for Bierce, either, so he went back to the U.S. Mint, where he spent the next year and a half, until a new publication, the *Argonaut,* was launched. Bierce was listed as associate editor, though in fact he pretty much ran the paper and revived his column, now called "Prattle." He also wrote sketches and poems, mostly satirical.

The job lasted until late 1879. Bierce had made the *Argonaut* a leading paper but quarreled often with the publisher, Frank Pixley. Bierce had moved his family to San Rafael earlier and settled for a role as only a columnist, but when Mrs. Day moved in with him, he moved out altogether, following the lead of his father-in-law by going to the gold fields, in his case to the Dakota Territory.

He was back in less than a year, broke, discouraged, and then enraged when Pixley wouldn't hire him back. (Bierce reviled him unceasingly from then on, all the way to the grave; when Pixley died, Bierce's epitaph was, "Here lies Frank Pixley—as usual.") He was forced to freelance, scrounging out a living again. In 1881, the new owner of *Wasp,* another satirical weekly, hired him in an effort to boost circulation.

Bierce was the editor and had a free hand now. His first official act was to appoint himself as a columnist, reviving "Prattle." He then began a section composed of epigrams, most contributed by himself; the definitions that became *The Devil's Dictionary* made up a large part of it.

In the four years that he wrote for *Wasp,* he created some of his best work, but, as usual, the circumstances weren't easy. His first publisher turned out to be a crook who siphoned his company's money into his pockets by way of the magazine; Bierce threatened to expose him, and the man sold out to another who eventually turned the paper into a vehicle for his own political self-interest. The resulting controversy gave comfort to Bierce's many enemies, although Bierce wasn't involved in the chicanery.

In 1885, the magazine was sold yet again, and Bierce was out of work yet again. Having inveighed against most of the other newspapers in town, he was apparently unemployable, to boot.

One day there was a hesitant knock on his door. Bierce opened it to find a diffident young man. He later described the scene this way:

"I am from the *San Francisco Examiner,*" he explained in a voice like the fragrance of violets made audible, and backed a little away.

"Oh," I said, "you come from Mr. Hearst." Then that unearthly child lifted its blue eyes and cooed: "I am Mr. Hearst."

Within a few minutes, one of the most unlikely alliances in American letters had been formed; the two men agreed on little but the necessity of raising hell and the circulation of the *Examiner,* thumping the railroad barons hard and often, and ignoring convention as much as possible. Bierce agreed to write two "Prattle" columns a week for thirty-five dollars and a promise that his copy would not be edited. The association with Hearst lasted twenty-three frequently stormy years.

Bierce now had a larger readership than ever, a steady and more than decent income, and the companionship of the wonderfully eccentric, hard-drinking staff Hearst had assembled. (Hearst used to say, referring to his reporters, that even though he didn't drink, he suffered from the drink habit.) Whatever satisfaction Bierce felt didn't last long, however. After a bitter quarrel with his loyal wife, he formalized his neglectfulness by officially separating from her, and shortly thereafter his eldest son committed suicide after losing a brawl over a girl.

Bierce had suffered from asthma all his life and aggravated it with his habits of hard work and drinking. Where before, he had fled the climate of San Francisco from time to time ("In London, they call the air smog, after the combination of smoke and fog; given the blend of dust and fog in San Francisco, I propose we call it dog"), he now became a nomad, living back and forth in Oakland, Sunol, Angwin, Los Gatos, St. Helena, and San Francisco.

Hearst published a number of Bierce's Civil War stories, and other publishers his supernatural tales. As his reputation grew, Bierce became more and more the literary arbiter of the West. He soothed the pains of family losses with a growing circle of protégés and disciples. The price of admission to this group was admiration of Bierce, a willingness to follow his advice, and great care not to offend him—an impossible challenge that, in the end, even the most syncophantic was unable to meet. Given the criteria, many of the anointed never amounted to much, but several who broke away early, like Edwin Markham and Gertrude Atherton, did quite well.

The same could not be said for Bierce's more ambitious work.

Several more collections of his stories and essays appeared and added to his reputation, but none appealed to a very wide public.

His reputation for audacious calumny grew rapidly in 1900, when, now living in Washington, D.C., he carelessly tossed off a poem after Governor Goebel of Kentucky was assassinated:

> The bullet that pierced Goebel's breast
> Can not be found in all the West;
> Good reason, it is speeding here
> To stretch McKinley on his bier.

Hearst was planning to run for president against McKinley in 1904, which may be why the poem was allowed to see print. Unfortunately, less than a year later McKinley was assassinated. The vicious attacks of Hearst and Bierce on him—especially this brutal bit of doggerel—were resurrected and turned against them by other papers and the administration of Theodore Roosevelt, uplifted from vice president to the "bully pulpit." Hearst's political ambitions were destroyed, and the glory that Bierce had recently accrued by exposing and helping to defeat the railroad barons' attempt to cheat the public out of millions of dollars was tarnished.

The episode did bring him in contact with Walter Neale, a wealthy young publisher who became Bierce's leading fan. After Bierce was transferred to *Cosmopolitan* magazine by Hearst, where his "Prattle" column ran once a month, Bierce slowed to a pace more appropriate for a man of sixty-three. He had a live-in female secretary, withdrew from some of his clubs, and began to collect his work, cheerfully and even a little coyly agreeing to Neale's suggestion that it be published in a multivolume set, beautifully printed and bound, to sell for one hundred dollars. The younger Bierce would have chortled at the idea of a writer whose books had rarely been successful enough to sell out their first printings undertaking such a venture, but the older Bierce, proud, egoistic, and defiant, steamed ahead, succumbing to the very kind of foolishness he had so often lampooned in others.

He was his own worst editor, including about three times as much material as was any good, unable to discard nearly anything he could lay hands upon, scraping the bottom of the barrel when Neale decided to print several extra volumes, and ignoring the criticism as the books began to appear; he even wrote some new material. The good work was so mixed up with the bad—there is no one volume that is unblended—that the whole project was a miserable failure. Surveying the ruins, Bierce rose to the occasion with his old form:

My, how my fame rings out in every zone—
A thousand critics shouting, "He's unknown!"

He wandered again, back to California for a while, but,
unhappy there, he continued moving. He visited Civil War battlefields
and other places he'd known—except for Indiana—and then, in 1913,
set out for Mexico. "This fighting in Mexico interests me," he wrote.
"I want to go down and see if these Mexicans shoot straight."

In a letter to his nephew's wife, he revealed what was perhaps
his truer purpose: "If you should hear of my being stood up against a
Mexican stone wall and shot to rags please know that I think it is a
pretty good way to depart this life. It beats old age, disease or fall-
ing down the cellar stairs. To be a Gringo in Mexico—ah, that is
euthanasia!"

The day after Christmas in 1913, he sent a letter to his secre-
tary, saying he was traveling with Pancho Villa's ragtag army, hoping to
see a major battle. He was never heard from again.

For many people, nothing became him in life as much as his
manner of leaving it. Fantastic stories sprang up about him and, given
the macabre bent in his writing, were believed—he was in South
America, he was in England advising Lord Kitchener on the conduct of
the European war, he was in the mental hospital at Napa. The specula-
tion continued for twenty years, but no trace of Bierce was ever found.

Over the years, his best work has been in and out of vogue,
depending on the temper of the times and society's requirements for
politeness or pessimism in the face of snake-oil salesmen in the guise of
statesmen, lawmakers, evangelicals, military peacemakers, and phi-
losophers. That has always been too narrow a standard; the judgement
of history is neither timely nor harsh enough, especially in a global
village armed to the teeth. The terrible swift sword of satire is not a
bad defense at all.

STORIES OF THE CIVIL WAR

For better and worse, Bierce was shaped as a man and a writer by his experience in the war. As a foot soldier he saw death firsthand, heroism, criminal stupidity, cupidity, and waste. Christians killed Christians, and self-interest ruled over proclaimed principles. "They were honest and courageous foemen, having little in common with the political madmen who had persuaded them to their doom," he wrote of the multitude of dead soldiers. "Their valor was not the fury of the non-combatant; they have no voice in the thunder of civilians."

The combination of memory, unflinching observation, and reporting skill made his realistic fiction a guidelight for the next generation of American writers, soon to confront wars of their own. His haunted him all his life. "To this day I cannot look over a landscape without noting the advantages of the ground for attack or defense," he wrote much later. "I never hear a rifle-shot without a thrill in my veins. I never catch the peculiar odor of gunpowder without having visions of the dead and dying." On his way to death in Mexico, he toured the battlefields of his youth, stalking through each on foot for miles, a solitary figure reflecting on what he had come to think of as the best times of his life.

A HORSEMAN IN THE SKY

One sunny afternoon in the autumn of the year 1861 a soldier lay in a clump of laurel by the side of a road in western Virginia. He lay at full length upon his stomach, his feet resting upon the toes, his head upon the left forearm. His extended right hand loosely grasped his rifle. But for the somewhat methodical disposition of his limbs and a slight rhythmic movement of the cartridge-box at the back of his belt he might have been thought to be dead. He was asleep at his post of duty. But if detected he would be dead shortly afterward, death being the just and legal penalty of his crime.

The clump of laurel in which the criminal lay was in the angle of a road which after ascending southward a steep acclivity to that point turned sharply to the west, running along the summit for perhaps one hundred yards. There it turned southward again and went zigzagging

downward through the forest. At the salient of that second angle was a large flat rock, jutting out northward, overlooking the deep valley from which the road ascended. The rock capped a high cliff; a stone dropped from its outer edge would have fallen sheer downward one thousand feet to the tops of the pines. The angle where the soldier lay was on another spur of the same cliff. Had he been awake he would have commanded a view, not only of the short arm of the road and the jutting rock, but of the entire profile of the cliff below it. It might well have made him giddy to look.

The country was wooded everywhere except at the bottom of the valley to the northward, where there was a small natural meadow, through which flowed a stream scarcely visible from the valley's rim. This open ground looked hardly larger than an ordinary door-yard, but was really several acres in extent. Its green was more vivid than that of the inclosing forest. Away beyond it rose a line of giant cliffs similar to those upon which we are supposed to stand in our survey of the savage scene, and through which the road had somehow made its climb to the summit. The configuration of the valley, indeed, was such that from this point of observation it seemed entirely shut in, and one could but have wondered how the road which found a way out of it had found a way into it, and whence came and whither went the waters of the stream that parted the meadow more than a thousand feet below.

No country is so wild and difficult but men will make it a theatre of war; concealed in the forest at the bottom of that military rat-trap, in which half a hundred men in possession of the exits might have starved an army to submission, lay five regiments of Federal infantry. They had marched all the previous day and night and were resting. At nightfall they would take to the road again, climb to the place where their unfaithful sentinel now slept, and descending the other slope of the ridge fall upon a camp of the enemy at about midnight. Their hope was to surprise it, for the road led to the rear of it. In case of failure, their position would be perilous in the extreme; and fail they surely would should accident or vigilance apprise the enemy of the movement.

■

The sleeping sentinel in the clump of laurel was a young Virginian named Carter Druse. He was the son of wealthy parents, an only child, and had known such ease and cultivation and high living as wealth and taste were able to command in the mountain country of western Virginia. His home was but a few miles from where he now lay. One morning he had risen from the breakfast-table and said, quietly but gravely: "Father, a Union regiment has arrived at Grafton. I am going to join it."

The father lifted his leonine head, looked at the son a moment in silence, and replied: "Well, go, sir, and whatever may occur do what you conceive to be your duty. Virginia, to which you are a traitor, must get on without you. Should we both live to the end of the war, we will speak further of the matter. Your mother, as the physician has informed you, is in a most critical condition; at the best she cannot be with us longer than a few weeks, but that time is precious. It would be better not to disturb her."

So Carter Druse, bowing reverently to his father, who returned the salute with a stately courtesy that masked a breaking heart, left the home of his childhood to go soldiering. By conscience and courage, by deeds of devotion and daring, he soon commended himself to his fellows and his officers; and it was to these qualities and to some knowledge of the country that he owed his selection for his present perilous duty at the extreme outpost. Nevertheless, fatigue had been stronger than resolution and he had fallen asleep. What good or bad angel came in a dream to rouse him from his state of crime, who shall say? Without a movement, without a sound, in the profound silence and the languor of the late afternoon, some invisible messenger of fate touched with unsealing finger the eyes of his consciousness—whispered into the ear of his spirit the mysterious awakening word which no human lips ever have spoken, no human memory ever has recalled. He quietly raised his forehead from his arm and looked between the masking stems of the laurels, instinctively closing his right hand about the stock of his rifle.

His first feeling was a keen artistic delight. On a colossal pedestal, the cliff,—motionless at the extreme edge of the capping rock and sharply outlined against the sky,—was an equestrian statue of impressive dignity. The figure of the man sat the figure of the horse, straight and soldierly, but with the repose of a Grecian god carved in the marble which limits the suggestion of activity. The gray costume harmonized with its aerial background; the metal of accoutrement and caparison was softened and subdued by the shadow; the animal's skin had no points of high light. A carbine strikingly foreshortened lay across the pommel of the saddle, kept in place by the right hand grasping it at the "grip"; the left hand, holding the bridle rein, was invisible. In silhouette against the sky the profile of the horse was cut with the sharpness of a cameo; it looked across the heights of air to the confronting cliffs beyond. The face of the rider, turned slightly away, showed only an outline of temple and beard; he was looking downward to the bottom of the valley. Magnified by its lift against the sky and by the soldier's testifying sense of the formidableness of a near enemy the group appeared of heroic, almost colossal, size.

For an instant Druse had a strange, half-defined feeling that he had slept to the end of the war and was looking upon a noble work of art reared upon that eminence to commemorate the deeds of an heroic past of which he had been an inglorious part. The feeling was dispelled by a slight movement of the group: the horse, without moving its feet, had drawn its body slightly backward from the verge; the man remained immobile as before. Broad awake and keenly alive to the significance of the situation, Druse now brought the butt of his rifle against his cheek by cautiously pushing the barrel forward through the bushes, cocked the piece, and glancing through the sights covered a vital spot of the horseman's breast. A touch upon the trigger and all would have been well with Carter Druse. At that instant the horseman turned his head and looked in the direction of his concealed foeman—seemed to look into his very face, into his eyes, into his brave, compassionate heart.

Is it then so terrible to kill an enemy in war—an enemy who has surprised a secret vital to the safety of one's self and comrades—an enemy more formidable for his knowledge than all his army for its numbers? Carter Druse grew pale; he shook in every limb, turned faint, and saw the statuesque group before him as black figures, rising, falling, moving unsteadily in arcs of circles in a fiery sky. His hand fell away from his weapon, his head slowly dropped until his face rested on the leaves in which he lay. This courageous gentleman and hardy soldier was near swooning from intensity of emotion.

It was not for long; in another moment his face was raised from earth, his hands resumed their places on the rifle, his forefinger sought the trigger; mind, heart, and eyes were clear, conscience and reason sound. He could not hope to capture that enemy; to alarm him would but send him dashing to his camp with his fatal news. The duty of the soldier was plain: the man must be shot dead from ambush—without warning, without a moment's spiritual preparation, with never so much as an unspoken prayer, he must be sent to his account. But no—there is a hope; he may have discovered nothing—perhaps he is but admiring the sublimity of the landscape. If permitted, he may turn and ride carelessly away in the direction whence he came. Surely it will be possible to judge at the instant of his withdrawing whether he knows. It may well be that his fixity of attention—Druse turned his head and looked through the deeps of air downward, as from the surface to the bottom of a translucent sea. He saw creeping across the green meadow a sinuous line of figures of men and horses—some foolish commander was permitting the soldiers of his escort to water their beasts in the open, in plain view from a dozen summits!

Druse withdrew his eyes from the valley and fixed them again upon the group of man and horse in the sky, and again it was through the

sights of his rifle. But this time his aim was at the horse. In his memory, as if they were a divine mandate, rang the words of his father at their parting: "Whatever may occur, do what you conceive to be your duty." He was calm now. His teeth were firmly but not rigidly closed; his nerves were as tranquil as a sleeping babe's—not a tremor affected any muscle of his body; his breathing, until suspended in the act of taking aim, was regular and slow. Duty had conquered; the spirit had said to the body: "Peace, be still." He fired.

■

An officer of the Federal force, who in a spirit of adventure or in quest of knowledge had left the hidden *bivouac* in the valley, and with aimless feet had made his way to the lower edge of a small open space near the foot of the cliff, was considering what he had to gain by pushing his exploration further. At a distance of a quarter-mile before him, but apparently at a stone's throw, rose from its fringe of pines the gigantic face of rock, towering to so great a height above him that it made him giddy to look up to where its edge cut a sharp, rugged line against the sky. It presented a clean, vertical profile against a background of blue sky to a point half the way down, and of distant hills, hardly less blue, thence to the tops of the trees at its base. Lifting his eyes to the dizzy altitude of its summit the officer saw an astonishing sight—a man on horseback riding down into the valley through the air!

Straight upright sat the rider, in military fashion, with a firm seat in the saddle, a strong clutch upon the rein to hold his charger from too impetuous a plunge. From his bare head his long hair streamed upward, waving like a plume. His hands were concealed in the cloud of the horse's lifted mane. The animal's body was as level as if every hoofstroke encountered the resistant earth. Its motions were those of a wild gallop, but even as the officer looked they ceased, with all the legs thrown sharply forward as in the act of alighting from a leap. But this was a flight!

Filled with amazement and terror by this apparition of a horseman in the sky—half believing himself the chosen scribe of some new Apocalypse, the officer was overcome by the intensity of his emotions; his legs failed him and he fell. Almost at the same instant he heard a crashing sound in the trees—a sound that died without an echo—and all was still.

The officer rose to his feet, trembling. The familiar sensation of an abraded shin recalled his dazed faculties. Pulling himself together he ran obliquely away from the cliff to a point distant from its foot; thereabout he expected to find his man; and thereabout he naturally failed. In the fleeting instant of his vision his imagination had been so wrought upon the apparent grace and ease and intention of the marvelous perfor-

mance that it did not occur to him that the line of march of aërial cavalry is directly downward, and that he could find the objects of his search at the very foot of the cliff. A half-hour later he returned to camp.

This officer was a wise man; he knew better than to tell an incredible truth. He said nothing of what he had seen. But when the commander asked him if in his scout he had learned anything of advantage to the expedition he answered:

"Yes, sir; there is no road leading down into this valley from the southward."

The commander, knowing better, smiled.

■

After firing his shot, Private Carter Druse reloaded his rifle and resumed his watch. Ten minutes had hardly passed when a Federal sergeant crept cautiously to him on hands and knees. Druse neither turned his head nor looked at him, but lay without motion or sign of recognition.

"Did you fire?" the sergeant whispered.

"Yes."

"At what?"

"A horse. It was standing on yonder rock—pretty far out. You see it is no longer there. It went over the cliff."

The man's face was white, but he showed no other sign of emotion. Having answered, he turned away his eyes and said no more. The sergeant did not understand.

"See here, Druse," he said, after a moment's silence, "It's no use making a mystery. I order you to report. Was there anybody on the horse?"

"Yes."

"Well?"

"My father."

The sergeant rose to his feet and walked away. "Good God!" he said.

AN OCCURRENCE AT OWL CREEK BRIDGE

A man stood upon a railroad bridge in northern Alabama, looking down into the swift water twenty feet below. The man's hands were behind his back, the wrists bound with a cord. A rope closely encircled his neck. It was attached to a stout cross-timber above his head and the slack fell to the level of his knees. Some loose boards laid upon the sleepers support-

ing the metals of the railway supplied a footing for him and his executioners—two private soldiers of the Federal army, directed by a sergeant who in civil life may have been a deputy sheriff. At a short remove upon the same temporary platform was an officer in the uniform of his rank, armed. He was a captain. A sentinel at each end of the bridge stood with his rifle in the position known as "support," that is to say, vertical in front of the left shoulder, the hammer resting on the forearm thrown straight across the chest—a formal and unnatural position, enforcing an erect carriage of the body. It did not appear to be the duty of these two men to know what was occurring at the centre of the bridge; they merely blockaded the two ends of the foot planking that traversed it.

Beyond one of the sentinels nobody was in sight; the railroad ran straight away into a forest for a hundred yards, then, curving, was lost to view. Doubtless there was an outpost farther along. The other bank of the stream was open ground—a gentle acclivity topped with a stockade of vertical tree trunks, loop-holed for rifles, with a single enbrasure through which protruded the muzzle of a brass cannon commanding the bridge. Midway of the slope between bridge and fort were the spectators—a single company of infinity in line, at "parade rest," the butts of the rifles on the ground, the barrels inclining slightly backward against the right shoulder, the hands crossed upon the stock. A lieutenant stood at the right of the line, the point of his sword upon the ground, his left hand resting upon his right. Excepting the group of four at the centre of the bridge, not a man moved. The company faced the bridge, staring stonily, motionless. The sentinels, facing the banks of the stream, might have been statues to adorn the bridge. The captain stood with folded arms, silent, observing the work of his subordinates, but making no sign. Death is a dignitary who when he comes announced is to be received with formal manifestations of respect, even by those most familiar with him. In the code of military etiquette silence and fixity are forms of deference.

The man who was engaged in being hanged was apparently about thirty-five years of age. He was a civilian, if one might judge from his habit, which was that of a planter. His features were good—a straight nose, firm mouth, broad forehead, from which his long, dark hair was combed straight back, falling behind his ears to the collar of his well-fitting frock-coat. He wore a mustache and pointed beard, but no whiskers; his eyes were large and dark gray, and had a kindly expression which one would hardly have expected in one whose neck was in the hemp. Evidently this was no vulgar assassin. The liberal military code makes provision for hanging many kinds of persons, and gentlemen are not excluded.

The preparations being complete, the two private soldiers

stepped aside and each drew away the plank upon which he had been standing. The sergeant turned to the captain, saluted and placed himself immediately behind that officer, who in turn moved apart one pace. These movements left the condemned man and the sergeant standing on the two ends of the same plank, which spanned three of the cross-ties of the bridge. The end upon which the civilian stood almost, but not quite, reached a fourth. This plank had been held in place by the weight of the captain; it was now held by that of the sergeant. At a signal from the former the latter would step aside, the plank would tilt and the condemned man go down between two ties. The arrangement commended itself to his judgment as simple and effective. His face had not been covered nor his eyes bandaged. He looked a moment at his "unsteadfast footing," then let his gaze wander to the swirling water of the stream racing madly beneath his feet. A piece of dancing driftwood caught his attention and his eyes followed it down the current. How slowly it appeared to move! What a sluggish stream!

He closed his eyes in order to fix his last thoughts upon his wife and children. The water, touched to gold by the early sun, the brooding mists under the banks at some distance down the stream, the fort, the soldiers, the piece of drift—all had distracted him. And now he became conscious of a new disturbance. Striking through the thought of his dear ones was a sound which he could neither ignore nor understand, a sharp, distinct, metallic percussion like the stroke of a blacksmith's hammer upon the anvil; it had the same ringing quality. He wondered what it was, and whether immeasurably distant or near by—it seemed both. Its recurrence was regular, but as slow as the tolling of a death knell. He awaited each stroke with impatience and—he knew not why—apprehension. The intervals of silence grew progressively longer; the delays became maddening. With their greater infrequency the sounds increased in strength and sharpness. They hurt his ear like the thrust of a knife; he feared he would shriek. What he heard was the ticking of his watch.

He unclosed his eyes and saw again the water below him. "If I could free my hands," he thought, "I might throw off the noose and spring into the stream. By diving I could evade the bullets and, swimming vigorously, reach the bank, take to the woods and get away home. My home, thank God, is as yet outside their lines; my wife and little ones are still beyond the invader's farthest advance."

As these thoughts, which have here to be set down in words, were flashed into the doomed man's brain rather than evolved from it the captain nodded to the sergeant. The sergeant stepped aside.

■

Peyton Farquhar was a well-to-do planter, of an old and highly respected Alabama family. Being a slave owner and like other slave

owners a politician he was naturally an original secessionist and ardently devoted to the Southern cause. Circumstances of an imperious nature, which it is unnecessary to relate here, had prevented him from taking service with the gallant army that had fought the disastrous campaigns ending with the fall of Corinth, and he chafed under the inglorious restraint, longing for the release of his energies, the larger life of the soldier, the opportunity for distinction. That opportunity, he felt, would come, as it comes to all in war time. Meanwhile he did what he could. No service was too humble for him to perform in aid of the South, no adventure too perilous for him to undertake if consistent with the character of a civilian who was at heart a soldier, and who in good faith and without too much qualification assented to at least a part of the frankly villainous dictum that all is fair in love and war.

One evening while Farquhar and his wife were sitting on a rustic bench near the entrance to his grounds, a gray-clad soldier rode up to the gate and asked for a drink of water. Mrs. Farquhar was only too happy to serve him with her own white hands. While she was fetching the water her husband approached the dusty horseman and inquired eagerly for news from the front.

"The Yanks are repairing the railroads," said the man, "and are getting ready for another advance. They have reached the Owl Creek bridge, put it in order and built a stockade on the north bank. The commandant has issued an order, which is posted everywhere, declaring that any civilian caught interfering with the railroad, its bridges, tunnels or trains will be summarily hanged. I saw the order."

"How far is it to the Owl Creek bridge?" Farquhar asked.

"About thirty miles."

"Is there no force on this side the creek?"

"Only a picket post half a mile out, on the railroad, and a single sentinel at this end of the bridge."

"Suppose a man—a civilian and student of hanging—should elude the picket post and perhaps get the better of the sentinel," said Farquhar, smiling, "what could he accomplish?"

The soldier reflected. "I was there a month ago," he replied. "I observed that the flood of last winter had lodged a great quantity of driftwood against the wooden pier at this end of the bridge. It is now dry and would burn like tow."

The lady had now brought the water, which the soldier drank. He thanked her ceremoniously, bowed to her husband and rode away. An hour later, after nightfall, he repassed the plantation, going northward in the direction from which he had come. He was a Federal scout.

■

As Petyon Farquhar fell straight downward through the bridge he lost consciousness and was as one already dead. From this state he was awakened—ages later, it seemed to him—by the pain of a sharp pressure upon his throat, followed by a sense of suffocation. Keen, poignant agonies seemed to shoot from his neck downward through every fibre of his body and limbs. These pains appeared to flash along well-defined lines of ramification and to beat with an inconceivably rapid periodicity. They seemed like streams of pulsating fire heating him to an intolerable temperature. As to his head, he was conscious of nothing but a feeling of fulness—of congestion. These sensations were unaccompanied by thought. The intellectual part of his nature was already effaced; he had power only to feel, and feeling was torment. He was conscious of motion. Encompassed in a luminous cloud, of which he was now merely the fiery heart, without material substance, he swung through unthinkable arcs of oscillation, like a vast pendulum. Then all at once, with terrible suddenness, the light about him shot upward with the noise of a loud plash; a frightful roaring was in his ears, and all was cold and dark. The power of thought was restored; he knew that the rope had broken and he had fallen into the stream. There was no additional strangulation; the noose about his neck was already suffocating him and kept the water from his lungs. To die of hanging at the bottom of a river!—the idea seemed to him ludicrous. He opened his eyes in the darkness and saw above him a gleam of light, but how distant, how inaccessible! He was still sinking, for the light became fainter and fainter until it was a mere glimmer. Then it began to grow and brighten, and he knew that he was rising toward the surface—knew it with reluctance, for he was now very comfortable. "To be hanged and drowned," he thought, "that is not so bad; but I do not wish to be shot. No; I will not be shot; that is not fair."

He was not conscious of an effort, but a sharp pain in his wrist apprised him that he was trying to free his hands. He gave the struggle his attention, as an idler might observe the feat of a juggler, without interest in the outcome. What splendid effort!—what magnificent, what superhuman strength! Ah, that was a fine endeavor! Bravo! The cord fell away; his arms parted and floated upward, the hands dimly seen on each side in the growing light. He watched them with a new interest as first one and then the other pounced upon the noose at his neck. They tore it away and thrust it fiercely aside, its undulations resembling those of a water-snake. "Put it back, put it back!" He thought he shouted these words to his hands, for the undoing of the noose had been succeeded by the direst pang that he had yet experienced. His neck ached horribly; his brain was on fire; his heart, which had been fluttering faintly, gave a great leap, trying to force itself out at his mouth. His whole body was racked and wrenched with an insupportable anguish!

But his disobedient hands gave no heed to the command. They beat the water vigorously with quick, downward strokes, forcing him to the surface. He felt his head emerge; his eyes were blinded by the sunlight; his chest expanded convulsively, and with a supreme and crowning agony his lungs engulfed a great draught of air, which instantly he expelled in a shriek!

He was now in full possession of his physical senses. They were, indeed, preternaturally keen and alert. Something in the awful disturbance of his organic system had so exalted and refined them that they made record of things never before perceived. He felt the ripples upon his face and heard their separate sounds as they struck. He looked at the forest on the bank of the stream, saw the individual trees, the leaves and the veining of each leaf—saw the very insects upon them: the locusts, the brilliant-bodied flies, the gray spiders stretching their webs from twig to twig. He noted the prismatic colors in all the dewdrops upon a million blades of grass. The humming of the gnats that danced above the eddies of the stream, the beating of the dragon-flies' wings, the strokes of the water-spiders' legs, like oars which had lifted their boat— all these made audible music. A fish slid along beneath his eyes and he heard the rush of its body parting the water.

He had come to the surface facing down the stream; in a moment the visible world seemed to wheel slowly round, himself the pivotal point, and he saw the bridge, the fort, the soldiers upon the bridge, the captain, the sergeant, the two privates, his executioners. They were in silhouette against the blue sky. They shouted and gesticulated, pointing at him. The captain had drawn his pistol, but did not fire; the others were unarmed. Their movements were grotesque and horrible, their forms gigantic.

Suddenly he heard a sharp report and something struck the water smartly within a few inches of his head, spattering his face with spray. He heard a second report, and saw one of the sentinels with his rifle at his shoulder, a light cloud of blue smoke rising from the muzzle. The man in the water saw the eye of the man on the bridge gazing into his own through the sights of the rifle. He observed that it was a gray eye and remembered having read that gray eyes were keenest, and that all famous markmen had them. Nevertheless, this one had missed.

A counter-swirl had caught Farquhar and turned him half round; he was again looking into the forest on the bank opposite the fort. The sound of a clear, high voice in a monotonous singsong now rang out behind him and came across the water with a distinctness that pierced and subdued all other sounds, even the beating of the ripples in his ears. Although no soldier, he had frequented camps enough to know the dread significance of that deliberate, drawling, aspirated chant; the lieutenant

on shore was taking a part in the morning's work. How coldly and pitilessly—with what an even, calm intonation, presaging, and enforcing tranquillity in the men—with what accurately measured intervals fell those cruel words:

"Attention, company! . . . Shoulder arms! . . . Ready! . . . Aim! . . . Fire!"

Farquhar dived—dived as deeply as he could. The water roared in his ears like the voice of Niagara, yet he heard the dulled thunder of the volley and, rising again toward the surface, met shining bits of metal, singularly flattened, oscillating slowly downward. Some of them touched him on the face and hands, then fell away, continuing their descent. One lodged between his collar and neck; it was uncomfortably warm and he snatched it out.

As he rose to the surface, gasping for breath, he saw that he had been a long time under water; he was perceptibly father down stream—nearer to safety. The soldiers had almost finished reloading; the metal ramrods flashed all at once in the sunshine as they were drawn from the barrels, turning in the air, and thrust into their sockets. The two sentinels fired again, independently and ineffectually.

The hunted man saw all this over his shoulder; he was now swimming vigorously with the current. His brain was as energetic as his arms and legs; he thought with the rapidity of lightning.

"The officer," he reasoned, "will not make that martinet's error a second time. It is as easy to dodge a volley as a single shot. He has probably already given the command to fire at will. God help me, I cannot dodge them all!"

An appalling plash within two yards of him was followed by a loud, rushing sound, *diminuendo,* which seemed to travel back through the air to the fort and died in an explosion which stirred the very river to its deeps! A rising sheet of water curved over him, fell down upon him, blinded him, strangled him! The cannon had taken a hand in the game. As he shook his head free from the commotion of the smitten water he heard the deflected shot humming through the air ahead, and in an instant it was cracking and smashing the branches in the forest beyond.

"They will not do that again," he thought; "the next time they will use a charge of grape. I must keep my eye upon the gun; the smoke will apprise me—the report arrives too late; it lags behind the missile. That is a good gun."

Suddenly he felt himself whirled round and round—spinning like a top. The water, the banks, the forests, the now distant bridge, fort and men—all were commingled and blurred. Objects were represented by their colors only; circular horizontal streaks of color—that was all he saw. He had been caught in a vortex and was being whirled on with a

velocity of advance and gyration that made him giddy and sick. In a few moments he was flung upon the gravel at the foot of the left bank of the stream—the southern bank—and behind a projecting point which concealed him from his enemies. The sudden arrest of his motion, the abrasion of one of his hands on the gravel, restored him, and he wept with delight. He dug his fingers into the sand, threw it over himself in handfuls and audibly blessed it. It looked like diamonds, rubies, emeralds; he could think of nothing beautiful which it did not resemble. The trees upon the bank were giant garden plants; he noted a definite order in their arrangement, inhaled the fragrance of their blooms. A strange, roseate light shone through the spaces among their trunks and the wind made in their branches the music of æolian harps. He had no wish to perfect his escape—was content to remain in that enchanting spot until retaken.

A whiz and rattle of grapeshot among the branches high above his head roused him from his dream. The baffled cannoneer had fired him a random farewell. He sprang to his feet, rushed up the sloping bank, and plunged into the forest.

All that day he traveled, laying his course by the rounding sun. The forest seemed interminable; nowhere did he discover a break in it, not even a woodman's road. He had not known that he lived in so wild a region. There was something uncanny in the revelation.

By nightfall he was fatigued, footsore, famishing. The thought of his wife and children urged him on. At last he found a road which led him in what he knew to be the right direction. It was as wide and straight as a city street, yet it seemed untraveled. No fields bordered it, no dwelling anywhere. Not so much as the barking of a dog suggested human habitation. The black bodies of the trees formed a straight wall on both sides, terminating on the horizon in a point, like a diagram in a lesson in perspective. Overhead, as he looked up through this rift in the wood, shone great golden stars looking unfamiliar and grouped in strange constellations. He was sure they were arranged in some order which had a secret and malign significance. The wood on either side was full of singular noises, among which—once, twice, and again—he distinctly heard whispers in an unknown tongue.

His neck was in pain and lifting his hand to it he found it horribly swollen. He knew that it had a circle of black where the rope had bruised it. His eyes felt congested; he could no longer close them. His tongue was swollen with thirst; he relieved its fever by thrusting it forward from between his teeth into the cold air. How softly the turf had carpeted the untraveled avenue—he could no longer feel the roadway beneath his feet!

Doubtless, despite his suffering, he had fallen asleep while

walking, for now he sees another scene—perhaps he has merely recovered from a delirium. He stands at the gate of his own home. All is as he left it, and all bright and beautiful in the morning sunshine. He must have traveled the entire night. As he pushes open the gate and passes up the wide white walk, he sees a flutter of female garments; his wife, looking fresh and cool and sweet, steps down from the veranda to meet him. At the bottom of the steps she stands waiting, with a smile of ineffable joy, an attitude of matchless grace and dignity. Ah, how beautiful she is! He springs forward with extended arms. As he is about to clasp her he feels a stunning blow upon the back of the neck; a blinding white light blazes all about him with a sound like the shock of a cannon—then all is darkness and silence!

Peyton Farquhar was dead; his body, with a broken neck, swung gently from side to side beneath the timbers of the Owl Creek bridge.

CHICKAMAUGA

One sunny autumn afternoon a child strayed away from its rude home in a small field and entered a forest unobserved. It was happy in a new sense of freedom from control, happy in the opportunity of exploration and adventure; for this child's spirit, in bodies of its ancestors, had for thousands of years been trained to memorable feats of discovery and conquest—victories in battles whose critical moments were centuries, whose victors' camps were cities of hewn stone. From the cradle of its race it had conquered its way through two continents and passing a great sea had penetrated a third, there to be born to war and dominion as a heritage.

The child was a boy aged about six years, the son of a poor planter. In his younger manhood the father had been a soldier, had fought against naked savages and followed the flag of his country into the capital of a civilized race to the far South. In the peaceful life of a planter the warrior-fire survived; once kindled, it is never extinguished. The man loved military books and pictures and the boy had understood enough to make himself a wooden sword, though even the eye of his father would hardly have known it for what it was. This weapon he now bore bravely, as became the son of an heroic race, and pausing now and again in the sunny space of the forest assumed, with some exaggeration, the postures of aggression and defense that he had been taught by the engraver's art. Made reckless by the case with which he overcame invisible foes attempting to stay his advance, he committed the common enough military error of pushing the pursuit to a dangerous extreme, until he found himself upon the margin of a wide but shallow brook,

whose rapid waters barred his direct advance against the flying foe that had crossed with illogical ease. But the intrepid victor was not to be baffled; the spirit of the race which had passed the great sea burned unconquerable in that small breast and would not be denied. Finding a place where some bowlders in the bed of the stream lay but a step or a leap apart, he made his way across and fell again upon the rear-guard of his imaginary foe, putting all to the sword.

Now that the battle had been won, prudence required that he withdraw to his base of operations. Alas; like many a mightier conqueror, and like one, the mightiest, he could not

curb the lust for war,
Nor learn that tempted Fate will leave the loftiest
star.

Advancing from the bank of the creek he suddenly found himself confronted with a new and more formidable enemy: in the path that he was following, sat, bolt upright, with ears erect and paws suspended before it, a rabbit! With a startled cry the child turned and fled, he knew not in what direction, calling with inarticulate cries for his mother, weeping, stumbling, his tender skin cruelly torn by brambles, his little heart beating hard with terror—breathless, blind with tears— lost in the forest! Then, for more than an hour, he wandered with erring feet through the tangled undergrowth, till at last, overcome by fatigue, he lay down in a narrow space between two rocks, within a few yards of the stream and still grasping his toy sword, no longer a weapon but a companion, sobbed himself to sleep. The wood birds sang merrily above his head; the squirrels, whisking their bravery of tail, ran barking from tree to tree, unconscious of the pity of it, and somewhere far away was a strange, muffled thunder, as if the partridges were drumming in celebration of nature's victory over the son of her immemorial enslavers. And back at the little plantation, where white men and black were hastily searching the fields and hedges in alarm, a mother's heart was breaking for her missing child.

Hours passed, and then the little sleeper rose to his feet. The chill of the evening was in his limbs, the fear of the gloom in his heart. But he had rested, and he no longer wept. With some blind instinct which impelled to action he struggled through the undergrowth about him and came to a more open ground—on his right the brook, to the left a gentle acclivity studded with infrequent trees; over all, the gathering gloom of twilight. A thin, ghostly mist rose along the water. It frightened and repelled him; instead of recrossing, in the direction whence he had come, he turned his back upon it, and went forward toward the dark

inclosing wood. Suddenly he saw before him a strange moving object which he took to be some large animal—a dog, a pig—he could not name it; perhaps it was a bear. He had seen pictures of bears, but knew of nothing to their discredit and had vaguely wished to meet one. But something in form or movement of this object—something in the awkwardness of its approach—told him that it was not a bear, and curiosity was stayed by fear. He stood still and as it came slowly on gained courage every moment, for he saw that at least it had not the long, menacing ears of the rabbit. Possibly his impressionable mind was half conscious of something familiar in its shambling, awkward gait. Before it had approached near enough to resolve his doubts he saw that it was followed by another and another. To right and to left were many more; the whole open space about him was alive with them—all moving toward the brook.

They were men. They crept upon their hands and knees. They used their hands only, dragging their legs. They used their knees only, their arms hanging idle at their sides. They strove to rise to their feet, but fell prone in the attempt. They did nothing naturally, and nothing alike, save only to advance foot by foot in the same direction. Singly, in pairs and in little groups, they came on through the gloom, some halting now and again while others crept slowly past them, then resuming their movement. They came by dozens and by hundreds; as far on either hand as one could see the deepening gloom they extended and the black wood behind them appeared to be inexhaustible. The very ground seemed in motion toward the creek. Occasionally one who had paused did not again go on, but lay motionless. He was dead. Some, pausing, made strange gestures with their hands, erected their arms and lowered them again, clasped their heads; spread their palms upward, as men are sometimes seen to do in public prayer.

Not all of this did the child note; it is what would have been noted by an elder observer; he saw little but that these were men, yet crept like babes. Being men, they were not terrible, though unfamiliarly clad. He moved among them freely, going from one to another and peering into their faces with childish curiosity. All their faces were singularly white and many were streaked and gouted with red. Something in this—something too, perhaps, in their grotesque attitudes and movements—reminded him of the painted clown whom he had seen last summer in the circus, and he laughed as he watched them. But on and ever on they crept, these maimed and bleeding men, as heedless as he of the dramatic contrast between his laughter and their own ghastly gravity. To him it was a merry spectacle. He had seen his father's Negroes creep upon their hands and knees for his amusement—had ridden them so, "making believe" they were his horses. He now approached one

of these crawling figures from behind and with an agile movement mounted it astride. The man sank upon his breast, recovered, flung the small boy fiercely to the ground as an unbroken colt might have done, then turned upon him a face that lacked a lower jaw—from the upper teeth to the throat was a great red gap fringed with hanging shreds of flesh and splinters of bone. The unnatural prominence of nose, the absence of chin, the fierce eyes, gave this man the appearance of a great bird of prey crimsoned in throat and breast by the blood of its quarry. The man rose to his knees, the child to his feet. The man shook his fist at the child; the child, terrified at last, ran to a tree near by, got upon the farther side of it and took a more serious view of the situation. And so the clumsy multitude dragged itself slowly and painfully along in hideous pantomime—moved forward down the slope like a swarm of great black beetles, with never a sound of going—in silence profound, absolute.

Instead of darkening, the haunted landscape began to brighten. Through the belt of trees beyond the brook shone a strange red light, the trunks and branches of the trees making a black lacework against it. It struck the creeping figures and gave them monstrous shadows, which caricatured their movements on the lit grass. It fell upon their faces, touching their whiteness with a ruddy tinge, accentuating the stains with which so many of them were freaked and maculated. It sparkled on buttons and bits of metal in their clothing. Instinctively the child turned toward the growing splendor and moved down the slope with his horrible companions; in a few moments had passed the foremost of the throng—not much of a feat, considering his advantages. He placed himself in the lead, his wooden sword still in hand, and solemnly directed the march, conforming his pace to theirs and occasionally turning as if to see that his forces did not straggle. Surely such a leader never before had such a following.

Scattered about upon the ground now slowly narrowing by the encroachment of this awful march to water, were certain articles to which, in the leader's mind, were coupled no significant associations: an occasional blanket, tightly rolled lengthwise, doubled and the ends bound together with a string; a heavy knapsack here, and there a broken rifle—such things, in short, as are found in the rear of retreating troops, the "spoor" of men flying from their hunters. Everywhere near the creek, which here had a margin of lowland, the earth was trodden into mud by the feet of men and horses. An observer of better experience in the use of his eyes would have noticed that these footprints pointed in both directions; the ground had been twice passed over—in advance and in retreat. A few hours before, these desperate, stricken men, with their more fortunate and now distant comrades, had penetrated the forest in thousands. Their successive battalions, breaking into swarms and reforming

in lines, had passed the child on every side—had almost trodden on him as he slept. The rustle and murmur of their march had not awakened him. Almost within a stone's throw of where he lay they had fought a battle; but all unheard by him were the roar of the musketry, the shock of the cannon, "the thunder of the captains and the shouting." He had slept through it all, grasping his little wooden sword with perhaps a tighter clutch in unconscious sympathy with his martial environment, but as heedless of the grandeur of the struggle as the dead who had died to make the glory.

The fire beyond the belt of woods on the farther side of the creek, reflected to earth from the canopy of its own smoke, was now suffusing the whole landscape. It transformed the sinuous line of mist to the vapor of gold. The water gleamed with dashes of red, and red, too, were many of the stones protruding above the surface. But that was blood; the less desperately wounded had stained them in crossing. On them, too, the child now crossed with eager steps; he was going to the fire. As he stood upon the farther bank he turned about to look at the companions of his march. The advance was arriving at the creek. The stronger had already drawn themselves to the brink and plunged their faces into the flood. Three or four who lay without motion appeared to have no heads. At this the child's eyes expanded with wonder; even his hospitable understanding could not accept a phenomenon implying such vitality as that. After slaking their thirst these men had not had the strength to back away from the water, nor to keep their heads above it. They were drowned. In rear of these, the open spaces of the forest showed the leader as many formless figures of his grim command as at first; but not nearly so many were in motion. He waved his cap for their encouragement and smilingly pointed with his weapon in the direction of the guiding light—a pillar of fire to this strange exodus.

Confident of the fidelity of his forces, he now entered the belt of woods, passed through it easily in the red illumination, climbed a fence, ran across a field, turning now and again to coquet with his responsive shadow, and so approached the blazing ruin of a dwelling. Desolation everywhere! In all the wide glare not a living thing was visible. He cared nothing for that; the spectacle pleased, and he danced with glee in imitation of the wavering flames. He ran about, collecting fuel, but every object that he found was too heavy for him to cast in from the distance to which the heat limited his approach. In despair he flung in his sword—a surrender to the superior forces of nature. His military career was at an end.

Shifting his position, his eyes fell upon some outbuildings which had an oddly familiar appearance, as if he had dreamed of them. He stood considering them with wonder, when suddenly the entire

plantation, with its inclosing forest, seemed to turn as if upon a pivot. His little world swung half around; the points of the compass were reversed. He recognized the blazing building as his own home!

For a moment he stood stupefied by the power of the revelation, then ran with stumbling feet, making a half-circuit of the ruin. There, conspicuous in the light of the conflagration, lay the dead body of a woman—the white face turned upward, the hands thrown out and clutched full of grass, the clothing deranged, the long dark hair in tangles and full of clotted blood. The greater part of the forehead was torn away, and from the jagged hole the brain protruded, overflowing the temple, a frothy mass of gray, crowned with clusters of crimson bubbles—the work of a shell.

The child moved his little hands, making wild, uncertain gestures. He uttered a series of inarticulate and indescribable cries—something between the chattering of an ape and the gobbling of a turkey—a startling, soulless, unholy sound, the language of a devil. The child was a deaf mute.

Then he stood motionless, with quivering lips, looking down upon the wreck.

ONE OF THE MISSING

Jerome Searing, a private soldier of General Sherman's army, then confronting the enemy at and about Kennesaw Mountain, Georgia, turned his back upon a small group of officers with whom he had been talking in low tones, stepped across a light line of earthworks, and disappeared in a forest. None of the men in line behind the works had said a word to him, nor had he so much as nodded to them in passing, but all who saw understood that this brave man had been intrusted with some perilous duty. Jerome Searing, though a private, did not serve in the ranks; he was detailed for service at division headquarters, being borne upon the rolls as an orderly. "Orderly" is a word covering a multitude of duties. An orderly may be a messenger, a clerk, an officer's servant—anything. He may perform services for which no provision is made in orders and army regulations. Their nature may depend upon his aptitude, upon favor, upon accident. Private Searing, an incomparable marksman, young, hardy, intelligent and insensible to fear, was a scout. The general commanding his division was not content to obey orders blindly without knowing what was in his front, even when his command was not on detached service, but formed a fraction of the line of the army; nor was he satisfied to receive his knowledge of his *vis-à-vis* through the customary channels; he wanted to know more than he was apprised of by the corps commander and the collisions of pickets and skirmishers. Hence Jerome

Searing, with his extraordinary daring, his woodcraft, his sharp eyes, and truthful tongue. On this occasion his instructions were simple: to get as near the enemy's lines as possible and learn all that he could.

In a few moments he had arrived at the picket-line, the men on duty there lying in groups of two and four behind little banks of earth scooped out of the slight depression in which they lay, their rifles protruding from the green boughs with which they had masked their small defenses. The forest extended without a break toward the front, so solemn and silent that only by an effort of the imagination could it be conceived as populous with armed men, alert and vigilant—a forest formidable with possibilities of battle. Pausing a moment in one of these rifle-pits to apprise the men of his intention Searing crept stealthily forward on his hands and knees and was soon lost to view in a dense thicket of underbrush.

"That is the last of him," said one of the men; "I wish I had his rifle; those fellows will hurt some of us with it."

Searing crept on, taking advantage of every accident of ground and growth to give himself better cover. His eyes penetrated everywhere, his ears took note of every sound. He stilled his breathing, and at the cracking of a twig beneath his knee stopped his progress and hugged the earth. It was slow work, but not tedious; the danger made it exciting, but by no physical signs was the excitement manifest. His pulse was as regular, his nerves were as steady as if he were trying to trap a sparrow.

"It seems a long time," he thought, "but I cannot have come very far; I am still alive."

He smiled at his own method of estimating distance, and crept forward. A moment later he suddenly flattened himself upon the earth and lay motionless, minute after minute. Through a narrow opening in the bushes he had caught sight of a small mound of yellow clay—one of the enemy's rifle-pits. After some little time he cautiously raised his head, inch by inch, then his body upon his hands, spread out on each side of him, all the while intently regarding the hillock of clay. In another moment he was upon his feet, rifle in hand, striding rapidly forward with little attempt at concealment. He had rightly interpreted the signs, whatever they were; the enemy was gone.

To assure himself beyond a doubt before going back to report upon so important a matter, Searing pushed forward across the line of abandoned pits, running from cover to cover in the more open forest, his eyes vigilant to discover possible stragglers. He came to the edge of a plantation—one of those forlorn, deserted homesteads of the last years of the war, upgrown with brambles, ugly with broken fences and desolate with vacant buildings having blank apertures in place of doors and windows. After a keen reconnoissance from the safe seclusion of a clump

of young pines Searing ran lightly across a field and through an orchard to a small structure which stood apart from the other farm buildings, on a slight elevation. This he thought would enable him to overlook a large scope of country in the direction that he supposed the enemy to have taken in withdrawing. This building, which had originally consisted of a single room elevated upon four posts about ten feet high, was now little more than a roof; the floor had fallen away, the joists and planks loosely piled on the ground below or resting on end at various angles, not wholly torn from their fastenings above. The supporting posts were themselves no longer vertical. It looked as if the whole edifice would go down at the touch of a finger.

Concealing himself in the débris of joists and flooring Searing looked across the open ground between his point of view and a spur of Kennesaw Mountain, a half-mile away. A road leading up and across this spur was crowded with troops—the rear-guard of the retiring enemy, their gun-barrels gleaming in the morning sunlight.

Searing had now learned all that he could hope to know. It was his duty to return to his own command with all possible speed and report his discovery. But the gray column of Confederates toiling up the mountain road was singularly tempting. His rifle—an ordinary "Springfield," but fitted with a globe sight and hair-trigger—would easily send its ounce and a quarter of lead hissing into their midst. That would probably not affect the duration and result of the war, but it is the business of a soldier to kill. It is also his habit if he is a good soldier. Searing cocked his rifle and "set" the trigger.

But it was decreed from the beginning of time that Private Searing was not to murder anybody that bright summer morning, nor was the Confederate retreat to be announced by him. For countless ages events had been so matching themselves together in that wondrous mosaic to some parts of which, dimly discernible, we give the name of history, that the acts which he had in will would have marred the harmony of the pattern. Some twenty-five years previously the Power charged with the execution of the work according to the design had provided against that mischance by causing the birth of a certain male child in a little village at the foot of the Carpathian Mountains, had carefully reared it, supervised its education, directed its desires into a military channel, and in due time made it an officer of artillery. By the concurrence of an infinite number of favoring influences and their preponderance over an infinite number of opposing ones, this officer of artillery had been made to commit a breach of discipline and flee from his native country to avoid punishment. He had been directed to New Orleans (instead of New York), where a recruiting officer awaited him on the wharf. He was enlisted and promoted, and things were so ordered

that he now commanded a Confederate battery some two miles along the line from where Jerome Searing, the Federal scout, stood cocking his rifle. Nothing had been neglected—at every step in the progress of both these men's lives, and in the lives of their contemporaries and ancestors, and in the lives of the contemporaries of their ancestors, the right thing had been done to bring about the desired result. Had anything in all this vast concatenation been overlooked Private Searing might have fired on the retreating Confederates that morning, and would perhaps have missed. As it fell out, a Confederate captain of artillery, having nothing better to do while awaiting his turn to pull out and be off, amused himself by sighting a field-piece obliquely to his right at what he mistook for some Federal officers on the crest of a hill, and discharged it. The shot flew high of its mark.

As Jerome Searing drew back the hammer of his rifle and with his eyes upon the distant Confederates considered where he could plant his shot with the best hope of making a widow or an orphan or a childless mother,—perhaps all three, for Private Searing, although he had repeatedly refused promotion, was not without a certain kind of ambition,—he heard a rushing sound in the air, like that made by the wings of a great bird swooping down upon its prey. More quickly than he could apprehend the gradation, it increased to a hoarse and horrible roar, as the missile that made it sprang at him out of the sky, striking with a deafening impact one of the posts supporting the confusion of timbers above him, smashing it into matchwood, and bringing down the crazy edifice with a loud clatter, in clouds of blinding dust!

When Jerome Searing recovered consciousness he did not at once understand what had occurred. It was, indeed, some time before he opened his eyes. For a while he believed that he had died and been buried, and he tried to recall some portions of the burial service. He thought that his wife was kneeling upon his grave, adding her weight to that of the earth upon his breast. The two of them, widow and earth, had crushed his coffin. Unless the children should persuade her to go home he would not much longer be able to breathe. He felt a sense of wrong. "I cannot speak to her," he thought; "the dead have no voice; and if I open my eyes I shall get them full of earth."

He opened his eyes. A great expanse of blue sky, rising from a fringe of the tops of trees. In the foreground, shutting out some of the trees, a high, dun mound, angular in outline and crossed by an intricate, patternless system of straight lines; the whole an immeasurable distance away—a distance so inconceivably great that it fatigued him, and he closed his eyes. The moment that he did so he was conscious of an insufferable light. A sound was in his ears like the low, rhythmic thunder of a distant sea breaking in successive waves upon the beach, and out of this

noise, seeming a part of it, or possibly coming from beyond it, and inter-mingled with its ceaseless undertone, came the articulate words: "Jerome Searing, you are caught like a rat in a trap—in a trap, trap, trap."

Suddenly there fell a great silence, a black darkness, an infinite tranquillity, and Jerome Searing, perfectly conscious of his rathood, and well assured of the trap that he was in, remembering all and nowise alarmed, again opened his eyes to reconnoitre, to note the strength of his enemy, to plan his defense.

He was caught in a reclining posture, his back firmly sup-ported by a solid beam. Another lay across his breast, but he had been able to shrink a little away from it so that it no longer oppressed him, though it was immovable. A brace joining it at an angle had wedged him against a pile of boards on his left, fastening the arm on that side. His legs, slightly parted and straight along the ground, were covered up-ward to the knees with a mass of débris which towered above his narrow horizon. His head was as rigidly fixed as in a vise; he could move his eyes, his chin—no more. Only his right arm was partly free. "You must help us out of this," he said to it. But he could not get it from under the heavy timber athwart his chest, nor move it outward more than six inches at the elbow.

Searing was not seriously injured, nor did he suffer pain. A smart rap on the head from a flying fragment of the splintered post, incurred simultaneously with the frightfully sudden shock to the ner-vous system, had momentarily dazed him. His term of unconsciousness, including the period of recovery, during which he had had the strange fancies, had probably not exceeded a few seconds, for the dust of the wreck had not wholly cleared away as he began an intelligent survey of the situation.

With his partly free right hand he now tried to get hold of the beam that lay across, but not quite against, his breast. In no way could he do so. He was unable to depress the shoulder so as to push the elbow beyond that edge of the timber which was nearest his knees; failing in that, he could not raise the forearm and hand to grasp the beam. The brace that made an angle with it downward and backward prevented him from doing anything in that direction, and between it and his body the space was not half so wide as the length of his forearm. Obviously he could not get his hand under the beam nor over it; the hand could not, in fact, touch it at all. Having demonstrated his inability, he de-sisted, and began to think whether he could reach any of the débris piled upon his legs.

In surveying the mass with a view to determining that point, his attention was arrested by what seemed to be a ring of shining metal immediately in front of his eyes. It appeared to him at first to surround

some perfectly black substance, and it was somewhat more than a half-inch in diameter. It suddenly occurred to his mind that the blackness was simply shadow and that the ring was in fact the muzzle of his rifle protruding from the pile of débris. He was not long in satisfying himself that this was so—if it was a satisfaction. By closing either eye he could look a little way along the barrel—to the point where it was hidden by the rubbish that held it. He could see the one side, with the corresponding eye, at apparently the same angle as the other side with the other eye. Looking with the right eye, the weapon seemed to be directed at a point to the left of his head, and *vice versa*. He was unable to see the upper surface of the barrel, but could see the under surface of the stock at a slight angle. The piece was, in fact, aimed at the exact centre of his forehead.

In the perception of this circumstance, in the recollection that just previously to the mischance of which this uncomfortable situation was the result he had cocked the rifle and set the trigger so that a touch would discharge it, Private Searing was affected with a feeling of uneasiness. But that was as far as possible from fear; he was a brave man, somewhat familiar with the aspect of rifles from that point of view, and of cannon too. And now he recalled, with something like amusement, an incident of his experience at the storming of Missionary Ridge, where, walking up to one of the enemy's embrasures from which he had seen a heavy gun throw charge after charge of grape among the assailants he had thought for a moment that the piece had been withdrawn; he could see nothing in the opening but a brazen circle. What that was he had understood just in time to step aside as it pitched another peck of iron down that swarming slope. To face firearms is one of the commonest incidents in a soldier's life—firearms, too, with malevolent eyes blazing behind them. That is what a soldier is for. Still, Private Searing did not altogether relish the situation, and turned away his eyes.

After groping, aimless, with his right hand for a time he made an ineffectual attempt to release his left. Then he tried to disengage his head, the fixity of which was the more annoying from his ignorance of what held it. Next he tried to free his feet, but while exerting the powerful muscles of his legs for that purpose it occurred to him that a disturbance of the rubbish which held them might discharge the rifle; how it could have endured what had already befallen it he could not understand, although memory assisted him with several instances in point. One in particular he recalled, in which in a moment of mental abstraction he had clubbed his rifle and beaten out another gentleman's brains, observing afterward that the weapon which he had been diligently swinging by the muzzle was loaded, capped, and at full cock—knowledge of which circumstance would doubtless have cheered his

antagonist to longer endurance. He had always smiled in recalling that blunder of his "green and salad days" as a soldier, but now he did not smile. He turned his eyes again to the muzzle of the rifle and for a moment fancied that it had moved; it seemed somewhat nearer.

Again he looked away. The tops of the distant trees beyond the bounds of the plantation interested him: he had not before observed how light and feathery they were, nor how darkly blue the sky was, even among their branches, where they somewhat paled it with their green; above him it appeared almost black. "It will be uncomfortably hot here," he thought, "as the day advances. I wonder which way I am looking."

Judging by such shadows as he could see, he decided that his face was due north; he would at least not have the sun in his eyes, and north—well, that was toward his wife and children.

"Bah!" he exclaimed aloud, "what have they to do with it?"

He closed his eyes. "As I can't get out I may as well go to sleep. The rebels are gone and some of our fellows are sure to stray out here foraging. They'll find me."

But he did not sleep. Gradually he became sensible of a pain in his forehead—a dull ache, hardly perceptible at first, but growing more and more uncomfortable. He opened his eyes and it was gone—closed them and it returned. "The devil!" he said, irrelevantly, and stared again at the sky. He heard the singing of birds, the strange metallic note of the meadow lark, suggesting the clash of vibrant blades. He fell into pleasant memories of his childhood, played again with his brother and sister, raced across the fields, shouting to alarm the sedentary larks, entered the sombre forest beyond and with timid steps followed the faint path to Ghost Rock, standing at last with audible heart-throbs before the Dead Man's cave and seeking to penetrate its awful mystery. For the first time he observed that the opening of the haunted cavern was encircled by a ring of metal. Then all else vanished and left him gazing into the barrel of his rifle as before. But whereas before it had seemed nearer, it now seemed an inconceivable distance away, and all the more sinister for that. He cried out and, startled by something in his own voice—the note of fear—lied to himself in denial: "If I don't sing out I may stay here till I die."

He now made no further attempt to evade the menacing stare of the gun barrel. If he turned away his eyes an instant it was to look for assistance (although he could not see the ground on either side the ruin), and he permitted them to return, obedient to the imperative fascination. If he closed them it was from weariness, and instantly the poignant pain in his forehead—the prophecy and menace of the bullet—forced him to reopen them.

The tension of nerve and brain was too severe; nature came to

his relief with intervals of unconsciousness. Reviving from one of these he became sensible of a sharp, smarting pain in his right hand, and when he worked his fingers together, or rubbed his palm with them, he could feel that they were wet and slippery. He could not see the hand, but he knew the sensation; it was running blood. In his delirium he had beaten it against the jagged fragments of the wreck, had clutched it full of splinters. He resolved that he would meet his fate more manly. He was a plain, common soldier, had no religion and not much philosophy; he could not die like a hero, with great and wise last words, even if there had been some one to hear them, but he could die "game," and he would. But if he could only know when to expect the shot!

Some rats which had probably inhabited the shed came sneaking and scampering about. One of them mounted the pile of débris that held the rifle; another followed and another. Searing regarded them at first with indifference, then with friendly interest; then, as the thought flashed into his bewildered mind that they might touch the trigger of his rifle, he cursed them and ordered them to go away. "It is no business of yours," he cried.

The creatures went away; they would return later, attack his face, gnaw away his nose, cut his throat—he knew that, but he hoped by that time to be dead.

Nothing could now unfix his gaze from the little ring of metal with its black interior. The pain in his forehead was fierce and incessant. He felt it gradually penetrating the brain more and more deeply, until at last its progress was arrested by the wood at the back of his head. It grew momentarily more insufferable: he began wantonly beating his lacerated hand against the splinters again to counteract that horrible ache. It seemed to throb with a slow, regular recurrence, each pulsation sharper than the preceding, and sometimes he cried out, thinking he felt the fatal bullet. No thoughts of home, of wife and children, of country, of glory. The whole record of memory was effaced. The world had passed away—not a vestige remained. Here in this confusion of timbers and boards is the sole universe. Here is immortality in time—each pain an everlasting life. The throbs tick off eternities.

Jerome Searing, the man of courage, the formidable enemy, the strong, resolute warrior, was as pale as a ghost. His jaw was fallen; his eyes protruded; he trembled in every fibre; a cold sweat bathed his entire body; he screamed with fear. He was not insane—he was terrified.

In groping about with his torn and bleeding hand he seized at last a strip of board, and, pulling, felt it give way. It lay parallel with his body, and by bending his elbow as much as the contracted space would permit, he could draw it a few inches at a time. Finally it was altogether loosened from the wreckage covering his legs; he could lift it clear of the

ground its whole length. A great hope came into his mind: perhaps he could work it upward, that is to say backward, far enough to lift the end and push aside the rifle; or, if that were too tightly wedged, so place the strip of board as to deflect the bullet. With this object he passed it backward inch by inch, hardly daring to breathe lest that act somehow defeat his intent, and more than ever unable to remove his eyes from the rifle, which might perhaps now hasten to improve its waning opportunity. Something at least had been gained: in the occupation of his mind in this attempt at self-defense he was less sensible of the pain in his head and had ceased to wince. But he was still dreadfully frightened and his teeth rattled like castanets.

The strip of board ceased to move to the suasion of his hand. He tugged at it with all his strength, changed the direction of its length all he could, but it had met some extended obstruction behind him and the end in front was still too far away to clear the pile of débris and reach the muzzle of the gun. It extended, indeed, nearly as far as the trigger guard, which, uncovered by the rubbish, he could imperfectly see with his right eye. He tried to break the strip with his hand, but had no leverage. In his defeat, all his terror returned, augmented tenfold. The black aperture of the rifle appeared to threaten a sharper and more imminent death in punishment of his rebellion. The track of the bullet through his head ached with an intenser anguish. He began to tremble again.

Suddenly he became composed. His tremor subsided. He clenched his teeth and drew down his eyebrows. He had not exhausted his means of defense; a new design had shaped itself in his mind—another plan of battle. Raising the front end of the strip of board, he carefully pushed it forward through the wreckage at the side of the rifle until it pressed against the trigger guard. Then he moved the end slowly outward until he could feel that it had cleared it, then, closing his eyes, thrust it against the trigger with all his strength! There was no explosion; the rifle had been discharged as it dropped from his hand when the building fell. But it did its work.

■

Lieutenant Adrian Searing, in command of the picket-guard on that part of the line through which his brother Jerome had passed on his mission, sat with attentive ears in his breastwork behind the line. Not the faintest sound escaped him; the cry of a bird, the barking of a squirrel, the noise of the wind among the pines—all were anxiously noted by his overstrained sense. Suddenly, directly in front of his line, he heard a faint, confused rumble, like the clatter of a falling building translated by distance. The lieutenant mechanically looked at his watch. Six o'clock and eighteen minutes. At the same moment an officer approached him on foot from the rear and saluted.

"Lieutenant," said the officer, "the colonel directs you to move forward your line and feel the enemy if you find him. If not, continue the advance until directed to halt. There is a reason to think that the enemy has retreated."

The lieutenant nodded and said nothing; the other officer retired. In a moment the men, apprised of their duty by the non-commissioned officers in low tones, had deployed from their rifle-pits and were moving forward in skirmishing order, with set teeth and beating hearts.

This line of skirmishers sweeps across the plantation toward the mountain. They pass on both sides of the wrecked building, observing nothing. At a short distance in their rear their commander comes. He casts his eyes curiously upon the ruin and sees a dead body half buried in boards and timbers. It is so covered with dust that its clothing is Confederate gray. Its face is yellowish white; the cheeks are fallen in, the temples sunken, too, with sharp ridges about them, making the forehead forbiddingly narrow; the upper lip, slightly lifted, shows the white teeth, rigidly clenched. The hair is heavy with moisture, the face as wet as the dewy grass all about. From his point of view the officer does not observe the rifle; the man was apparently killed by the fall of the building.

"Dead a week," said the officer curtly, moving on and absently pulling out his watch as if to verify his estimate of time. Six o'clock and forty minutes.

KILLED AT RESACA

The best soldier of our staff was Lieutenant Herman Brayle, one of the two aides-de-camp. I don't remember where the general picked him up; from some Ohio regiment, I think; none of us had previously known him, and it would have been strange if we had, for no two of us came from the same State, nor even from adjoining States. The general seemed to think that a position on his staff was a distinction that should be so judiciously conferred as not to beget any sectional jealousies and imperil the integrity of that part of the country which was still an integer. He would not even choose officers from his own command, but by some jugglery at department headquarters obtained them from other brigades. Under such circumstances, a man's services had to be very distinguished indeed to be heard of by his family and the friends of his youth; and "the speaking trump of fame" was a trifle hoarse from loquacity, anyhow.

Lieutenant Brayle was more than six feet in height and of splendid proportions, with the light hair and gray-blue eyes which men

so gifted usually find associated with a high order of courage. As he was commonly in full uniform, especially in action, when most officers are content to be less flamboyantly attired, he was a very striking and conspicuous figure. As to the rest, he had a gentleman's manners, a scholar's head, and a lion's heart. His age was about thirty.

We all soon came to like Brayle as much as we admired him, and it was with sincere concern that in the engagement at Stone's River—our first action after he joined us—we observed that he had one most objectionable and unsoldierly quality: he was vain of his courage. During all the vicissitudes and mutations of that hideous encounter, whether our troops were fighting in the open cotton fields, in the cedar thickets, or behind the railway embankment, he did not once take cover, except when sternly commanded to do so by the general, who usually had other things to think of than the lives of his staff officers—or those of his men, for that matter.

In every later engagement while Brayle was with us it was the same way. He would sit his horse like an equestrian statue, in a storm of bullets and grape, in the most exposed places—wherever, in fact, duty, requiring him to go, permitted him to remain—when, without trouble and with distinct advantage to his reputation for common sense, he might have been in such security as is possible on a battlefield in the brief intervals of personal inaction.

On foot, from necessity or in deference to his dismounted commander or associates, his conduct was the same. He would stand like a rock in the open when officers and men alike had taken to cover; while men older in service and years, higher in rank and of unquestionable intrepidity, were loyally preserving behind the crest of a hill lives infinitely precious to their country, this fellow would stand, equally idle, on the ridge, facing in the direction of the sharpest fire.

When battles are going on in open ground it frequently occurs that the opposing lines, confronting each other within a stone's throw for hours, hug the earth as closely as if they loved it. The line officers in their proper places flatten themselves no less, and the field officers, their horses all killed or sent to the rear, crouch beneath the infernal canopy of hissing lead and screaming iron without a thought of personal dignity.

In such circumstances the life of a staff officer of a brigade is distinctly "not a happy one," mainly because of its precarious tenure and the unnerving alternations of emotion to which he is exposed. From a position of that comparative security from which a civilian would ascribe his escape to a "miracle," he may be despatched with an order to some commander of a prone regiment in the front line—a person for the moment inconspicuous and not always easy to find without a deal of search among men somewhat preoccupied, and in a din in which ques-

tion and answer alike must be imparted in the sign language. It is customary in such cases to duck the head and scuttle away on a keen run, an object of lively interest to some thousands of admiring marksmen. In returning—well, it is not customary to return.

Brayle's practice was different. He would consign his horse to the care of an orderly,—he loved his horse,—and walk quietly away on his perilous errand with never a stoop of the back, his splendid figure, accentuated by his uniform, holding the eye with a strange fascination. We watched him with suspended breath, our hearts in our mouths. On one occasion of this kind, indeed, one of our number, an impetuous stammerer, was so possessed by his emotion that he shouted at me:

"I'll b-b-bet you t-two d-d-dollars they d-drop him b-b-before he g-gets to that d-d-ditch!"

I did not accept the brutal wager; I thought they would.

Let me do justice to a brave man's memory; in all these needless exposures of life there was no visible bravado nor subsequent narration. In the few instances when some of us had ventured to remonstrate, Brayle had smiled pleasantly and made some light reply, which, however, had not encouraged a further pursuit of the subject. Once he said:

"Captain, if ever I come to grief by forgetting your advice, I hope my last moments will be cheered by the sound of your beloved voice breathing into my ear the blessed words 'I told you so.'"

We laughed at the captain—just why we could probably not have explained—and that afternoon when he was shot to rags from an ambuscade Brayle remained by the body for some time, adjusting the limbs with needless care—there in the middle of a road swept by gusts of grape and canister! It is easy to condemn this kind of thing, and not very difficult to refrain from imitation, but it is impossible not to respect, and Brayle was liked none the less for the weakness which had so heroic an expression. We wished he were not a fool, but he went on that way to the end, sometimes hard hit, but always returning to duty about as good as new.

Of course, it came at last; he who ignores the law of probabilities challenges an adversary that is seldom beaten. It was at Resaca, in Georgia, during the movement that resulted in the taking of Atlanta. In front of our brigade the enemy's line of earthworks ran through open fields along a slight crest. At each end of this open ground we were close up to him in the woods, but the clear ground we could not hope to occupy until night, when darkness would enable us to burrow like moles and throw up earth. At this point our line was a quarter-mile away in the edge of a wood. Roughly, we formed a semicircle, the enemy's fortified line being the chord of the arc.

"Lieutenant, go tell Colonel Ward to work up as close as he can

get cover, and not to waste much ammunition in unncessary firing. You may leave your horse."

When the general gave this direction we were in the fringe of the forest, near the right extremity of the arc. Colonel Ward was at the left. The suggestion to leave the horse obviously enough meant that Brayle was to take the longer line, through the woods and among the men. Indeed, the suggestion was needless; to go by the short route meant absolutely certain failure to deliver the message. Before anybody could interpose, Brayle had cantered lightly into the field and the enemy's works were in crackling conflagration.

"Stop that damned fool!" shouted the general.

A private of the escort, with more ambition than brains, spurred forward to obey, and within ten yards left himself and his horse dead on the field of honor.

Brayle was beyond recall, galloping easily along, parallel to the enemy and less than two hundred yards distant. He was a picture to see! His hat had been blown or shot from his head, and his long, blond hair rose and fell with the motion of his horse. He sat erect in the saddle, holding the reins lightly in his left hand, his right hanging carelessly at his side. An occasional glimpse of his handsome profile as he turned his head one way or the other proved that the interest which he took in what was going on was natural and without affectation.

The picture was intensely dramatic, but in no degree theatrical. Successive scores of rifles spat at him viciously as he came within range, and our own line in the edge of the timber broke out in visible and audible defense. No longer regardful of themselves or their orders, our fellows sprang to their feet, and swarming into the open sent broad sheets of bullets against the blazing crest of the offending works, which poured an answering fire into their unprotected groups with deadly effect. The artillery on both sides joined the battle, punctuating the rattle and roar with deep, earth-shaking explosions and tearing the air with storms of screaming grape, which from the enemy's side splintered the trees and spattered them with blood, and from ours defiled the smoke of his arms with banks and clouds of dust from his parapet.

My attention had been for a moment drawn to the general combat, but now, glancing down the unobscured avenue between these two thunderclouds, I saw Brayle, the cause of the carnage. Invisible now from either side, and equally doomed by friend and foe, he stood in the shot-swept space, motionless, his face toward the enemy. At some little distance lay his horse. I instantly saw what had stopped him.

As topographical engineer I had, early in the day, made a hasty examination of the ground, and now remembered that at that point was a deep and sinuous gully, crossing half the field from the enemy's line, its

general course at right angles to it. From where we now were it was invisible, and Brayle had evidently not known about it. Clearly, it was impassable. Its salient angles would have afforded him absolute security if he had chosen to be satisfied with the miracle already wrought in his favor and leapt into it. He could not go forward, he would not turn back; he stood awaiting death. It did not keep him long waiting.

By some mysterious coincidence, almost instantaneously as he fell, the firing ceased, a few desultory shots at long intervals serving rather to accentuate than break the silence. It was as if both sides had suddenly repented of their profitless crime. Four stretcher-bearers of ours, following a sergeant with a white flag, soon afterward moved unmolested into the field, and made straight for Brayle's body. Several Confederate officers and men came out to meet them, and with uncovered heads assisted them to take up their sacred burden. As it was borne toward us we heard beyond the hostile works fifes and a muffled drum—a dirge. A generous enemy honored the fallen brave.

Amongst the dead man's effects was a soiled Russia-leather pocketbook. In the distribution of mementos of our friend, which the general, as administrator, decreed, this fell to me.

A year after the close of the war, on my way to California, I opened and idly inspected it. Out of an overlooked compartment fell a letter without envelope or address. It was a woman's handwriting, and began with words of endearment, but no name.

It had the following date line: "San Francisco, Cal., July 9, 1862." The signature was "Darling," in marks of quotation. Incidentally, in the body of the text, the writer's full name was given—Marian Mendenhall.

The letter showed evidence of cultivation and good breeding, but it was an ordinary love letter, if a love letter can be ordinary. There was not much in it, but there was something. It was this:

"Mr. Winters, whom I shall always hate for it, has been telling that at some battle in Virginia, where he got his hurt, you were seen crouching behind a tree. I think he wants to injure you in my regard, which he knows the story would do if I believed it. I could bear to hear of my soldier lover's death, but not of his cowardice."

These were the words which on that sunny afternoon, in a distant region, had slain a hundred men. Is woman weak?

One evening I called on Miss Mendenhall to return the letter to her. I intended, also, to tell her what she had done—but not that she did it. I found her in a handsome dwelling on Rincon Hill. She was beautiful, well bred—in a word, charming.

"You knew Lieutenant Herman Brayle," I said, rather abruptly.

"You know doubtless, that he fell in battle. Among his effects was found this letter from you. My errand here is to place it in your hands."

She mechanically took the letter, glanced through it with deepening color, and then, looking at me with a smile, said:

"It is very good of you, though I am sure it was hardly worth while." She started suddenly and changed color. "This stain," she said, "is it—surely it is not—"

"Madam," I said, "pardon me, but that is the blood of the truest and bravest heart that ever beat."

She hastily flung the letter on the blazing coals. "Uh! I cannot bear the sight of blood!" she said. "How did he die?"

I had involuntarily risen to rescue that scrap of paper, sacred even to me, and now stood partly behind her. As she asked the question she turned her face about and slightly upward. The light of the burning letter was reflected in her eyes and touched her cheek with a tinge of crimson like the stain upon its page. I had never seen anything so beautiful as this detestable creature.

"He was bitten by a snake," I replied.

CALIFORNIANS

Bierce didn't have to till the soil of his adopted home state, nor sow it, in order to reap a bountiful harvest of fools, rascals, rogues, and pretenders that made the region a cynic's paradise. In fairness, there were a number of people laboring to improve life in California, and some of the others—let us not forget the Huntington and Bancroft libraries and Stanford University—helped future generations immeasurably.

At that time those Bierce saw as malefactors were thriving, however, and they presented a satirist with delights impossible to resist. Lucky Baldwin, Leland Stanford, and Collis Huntington made fortunes and bent the laws to increase them; Mike deYoung, publisher of the *San Francisco Chronicle,* used the paper to advance various of his political aims; Governor Stoneman of California was soft on criminals, pardoning enough for Bierce to think there might be a pecuniary interest involved. Others simply challenged Bierce, and that was enough. As he summed it up, "To despise my enemy and make him respect me—that is the whole battle . . . Let the infernal show proceed!"

The Returned Californian

A Man was hanged by the neck until he was dead.

"Whence do you come?" Saint Peter asked when the Man presented himself at the gate of Heaven.

"From California," replied the applicant.

"Enter, my son, enter; you bring joyous tidings."

When the Man had vanished inside, Saint Peter took his memorandum-tablet and made the following entry:

February 16, 1893. California occupied by the Christians.

The Tried Assassin

An Assassin being put upon trial in a New England court, his Counsel rose and said: "Your Honour, I move for a discharge on the ground of 'once in jeopardy': my client has been already tried for that murder and acquitted."

"In what court?" asked the Judge.

"In the Superior Court of San Francisco," the Counsel replied.

"Let the trial proceed—your motion is denied," said the Judge. "An Assassin is not in jeopardy when tried in California."

Very Lucky Baldwin

Lucky Baldwin's wound is not doing as well as it was hoped it would, and it is now feared that he will recover. His returning appetite is considered a most dangerous symptom, and the attending undertaker has about given him up. Unless there should ensue some unforeseen check to the fearful progress of his recuperative powers the community will soon be shrouded in the deepest gloom.

Wasp, 1883

Mike deYoung's Ambition

The Czar avers that Mr. deYoung was never in Russia; that he has no experience as a sovereign; that his knowledge of the Russian laws, manners, customs, traditions and character is necessarily imperfect; that his relations with the other Powers are shadowy and whimsical, and that he isn't a very nice fellow anyhow. To this I reply that Mr. deYoung is a journalist of good physique, with a brilliant career behind him. It is the career of his brother, the late Charles deYoung.

Wasp, 1881

To an Aspirant

What! you a Senator?—you, Mike deYoung?
Still reeking of the gutter whence you sprung?
Sir, if all Senators were such as you—
Their hands so slender and so crimson too
(Shaped to the pocket for commercial work,
For literary, fitted to the dirk)—
So black their hearts, so lily-white their livers—
The toga's touch would give a man the shivers!

California Pioneers Smile

The Society of California Pioneers have elected another batch of members, mostly, we believe, recently arrived from the States, and consisting principally of people who had heard of California previously to 1856.

The Society now numbers five hundred and sixty thousand members, and thirteen constitute a quorum. As soon as this number can be got together, there will be a vote taken upon the question of admitting all who will pledge themselves to stubbornly maintain that the water once came up to Montgomery Street, a proposition that is beginning to be faintly discredited. We note, by the way, that President Carter offered a resolution abolishing the liquor bar in the rooms of the Society, which measure was indignantly voted down; not, as Mr. Carter says, "Upon the principle that a rhinoceros may smile at bullets," but upon the more pertinent one that a Pioneeer may "smile" at bars. We cannot help regarding the resolution offered by Mr. Carter as an incendiary attempt to cripple the Society by rendering it impossible to secure the attendance of a quorum.

News Letter, 1870

Board of Education Boring

The Board of Education met on Tuesday evening and shamefully disappointed the hopes of the public. Not a man was called a liar, not a spitoon was cast, there was never an inkstand flung. We should like to know what these men are for, if not to furnish their quota of the city amusement and contribute to the sensational literature of the town. The bear garden may as well be closed, if it cannot compete with the young camel at Woodward's Gardens. Cobb, what do you mean; what *do* you mean?

News Letter, 1869

Board of Education Purging

A list of two hundred books which it is proposed to purchase for the library of the Lincoln School has been referred to a committee of the Board of Education, with power to reject any objectionable volumes. As it is not probable that the members of the committee are familiar with a half-dozen volumes comprised in this list or any other, it may reasonably be affirmed that a conscientious performance of their duty will require the first intellectual labor they have ever done in all their lives. It is to be hoped the works are printed in large, clear type, with the syllables properly estranged.

News Letter, 1871

Co-education Coercion

On last Wednesday that gruesome old body, the Teachers' Institute, held a solemn debate upon the question of educating boys and girls together—that is, in the same school. We approach this subject with the natural delicacy of a man who has never been educated together, and is therefore more likely to take a one-sided view of it than one who has never been educated at all; but really it appears to us that a tender regard for our young would dictate that they be kept out of one another's way while preparing for matrimony. They gather more strength in that way, and, as it were, secrete more moisture to sustain them in their sweltering travel across conjugal sands. It is a refinement of cruelty to subject the youth of either sex to the society of the other until they are themselves willing to submit to the infliction and take to it naturally, as an insolvent cobbler to the bottom of Mission Bay, or a remorseful parson to ratsbane.

News Letter, 1869

The Political Horizon

In a lecture at the State University on Wednesday last Professor Pomeroy was pleased to urge the study of politics, "the noblest subject within our limits of comprehension." Let us, O brethren, begin with the politics of our own country and time—the statesmanship of the Here and Now. Let us, with lifted faces and considering eyes, explore "the political horizon" for grand and instructive examples in the science of government.

Ah, rapture! what do we see? (Denis Kearney, you odious blackguard, take your carcass aside—you obstruct our view of "the noblest subject.") *What,* gentlemen, do we see? (Jim Anderson, Olympic liar, be good enough to sit, and leave off making a noise—you baffle the "finite comprehension.") I repeat, fellow students, what *do* we see? (Ben Butler, you radiant thief, will you never have done making protrusion of your paunch across the line of inquiry? *Evanish!*) Really, my friends, it isn't any use to pursue this "noblest subject." The central figures of American contemporary politics are not transparent.

Argonaut, 1878

Education's Benefits

It is stated that the Regents of the State University contemplate establishing a department of mechanism, in which the student may learn all about machinery and how to run an engine. The plan is a comprehensive

one, but it should be supplemented by the endowment of a department of blacksmithing, horse-shoeing and wagon-making. Butchering might also be advantageously taught and a chair of railsplitting would be of great practical benefit. This latter would also keep green the memory of one of the most carefully uneducated men of modern times, who nevertheless became President of these United States, as every graduate of the University will have a chance to do, despite a precisely similar obstacle.

News Letter, 1870

Bancroft's Library

There has been received at this office—for review, doubtless— a mean-looking pamphlet entitled, *The Bancroft Library as Materials for Pacific States History.* It consists mainly in two long descriptive articles written by Mr. Hubert Howe Bancroft's employees, published in local newspapers and paid for with Mr. Bancroft's money. Mr. Bancroft has recently issued another ponderous volume of his *History of the Pacific States;* he turns them off at the rate of three a year and his history mill works as well when he is absent in Mexico as when he is present in San Francisco. But the publication of this pamphlet is a "new departure"; it tends significantly to confirm what this paper has repeatedly asserted—that it is this cunning tradesman's hope to sell his library to the State University as soon as his crew of hack-writers shall have "finished making history" at ten dollars a week without board. Either the present or some future Legislature will assuredly be asked to appropriate a swindling sum of money for the spoils of this literary *chiffonier's* rag-hook. The value of the collection may be guessed from the fact that it consists mainly of books and manuscripts in Latin and Spanish, collected in Spanish-American countries by their present owner, Mr. Bancroft. This eminent scholar, historian and bibliophile has not the happiness to know the Latin and Spanish languages.

He does not know any language. He not only cannot read the diploma with which some Eastern college hastily signified its sense of his merits, but he cannot speak good English. As for writing—well, by the terms of his contract with his lettered employees he is not required to write.

Wasp, 1884

Reconciliation

Stanford and Huntington, so long at outs,
Kissed and made up. If you have any doubts
Dismiss them, for I saw them do it, man;
And then—why, then I clutched my purse and ran.

The Genesis of Crime

God said, "Let there be Crime," and the command
Brought Satan, leading Stoneman by the hand.
"Why, that's Stupidity, not Crime," said God—
"Bring what I ordered." Satan with a nod
Replied, "This is *one* element—when I
The *other*—Opportunity—supply
In just equivalent, the two'll affine
And in a chemical embrace combine
And Crime result; for Crime can only be
Stupiditate of Opportunity."
So leaving Stoneman (not as yet endowed
With soul) in special session on a cloud,
Nick to his sooty laboratory went,
Returning soon with t'other element.
"Here's Opportunity," he said, and put
Pen, ink and paper down at Stoneman's foot.
He seized them—Heaven was filled with fires and
 thunders,
And Crime was added to Creation's wonders!

A Trencher-Knight

Stranger, uncover; here you have in view
The monument of Chauncey M. Depew,
Eater and orator, the whole world round
For feats of tongue and tooth alike renowned.
Dining his way to eminence, he rowed
With knife and fork up water-ways that flowed
From lakes of favor—pulled with all his force
And found each river sweeter than the source.

Like rats, obscure beneath a kitchen floor,
Gnawing and rising till obscure no more,
He ate his way to eminence, and Fame
Inscribes in gravy his immortal name.
A trencher-knight, he, mounted on his belly,
So spurred his charger that its sides were jelly.
Grown desperate at last, it reared and threw him,
And Indigestion, overtaking, slew him.

Marshall's Relief

It is perhaps unkind, but it is natural to reflect with satisfaction that
Mr. Marshall, the discoverer of gold in California, will in the course of
time be gathered to his fathers. Before the Legislature at every session is
a measure for his "relief." He is not entitled to any relief. His discovery
was purely accidental, and it has been proved a hundred times that he
made every effort (as any sensible and selfish man would do) to keep it
secret and get all its advantages for himself and his associates. To talk of a
man whose services were of that character as a "benefactor" is the idlest
nonsense. He is no more a benefactor than a pig would have been that
had turned up a nugget with its nose while prospecting for wild onions.
Less, for the pig would have left the metal exposed, whereas Marshall hid
it away. Less than any other man in California at the time, for he had at
least the gold that he picked up and the first chance at that remaining in
the gulches. True, he is old and poor and worthy, but if that constitutes a
claim upon the public treasury let a handsome sum be appropriated for
Mr. William Sharon, Mr. John S. Gray and the writer of these lines; for
Mr. Sharon is old, Mr. Gray is poor, and when the other gentleman
contemplates the infinite versatility and incalculable magnitude of his
own worth he is dazed with astonishment and filled with admiration.

Wasp, 1885

Genesis

God said: "Let there be Man," and from the clay
Adam came forth and, thoughtful, walked away.
The matrix whence his body was obtained,
An empty, man-shaped cavity, remained
All unregarded from that early time
Till in a recent storm it filled with slime.

Now Satan, envying the Master's power
To make the meat himself could but devour,
Strolled to the place and, standing by the pool,
Exerted all his will to make a fool.
A miracle!—from out that ancient hole
Rose Doxey, lacking nothing but a soul.
"To give him that I've not the power divine,"
Said Satan, sadly, "but I'll lend him mine."
He breathed it into him, a vapor black,
And to this day has never got it back.

A Kit

Here Ingalls, sorrowing, has laid
The tools of his infernal trade—
His pen and tongue. So sharp they grew,
And such destruction from them flew,
His hand was wounded when he wrote,
And when he spoke he cut his throat.

A Culinary Challenge

Speaking of hogs, I am told that there has been no notable improvement in the manners of our own electro-plated youth. I am told that at the "receptions" in our great houses they are still overmuch addicted to the unholy orgies of the supper room, double-charging their paunches with meat, perilously distending their hides with tope and pocketing preposterous multitudes of cigars. It is a fault of youth. Not that they are young, these bouncing bucks; but that our Californian civilization is as downy and callow as the blind young robin splitting its upthrust pate for the maternal worm. It is quite appalling to think of the excesses that may be expected of this guttling gentry after their long Lenten fast at the domestic board.

Frank Pixley said a rather neat thing anent this matter once. He had returned from a Sharon reception, where his good breeding and broad physique had kept him in the rear rank at feeding time. He was inveighing against the vulgar scramble of the gluttons whose crowding had prevented the ladies getting anything to eat, and his corrosive speech flowed over the topic like a tranquil rill of nitric acid. "The d---- hogs!" he said; "they crowded about the table four deep. There wasn't the ghost of a show for the sows."

When wicked Circe gave a feast
　To those her charms delighted:
She changed into a groveling beast
　Each man that she'd invited.

The San Francisco hostess fine,
　As an enchantress rating,
Turns all her gentlemen to swine
　By saying: "Supper's waiting."

Wasp, 1881

JOURNALISM, BY AND LARGE

Bierce's ambiguity toward his profession was nowhere more evident than in his broadsides against it. Every writer will understand calumnies against editors, even those who have been editors, but Bierce took on the whole range of what has come to be called the media, and he did so savagely. On the other hand, most of his friends were journalists, admitted to his small circle if they could tell a good story and hold their liquor. Furthermore, Bierce never contemplated any other career.

Of course, the press has always had some ambiguity toward itself. Journalists are alternately self-congratulatory, defensive, or especially self-righteous when attempting to knock some mud from their shoes as unobtrusively as possible. Occasionally, they are sure of their ends but insecure about the means, sometimes the other way round. "From whom, my friends, do you hear all this talk about the great good wrought by the press, its vigilant guardianship of the public interest, its conservation of the public morals?" Bierce asked, and answered, "From the newspapers."

All in all, the press was a perfect subject for Bierce. Here too, the hated Frank Pixley surfaced (Bierce could always find a context to vilify him) as does a former friend, Arthur McEwen, who made the mistake of questioning one of Bierce's contentions in print and found that once was once too often.

The Highwayman and the Traveller

A Highwayman confronted a Traveller, and covering him with a firearm, shouted: "Your money or your life!"

"My good friend," said the Traveller, "according to the terms of your demand my money will save my life, my life my money; you imply you will take one or the other, but not both. If that is what you mean, please be good enough to take my life."

"That is not what I mean," said the Highwayman; "you cannot save your money by giving up your life."

"Then take it, anyhow," the traveller said. "If it will not save my money, it is good for nothing."

The Highwayman was so pleased with the Traveller's philosophy

and wit that he took him into partnership, and this splendid combination of talent started a newspaper.

The Prerogative of Might

A Slander travelling rapidly through the land upon its joyous mission was accosted by a Retraction and commanded to halt and be killed.

"Your career of mischief is at an end," said the Retraction, drawing his club, rolling up his sleeves, and spitting on his hands.

"Why should you slay me?" protested the Slander. "Whatever my intentions were, I have been innocuous, for you have dogged my strides and counteracted my influence."

"Dogged your grandmother!" said the Retraction, with contemptuous vulgarity of speech. "In the order of nature it is appointed that we two shall never travel the same road."

"How then," the Slander asked, triumphantly, "have you overtaken me?"

"I have not," replied the Retraction; "we have accidentally met. I came round the world the other way."

But when he tried to execute his fell purpose he found that in the order of nature it was appointed that he himself perish miserably in the encounter.

Twin Intolerables

A Rattlesnake observing the approach of a Man with a Camera crept under a flat stone, leaving nothing exposed but the tip of his nose.

"I was not going to photograph you," the Man with a Camera explained with a touch of sadness in his voice. "Holding the ancient faith in the divine wisdom of serpents, I have come to ask you why I am hated and shunned by all mankind."

"Alas," said the Rattlesnake, "the gods have denied me that knowledge. Can you tell me why I am myself not very much sought after as a companion?"

Wolf and Crane

A Rich Man wanted to tell a certain lie, but the lie was of such monstrous size that it stuck in his throat; so he employed an Editor to write it out and publish it in his paper as an editorial. But when the Editor presented his bill the Rich Man said:

"Be content—is it nothing that I refrained from advising you about investments?"

A Causeway

A Rich Woman having returned from abroad disembarked at the foot of Knee-deep Street, and was about to walk to her hotel through the mud.

"Madam," said a Policeman, "I cannot permit you to do that; you would soil your shoes and stockings."

"Oh, that is of no importance, really," replied the Rich Woman, with a cheerful smile.

"But, madam, it is needless; from the wharf to the hotel, as you observe, extends an unbroken line of prostrate newspaper men who crave the honour of having you walk upon them."

"In that case," she said, seating herself in a doorway and unlocking her satchel, "I shall have to put on my rubber boots."

Something in the Papers

"What's in the paper?" O, it's dev'lish dull:
There's nothing happening at all—a lull
After the war-storm. Mr. Someone's wife
Killed by her lover with, I think, a knife.
A fire on Blank Street and some babies—one,
Two, three or four, I don't remember, done
To quite a delicate and lovely brown.
A husband shot by woman of the town—
The same old story. Shipwreck somewhere south,
The crew all saved—or lost. Uncommon drouth
Makes hundreds homeless up the River Mud—
Though, come to think, I guess it was a flood.
'Tis feared some bank will burst—or else it won't;
They always burst I fancy—or they don't;
Who cares a cent?—the banker pays his coin
And takes his chances. Bullet in the groin—
But that's another item. Suicide—
Fool lost his money (serve him right) and died.
Heigh-ho! there's noth— Jerusalem! what's this?
Tom Jones has failed! My God, what an abyss
Of ruin!—owes me seven hundred, clear!
Was ever such a damned disastrous year?

The Fabulist and the Animals

A wise and illustrious Writer of Fables was visiting a travelling menagerie with a view to collecting literary materials. As he was passing near the Elephant, that animal said:

"How sad that so justly famous a satirist should mar his work by ridicule of people with long noses—who are the salt of the earth!"

The Kangaroo said:

"I do so enjoy that great man's censure of the ridiculous—particularly his attacks on the Proboscidæ; but, alas! he has no reverence for the Marsupials, and laughs at our way of carrying our young in a pouch."

The Camel said:

"If he would only respect the sacred Hump, he would be faultless. As it is, I cannot permit his fables to be read in the presence of my family."

The Ostrich, seeing his approach, thrust her head in the straw, saying:

"If I do not conceal myself, he may be reminded to write something disagreeable about my lack of a crest or my appetite for scrap-iron; and although he is inexpressibly brilliant when he devotes himself to censure of folly and greed, his dullness is matchless when he transcends the limits of legitimate comment."

"That," said the Buzzard to his mate, "is the distinguished author of that glorious fable, 'The Ostrich and the Keg of Raw Nails.' I regret to add, that he wrote, also, 'The Buzzard's Feast,' in which a carrion diet is contumeliously disparaged. A carrion diet is the foundation of sound health. If nothing else but corpses were eaten, death would be unknown."

Seeing an attendant approaching, the wise and illustrious Writer of Fables passed out of the tent and mingled with the crowd. It was afterward discovered that he had crept in under the canvas without paying.

The Christian Serpent

A Rattlesnake came home to his brood and said: "My children, gather about and receive your father's last blessing, and see how a Christian dies."

"What ails you, Father?" asked the Small Snakes.

"I have been bitten by the editor of a partisan journal," was the reply, accompanied by the ominous death-rattle.

The Poet's Doom

An Object was walking along the King's highway wrapped in meditation and with little else on, when he suddenly found himself at the gates of a strange city. On applying for admittance, he was arrested as a necessitator of ordinances, and taken before the King.

"Who are you," said the King," and what is your business in life?"

"Snouter the Sneak," replied the Object, with ready invention; "pick-pocket."

The King was about to command him to be released when the Prime Minister suggested that the prisoner's fingers be examined. They were found greatly flattened and calloused at the ends.

"Ha!" cried the King; "I told you so!—he is addicted to counting syllables. This is a poet. Turn him over to the Lord High Dissuader from the Head Habit."

"My liege," said the Inventor-in-Ordinary of Ingenious Penalties, "I venture to suggest a keener affliction."

"Name it," the King said.

"Let him retain that head!"

It was so ordered.

The Scurril Press

Tom Jonesmith (*loquitur*): I've slept right through
The night—a rather clever thing to do.
How soundly women sleep [*looks at his wife*].
They're all alike. The sweetest thing in life
Is woman when she lies with folded tongue,
Its toil completed and its day-song sung.
[*Thump!*] That's the morning paper. What a bore
That it should be delivered at the door.
There ought to be some expeditious way
To get it *to* one. By this long delay
The fizz gets off the news [*a rap is heard*].
That's Jane, the housemaid; she's an early bird;
She's brought it to the bedroom door, good soul.
[*Gets up and takes it in.*] Upon the whole,
The system's not so bad a one. What's here?
Gad! if they've not got after—listen, dear,
[*To sleeping wife*]—young Gastrotheos. Well,

If Freedom shrieked when Kosciusko fell
She'll shriek again—with laughter—seeing how
They treated Gast. with her. Yet I'll allow
'Tis right if he goes dining at The Pup
With Mrs. Thing.

 WIFE [*briskly, waking up*]:
With her? The hussy! Yes, it serves him right.

 JONESMITH [*continuing to* "seek the light"]:
What's this about old Impycu? That's good!
Grip—that's the funny man—says Impy should
Be used as a decoy in shooting tramps.
I knew old Impy when he had the "stamps"
To buy us all out, and he wasn't then
So bad a chap to have about. Grip's pen
Is just a tickler!—and the world, no doubt,
Is better with it than it was without.
What? thirteen ladies—Jumping Jove! we know
Them nearly all!—who gamble at a low
And very shocking game of cards called "draw"!
O cracky, how they'll squirm! ha-ha! haw-haw!
Let's see what else [*wife snores*]. Well, I'll be blest!
A woman doesn't understand a jest.
Hello! What, what? the scurvy wretch proceeds
To take a fling at *me,* condemn him! [*reads*]:
Tom Jonesmith—my name's Thomas, vulgar cad!—
Of the new Shavings Bank—the man's gone mad!
That's libelous; I'll have him up for that—
Has had his corns cut. Devil take the rat!
What business is't of his, I'd like to know?
He didn't have to cut them. Gods! what low
And scurril things our papers have become!
You skim their contents and you get but scum.
Here, Mary [*waking wife*], I've been attacked
In this vile sheet. By Jove, it is a fact!

 WIFE [*reading it*]: How wicked! Who do you
Suppose 'twas wrote it?

 JONESMITH: Who? why, who
But Grip, the so-called funny-man—he wrote
Me up because I'd not discount his note.
[*Blushes like sunset at the hideous lie—*

He'll think of one that's better by and by;
Throws down the paper on the floor, and treads
A merry measure on it; kicks the shreds
And patches all about the room, and still
Performs his jig with unabated will.]
 WIFE [*warbling sweetly, like an Elfland horn*]:
Dear, do be careful of that second corn.

The Shame of Satire

A correspondent who seems to suffer from poignant ignorance of the uses of abuse is quite horrified that we should "ridicule and satirize the very public upon which we rely for support." Our correspondent is meekly informed that, stricken with remorse for past offences, we have determined to sin no more. Hereafter the thunderbolts of our displeasure will be directed solely against the State polity and social fabric of the Patagonians, whom we hope to make heartily ashamed of themselves in less than a month, to the unspeakable advancement of good Government and Christian morality. It is certainly shameful that a satirical newspaper should mar its usefulness by lashing the knaves who infest the very country in which it is published. We had not hitherto perceived the absurdity of our course, and are thankful to have it pointed out to us by one who has so closely studied the subject as to become a hopeless blockhead.

News Letter, 1870

An Editorial Paradox

Upon the bulletin board of the San Francisco Yacht Club, whereon are posted the names and occupations of persons proposed for membership, appears the following unique inscription: "William M. Laffan, Editor and Capitalist!" We bow in profound veneration before this affluent editor; we congratulate our neighbor, the sprightly *Bulletin,* upon possessing him; we point out to the honest workingman the obvious explanation of that paper's consistent hostility to labor. Editor and capitalist—capitalist and editor! How may an editor become a capitalist—how a capitalist remain an editor? Profound problem! Infinite paradox! Illimitable conundrum! We speculate wildly upon it and find no end! The intellect reaches blindly in to the unknown, groping vainly for a solution of the portentous enigma! The imagination reels and staggers under the effort to comprehend the inconceivable, to conceive the in-

comprehensible! And, finally, our entire intellectual entity turns back upon itself, gives it up and doubles away to sleep. Editor and Capitalist—Great Scott!

News Letter, 1870

The Treatment of Drunkards

Here's another telegram from over the sea: "Dalrymple, member of Parliament for Bath, goes to America to study the treatment of drunkards." He need not come; we can tell him all about it. The treatment of drunkards in this country is infamous; they have to hold all the offices and do most of the hard stealing. Many of them are condemned to the pulpit for long terms; and newspaper editing—in America the most dishonorable vocation known—is done by them exclusively. At least one of them is compelled to write two columns a week for the *News Letter,* and another one has to pay him for it. There is no limit to the impositions practiced upon that interesting class, the drunkards of America; they are just trodden under foot by everybody who is sober enough to tread. If Dalrymple, M.P. for B., can do anything for them he will find himself very popular, and will be expected to take a drink with every man he meets.

News Letter, 1871

Editorial Truths

There is no profession, trade or calling more unceasingly laborious than journalism, and none from which the compensation derived is less commensurate with the labor performed.—*Vallejo Chronicle.* Stuff and nonsense! Your talented editor with a genius for his humble pursuit knows as well how to evade hard work as the sleekest parson of them all, and as to compensation, the rascal usually manages to get more than he deserves. These truths may not have obtained editorial recognition at Vallejo, but in this establishment they are self-evident. Our cow-county contemporary seems to be densely ignorant that the public has outgrown its fondness for editorial cant. If the journalist is dissatisfied with his lot let him embark in some profession for which his experience has eminently fitted him—that of an auctioneer, lawyer, exhorter, or other liar.

News Letter, 1870

Editor's Prescription Denied

Concerning a man who pitched himself into a two hundred-fathom mining shaft, as the thoughtless batrachian takes a hopeful header into a dry post-hole, the *Bulletin* explains that "he was a man of steady habits, but enjoyed poor health." What a crested idiot to go kill himself, with consumption wooing him in every breeze, and dyspepsia beckoning him from the summit of every pudding!—chills and fever fighting for possession of his person, and neuralgia languishing to kiss him on both cheeks! Why a man who can really enjoy poor health should wish to part with his body transcends conjecture by as much as the flight of an eagle outrises the clumsy tumbling of a headless hen.

Argonaut, 1877

On Encouraging Amateurs

If there is no hell, what follows? That the delights of heaven are by no means uniform, and range from the ecstatic down to the merely endurable. This is a necessity of human nature. Reader, it is not conceivable that you and I are to have in the next world no greater happiness than the editor of the *Call,* who never hesitates to use the editor's malevolent power of unbalancing a human intellect by a confirming nod. I am quite serious: every time that an editor accepts and prints literary matter of a worthless kind from an amateur writer he does its author an irreparable injury. In weak and intractable minds the rage for writing once kindled is inextinguishable; each gratification is a new incitement, and the luckless fool's ambition, which like the Lord's Prayer might once have been inscribed upon a nut-shell, grows by indulgence until the wall of a mad-house is too narrow for its display.

Argonaut, 1878

The Editor and the Monkey

The editor of the *Barnacle* has a hobby which he has ridden for a number of years, to the perfect satisfaction of his readers and the unspeakable delight of ourselves. That hobby—now somewhat sore in the back—is the Darwinian theory. How much the rider knows about his horse will be seen from the following, upon the freedom of thought: "One man is not to be deterred from advocating the Darwinian theory because his neighbor is shocked at the idea that man is a development of the monkey." Very

true, but he ought to be debarred from advocating it if he shocks his neighbor at his utter ignorance of what it really is. The Darwinian theory, James, does *not* imply that man is "a development of the monkey," but that both are descended from a common parent. See the difference? Your error is the same as if you should claim to be the offspring of a mule, instead of admitting that the ass is the father of both the mule and yourself. In the one case you would assert a physical impossibility, in the other you would simply support an extremely probable hypothesis.

News Letter, 1869

Literally and Habitually

Nothing is better known than that words which formerly meant one thing, come in time to have a wholly different signification; one thousand years from the present time, whenever this paragraph is printed it will be accompanied by copious explanatory notes and a glossary, to render it intelligible. Likewise, nothing is more certain than that within a few years the word "literally" will mean "figuratively." And this because journalists, with a greater desire to write forcibly than ability to do so, habitually use it in that sense. For example, it is quite usual to read, "The ground was literally alive with ants"—meaning that it was figuratively alive with them; or, "The unfortunate man was literally cut to pieces"—meaning that he was not. The most amazing example of this abuse of words occurs in an editorial article of the *Alta California* newspaper, in which the editor says: "This is literally crossing the stream before coming to it!" Now, we vehemently and violently assert that it is impossible to do this thing and that it is not desirable; we shall be quite satisfied if the editor in question shall await until he approaches the stream of Jordan before he crosses over. But we beg him to hurry up.

News Letter, 1871

Art for Whose Sake?

There is not only an apparent dearth of art patronage in this city, but there is a dearth of art culture. — *The Bulletin.*

Does it not strike you, my fine friend, that you—you, the *Bulletin*—have been the instrument, under Providence, by which this state of things has been perpetuated? During the whole term of your hateful existence you have published "friendly" criticism for the "en-

couragement" of art. Than friendly criticism nothing is more quickly fatal to art in all its forms. By encouraging every booby who thought he could paint or model or write, you have discouraged and assisted to drive away every man and woman who really could. . . . By fostering "home production" to the extent of your mean ability, you have done what was possible to you to shut out from our people and our self-taught artists the light that would have streamed in from the cultivated East. Call you this "love of art for art's sake"? . . .

Whenever you have persuaded a rich man to buy a bad picture painted by a Californian you have counted it a gain to him who can paint a good one. When you have assisted a "struggling" magazine full of bad writing by ambitious and unpaid amateurs you have prided yourself on your distinguished service to literature. You are a versatile champion, *Bulletin:* you can stab your *protege* under the fourth rib, and under the fifth.

What! do you not habitually puff the thin inanities and thick turgidities of the *Warmedoverland Monthly?* Do you not for hire fawn upon and flatter that one thousand times convicted literary imposter, Hubert Howe Bancroft? At every exhibition of the Art Association do you not praise scores of the vilest paintings? . . . When some blowsy capitalist erects a hideous building, who so alert as you to affirm its beauty, for pay, though the very stones in the street resent the indignity of its shadow? . . . And now, double dunderhead, you have the polar effrontery to bewail the "dearth of art culture?"! May all affected by your influence run down a steep place into the sea.

Wasp, 1885

The Mangle of Satire

Satire should be not like a saw, but a sword; it should cut, not mangle.— *Exchange.* O, certainly; it should be "delicate." Every man of correct literary taste will tell you it should be "delicate"; and so will every scoundrel who fears it. If there is one main quality in satire to which everything should be subordinate—which should be kept constantly in view as solely worthy of achieving, it is "delicacy"—that is, obscurity— that is, ineffectiveness. Your satire, my young reader, should not mangle; our contemporary has *told* you it should not mangle. He has not explained why a thing that is a legitimate object of satire—that is, a thing that is bad and worthy of extermination—ought not to be mangled; but it is doubtless true that it ought not. It ought only to be made to slightly wince—"delicately." A man who is exposed to satire must not be made unhappy—O dear, no! He must find it very good

reading—a little pungent and peculiar, but upon the whole invigorating and breezy. Don't mangle him. If he is a thief, don't call him so by name, but insinuate darkly—and "delicately"—that "possibly some gentleman to whose outward seeming his own aspect conforms, might justly be suspected of confusion in his conception of *meum* and *tuum*." Don't mangle the man, like that coarse Juvenal, and that horrid Swift, but touch him up neatly, like Horace or a modern magazinist.

Then, in faith, you shall be in fashion, and every critic shall glow—"delicately"—with admiration of your niceness and polish; and your victim shall give your censures into the hands of his young daughter to read to him, that he may be free to writhe. It was not long ago that the *Atlantic* gravely praised somebody's satire, because it was "so subtle as to leave a half doubt of its intent!" What a jackass-taste is this. Gad! If Miss Nancy is going to "sentence letters" much longer, there will be little tatting made. Let us mangle!

News Letter, 1872

Newspaper War

If General Miles fail in capturing Geronimo and his political supporters, upon his own head be it—the press of this city has discharged its whole duty in the matter, and can "point with pride" to its military record.

Colonel Pickering has repeatedly pointed out the strategical errors of General Crook and warned his successor against yielding to their fascination. General deYoung has not failed to expose the tactics of the Red Man and lay bare the simple secret of his success. General Miles has only to "get on to it"—and there you are! In the writings of Field Marshal John P. Irish and Generals Pixley, Fitch and Greathouse the downiest cadet of the State University will find all the conditions of success set forth with luminous lucidity. In Corporal Backus' paper the basic and essential principles of savage warfare have been so frequently "given away" that the editor is ashamed to look a wooden Indian in the face when passing a tobacco-shop.

That General Miles will discharge his Apache scouts and trail the hostiles with cowboys; that he will wall in all the water-holes, so that the wells shall be accessible only to those whom he intrusts with the combination; that he will follow the trails by night as well as by day; always surround before attacking; keep his own troops fresh and fight the enemy's only when they are tired; head them off from the mountains and prevent them from gaining the plains; and, in short, take the advice of those whose business it is to give it, is confidently expected by all who know him. "Colonel," said the commander, on the eve of an engage-

ment, "you will find in this paper detailed instructions for every move-
ment you are to make in the grand attack: I shall expect you to carry
them out to the letter." "Certainly, General, certainly—nothing will
give me greater pleasure, if the enemy is willing."

Examiner, 1886

Decanting Journalism

True journalism cannot serve a party, simply because it must serve the
public by accurate and full statements of fact.—*Bulletin.* (It strikes us
we have heard this song before. Allow us, *Bulletin,* to respectfully in-
quire if that remark about serving the public is strictly original, and if so
is it copyrighted? Allow us further to remark that of all cant, the cant of
journalism is the most wearisome and offensive.)

News Letter, 1870

Decanting Still Necessary

The great moral influence of the press is the central fact of the nineteenth
century.—*N. Y. Tribune.* (Hey, what's that? Once more, please. We seem
to have heard that strain before. Could it have been from the press? Ah,
yes! now we think of it, it *was* from the press. Brethren, let us believe.)

News Letter, 1871

The Value of the Press

One of the speakers, a journalist, at Platt's Hall, on Wednesday evening,
delivered an address on the "Freedom of the Press," which a morning
journal epitomized as follows: "A free press is the foundation of republi-
can government, and the bulwark of a free people, and when it is curbed
by such laws as those in France the liberties of the people are in danger."
That is a faultless crystallization of what may be called the editorial
religion—nothing added, nothing omitted. It is the Thirty-Nine Ar-
ticles of the newspaper faith, expounded by one of its prelates, and
digested by a clerk in holy orders. It is a pretty bit of bosh, immodest,
shoppy, and without a grain of saving sense. There is no such thing as
"the press"; there are newspapers. Except as regards their mechanical
characteristics they have nothing in common; to class them under a
generic name with reference to their effect on popular liberty—whatever

that may be—is as indocible and impenitent nonsense as it would be to include sea-serpents and stop-watches under one comprehensive designation for convenience of considering their collective influence on atmospheric tides.

<div align="right">Argonaut, 1878</div>

The Pride of the Press

Sam Williams, we are ashamed of you. What the hoary mischief did you mean by that gabble at the Japanese banquet, in response to the toast of "The Press"? Nice talk this—and modest too—from a journalist. "The press is proud to be accounted one of those vital forces that impel mankind toward a noble goal and a higher destiny; one of the chief motors of human progress, and one of the chief instruments of a higher civilization!" Is a toast to be regarded as an invitation for the thing toasted to glorify itself? You know very well that this stale old compliment to the press is lugged in at every banquet only to tickle the reporters with a sense of their importance and prevent them from ridiculing the whole affair.

Besides, your apotheosis of your own profession is mostly bosh, and a very poor article of bosh at that. The press is nothing of the kind that you describe; and no one knows it better than yourself. By "the press" you mean the *Bulletin,* and your remarks are more notably untrue of that journal than of journalism. You are very well assured that the *Bulletin* is published, not to impel mankind toward a noble goal, but to make money out of mankind. (That is what the *News Letter* is published for, too; but we have the honesty to confess it.) You know that if Ben. Avery, or Bunker, or Parson Bartlett, or any one of your fellows would say to you in private conversation about the mission of the press what you said at that banquet, you would laugh in his face.

Sam, your remarks were not only false and in bad taste, but they were absurd. Suppose Deacon Fitch should come to you with the fascinating prospectus of the Big Bilk Homestead Swindle, and say— "Mr. Williams, these scoundrels have paid me well to puff their infernal scheme, and I wish you would put this in as a piece of news, adding such editorial commendation as you think safe." Would this be impelling mankind to a higher destiny? In carrying out Mr. Fitch's instructions would you be a chief motor of human progress, and a chief instrument of a higher civilization? Sam, we doubt it.

<div align="right">News Letter, 1872</div>

The Transmigrations of a Soul

What! Pixley, must I hear you call the roll
Of all the vices that infest your soul?
Was't not enough that lately you did bawl
Your money-worship in the ears of all?
Still must you crack your brazen cheek to tell
That though a miser you're a sot as well?
Still must I hear how low your taste has sunk—
From getting money down to getting drunk?
Who worships money, damning all beside,
And shows his callous knees with pious pride,
Speaks with half-knowledge, for no man e'er scorns
His own possessions, be they coins or corns.
You've money, neighbor; had you gentle birth
You'd know, as now you never can, its worth.

You've money; learning is beyond your scope,
Deaf to your envy, stubborn to your hope.
But if upon your undeserving head
Science and letters had their glory shed;
If in the cavern of your skull the light
Of knowledge shone where now eternal night
Breeds the blind, poddy, vapor-fatted naughts
Of cerebration that you think are thoughts—
Black bats in cold and dismal corners hung
That squeak and gibber when you move your
 tongue—
You would not write, in Avarice's defense,
A senseless eulogy on lack of sense,
Nor show your eagerness to sacrifice
All noble virtues to one loathsome vice.

You've money; if you'd manners too you'd shame
To boast your weakness or your baseness name.
Appraise the things you have, but measure not
The things denied to your unhappy lot.
He values manners lighter than a cork
Who combs his beard at table with a fork.
Hare to seek sin and tortoise to forsake,

The laws of taste condemn you to the stake
To expiate, where all the world may see,
The crime of growing old disgracefully.

Distinction, learning, birth and manners, too,
All that distinguishes a man from you,
Pray damn at will: all shining virtues gain
An added luster from a rogue's disdain.
But spare the young that proselyting sin,
A toper's apotheosis of gin.
If not our young, at least our pigs may claim
Exemption from the spectacle of shame!

Are you not he who lately out of shape
Blew a brass trumpet to denounce the grape?—
Who led the brave teetotalers afield
And slew your leader underneath your shield?—
Swore that no man should drink unless he flung
Himself across your body at the bung?—
Who vowed if you'd the power you would fine
The Son of God for making water wine?

All trails to odium you tread and boast,
Yourself enamored of the dirtiest most.
One day to be a miser you aspire,
The next to wallow drunken in the mire;
The third, lo! you're a meritorious liar!
Pray, in the catalogue of all your graces
Have theft and cowardice no honored places?

Yield thee, great Satan—here's a rival name
With all thy vices and but half thy shame!
Quick to the letter of the precept, quick
To the example of the elder Nick;
With as great talent as was e'er applied
To fool a teacher and to fog a guide;
With slack allegiance and boundless greed,
To paunch the profit of a traitor deed,
He aims to make thy glory all his own,
And crowd his master from the infernal throne!

Arthur McEwen

Posterity with all its eyes
Will come and view him where he lies.
Then, turning from the scene away
With a concerted shrug, will say:
"H'm, *Scarabœus Sisyphus*—
What interest has that to us?
We can't admire at all, at all,
A tumble-bug without its ball."
And then a sage will rise and say:
"Good friends, you err—turn back, I pray:
This freak that you unwisely shun
Is bug and ball rolled into one."

LITERATURE AND THE ARTS

George Bernard Shaw once wrote that "Those who can't, teach." There is of course another avenue—they can become critics. Bierce, as a failed poet and as a collaborator on a novel that was an esthetic and commercial disaster, was thus seemingly qualified to pronounce on both poets and novelists. He was superbly wrongheaded most of the way; he disliked the good work of Jack London and Frank Norris, detested the poetry of Walt Whitman and Edwin Markham, and took swipes at writers such as Bret Harte and Mark Twain who might be thought to be more important on the literary scene.

At the same time, he fulminated eloquently about the stranglehold of Eastern literary magazines and the cliques of elegant and likeminded authors who contributed to them. He was especially critical of Henry James and William Dean Howells, describing them as "eminent triflers and cameo-cutters-in-chief to Her Littleness the Bostonese."

Of all his targets, Oscar Wilde aroused the most biliousness. The eminent wit had arrived in New York for his lecture tour and declared loudly that "Satire is always as sterile as it is shameful, and as impotent as it is insolent." That, for Bierce, was the largest red flag ever unfurled, and he charged into print; to his chagrin, Wilde never noticed.

The Pavior

An Author saw a Labourer hammering stones into the pavement of a street, and approaching him said:

"My friend, you seem weary. Ambition is a hard taskmaster."

"I'm working for Mr. Jones, sir," the Labourer replied.

"Well, cheer up," the Author resumed; "fame comes at the most unexpected times. To-day you are poor, obscure, and disheartened, and to-morrow the world may be ringing with your name."

"What are you giving me?" the Labourer said. "Cannot an honest pavior perform his work in peace, and get his money for it, and his living by it, without others talking rot about ambition and hopes of fame?"

"Cannot an honest writer?" said the Author.

Fortune and the Fabulist

A Writer of Fables was passing through a lonely forest when he met a Fortune. Greatly alarmed, he tried to climb a tree, but the Fortune pulled him down and bestowed itself upon him with cruel persistence.

"Why did you try to run away?" said the Fortune, when his struggles had ceased and his screams were stilled. "Why do you glare at me so inhospitably?"

"I don't know what you are," replied the Writer of Fables, deeply disturbed.

"I am wealth; I am respectability," the Fortune explained; "I am elegant houses, a yacht, and a clean shirt every day. I am leisure, I am travel, wine, a shiny hat, and an unshiny coat. I am enough to eat."

"All right," said the Writer of Fables, in a whisper; "but for goodness' sake speak lower."

"Why so?" the Fortune asked, in surprise.

"So as not to wake me," replied the Writer of Fables, a holy calm brooding upon his beautiful face.

The Critics

While bathing, Antinous was seen by Minerva, who was so enamoured of his beauty that, all armed as she happened to be, she descended from Olympus to woo him; but, unluckily displaying her shield, with the head of Medusa on it, she had the unhappiness to see the beautiful mortal turn to stone from catching a glimpse of it. She straightway ascended to Jove to restore him; but before this could be done a Sculptor and a Critic passed that way and espied him.

"This is a very bad Apollo," said the Sculptor: "the chest is too narrow, and one arm is at least a half-inch shorter than the other. The attitude is unnatural, and I may say impossible. Ah! my friend, you should see my statue of Antinous."

"In my judgment, the figure," said the Critic, "is tolerably good, though rather Etrurian, but the expression of the face is decidedly Tuscan, and therefore false to nature. By the way, have you read my work on 'The Fallaciousness of the Aspectual in Art'?"

On Putting One's Head into One's Belly

Mr. Henry Holt, a publisher, has uttered his mind at no inconsiderable length in deprecation of what he calls "the commercialization of literature." That literature, in this country and England at least, has some-

what fallen from its high estate and is regarded even by many of its purveyors as a mere trade is unfortunately true, as we see in the genesis and development of the "literary syndicates"; in the unholy alliance between the book reviewer and the head of the advertising department; in the systematic "booming" of certain books and authors by methods, both supertabular and submanual, not materially different from those used for the promotion of a patent medicine; in the reverent attitude of editors and publishers toward authors of "best sellers," and in more things than can be here set down. In the last century when, surely by no fortuitous happening, American literature was made by such men as Irving, Cooper, Bryant, Poe, Emerson, Whittier, Hawthorne, Longfellow, Holmes and Lowell, these purely commercial phenomena were in less conspicuous evidence and some of them were altogether indiscernible.

That the period of literature's commercialization should be that of its decay is obviously more than a coincidence. Mr. Holt observes both, and is sad, but *that* is a coincidence pure and simple: his melancholy is due to something else. The "commercialization" is confessedly compelling him to do a good deal more advertising than he likes to pay for; for commerce spells competition. The authors of to-day and their agents have acquired the disagreeable habit of taking their wares to the highest bidder—the publisher who will give the highest royalties and the broadest publicity. The immemorial relation whereby the publisher was said to drink wine out of the author's skull has been rudely disturbed by the latter demanding some of the wine for himself and refusing to supply the skull—an irritating infraction of a good understanding sanctified by centuries of faithful observance. It is only natural that Mr. Holt, being a conservative man and a protagonist of established order, should experience some of the emotions appropriate to the defenders in a servile insurrection.

With a candor that is most becoming, Mr. Holt expressly bewails the passing of the old régime—the departed days when authors "had other resources" than authorship. This is the second time that it has been my melancholy privilege to hear the head of a prosperous American publishing house make this moan. Another one, a few years ago, in addressing a company of authors, solemnly advised them to have some means of support additional to writing. I was not then, and am not now, assured that publishers find it necessary to have any means of support additional to publishing.

The Humorist

"What is that, mother?"

"The humorist, child.
His hands are black, but his heart is mild."

"May I touch him, mother?"

"'Twere needlessly
done:
He is slightly touched already, my son."

"O, why does he wear such a ghastly grin?"

"'Tis the outward sign of a joke within."

"Will he crack it, mother?"

"Not so, my saint;
'Tis meant for the *Saturday Livercomplaint*."

"Does he suffer, mother?

"God help him, yes!—
A thousand and fifty kinds of distress."

"What makes him sweat so?"

"The demons that lurk
In the fear of having to go to work."

"Why doesn't he end, then, his life with a rope?"

"Abolition of Hell has deprived him of hope."

A Dilemma

Filled with a zeal to serve my fellow men,
For years I criticized their prose and verses:
Pointed out all their blunders of the pen,
Their shallowness of thought and feeling; then
Damned them up hill and down with hearty curses!

They said: "That's all that he can do—just sneer,
And pull to pieces and be analytic.
Why doesn't he himself, eschewing fear,
Publish a book or two, and so appear
As one who has the right to be a critic?"

"Let him who knows it all forbear to tell
How little others know, but *show* his learning."

And then they added: "Who has written well
May censure freely"—quoting Pope. I fell
Into the trap and books began out-turning,—

Books by the score—fine prose and poems fair,
And not a book of them but was a terror,
They were so great and perfect; though I swear
I tried right hard to work in, here and there,
(My nature still forbade) a fault or error.

'Tis true, some wretches, whom I'd scratched, no
 doubt,
Professed to find—but that's a trifling matter.
Now, when the flood of noble books was out
I raised o'er all that land a joyous shout
Till I was thought as mad as any hatter!

(Why hatters all are mad, I cannot say.
'Twere wrong in their affliction to revile 'em,
But truly, you'll confess 'tis very sad
We wear the ugly things they make. Begad,
They'd be less mischievous in an asylum!)

Consistency, thou art a—well, you're *paste!*
When next I felt my demon in possession,
And made the field of authorship a waste,
All said of me: "What execrable taste,
To rail at others of his own profession!"

Good Lord! where do the critic's rights begin
Who has of literature some clear-cut notion,
And hears a voice from Heaven say: "Pitch in"?
He finds himself—alas, poor son of sin—
Between the devil and the deep blue ocean!

The Ox and The Ass

"I say, you," bawled a fat Ox in a stall to a lusty young Ass who was
braying outside; "the like of that is not in good taste."

"In whose good taste, my adipose censor?" inquired the Ass, not too respectfully.

"Why—ah—h'm. I mean that it does not suit me. You should bellow."

"May I ask how it concerns you whether I bellow or bray, or do both, or neither?"

"I cannot tell you," said the Ox, shaking his head despondingly—"I do not at all understand the matter. I can only say that I have been used to censure all discourse that differs from my own."

"Exactly," said the Ass; "you have tried to make an art of impudence by calling preferences principles. In 'taste' you have invented a word incapable of definition to denote an idea impossible of expression, and by employing the word 'good' or 'bad' in connection with it you indicate a merely subjective process, in terms of an objective quality. Such presumption transcends the limits of mere effrontery and passes into the boundless empyrean of pure gall!"

The bovine critic having no words to express his disapproval of this remarkable harangue, said it was in bad taste.

The Powerless Poet

A Poet whose lines never would scan was summoned before the King and commanded to show cause why he should not be put to death.

"If your ear is imperfect," said the King, "you could count your syllables on your fingers, like an honest workman."

"May your Majesty outlive your Prime Minister by as many years as remain to you," said the Poet, reverently. "I do count my syllables. But observe: my left hand lacks a finger—bitten off by a critic."

"Then," said the King, "why don't you count on the right hand?"

"Alas!" was the reply of the Poet, as he held up the mutilated left, "that is impossible—there is nothing to count with! It is the forefinger that is lacking."

"Unfortunate man!" exclaimed the sympathetic monarch. "We must make your limitations and disabilities immaterial. You shall write for the magazines."

Mark Twain Marries

Mark Twain, who, whenever he has been long enough sober to permit an estimate, has been uniformly found to bear a spotless character, has got

married. It was not the act of a desperate man—it was not committed while laboring under temporary insanity; his insanity is not of that type, nor does he ever labor—it was the cool, methodical, cumulative culmination of human nature, working in the breast of an orphan hankering for some one with a fortune to love—some one with a bank account to caress. For years he has felt this matrimony coming on. Ever since he left California there has been an undertone of despair running through all his letters like the subdued wail of a pig beneath a washtub. He felt that he was going, that no earthly power could save him, but as a concession to his weeping publishers he tried a change of climate by putting on a linen coat and writing letters from the West Indies. Then he tried rhubarb, and during his latter months he was almost constantly under the influence of this powerful drug. But rhubarb, while it may give a fitful glitter to the eye and a deceitful ruddiness to the gills, cannot long delay the pangs of approaching marriage. Rhubarb was not what Mark wanted. Well, that genial spirit has passed away; that long, bright smile will no more greet the early bar-keeper, nor the old familiar "chalk it down" delight his ear. Poor Mark! he was a good scheme, but he couldn't be made to work.

News Letter, 1870

Mark Twain Retires

It is announced that Mark Twain, being above want, will lecture no more. We didn't think that of Mark; we supposed that after marrying a rich girl he would have decency enough to make a show of working for a year or two anyhow. But it seems his native laziness has wrecked his finer feelings, and he has abandoned himself to his natural vice with the stolid indifference of a pig at his ablutions. We have our own private opinion of a man who will do this kind of thing; we regard him as an abandoned wretch. We should like to be abandoned in that way.

News Letter, 1870

Mark Twain Prospers

Mark Twain's father-in-law is dead, and has left that youth's wife a quarter of a million dollars. At the time of Mark's marriage, a few months since, we expressed some doubt as to the propriety of the transaction. That doubt has been removed by death.

News Letter, 1870

Mark Twain Holds Forth

Mark Twain's Boston speech, in which the great humorist's coltish imagination represented Longfellow, Emerson, and Whittier engaged at a game of cards in the cabin of a California miner, is said to have so wrought upon the feelings of "the best literary society" in that city that the daring joker is in danger of lynching. I hope they won't lynch him; it would be irregular and illegal, however roughly just and publicly beneficial. Besides, it would rob many a worthy sheriff of an honorable ambition by dispelling the most bright and beautiful hope of his life.

Argonaut, 1878

Bret Harte: The Professor

In a civilization in which everything should work as it ought, a man after committing an essentially mean act would make his will, bid his weeping creditors a long farewell, pick up a handsaw, and go out and disembowel himself by rasping it transversely across his abdomen.

Under this *regime* the editors of the *Call* and the *Examiner* would be dead as door nails. We must do the *Examainer* man the justice to say that he does a mean thing with an openness and candor that go far toward concealing, and even atoning for, the malice of his motive. The *Call* person, on the other hand, goes about a dirty business with a sneaking silence and a slinking limp, like a coyote invading a graveyard by the uncertain light of the moon. The Regents of the University have elected Mr. Bret Harte to the professorship of recent literature—which he has done even more to adorn than the editors of the *Call* and *Examiner* to disgrace—and these journalists, who know nothing about recent or any other literature, must needs have their fling at him.

The *Examiner,* as above intimated, picks up the honest brick and lets it go at Mr. Harte's head in a straight-forward way. It takes the boldly idiotic stand that no such chair is needed at the University, and argues it with unblushing stupidity. The *Call* sidles up behind a man of straw, whom with rare humor it calls "a Correspondent," shies its handful of mud at Mr. Harte's back, and runs and hides under the coat-tail of its accomplice. It seems some stonecutters employed on the University buildings have had their wages reduced. "And are the wages of workmen to be reduced," snivels the *Call,* "in order to pay Mr. Harte $3,600 per annum?" That is where the shoe pinches the corny foot of the *Call;* a half-dozen loafing stonemasons are getting no more than they earn. It is useless to talk of the rainbow to a man blind from birth, or to prate of the differential calculus to a plowboy. But even the blind man, although he

cannot conceive a rainbow, may be made to understand that it is nice; and the plowboy may be got to admit the figures are of some assistance in computation. We doubt if the editors in question can be made to acknowledge that literature *is* a creditable thing, or that a State University is not established for the sole benefit of the men who hew the shaft or lay the architrave.

<div align="right">

News Letter, 1870

</div>

Bret Harte: The Editor

There never was a sillier idea than that which magnifies the importance of an individual writer, no matter how distinguished his talent, to such proportions as to make him indispensable to the prosperity of a popular publication. No fact has been more clearly demonstrated by experience than that no writer is so clever or so brilliant that his place cannot be filled. Some of Mr. Harte's more enthusiastic admirers have entertained the notion that the *Overland* owes all its reputation and vitality to him. There is an unjust disparagement of the numerous corps of talented contributors whose varied productions have enriched the pages of our favorite magazine. Take away the papers and poems furnished by Bartlett, Ver Mehyr, Stoddard, Jno. D. Collraith, Mulford, Watkins, Kip, Well, Evans, and scores of other gifted contributors, and "Truthful James" left to stalk the stage in solitary egotism would cut but a shabby figure.

The probability now seems to be that in a business point of view Harte's loss will be a gain to the magazine. His reputed fastidiousness of taste, and his alleged disposition to set up a close corporation of favored contributors—a little literary coterie of which he should be the center and oracle, and to whom he could dispense a benignant patronage—these have deterred many of the best writers in the State from attempting to furnish anything for the periodical. The same fastidiousness, together with an undue partiality for light and airy topics has excluded from its pages valuable papers on solid subjects relating to the business and industrial interests of the State. We learn that since the report of Mr. Harte's retiracy from the editorial chair has gone forth, the number of contributions sent in has been more than double that received during any previous month, and new subscriptions to the number of over six hundred have come in.

The truth seems to be that the real interests of the *Overland* have been to a certain extent sacrificed to the editor's individual glory; and the probability is that under the careful management of a less

conceited and ambitious genius than Mr. Harte, it would become more acceptable to the general public than it has heretofore been, though it would no doubt be subjected to the disparaging criticism of the little clique of Mr. Harte's special idolaters. We think it almost certain that a wider and less exclusive popularity would be attained by the magazine if a larger share of the practical element were infused into it; its chief defects thus far have consisted in too decided a preponderance of literary *dilettantism* in its pages, and that lack of breadth and variety naturally incident to a periodical that has been run as a "one-man publication."

News Letter, 1871

The Eastern Literary Conspiracy

I have not seen the current number of the *London Quarterly Review,* but the *Bulletin* of Saturday last reprinted from it some coldly just criticism of the literary work of Messrs. W. D. Howells and Henry James, Jr. These two eminent triflers and cameo-cutters-in-chief to Her Littleness the Bostonese small virgin, have for some years been the acknowledged leaders of American Literature. Their measureless, meaningless and unimaginative novels, destitute of plot, destitute of purpose, destitute of art, are staple subjects of discussion in coteries of the "cultured." One may not have read Homer, Goethe or Hugo, but let him look to himself if he have not studied James. One may venture to fall ill of Scott, but woe betide the luckless wight unwell of too much Howells. For there shall arise a soft-eyed Creature of the Craze and slay him in the midst of tumultuous applause.

Hawthorne, Bryant, Emerson, Longfellow—these are dead and damned. Whittier, Lowell, Holmes—they speak to averted understandings. These noble names of a golden age amongst whose palaces and temples we moved unaware gleam dim and spectral in the enchanted moondawn of their successors. While yet the sky is all ablaze with crimson glories of the day that is done, the orb of the new dispensation unveils her fat and foolish face and looks over the hills like a man with a lantern. Outlined against her disc in transient silhouette, behold the figures of this brace of nobodies, complacently enamored of their own invirility and poring like sponges the vocal incense of a valleyful of idiots.

> The conscious swains, rejoicing in the
> > sight,
> Eye the blue vault and bless the useful light,

But I venture to tell them it is all moonshine—that this new literature is the offspring of mental incapacity wet-nursed by a conspiracy. The American literature that is in vogue at any one time is the literature of the magazines, the form and direction being given by the *Atlantic Monthly,* whose editor may easily be a fool, but *ex officio* he is an Olympian deity. Our magazines are the advertising circulars of the book-publishers who own them. Their function is to "puff" the books which first appeared as serials in their pages. In their pages their writers "puff" one another. In the *Atlantic,* for example, the editor, T. B. Aldrich (a nerveless, colorless jelly-fish of literature) will have a long laudatory review of W. D. Howells. A few months later W. D. Howells will have a long laudatory review of Henry James, Jr. Later, Henry James, Jr., will come to the fore with a long laudatory review of T. B. Aldrich, and the circle is complete. Three dwarfs have towered above the heads of their fellow men by standing on one another's shoulders in turn.

The public does not "drop on to" this thrifty game; even the press is deluded by it. The *Atlantic* has played it boldly with marked cards since its foundation. *Harper* was quick to emulate, and the *Century* has been taken into full fellowship. There is no kind of cheating that this trinity of literary blacklegs do not practice: their play understands itself all the time. Ladies and gentlemen of culture, you have the distinguished honor of assisting at it as victims of it. Men and women of cultivation are otherwise engaged at another table.

Out of all this are evolved literary reputations. Men of letters manufacture one another. The two finest products of the mill are James and Howells. Neither can think and the latter cannot write. He cannot write at all. The other day, in fulfillment of a promise, I took a random page of this man's work and in twenty minutes had marked forty solecisms—instances of the use of words without a sense of their importance or a knowledge of their meaning—the substitution of a word that he did not want for a word that he did not think of. Confusion of thought leads to obscurity of expression. Without words there is no thought, only feeling, emotion. Words are the mechanism of thought. The master knows his machine, and precision is nine parts of style. This fellow Howells thinks into the hopper and the mangled thought comes out all over his cranky apparatus in gobs and splashes of expression. His loose locutions resemble the clean-cut rhetoric of a master as the ropy rid-dances of a cowfrog resemble polished and definite productions of a lady linnet.

Wasp, 1883

The Ineffable Oscar Wilde

That sovereign of insufferables, Oscar Wilde, has ensued with his opulence of twaddle and his penury of sense. He has mounted his hind legs and blown crass vapidities through the bowel of his neck, to the capital edification of circumjacent fools and foolesses, fooling with their foolers. He has tossed off the top of his head and uttered himself in copious overflows of ghastly bosh. The ineffable dunce has nothing to say and says it—says it with a liberal embellishment of bad delivery, embroidering it with reasonless vulgarities of attitude, gesture and attire. There was never an impostor so hateful, a blockhead so stupid, a crank so variously and offensively daft. Therefore is the she fool enamored of the feel of his tongue in her ear to tickle her understanding.

The limpid and spiritless vacuity of this intellectual jellyfish is in ludicrous contrast with the rude but robust mental activities that he came to quicken and inspire. Not only has he no thoughts, but no thinker. His lecture is mere verbal ditch-water—meaningless, trite and without coherence. It lacks even the nastiness that exalts and refines his verse. Moreover, it is obviously his own; he had not even the energy and independence to steal it. And so, with a knowledge that would equip an idiot to dispute with a cast-iron dog, an eloquence to qualify him for the duties of caller on a hog-ranch and an imagination adequate to the conception of a tom-cat, when fired by contemplation of a fiddle-string, this consummate and star-like youth, missing everywhere his heaven-appointed functions and offices, wanders about, posing as a statue of himself, and, like the sun-smitten image of Memnon, emitting meaningless murmurs in the blaze of women's eyes. He makes me tired.

And this gawky gowk has the divine effrontery to link his name with those of Swinburne, Rossetti and Morris—this dunghill he-hen would fly with eagles. He dares to set his tongue to the honored name of Keats. He is the leader, quoth'a, of a *renaissance* in art, this man who cannot draw—of a revival in letters, this man who cannot write! This littlest and looniest of a brotherhood of simpletons, whom the wicked wits of London, haling him dazed from his obscurity, have crowned and crucified as King of the Cranks, has accepted the distinction in stupid good faith and our foolish people take him at his word. Mr. Wilde is pinnacled upon a dazzling eminence but the earth still trembles to the dull thunder of the kicks that set him up.

Wasp, 1882

To Oscar Wilde

Because from Folly's lips you got
 Some babbled mandate to subdue
 The realm of Common Sense, and you
Made promise and considered not,—

Because you strike a random blow
 At what you do not understand,
 And beckon with a friendly hand
To something that you do not know,

I hold no speech of your dessert,
 Nor baffle with porrected shield
 The wooden weapon that you wield,
But meet you with a cast of dirt.

Dispute with such a thing as you—
 Twin show to the two-headed calf?
 Why, sir, if I repress my laugh,
'Tis more than half the world can do.

With a Book

Words shouting, singing, smiling, frowning—
 Sense lacking.
Ah, nothing more obscure than Browning,
 Save blacking.

In Warning

They tell us, dear Kipling, you're coming to shoot
 In the hills of the wide, wild West.
There's a lot of cost and a risk to boot—
 I don't at all think it is best,
 And hope it is only a jest.

For, Rudyard, although you're a terrible swell
 You're not in high favor out here;
For you said San Francisco was meaner than—well,

You said it was very small beer
And Chicago uncommonly queer.

You put your legs under our tables, you did,
 You dined at the Jollidog Club;
And when of your hunger you well were rid
 (And your manners too) like a cub
 You snarled at the speeches and grub.

You said—I don't know the one half that you said,
 But I know you pretended to meet
Some folk that existed not out of your head
 Or an English comical sheet.
 And you vilified Kearny street!

Our statesmen apparently didn't get far
 In the favor of one so too,
Too utterly fine. Nor the plump cigar
 Nor the shiny hat could woo
 The sweet and beautiful You.

But hardest of all our hearts you wrung
 With assorted pangs and woes
When you said you could speak the English tongue,
 But not the American nose.
 And you damned our orators' o's!

For all of this and for all of that
 You'd better abate your flame,
And remain where pheasants are tame and fat
 And the sportsman takes his aim,
 As a general thing, at the game.

Out here when we go to shoot, perhaps
 Nor beast nor bird we see;
So we just let go at the Britisher chaps
 Who have made remarks too free,
 And the same surcease to be.

To Elevate the Stage

The existence of a theatrical company, composed entirely of Cambridge and Harvard *alumni* who have been in jail, strikes the imagination with a peculiar force. In the theatrical world the ideal condition conceived by certain social philosophers is being rapidly realized and reduced to practice. "It does not matter," say these superior persons, "what one does; it is only important what one is." The theater folk have long been taking that view of things, as is amply attested by the histrionic careers (for examples) of Mrs. Lily Langtry and Mr. John L. Sullivan. Managers— and, we may add, the public—do not consider it of the least importance what Mrs. Langtry *does* on the stage, nor how she does it, so long as she *is* a former favorite of a Prince and a tolerably fair counterpart of a Jersey cow. And who cares what Mr. Sullivan's pronunciation of the word "mother" may be, or what degree of sobriety he may strive to simulate?—in seeing his performance we derive all our delight from the consciousness of the great and godlike thing that he has the goodness to *be*.

It is needless to recall other instances; every playgoer's memory is richly stored with them; but this troupe of convictetd collegians is the frankest application of the principle to which we have yet been treated. At the same time, it opens up "vistas" of possibilities extending far-and-away beyond what was but yesterday the longest reach of conjecture. Why should we stop with a troupe of educated felons? Let us recognize the principle to the full and apply it with logical heroism, unstayed by considerations of taste and sense. Let us have theater companies composed of reformed assassins who have been preachers. A company of deaf mutes whose grandfathers were hanged, would prove a magnetic "attraction" and play to good houses—that is to say, they would *be* to good houses. In a troupe of senators with warts on their noses the pleasure-shoving public would find an infinite gratification and delight. It might lack the allurement of feminine charm, most senators being rather old women, but for magnificent inaction it would bear the palm. Even better would be a company of distinguished corpses supporting some such star inactor, as the mummy of his late Majesty, Rameses II of Egypt. In them the do-nothing-be-something principle would have its highest, ripest and richest development. In the broad blaze of their histrionic glory Mrs. Langtry would pale her ineffectual fire and Mr. Sullivan hide his diminished head.

From the example of such a company streams of good would radiate in every direction, with countless ramifications. Not only would it accomplish the long desired "elevation of the stage" to such a plane that even the pulpit need not be ashamed to work with it in elicitation of

the human snore, but it would spread the light over other arts and industries, causing "the dawn of a new era" generally. Even with the comparatively slow progress we are making now, it is not unreasonable to hope that eventually Man will cease his fussy activity altogether and do nothing whatever, each individual of the species becoming a veritable monument of philosophical inaction, rapt in the contemplation of his own abstract worth and perhaps taking root where he stands to survey it.

The American Chair

A London philosopher was once pleased to remark that the American habit of sitting on the middle of the back with the feet elevated might in time profoundly alter the American physical structure, producing a race having its type in the Bactrian camel. If "our cousins across the water" understood this matter they would not adopt the flippant tone toward us that they now do, but in place of ridicule would bestow compassion. Before endeavoring to clear away the misconceptions surrounding the subject, so as to let in upon ourselves the holy light of British sympathy I must explain that the practice of sitting in the manner which the British philosopher somewhat inaccurately describes is confined mostly to the males of our race; the American woman will not, I trust, partake of the structural modification foreseen by the scientific eye, but remain, as now, simply and sweetly dromedarian. True, Nature may punish her for being found in bad company, but at the first stroke of the lash she will doubtless forsake us and seek sanctuary in the companionship of that bolt-upright vertebrate, the English nobleman.

The national peculiarity which, one is sorry to observe, provokes nothing but levity in the British mind—and British levity is no light affliction—is not our fault but our misfortune. Like every other people, we Americans are the slaves of those who serve us. Not one of us in a thousand (so busy are we in "subduing the wilderness" and guarding our homes against the Redskins) has leisure to plan and order his surroundings; and to the few whom Fortune has favored with leisure she has denied the means. We take everything ready-made—our houses, grounds, carriages, furniture and all. In some of these things Providence has by special interposition introduced new designs and revived old ones, but in most of them there is neither change nor the shadow of turning. They are to-day what they were a century ago, and a century hence will be what they are to-day. The chairmaker, for example, is the obscure intelligence and indirigible energy that his grandfather was before him: the American chair maintains through the ages its bad eminence as an instrument of torture. Time can not wither nor custom stale its infinite malevolence. The type of the species is the familiar

hardpan chair of the kitchen; in the dining-room this has been deplaced by the "splint-bottom," and in the parlor by an armed and upholstered abomination which tempts us to session only to turn to ashes, as it were, upon our bodies. They are essentially the same old chair—worthy descendants of the original Adam of Chairs, created from a block in the image of its maker's head. The American chair is never made to measure; it is supposed to fit anybody and be universally applicable.

It is to the American chair that we must look for the genesis and rationale of the American practice of shelving the American feet on the most convenient dizzy eminence. We naturally desire as little contact with the chair as possible, so we touch it with the acutest angle that we are able to achieve. The feet must rest somewhere, and a place must be found for them. It is admitted that the mantel, the sideboard, the window-sill, the *escritoire* and the dining table (at least during meals) are not good places, but *que voulez vous?*—the chairmakers have not chosen to invent anything to mitigate the bitterness of the situation as by their genius for evil they have made it.

I humbly submit that in all this there is nothing deserving of ridicule. It is a situation with a pathos of its own, which ought to appeal strongly to a people suffering so many of the ills of conservitude, as do the English. It is all very well (to use their own pet locution) to ask why we do not abolish the American chair, but really the question ought not to come from a nation that endures *Mr. Punch,* pities the House of Lords and embraces that of Hanover. The American chair was probably divinely designed and sent upon us for the chastening of our national spirit, and we accept it with the same reverent submission that distinguishes our English critic in bowing his neck to the heavy yoke of his own humor.

WOMEN

Bierce was a ferocious misogynist. His satirical swipes at women were bitterly concise, as though reflexive and automatic. At the same time, he seems reluctantly to acknowledge that they would not be such important subjects if they weren't so charming, pretty, and impossible to resist.

He was too much of a prude to write about sex except glancingly and too honest not to confess his enjoyment of women. He adored them, loved a few, had many, and always insisted they take him on terms impossibly narrow; when they couldn't, he stormed away, denying all attraction or commitment, renewing his attacks with savage glee. "There is positively no betting on the discreet reticence of any woman whose silence you have not secured with a meat-ax," he wrote one time when he feared some of his love letters might be published.

As so often with women, he was wrong. For the most part, they went to their graves without remarking him; perhaps their reticence was the best final commentary.

Epigrams on Women

Our luxuries are always masquerading as necessaries. Woman is the only necessary having the boldness and address to compel recognition as a luxury.

Woman would be more charming if one could fall into her arms without falling into her hands.

True, man does not know woman. But neither does woman.

When God makes a beautiful woman, the devil opens a new register.

Men talk of selecting a wife; horses, of selecting an owner.

He gets on best with women who best knows how to get on without them.

Do not permit a woman to ask forgiveness, for that is the first step. The second is justification of herself by accusation of you.

When Eve first saw her reflection in a pool, she sought Adam and accused him of infidelity.

Of two kinds of temporary insanity, one ends in suicide, the other in marriage.

In order that the lists of able women may be memorized for use at meetings of the oppressed sex, Heaven has considerately made it brief.

What a woman most admires in a man is distinction among men. What a man most admires in a woman is devotion to himself.

If women did the writing of the world, instead of the talking, men would be regarded as the superior sex in beauty, grace and goodness.

Although one has loved a dozen times, yet will the latest love seem the first. He who says he has loved twice has not loved once.

When God saw how faulty was man He tried again and made woman. As to why He then stopped there are two opinions. One of them is woman's.

You are not permitted to kill a woman who has wronged you, but nothing forbids you to reflect that she is growing older every minute. You are avenged fourteen hundred and forty times a day.

The Crimson Candle

A man lying at the point of death called his wife to his bedside and said:

"I am about to leave you forever; give me, therefore, one last proof of your affection and fidelity, for, according to our holy religion, a married man seeking admittance at the gate of Heaven is required to swear that he has never defiled himself with an unworthy woman. In my desk you will find a crimson candle, which has been blessed by the High Priest and has a peculiar mystical significance. Swear to me that while it is in existence that you will not remarry."

The Woman swore and the Man died. At the funeral the woman stood at the head of the bier, holding a lighted crimson candle till it was wasted entirely away.

The Reform School Board

The members of the School Board in Doosnoswair being suspected of appointing female teachers for an improper consideration, the people elected a Board composed wholly of women. In a few years the scandal was at an end; there were no female teachers in the Department.

Matrimonial Rights

It is difficult to regard Mr. John Beever, of St. Cloud, Minn., with feelings of respect tempered with disapprobation. This Mr. Beever is the gentleman who, the other day, went to call upon his wife, from whom he had been some time separated, and before leaving took occasion to inveigle her into a back kitchen by the chignon, and then threw off the disguise and revealed himself in his true colors with a sharp hatchet. He chopped away at the lady's head until he had made of it a basketful of unsightly chips, hanging confusedly together by tangled skeins of hair, clogged with warm brain and smoking with blood—altogether a very discouraging spectacle for the hired girl who had to clean up after him. It doesn't seem right to treat a woman in this way after having left her. When one frees himself from the obligations of matrimony he should be held to have renounced its privileges, which he has no right to resume until he shall consent to again become responsible for the household expenses. The privilege to hack and mangle the conjugal head should be very sparingly exercised anyhow, as it is one of doubtful utility, barren of satisfaction. To prevent a recurrence of such scenes as that weakly described above, we must look to a more healthy public opinion.

News Letter, 1872

The Devoted Widow

A Widow weeping on her husband's grave was approached by an Engaging Gentleman who, in a respectful manner, assured her that he had long entertained for her the most tender feelings.

"Wretch!" cried the Widow. "Leave me this instant! Is this a time to talk to me of love?"

"I assure you, madam, that I had not intended to disclose my affection," the Engaging Gentleman humbly explained, "but the power of your beauty has overcome my discretion."

"You should see me when I have not been crying," said the Widow.

The Tourist Trade

It is with considerable regret that I observe the continued activity of the girl-burglar boom. A pious old gentleman of Chicago is the latest victim. He had the indiscretion to sleep in the third story with his window open, and avers that, to the best of his knowledge and belief, the

young woman upon whom his money was found obtained access and egress by that aperture. It is to be hoped she did, but his eager desire not to prosecute if she will restore the coin looks very much as if he were guiltily conscious that she got in through the mirror.

Wasp, 1881

A Weary Echo

A Convention of female writers, which for two days had been stuffing Woman's couch with goose-quills and hailing the down of a new era, adjourned with unabated enthusiasm, shouting, "Place aux dames!" And Echo wearily replied, "Oh, damn."

At Heaven's Gate

Having arisen from the tomb, a Woman presented herself at the gate of Heaven, and knocked with a trembling hand.

"Madam," said Saint Peter, rising and approaching the wicket, "whence do you come?"

"From San Francisco," replied the Woman, with embarrassment, as great beads of perspiration spangled her spiritual brow.

"Never mind, my good girl," the Saint said, compassionately. "Eternity is a long time; you can live that down."

"But that, if you please, is not all." The Woman was growing more and more confused. "I poisoned my husband. I chopped up my babies. I———"

"Ah," said the Saint, with sudden austerity, "your confession suggests a very grave possibility. Were you a member of the Women's Press Association?"

The lady drew herself up and replied with warmth:

"I was not."

The gates of pearl and jasper swung back upon their golden hinges, making the most ravishing music, and the Saint, stepping aside, bowed low, saying:

"Enter, then, into thine eternal rest."

But the Woman hesitated.

"The poisoning—the chopping—the—the—" she stammered.

"Of no consequence, I assure you. We are not going to be hard on a lady who did not belong to the Women's Press Association. Take a harp."

"But I applied for membership—I was blackballed."
"Take two harps."

The Inconsolable Widow

A Woman in widow's weeds was weeping upon a grave.

"Console yourself, madam," said a Sympathetic Stranger. "Heaven's mercies are infinite. There is another man somewhere, besides your husband, with whom you can still be happy."

"There was," she sobbed—"there was, but this is his grave."

Wanted: One Virgin

A gentleman who is suspected of insanity has been committed to the Asylum. His idea is that the devil is in him, and he wishes to find the Virgin to cure him. It is just as well that he is gone to the Asylum; it is not likely that in San Franciscso he would find any virgin of sufficient age to undertake his restoration to health.

News Letter, 1871

Bereavement

A Countess (so they tell the tale)
Who dwelt of old in Arno's vale,
Where ladies, even of high degree,
Know more of love than of A, B, C,
Came once with a prodigious bribe
Unto the learned village scribe,
That most discreet and honest man
Who wrote for all the lover clan,
Nor e'er a secret had betrayed
Save when inadequately paid.
"Write me," she sobbed—"I pray thee do—
A book about the Prince di Giu—
A book of poetry in praise
Of all his works and all his ways;
The godlike grace of his address,
His more than woman's tenderness,
His courage stern and lack of guile,

The loves that wantoned in his smile.
So great he was, so rich and kind,
I'll not within a fortnight find
His equal as a lover. O,
My God! I shall be drowned in woe!"
"What! Prince di Giu is dead?" exclaimed
The honest man for letters famed,
The while he pocketed her gold;
"Of what?—if I may be so bold."
Fresh storms of tears the lady shed:
"I stabbed him fifty times," she said.

Disappointment

A Dog that had been engaged in pursuit of his own tail abandoned the chase and lying down curled up for repose. In his new posture he found his tail within easy reach of his teeth and seized it with avidity, but immediately released it, wincing with pain.

"After all," he said, "there is more joy in pursuit than in possession."

Nurse Wanted

The *Town Crier* is sick; he needs careful nursing and a multiplicity of medicines. His days are cheerless; he requires some one to sit up with him. His nights are feverish; he must have some one to lie—to him out of the *News Letter*. Males will not do; he is fatigued of them, and desires that they all travel in foreign countries—visit the Europeans or other distant tribes. What he wants is rhubarb, with a woman at the other end of the spoon. A very little rhubarb, a great quantity of woman, and a brief spoon. The rhubarb may be weak, but the woman should be strong enough to keep him from getting out of bed.

Before assuming this Christian duty, the lady should understand that the *Town Crier* is twenty-eight years of age, powerfully constructed, very good looking, and—rather obviously—a bachelor. That is the nature of his disease. He is confident of his ability to cheer up and entertain an intelligent nurse through the silent watches of the night, by detailing his various symptoms, their probable cause, and the manner of their cure. Nothing will be said calculated to excite alarm in the bosom of the most fastidious. The best of references will be given, and none required if the applicant is handsome.

All woman are handsome. Some, however, are more handsome

than others, and it is natural for the sick to prefer that kind. The mind weakened by suffering clings to beauty as a drowning sailor to a spar, and the body similarly affected likes to cling a little also. Salary is no object, and application may be made by photograph. Blondes will be gratefully rejected; the patient is himself a blonde, and that game will not impress. *Similia similibus non curantur.* LATER.—the *Town Crier* is convalescent, and will try to worry along without any assistance, thank you.

News Letter, 1870

Again

Well, I've met her again—at the Mission.
　　She'd told me to see her no more;
It was not a command—a petition;
　　I'd granted it once before.

Yes, granted it, hoping she'd write me,
　　Repenting her virtuous freak—
Subdued myself daily and nightly
　　For the better part of a week.

And then ('twas my duty to spare her
　　The shame of recalling me) I
Just sought her again to prepare her
　　For an everlasting good-bye.

O that evening of bliss—shall I ever
　　Cease living it over?—although
She said, when 'twas ended: "You're never
　　To see me again. And now go."

As we parted with kisses 'twas human
　　And natural for me to smile
As I thought, "She's in love, and a woman:
　　She'll send for me after a while."

But she didn't; so—well, the old Mission
　　Is fine, picturesque and gray;
'Tis an excellent place for contrition—
　　And sometimes she passes that way.

That's how it occurred that I met her,
 And that's all there is to tell—
Except that I'd like to forget her
 Calm way of remarking: "I'm well."

It was hardly worth while, all this keying
 My soul to such tensions and stirs
To learn that her food was agreeing
 With that little stomach of hers.

Justice

She jilted me. I madly cried:
 "The grave at least can hold her!"
Reflecting then that if she died
 'Twould stop her growing older,
I pitilessly sheathed the knife
And sternly sentenced her to life!

CURRIED COW

My Aunt Patience, who tilled a small farm in the state of Michigan, had
a favorite cow. This creature was not a good cow, nor a profitable one, for
instead of devoting a part of her leisure to secretion of milk and produc-
tion of veal she concentrated all her faculties on the study of kicking. She
would kick all day and get up in the middle of the night to kick.
She would kick at anything—hens, pigs, posts, loose stones, birds in
the air and fish leaping out of the water; to this impartial and catholic-
minded beef, all were equal—all similarly undeserving. Like old
Timotheus, who "raised a mortal to the skies," was my Aunt Patience's
cow; though, in the words of a later poet than Dryden, she did it "more
harder and more frequently." It was pleasing to see her open a passage for
herself through a populous barnyard. She would flash out, right and left,
first with one hind-leg and then with the other, and would sometimes,
under favoring conditions, have a considerable number of domestic
animals in the air at once.

 Her kicks, too, were as admirable in quality as inexhaustible in
quantity. They were incomparably superior to those of the untutored
kine that had not made the art a life study—mere amateurs that kicked
"by ear," as they say in music. I saw her once standing in the road,
professedly fast asleep, and mechanically munching her cud with a sort
of Sunday morning lassitude, as one munches one's cud in a dream.

Snouting about at her side, blissfully unconscious of impending danger and wrapped up in thoughts of his sweetheart, was a gigantic black hog—a hog of about the size and general appearance of a yearling rhinoceros. Suddenly, while I looked—without a visible movement on the part of the cow—with never a perceptible tremor of her frame, nor a lapse in the placid regularity of her chewing—that hog had gone away from there—had utterly taken his leave. But away toward the pale horizon a minute black speck was traversing the empyrean with the speed of a meteor, and in a moment had disappeared, without audible report, beyond the distant hills. It may have been that hog.

Currying cows is not, I think a common practice, even in Michigan; but as this one had never needed milking, of course she had to be subjected to some equivalent form of persecution; and irritating her skin with a curry-comb was thought as disagreeable an attention as a thoughtful affection could devise. At least she thought it so; though I suspect her mistress really meant it for the good creature's temporal advantage. Anyhow my aunt always made it a condition to the employment of a farm-servant that he should curry the cow every morning; but after just enough trials to convince himself that it was not a sudden spasm, nor a mere local disturbance, the man would always give notice of an intention to quit, by pounding the beast half-dead with some foreign body and then limping home to his couch. I don't know how many men the creature removed from my aunt's employ in this way, but judging from the number of lame persons in that part of the country, I should say a good many; though some of the lameness may have been taken at second-hand from the original sufferers by their descendants, and some may have come by contagion.

I think my aunt's was a faulty system of agriculture. It is true her farm labor cost her nothing, for the laborers all left her service before any salary had accrued; but as the cow's fame spread abroad through the several States and Territories, it became increasingly difficult to obtain hands; and, after all, the favorite was imperfectly curried. It was currently remarked that the cow had kicked the farm to pieces—a rude metaphor, implying that the land was not properly cultivated, nor the buildings and fences kept in adequate repair.

It was useless to remonstrate with my aunt; she would concede everything, amending nothing. Her late husband had attempted to reform the abuse in this manner, and had had the argument all his own way until he had remonstrated himself into an early grave; and the funeral was delayed all day, until a fresh undertaker could be procured, the one originally engaged having confidingly undertaken to curry the cow at the request of the widow.

Since that time my Aunt Patience had not been in the matri-

monial market; the love of that cow had usurped in her heart the place of a more natural and profitable affection. But when she saw her seeds unsown, her harvests ungarnered, her fences overtopped with rank brambles and her meadows gorgeous with the towering Canada thistle she thought it best to take a partner.

When it transpired that my Aunt Patience intended wedlock there was intense popular excitement. Every adult single male became at once a marrying man. The criminal statistics of Badger county show that in that single year more marriages occurred than in any decade before or since. But none of them was my aunt's. Men married their cooks, their laundresses, their deceased wives' mothers, their enemies' sisters— married whomsoever would wed; and any man who, by fair means or courtship, could not obtain a wife went before a justice of the peace and made an affidavit that he had some wives in Indiana. Such was the fear of being married alive by my Aunt Patience.

Now, where my aunt's reflection was concerned she was, as the reader will have already surmised, a rather determined woman; and the extraordinary marrying epidemic having left but one eligible male in all that county, she had set her heart upon that one eligible male; then she went and carted him to her home. He turned out to be a long Methodist parson, named Huggins.

Aside from his unconscionable length, the Rev. Berosus Huggins was not so bad a fellow, and was nobody's fool. He was, I suppose, the most ill-favored mortal, however, in the whole northern half of America—thin, angular, cadaverous of visage and solemn out of all reason. He commonly wore a low-crowned black hat, set so far down upon his head as partly to eclipse his eyes and wholly obscure the ample glory of his ears. The only other visible article of his attire (except a brace of wrinkled cowskin boots, by which the word "polish" would have been considered the meaningless fragment of a lost language) was a tight-fitting black frock-coat, preternaturally long in the waist, the skirts of which fell about his heels, sopping up the dew. This he always wore snugly buttoned from the throat downward. In this attire he cut a tolerably spectral figure. His aspect was so conspicuously unnatural and inhuman that whenever he went into a cornfield, the predatory crows would temporarily forsake their business to settle upon him in swarms, fighting for the best seats upon his person, by way of testifying their contempt for the weak inventions of the husband-man.

The day after the wedding my Aunt Patience summoned the Rev. Berosus to the council chamber, and uttered her mind to the following intent:

"Now, Huggy, dear, I'll tell you what there is to do about the place. First, you must repair all the fences, clearing out the weeds and

repressing the brambles with a strong hand. Then you will have to exterminate the Canadian thistles, mend the wagon, rip up a plow or two, and get things into ship-shape generally. This will keep you out of mischief for the better part of two years; of course you will have to give up preaching, for the present. As soon as you have—O! I forgot poor Phœbe. She—"

"Mrs. Huggins," interrupted her solemn spouse, "I shall hope to be the means, under Providence, of effecting all needful reforms in the husbandry of this farm. But the sister you mention (I trust she is not of the world's people)—have I the pleasure of knowing her? The name, indeed, sounds familiar, but—"

"Not know Phœbe!" cried my aunt, with unfeigned astonishment; "I thought everybody in Badger knew Phœbe. Why, you will have to scratch her legs, every blessed morning of your natural life!"

"I assure you, madam," rejoined the Rev. Berosus, with dignity, "it would yield me a hallowed pleasure to minister to the spiritual needs of sister Phœbe, to the extent of my feeble and unworthy ability; but, really, I fear the merely secular ministration of which you speak must be entrusted to abler and, I would respectfully suggest, female hands."

"Whyyy, youuu ooold foooool!" replied my aunt, spreading her eyes with unbounded amazement, "Phœbe is a *cow!*"

"In that case," said the husband, with unruffled composure, "it will, of course, devolve upon me to see that her carnal welfare is properly attended to; and I shall be happy to bestow upon her legs such time as I may, without sin, snatch from my strife with Satan and the Canadian thistles."

With that the Rev. Mr. Huggins crowded his hat upon his shoulders, pronounced a brief benediction upon his bride, and betook himself to the barn-yard.

Now, it is necessary to explain that he had known from the first who Phœbe was, and was familiar, from hearsay, with all her sinful traits. Moreover, he had already done himself the honor of making her a visit, remaining in the vicinity of her person, just out of range, for more than an hour and permitting her to survey him at her leisure from every point of the compass. In short, he and Phœbe had mutually reconnoitered and prepared for action.

Amongst the articles of comfort and luxury which went to make up the good parson's *dot,* and which his wife had already caused to be conveyed to his new home, was a patent cast-iron pump, about seven feet high. This had been deposited near the barn-yard, preparatory to being set up on the planks above the barn-yard well. Mr. Huggins now sought out this invention and conveying it to its destination put it into

position, screwing it firmly to the planks. He next divested himself of his long gaberdine and his hat, buttoning the former loosely about the pump, which it almost concealed, and hanging the latter upon the summit of the structure. The handle of the pump, when depressed, curved outwardly between the coat-skirts, singularly like a tail, but with this inconspicuous exception, any unprejudiced observer would have pronounced the thing Mr. Huggins, looking uncommonly well.

The preliminaries completed, the good man carefully closed the gate of the barnyard, knowing that as soon as Phœbe, who was campaigning in the kitchen garden, should note the precaution she would come and jump in to frustrate it, which eventually she did. Her master, meanwhile, had laid himself, coatless and hatless, along the outside of the close board fence, where he put in the time pleasantly, catching his death of cold and peering through a knot-hole.

At first, and for some time, the animal pretended not to see the figure on the platform. Indeed she had turned her back upon it directly she arrived, affecting a light sleep. Finding that this stratagem did not achieve the success that she had expected, she abandoned it and stood for several minutes irresolute, munching her cud in a half-hearted way, but obviously thinking very hard. Then she began nosing along the ground as if wholly absorbed in a search for something that she had lost, tacking about hither and thither, but all the time drawing nearer to the object of her wicked intention. Arrived within speaking distance, she stood for a little while confronting the fraudful figure, then put out her nose toward it, as if to be caressed, trying to create the impression that fondling and dalliance were more to her than wealth, power and the plaudits of the populace—that she had been accustomed to them all her sweet young life and could not get on without them. Then she approached a little nearer, as if to shake hands, all the while maintaining the most amiable expression of countenance and executing all manner of seductive nods and winks and smiles. Suddenly she wheeled about and with the rapidity of lightning dealt out a terrible kick—a kick of inconceivable force and fury, comparable to nothing in nature but a stroke of paralysis out of a clear sky!

The effect was magical! Cows kick, not backward but sidewise. The impact which was intended to project the counterfeit theologian into the middle of the succeeding conference week reacted upon the animal herself, and it and the pain together set her spinning like a top. Such was the velocity of her revolution that she looked like a dim, circular cow, surrounded by a continuous ring like that of the planet Saturn—the white tuft at the extremity of her sweeping tail! Presently, as the sustaining centrifugal force lessened and failed, she began to sway and wabble from side to side, and finally, toppling over on her side,

rolled convulsively on her back and lay motionless with all her feet in the air, honestly believing that the world had somehow got atop of her and she was supporting it at a great sacrifice of personal comfort. Then she fainted.

How long she lay unconscious she knew not, but at last she unclosed her eyes, and catching sight of the open door of her stall, "more sweet than all the landscape smiling near," she struggled up, stood wavering upon three legs, rubbed her eyes, and was visibly bewildered as to the points of the compass. Observing the iron clergyman standing fast by its faith, she threw it a look of grieved reproach and hobbled heart-broken into her humble habitation, a subjugated cow.

For several weeks Phœbe's right hind leg was swollen to a monstrous growth, but by a season of judicious nursing she was "brought round all right," as her sympathetic and puzzled mistress phrased it, or "made whole," as the reticent man of God preferred to say. She was now as tractable and inoffensive "in her daily walk and conversation" (Huggins) as a little child. Her new master used to take her ailing leg trustfully into his lap, and for that matter, might have taken it into his mouth if he had so desired. Her entire character appeared to be radically changed—so altered that one day my Aunt Patience, who, fondly as she loved her, had never before so much as ventured to touch the hem of her garment, as it were, went confidently up to her to soothe her with a pan of turnips. Gad! how thinly she spread out that good old lady upon the face of an adjacent stone wall! You could not have done it so evenly with a trowel.

RELIGION AND RELIGIOSITY

For the professional naysayer, there are few arenas better than religion in which to vocalize. Like many atheists, Bierce admired Jesus and his teachings but despised the religions claiming him. San Francisco was always viewed as a rather wicked place and drew a flock of evangelists who added a great deal to its social texture as well as fuel for Bierce's ire.

It's interesting that a number of the issues raised so long ago are still with us—prayer in the schools, God on the side of an army, intolerance and racism by some steady churchgoers, and preachers meddling in politics, for example. Wherever he resides, Bierce must still be laughing grimly, as he undoubtedly was when he wrote:

> By plain analogy we're told
> Why first the church was called the fold:
> Into the fold the sheep are steered
> There guarded from the wolf and—sheared.

Saint and Sinner

"My friend," said a distinguished officer of the Salvation Army, to a Most Wicked Sinner, "I was once a drunkard, a thief, an assassin. The Divine Grace has made me what I am."

The Most Wicked Sinner looked at him from head to foot.

"Henceforth," he said, "the Divine Grace, I fancy, will let well enough alone."

Arma Virumque

"Ours is a Christian army"; so he said
A regiment of bangomen who led.
"And ours a Christian navy," added he
Who sailed a thunder-junk upon the sea
Better they know than men unwarlike do

What is an army, and a navy too.
Pray God there may be sent them by-and-by
The knowledge what a Christian is, and why.
For somewhat lamely the conception runs
Of a brass-buttoned Jesus firing guns.

Religions of Error

Hearing a sound of strife, a Christian in the Orient asked his Dragoman the cause of it.

"The Buddhists are cutting Mohammedan throats," the Dragoman replied, with oriental composure.

"I did not know," remarked the Christian, with scientific interest, "that that would make so much noise."

"The Mohammedans are cutting Buddhist throats, too," added the Dragoman.

"It is astonishing," mused the Christian, "how violent and how general are religious animosities. Everywhere in the world the devotees of each local faith abhor the devotees of every other, and abstain from murder only so long as they dare not commit it. And the strangest thing about it is that all religions are erroneous and mischievous excepting mine. Mine, thank God, is true and benign."

So saying he visibly smugged and went off to telegraph for a brigade of cutthroats to protect Christian interests.

A Constructor

I saw the devil. He was working free—
A customs-house he builded by the sea.
"Why do you this?" The devil raised his head:
"Of churches I have built enough," he said.

A Smiling Idol

An Idol said to a Missionary, "My friend, why do you seek to bring me into contempt? If it had not been for me, what would you have been? Remember thy creator that thy days be long in the land."

"I confess," replied the Missionary, fingering a number of ten-cent pieces which a Sunday-school in his own country had forwarded to him, "that I am a product of you, but I protest that you cannot quote

Scripture with accuracy and point. Therefore will I continue to go up against you with the Sword of the Spirit."

Shortly afterwards the Idol's worshippers held a great religious ceremony at the base of his pedestal, and as a part of the rites the Missionary was roasted whole. As the tongue was removed for the high priest's table, "Ah," said the Idol to himself, "that is the Sword of the Spirit—the only Sword that is less dangerous when unsheathed."

And he smiled so pleasantly at his own wit that the provinces of Ghargaroo, M'gwana, and Scowow were affected with a blight.

The Foolish Woman

A Married Woman, whose lover was about to reform by running away, procured a pistol and shot him dead.

"Why did you do that, Madam?" inquired a Policeman, sauntering by.

"Because," replied the Married Woman, "he was a wicked man, and had purchased a ticket to Chicago."

"My sister," said an adjacent Man of God, solemnly, "you cannot stop the wicked from going to Chicago by killing them."

The Old Man and the Pupil

A Beautiful Old Man, meeting a Sunday-school Pupil, laid his hand tenderly upon the lad's head, saying: "Listen, my son, to the words of the wise and heed the advice of the righteous."

"All right," said the Sunday-school Pupil; "go ahead."

"Oh, I haven't anything to do with it myself," said the Beautiful Old Man. "I am only observing one of the customs of the age. I am a pirate."

And when he had taken his hand from the lad's head, the latter observed that his hair was full of clotted blood. Then the Beautiful Old Man went his way, instructing other youth.

Theory and Practice

The Rev. Dr. Fitch, Professor of Divinity in Yale college, is gone to glory. It affords us a cheerful satisfaction to reflect that the Doctor has been accorded an opportunity to test the correctness of his theological theories by actual examination of the records at Headquarters. After explaining the New Life for a series of years, it is proper that he should go and learn

what it is like. We beg for all his co-workers a similar privilege; as for us, we are content that the revealing light shall shine upon us from a great distance. We have an unpleasant apprehension that it gleams from the throat of a furnace.

News Letter, 1871

Eliminating Wickedness

The devil has not only a monopoly of the good music and the good fun, but has of late acquired a controlling interest in the good writing. In comparing the religious with the secular newspapers this fact becomes strikingly apparent. The Lord's people are probably as fond of sharp, hard-sense writing as anybody, but somehow they do not manage to get much of it in their own prints, and there is reason to suspect that what they do get is supplied by the fellows on our side—as during our late war the fat Federal soldiers used sometimes to supply the lean enemy with surreptitious coffee and furtive tobacco.

The fact is that as a rule Straighthair does not write well, and it is to be feared he does not pay well also; else he could command the incisive pens of the mercenary ungodly, who would soon make it very lively indeed for the sinners. Now, all manner of wickedness is so conspicuously indefensible—so grossly and openly absurd—that to be utterly exterminated it needs but to be intelligently attacked by the clever wits of our secular press, who would like no better fun than to hurl bombshells into their own camp, if they were but paid for the service. Certainly they know well enough the vulnerable points of the position, and would not be restrained from attacking those points by the common clerical fear of exhibiting a too great familiarity with their subject. We are quite confident that the world will never be evangelized until these keen rascals are bought over and the devil made ridiculous. In about a score of years they would convert all the world, and should then be exterminated by law.

News Letter, 1871

Inglorious Soup

The pious benevolent have determined not to establish that soup house for the beanless poor, under the flimsy pretense that it would develop an appetite for beans which might have to be eradicated by prohibitory

legislation, like the cognate passion for strong drink. Well, beans are cheap, and prohibitory legislation is cheap. It is noticeable, also, that pious benevolence is cheap.

News Letter, 1870

Theological Questions Answered

A Lutheran clergyman at Pittsburg poisoned himself the other day because he could not make up his mind about a certain theological question.—*Exchange.* What an ass! Whenever a theological question is too tough for *us,* we take a deck of cards and decide it directly and forever by turning a jack. In that simple and intelligible manner we have established a body of doctrine that would astonish a Bishop, but has proved of unspeakable comfort to ourselves. A red jack is always "yes," a black one "no." You state one of two antagonistic interpretations, shuffle the cards thoroughly and keep drawing off the top of the pack till you come to your answer. In that way we have proven that hell is hot, that there is no heaven, and that the wicked have no souls. We have likewise ascertained that the devil was baptized by immersion, that sprinkling is a swindle, that Peter's real name was Hiram Johnson, that Abraham's bosom was a mountain in the Mesopotamia, that John the Baptist's locusts and wild honey were grasshoppers and molasses, that the doctrine of election is perfectly ridiculous, that the mystery of redemption is sublime but unintelligible, that Calvinism is a nice thing for an early tea party, that the first one hundred and fifty of the psalms of David were composed by some one else, and that the menagerie of the Apocalypse comprised more malformed and hideous beasts than were ever before collected under a single canvas. These are but a few of the results at which we have arrived; the whole thing forms the most beautiful and perfect system of Theology the world has ever seen. A limited number of disciples will be taken. Terms moderate.

News Letter, 1871

The Practical Parson

It is gratifying to record occasionally an incident which puts to shame the slanderers who would have us believe that the clergy, whom we justly revere, are behind the age in which we live; or, as the vulgar express it, are not up to snuff. These iconoclasts are in the habit of asserting that parsons are not practical men; as if there were anything in the sacred calling which tends to unfit them for the serious business of this life. An

event has recently occurred which completely overthrows the hypothesis that the men who labor for our spiritual welfare are unmindful of their own temporal good. The Rev. A. L. Stone, of this city, has received a call from a wealthy congregation in Chicago to accept the pastorate of that flock, at a salary of seven thousand dollars per annum. Did he basely accept it and relinquish a lucrative position here? Not so; he declined. He did more; he caused the fact to be made known far and wide through the medium of the press. Did this in Stone seem impractical? Bah! the man who has mastered the principles of judicious advertising is as competent to elbow his pious way through a sordid world as you or we. Such a one can afford to decline a seven-thousand bird in the Chicago bush—if he has a better songster in hand.

News Letter, 1869

Farewell and Amen

The Rev. Dr. Hallelujah Cox has played his farewell engagement, and will appear no more before a California audience. In parting with the Rev. Doctor we cannot withhold the present slight tribute to his equally slight talent. We know of no public performer who has had to contend against equal natural disadvantages of personal ignorance and professional incapacity, and the fact that with such heavy odds against him he has succeeded in getting away without incurring actual disgrace is evidence of indomitable energy upon his part and criminal neglect upon our own. We hope never to hear of the Doctor again, and are confident he is willing to waive his privilege of hearing us. Good-bye, Doctor; may God grant thee a safe—and speedy—journey to that blessed clime where the *News Letter* ceases from troubling and the parsons are at rest.

News Letter, 1869

Bible Belts

Tombstone, Arizona, is said to have three-score liquor saloons and only one Bible, yet the run on the sixty saloons is greater than the struggle to get at the one Bible. Tombstone desires less Scripture and more

Brine,	Liverpickle,	Rotgut,
Lush,	Eyebung,	Breakleg,
Stonefence,	Dogsnose,	Tanglefoot,
Knockdown,	Busthead,	Bluebelly,
Hellfire,	St. Satan,	Walleye,
Snicklefritz,	Tarantula,	Tomcat,

Jersey Lightning,	Sodcorn,	Fortyrod,
Swill,	Splayfoot,	Wild William,
Stingo,	Screwmouth,	Scorpion,
Devil,	Gripgullet,	Billybedam,
Old Adam,	Polly Mariar,	Snake and
Thunderbolt,	Lonehand,	Sneakthief.

Wasp, 1881

The Show Business

We hear a good deal about certain Pharisees who "steal the livery of Heaven to serve the devil in"; but has it never occurred to goody-goody people that there are those who steal the livery of the devil to serve Heaven in? What are these new fangled tunes that Revivalists chant, these jerky, rollicking "popular" melodies that one hears whistled by the *gamins* or shouted vociferously through the open saloon door? Are they not the music of the ungodly tacked on to pietistic words whose intent in that connection seems utterly incongruous? Comic songs with religious tendencies!

And what can be said of the gestures, the manner, the pious slang, the theatrical tricks and display affected by revivalists? Are they not in some sort (according to strict moralists), the livery of Satan? And yet the revivalist who would be bold enough to neglect them would preach to a beggarly array of empty boxes and be considered woefully behind the times. Does religion need these meretricious aids? If we thought so it would lessen our opinion of religion. The "revival" now drawing to a close in this city has been decently conducted—for a revival; but it has not been altogether free from the objections we mention. We should like to see the revival business divorced from the show business; and the question of religion tested upon its merits.

Wasp, 1881

The Provocations of the Pious

We have received from a prominent clergyman a long letter of earnest remonstrance against what he is pleased to term our "unprovoked attacks upon God's elect." We emphatically deny that we have ever made any unprovoked attacks upon them. "God's elect" are always irritating us. They are eternally lying in wait with some monstrous absurdity, to spring it upon us at the very moment when we are least prepared. They take a fiendish delight in torturing us with tantrums, galling us with

gammon, and pelting us with platitudes. Whenever we disguise ourselves in the seemly toggery of the godly, and enter meekly into the tabernacle, hoping to pass unobserved, the parson is sure to detect us and explode a bomb-ful of bosh upon our devoted head. No sooner do we pick up a religious weekly than we stumble and sprawl through a bewildering succession of inanities, manufactured expressly to ensnare our simple feet. If we pick up a tract we are laid out cold by an apostolic knock straight from the clerical shoulder. We cannot walk out on a pleasant Sunday without being keeled over by a stroke of pious lightning flashed from the tempestuous eye of an irate churchman at our secular attire. Should we cast our thoughtless glance upon the demure Methodist Rachel we are paralyzed by a scowl of disapprobation, which prostrates like the shock of a gymnotus; and any of our mild pleasantry at the expense of young Squaretoes is cut short by a Bible rebuke, shot out of his mouth like a rock from a catapult. Is it any wonder that we wax gently facetious in conversing of "the elect"?—that in our weak way we seek to get even on them? Now, good clergyman, go thou to the devil, and leave us to our own devices; or the *Town Crier* shall skewer thee upon his spit, and roast thee in a blaze of righteous indignation.

News Letter, 1869

Religious Progress

Every religion is important. When men rise above existing conditions a new religion comes in, and it is better than the old one.—Professor Howison.

> Professor dear, I think it queer
> That all these good religions
> ('Twixt you and me, some two or three
> Are schemes for plucking pigeons)—
>
> I mean 'tis strange that every change
> Our poor minds to unfetter
> Entails a new religion—true
> As t' other one, and better.
>
> From each in turn the truth we learn,
> That wood or flesh or spirit
> May justly boast it rules the roast
> Until we cease to fear it.

Nay, once upon a time long gone
Man worshipped Cat and Lizard:
His God he'd find in any kind
Of beast, from a to izzard.

When risen above his early love
Of dirt and blood and slumber,
He pulled down these vain deities,
And made one out of lumber.

Far better that than even a cat,"
The Howisons all shouted;
"When God is wood religion's good!"
But one poor cynic doubted.

"A timber God—that's very odd!"
Said Progress, and invented
The simple plan to worship Man,
Who, kindly soul! consented.

But soon our eye we lift asky,
Our vows all unregarded,
And find (at least so says the priest)
The Truth—and Man's discarded.

Along our line of march recline
Dead gods devoid of feeling;
And thick about each sun-cracked lout
Dried Howisons are kneeling.

Born Again—and Again

A liver-faced contemporary remarks: "For our own part, we sorrowfully admit that we have found sin very seductive, and have often done that for which we hope to be forgiven." We hope you will *not* be forgiven, and it is bald effrontery in you to expect it. If you believe sin to be wicked, and continue to sin, you deserve to be toasted for it. There is not a more pusillanimous pack of rogues in the land than these sinners. They will tell you with a piteous whine that they know they are great scoundrels, but they are weak and God is merciful—and then they will go off to complete the arrangements for some new and elaborate villainy. They

ought to either openly admit—as we do—that they sin because they like to, and are willing to take the chances hereafter, or stop sinning and go to praying, like some really good fellows in the various churches. The knaves are cowardly in their knavishness, without being consistent in their cowardice. We despise the conventional sinner with active contempt.

News Letter, 1870

Faithful Followers

An exchange says the Chinese missionaries are discussing the question whether parents who compress the feet of their children shall be admitted into the Church. The Flathead Indians, who compress the brains of their papooses, are admitted without question. The missionaries naturally regard it as a sin to cripple the feet of children, because that keeps them from walking to church; but the crippling of the brain is a virtue, for that impels the sufferer Zionward, as irresistibly as cropping the ears of a donkey forces him to seek the society of those similarly afflicted.

News Letter, 1870

A Racial Parallel

Some White Christians engaged in driving Chinese Heathens out of an American town found a newspaper published in Peking in the Chinese tongue, and compelled one of their victims to translate an editorial. It turned out to be an appeal to the people of the Province of Pang Ki to drive the foreign devils out of the country and burn their dwellings and churches. At this evidence of Mongolian barbarity the White Christians were so greatly incensed that they carried out their original design.

Christianity in Action

On last Monday two little Christians (with a big C) were up before his Honor (with a big H) for pelting a Chinaman with rocks. On account of their youth, good character, color, nationality, religion and the politics of their fathers, they were let off with a reprimand.

News Letter, 1869

Educating the Heathens

A new school for Chinese children has been opened by some of our public-spirited citizens. Will some of our public-spirited Chinese open a school for American children? Considered as either a reciprocatory measure or a retaliatory measure, the plan would be a good one. The difficulty would be to induce our little white heathens to attend, and to abstain from shying brickbats at the heads of the Mongolian Professors, when they should be learning the principles of Christian morality from the pages of Confucius.

News Letter, 1869

More Christianity in Action

The dead body of a Chinese woman was found last Tuesday morning lying across the sidewalk in a very uncomfortable position. The cause of her death could not be accurately ascertained, but as her head was caved in it is thought by some physicians that she died of galloping Christianity of the malignant California type.

News Letter, 1870

School Prayer

At the last meeting of the Board of Education, Mr. Maegher called attention to the chanting of the Lord's Prayer in the public schools, which is in violation of a rule which forbids the introduction of religious matters. We are glad this subject has come up at last. The Lord's Prayer has been brought into disrepute about long enough by being snarled through the dirty noses of a hundred bad boys and preposterous girls. The *Town Crier* attributes every wicked action of his next-door neighbor's children directly to this barbarous practice. Down with the Lord's Prayer!—in schools.

News Letter, 1869

Scudder Comes

On Tuesday evening, the young Evangels of the Christian Association were edified by a lecture on Brahmanism, by Dr. Scudder. The Doctor set forth the leading characteristics of the Hindus by illustrations drawn

from his own life. It's as natural for the Doctor to talk Brahmanism as it was for Silas Wegg to drop into poetry. He seems to be an amphibious being, who spends half his time sunning himself on the dry rocks of Western Theology, and the other half sloshing about in the slimy pools of Oriental paganism. He prefers the latter, however, because it makes more noise, and he has the satisfaction of knowing that all the commotion is caused by his own tail.

News Letter, 1868

Scudder Evolves

On last Sunday, Dr. Scudder spent a pleasant half hour trying to evolve from his inner consciousness the particular kind of wine into which Christ changed that water. In the absence of any accurate information upon this important problem we would suggest that it be not left for individual parsons to decide, each according to his own folly, but that the aggregate wisdom of the Church be brought to bear upon it. Let an international council of clerics be called at once, that this vital question may be forever settled to the unspeakable advancement of morality and the immediate revival of the languishing industry of saving souls.

News Letter, 1869

Scudder Anticipates

On next Sunday evening Dr. Scudder will preach on the question "Should we drink wine?" Clearly we think we should not—unless some godless publican in our congregation should send it to us upon the sly. The Doctor will continue this course of sermons, preaching from the following texts in the order given: Should we read magazines? Should we ride velocipedes? Should we play the fool? Should we be a Scudder?

News Letter, 1869

Scudder Departs

Dr. Scudder, it seems, is really going away. Lest the dazed understanding, incapable of at once ingesting so portentous a fact, should choke upon it, we will kindly crowd it down: Dr. Scudder has had an offer of a lucrative sinecure in Brooklyn. Upon receiving this grateful proposition, the Reverend Doctor speedily became aware that he was intensely

sick, and had been so for some months, and his life depended upon a change of climate.

The imagination reels and staggers in the attempt to conceive what might have been the fate of Dr. Scudder had his illness been revealed to him before hearing of the lucrative sinecure at Brooklyn; he would probably have broken his neck to get away from his present paltry salary to a more salubrious climate, in which to repair his shattered constitution by peacefully starving. But God tempers the wind to the shorn lamb. In this case the wind was tempered before the lamb was shorn; the offer came before the illness was discovered.

But let us not growl, even at the most inscrutable of the dispensations of a singular Providence; it is very nice to have him go, upon any pretext, but we are touched with grief that he had not sufficient originality to reject one so flimsy in itself and so hackneyed with the profession; he might at least have claimed that a poverty-stricken mother in the congregation to which he had been called demanded his filial care. We will waive all that; profoundly satisfied with the result, let us not cavil about the method. . . .

News Letter, 1871

Sunday in San Francisco

An Indiana Member of Congress, who has been "doing" California and its inhabitants *incog.*, has finally incubated an opinion of us, and sent it forth to scratch for a living in the hearts of his countrymen. He says: "A Sunday in San Francisco will convince any one that at least two-thirds of the population are composed of heathens and infidels." Had he been detected collecting data for that opinion his Sunday in San Francisco would have convinced him of nothing so much as the peculiar hardness of California brick-bats. But does the Indiana mind suppose that we came all the way to the Pacific to acquire faith and practice virtue? We could have done that sort of stupid business at home. It is hardly fair to expect piety of us when we are here on an entirely different "lay." However, since our mines have begun to give out and we are deprived of the consolations of faro, we have begun to pucker our lips into a pious rotundity, and when we do emit a holy whoop it will be as loud, as long and as unctuous as that of our whey-faced brethren beyond the mountains. Whenever we do start in to sing psalms we'll wake up the heavenly host. You bet!

News Letter, 1869

Sunday in San Francisco, continued

Mr. J. G. Methua was arrested for giving a theatrical exhibition on Sunday. Mr. J. G. Methua would better have a care how he conducts himself in a country of equal rights. Sunday theatricals may be safe in the crumbling despotisms and rotten aristocracies of the old world, but not in the lusty young republic of religious toleration—not in a land of religious liberty! Rally round the Cross, O leathern-lunged elect, for the recognition of Christianity, and its relentless enforcement by law! Let us jam our holy religion down the protesting throats of the heathen and the infidel, so that they shall be brought to know God, and to love him as we do; yea, that they may hanker after him, even as a baby craveth rhubarb, or a cat lusteth after soft soap.

News Letter, 1869

On Common Sense

The number of men known to me who are not in some important respects fools does not exceed a half dozen. I understand the word fool to mean one who is subject to some silly and senseless delusion—some ten thousand times discredited errror evincing an infantile lack of observation or want òf common sense. If a well-known citizen should announce his conviction that small-pox in Vallejo could be prevented by anointing Red Rock with the blood of a yellow dog, and saying "Baa," while facing the southeast, we should all laugh. The plan is to me no more absurd than the idiosyncracies of the respectable cranks mentioned in the foregoing paragraph—no more than any one of ten thousand similar ones familiar as household words. I should respect the intelligence of such a man just as much as I do that of the person who takes a patent medicine, thinks there is "something" in spiritualism, believes a religion, or thinks it dangerous to pull a hair out of a mole.

Such is the disease; what is the remedy? Good brother fools, there is none. Nobody can hope to know much outside his specialty, and all are specialists. An astronomer knows that the growth of the human hair is not affected by the phases of the moon. A physician knows that homoeopathy is a humbug. A clergyman is aware of the spurious nature of his calling, and a man of general scientific attainments can make him confess it. And so through the list; all *can* know some form of error to be such, but few *will* know this of more than two or three kinds of error. We have not the time to go outside our vocations to discriminate between the true and the false elsewhere. To have common sense, one would have to

make common sense his profession. He must study it as a science, and practice it as an art. It is not a very lucrative business.

Wasp, 1882

Merit in Suicide

We hold that genius in suicide is but indifferently appreciated: many cases are daily occurring in which the most splendid results are achieved with appliances seemingly inadequate to the production of even a temporary paralysis; and it is not uncommon for persons of little learning and no experience to make away with themselves after some ingenious fashion that mere talent and ripe scholarship might have sought in vain to devise. And yet these skillful operators receive no greater credit than the simple clod-pate who vulgarly disembowels himself with a grain sickle, or crushes out his soul under a steam hammer. This is all wrong, and tends to the discouragement of art.

The question of the morality of suicide is not at all involved. It may be granted that this is a vice, without at all affecting the matter with which we are now concerned—the matter of method. Even murder is less repulsive when neatly and artistically committed, and there is no doubt but the slovenly practitioner who opens his victim's head with a knotty club gets it much hotter down below than the dainty gentleman who works deftly with a keen cleaver. But even a lack of genius and originality may be pardoned if accompanied with a firm determination and unwavering perseverance. The surgeon who amputated a patient's leg below the injury was an execrable bungler; when he severed it again immediately at the wound he became a tolerable operator; but when he finally cut the member off as high up as he could work, he rose to the dignity of a hero by virtue of that unyielding patience which will shed a lustre upon even the meanest acquirements.

It is so with the kindred science of self-slaughter: if one do but adorn his awkwardness with the grace of persistence, he merits a certain temperate meed of praise only less than that accorded to actual genius.

For this reason we regard Mr. Michael Brannan, of Los Angeles, with feelings of unmixed admiration, and we clamor shrilly against the legal obtuseness that lodged him in jail. Mr. Brannan had tired of life's fitful fever, and sought to effect a cure with a pistol—a vulgar, hackneyed expedient justly deserving of emphatic disapproval. But mark the high qualities of this man! He emptied five barrels of that weapon at his head, each leaden pellet plowing its crimson groove through the Brannan scalp, but not ducking beneath the bone to the heroic brain within. The man who could look upon this marvelous

attempt unmoved with admiration—nay, who could himself withhold a friendly shot, or deny the succor of the exterminating axe, is not to be lightly classed with Christian gentlemen. The scoundrel who could, and did, arrest and imprison Mr. Brannan can only be fitly characterized as a moral and social hog!

<div style="text-align: right">News Letter, 1872</div>

The Grace of God

If there is a God—a proposition that the wise are neither concerned to deny nor hot to affirm—nothing is more obvious than that for some purpose known only to himself he has ordered all the arrangements of this world utterly regardless of the temporal needs of man. Considered as a habitation of man, this earth is about the worst that a malevolent ingenuity, an unquickened apathy or an extreme incapacity could have devised. In the first place, three fourths of its surface is given over to an environment in which man cannot breathe. In only a comparatively narrow belt of the remainder can he exist with occasional intervals of comfort, while in vast regions he cannot exist at all. The most habitable portions are scourged by storms, infested by savage animals and noxious reptiles and insects, cursed with recurrent plagues, subject to earthquakes, inundations and preachers. A third of the time all are whelmed in darkness, during which a cat is better off than Man.

Man is engaged all his life in bitter warfare with a million energies that conspire to kill him. Let him rest upon his weapons, let him relax his vigilance, let him commit his defence to the Power that has organized the attacking forces, and he is gone. Under the most favorable conditions, and despite the exercises of his wisest prudence, the enemy wears him out; he tumbles wearily into his grave, and above his battered carcass some smirking preacher iterates the offensive platitudes to which the dead man's every experience has appended the comment, *Quid est absurdum*.

<div style="text-align: right">Wasp, 1883</div>

The Late Lamented

How long one must be dead before his "relics"—including not only his remains proper, but the several appurtenances thereunto belonging— cease to be "sacred," is a question which has never been settled. London was once divided in opinion, or rather in feeling, as to the propriety of publicly exhibiting the body-linen worn by Charles I when that unhappy

monarch had the uncommon experience of losing his head. Not only was this underwear shown, but also some of the royal hair which was cut away by the headsman. Many persons considered the exhibition distasteful and in a measure sacrilegious. But the entire body of the great Rameses has been dug out and is freely shown without provoking a protest.

Rameses was a mightier king than Charles, and a more famous. He was the veritable Pharaoh of sacred history whose daughter (who, I regret to say, was also his wife) found the infant Moses in the bulrushes. He could also point with pride to his record in profane history, and was, altogether, a most respectable person. Between the power, splendor and civilization of the Egypt of Rameses and the England of Charles there is no comparison: in the imperishable glory of the former the latter seems a nation of savage pigmies. Why, then, are the actual remains of the one monarch considered a fit and proper "exhibit" in a museum and the mere personal adornments of the other too sacred for desecration by the public eye? Probably political and ethnic considerations have something to do with it: perhaps in Cairo the sentiment would be the other way, though the stoical indifference of successive Egyptian Governments to mummy-mining by the thrifty European does not sustain that view.

Schliemann and many of his moling predecessors have dug up and removed the sleeping ancients from what these erroneously believed to be their last resting-places in Asia Minor and the other classic countries, without rebuke, and the funeral urn of an illustrious Roman can be innocently haled from its pigeon-hole in a *columbarium*. We open the burial mounds of our Indian predecessors and pack off their skulls with never a thought of wrong, and even the bones of our own early settlers when in course of removal to make way for a new city hall are treated with but scant courtesy. There seems to be no statute of limitations applicable to the sanctity of tombs; every case is judged on its merits, with a certain loose regard to local conditions and considerations of expediency.

It was an ancient belief that the shade of even the most worthy deceased could not enter Elysium so long as the body was unburied, but no provision was made for expulsion of those already in if their bodies were exhumed and used as "attractions" for museums. So we may reasonably hope that the companions of Agamemnon contemplate the existence of Schliemanns with philosophic indifference; and doubtless Rameses the Great, who, according to the religion of his country, had an immortality conditioned on the preservation of his mortal part, is as well content that it lie in a museum as in a pyramid.

A Dubious Vindication

Hardly any class of persons enjoys complete immunity from injustice and calumny, even if "armed with the ballot"; but probably no class has so severely suffered from slander's mordant tooth as our man-eating brethren of that indefinite region known as the "Cannibal Islands." Nations which do not eat themselves, and which, with even greater self-denial, refrain from banqueting on other nations, have for generations been subjected to a species of criticism that must be a sore trial to their patience. Every reprobate among us who has sense enough to push a pencil along the measured mile of a day's task in a newspaper office without telling the truth has experienced a sinful pleasure in represent-ing anthropophagi as persons of imperfect refinement and ailing morals. They have been censured even, for murder; though surely it is kinder to take the life of a man whom you set apart for your dinner than to eat him struggling. It has been said of them that they are particularly partial to the flesh of missionaries.

It appears that this is not so. The Rev. Mr. Hopkins, of the Methodist Church, who returned to New York after a residence of fifteen years in the various islands of the South Pacific, assured his brethren that in all that period he could not recollect a single instance in which he was made to feel himself a comestible. He averred that his spiritual character was everywhere recognized, and so far as he knew he was never in peril of being put to the tooth.

His testimony, unluckily, has not the value that its obvious sincerity and truth merit. In point of physical structure he was conspicu-ously inedible; so much so, in truth, that an unsympathetic reporter coldly described him as "fibrous" and declared that in a country where appetizers are unknown and pepsin a medicine of the future, Mr. Hopkins could under no circumstances cut any figure as a viand. And this same writer meaningly inquired of the cartilaginous missionary the present address of one "Fatty Dawson."

Fully to understand the withering sarcasm of this inquiry it is necessary to know that the person whose whereabouts it was desired to ascertain was a co-worker of Mr. Hopkins in the same missionary field. His success in spreading the light was such as to attract the notice of the native king. In the last letter received from Mr. Dawson he explained that the potentate had just done him the honor to invite him to dinner.

Mr. Hopkins being a missionary, one naturally prefers his views to those of anyone who is still in the bonds of iniquity, and moreover, writes for the newspapers; nevertheless, I do not see that any harm would come of a plain statement of the facts in the case of the Rev. Mr. Dawson. He was not eaten by the dusky monarch—in the face of

Mr. Hopkins' solemn assurance that cannibalism is a myth, it is impossible to believe that Mr. Dawson was himself the dinner to which he was invited. That he was eaten by Mr. Hopkins himself is a proposition so abysmally horrible that none but the hardiest and most impenitent calumniator would have the depravity to suggest it.

LAWYERS AND JUDGES

It's not entirely clear why Bierce had such a profound contempt for lawyers; certainly he had a profound sense of justice and felt that it was a commodity not easily secured by those gentlemen. He was involved in only two lawsuits, neither of which amounted to much. One concerned proprietary rights to a book, and he beat it back with words, in correspondence and his columns. The other was a result of his ill-fated gold fever in the Dakotas (he had managed a mine, and when the corporation pulled the plug on the operation, they tried to make him a scapegoat in order to look good with the stockholders). Both cases came after he had become a skilled skewer of the courts and their officers, obviously agreeing with Dickens' Mr. Bumble that "the law is a ass."

Amazingly, he was only threatened with one action for libel in his long career of poison-penmanship. His response was a stream of hilarious, vituperative columns that persuaded the subject, by then the laughingstock of San Francisco, to drop the action and lapse back into well-deserved obscurity.

The Deceased and His Heirs

A Man died leaving a large estate and many sorrowful relations who claimed it. After some years, when all but one had had judgment given against them, that one was awarded the estate, which he asked his Attorney to have appraised.

"There is nothing to appraise," said the Attorney, pocketing his last fee.

"Then," said the Successful Claimant, "what good has all this litigation done me?"

"You have been a good client to me," the Attorney replied, gathering up his books and papers, "but I must say you betray a surprising ignorance of the purpose of litigation."

An Error

"I never have been able to determine
Just how it is that the judicial ermine
Is safely guarded from predacious vermin."
"It is not so, my friend; though in a garret
'Tis kept in camphor, and you often air it,
The vermin will get into it and wear it."

A Defective Petition

An Associate Justice of the Supreme Court was sitting by a river when a Traveler approached and said:

"I wish to cross. Will it be lawful to use this boat?"

"It will," was the reply; "it is my boat."

The Traveler thanked him, and pushing the boat into the water embarked and rowed away. But the boat sank and he was drowned.

"Heartless man!" said an Indignant Spectator. "Why did you not tell him that your boat had a hole in it?"

"The matter of the boat's condition," said the great jurist, "was not brought before me."

The Justice and His Accuser

An eminent Justice of the Supreme Court of Patagascar was accused of having obtained his appointment by fraud.

"You wander," he said to the Accuser; "it is of little importance how I obtained my power; it is only important how I have used it."

"I confess," said the Accuser, "that in comparison with the rascally way in which you have conducted yourself on the Bench, the rascally way in which you got there does seem rather a trifle."

A Hasty Settlement

"Your Honour," said an Attorney, rising, "what is the present status of this case—as far as it has gone?"

"I have given a judgment for the residuary legatee under the will," said the Court, "put the costs upon the contestants, decided all questions relating to fees and other charges; and, in short, the estate in litigation has been settled, with all controversies, disputes, misunderstandings, and differences of opinion thereunto appertaining."

"Ah, yes, I see," said the Attorney, thoughtfully, "we are making progress—we are getting on famously."

"Progress?" echoed the Judge—"progress? Why, sir, the matter is concluded!"

"Exactly, exactly; it had to be concluded in order to give relevancy to the motion that I am about to make. Your Honour, I move that the judgment of the Court be set aside and the case reopened."

"Upon what ground, sir?" the Judge asked in surprise.

"Upon the ground," said the Attorney, "that after paying all fees and expenses of litigation and all charges against the estate there will still be something left."

"There may have been an error," said His Honour, thoughtfully—"the Court may have underestimated the value of the estate. The motion is taken under advisement."

Unexpounded

On Evidence, on Deeds, on Bills,
On Copyhold, on Loans, on Wills,
Lawyers great books indite.
The creaking of their busy quills
 I never heard on Right.

The No Case

A Statesman who had been indicted by an unfeeling Grand Jury was arrested by a Sheriff and thrown into jail. As this was abhorrent to his fine spiritual nature, he sent for the District Attorney and asked that the case against him be dismissed.

"Upon what grounds?" asked the District Attorney.

"Lack of evidence to convict," replied the accused.

"Do you happen to have the lack with you?" the official asked. "I should like to see it."

"With pleasure," said the other; "here it is."

So saying he handed the other a check, which the District Attorney carefully examined, and then pronounced it the most complete absence of both proof and presumption that he had ever seen. He said it would acquit the oldest man in the world.

The Party Over There

A Man in a Hurry, whose watch was at his lawyer's, asked a Grave Person the time of day.

"I heard you ask that Party Over There the same question," said the Grave Person. "What answer did he give you?"

"He said it was about three o'clock," replied the Man in a Hurry; "but he did not look at his watch, and as the sun is nearly down, I think it is later."

"The fact that the sun is nearly down," the Grave Person said, "is immaterial, but the fact that he did not consult his timepiece and make answer after due deliberation and consideration is fatal. The answer given," continued the Grave Person, consulting his own timepiece, "is of no effect, invalid, and absurd."

"What, then," said the Man in a Hurry, eagerly, "is the time of day?"

"The question is remanded to the Party Over There for a new answer," replied the Grave Person, returning his watch to his pocket and moving away with great dignity.

He was a Judge of an Appellate Court.

The Disinterested Arbiter

Two Dogs who had been fighting for a bone, without advantage to either, referred their dispute to a Sheep. The Sheep patiently heard their statements, then flung the bone into a pond.

"Why did you do that?" said the Dogs.

"Because," replied the Sheep, "I am a vegetarian."

Murderous Madness

Practically there is no longer such a crime as murder in the first degree; it is all manslaughter. If you brain your mother-in-law in the heat of debate with a bench-leg, that is manslaughter. If you prepare her for sepulture by the slower process of methodical poisoning, that is manslaughter, too. The punishment is the same in either case. It appears from this that there is no use in getting unduly excited and making nasty looking corpses by sudden and unskillful work. If any body shall tweak you by the nose, don't mellow him with a mallet, mangle him with a meat-ax nor bust him with a bludgeon. Lay for him. Watch your opportunity, and while he is off his guard some night, drag him from the arms of his wife and coil him up carefully in a kettle of boiling soap. If you

have previously taken the precaution to write a few incoherent letters with regard to your dishonored proboscis, that circumstance will have its effect in establishing your future pleas of temporary insanity. In any case you will not be hanged, for the jury will find you guilty of manslaughter, and recommend you to the mercy of the court, which will cost you five hundred dollars. That is the price in Chicago.

News Letter, 1870

A Capital Crime

Charles O'Neil was, it seems, temporarily insane when he threw his wife off the balcony, and broke her precious neck. Charles O'Neil, would that we had but had the sentencing of thee—there would have been another neck broken. We yearn for a law making temporary insanity a capital offense.

News Letter, 1868

Judicial Homicide

"In this case," said Judge Lawler, of the Police Court, with both eyes solemnly fixed upon his political future, "there is no doubt that Levison was shot, but the question which arises is whether the defendant had any justification in shooting him." Any *legal* justification, your Honor—any *legal* justification. Of course, your Honor has nothing to do with justification which the law does not distinctly and expressly recognize as valid. You do not occupy the bench to give to any plea in justification an effect denied it by the statute. You discharged this defendant—a wife who had shot her husband—upon the ground that the latter would not work, "and frequently expressed a desire that his wife should support him by leading a life of shame." I ask you, Judge Lawler, where in the laws which you have sworn to administer, the expression of such a desire is mentioned as justifying assassination. You know, sir, that in discharging the defendant in this case you acted without legal warrant, betrayed your trust and violated your oath of office.

You say, Judge Lawler, that to rid the community of the class to which Levison—the shot *maquereau*—belongs "would indeed be a great boon," and you add that the defendant was "fully justified in acting as she did." Sir, you are an extremely dangerous person. You encourage assassination not only by condoning it, but by suggesting. To the probable retort of such a reasoner as you that I am defending the class to which

the shot man belongs, I will deign no reply; the proposition that the community would be benefited by the extinction of the tribe, I scorn to employ my pen upon. You are welcome to whatever advantage you can derive from my indifference to the plaudits of the social gallery whose claps you trap. The essential point is that the law makes no provision for "ridding the community" of any class of men by private assassination. Judge Lawler, the Devil is ashamed of you; your example is making sin detestable.

Examiner, 1886

Irreproachable Evidence

We have the highest possible regard for Mr. Freelon, the Assistant District Attorney, but if we had caused as many murder cases to be dismissed in one week as he has, we should expect somebody to affirm that we were bribed. That nobody has made that charge against Mr. Freelon is extremely creditable to our community, and very fortunate for Mr. Freelon. If it were once made somebody would be sure to believe it, and would swear that it was the only intelligible explanation of his conduct. Let us give thanks that Mr. Freelon is above suspicion, and let Mr. Freelon feel grateful that we are above suspecting him.

News Letter, 1871

Do You Swear, Too?

In order somewhat to abate the terrors of testifying in the courts, an exchange proposes that a law be passed permitting a witness fully to explain any matter affecting his own reputation, whether relevant or not, if counsel in cross-examination shall have opened up the subject by questions regarding it. I would go still farther in this direction; after the lawyer has done torturing the witness, he should himself be sworn and compelled to explain any matter affecting his own character and credibility that the witness may wish to question him about. Surely it is important that the great influence of counsel upon judge and jury be exercised by men of truth and cleanly record.

I am entirely serious in this. It is safe to estimate the influence of a lawyer in an ordinary case at more than double that of any witness. It is the lawyer who advises the Court; it is he who directly addresses and persuades the jury. The jury is not nearly so much moved by the facts related by witnesses as by the manner in which they are presented, expounded, elucidated or perverted by counsel. What is more reason-

able than that the minds of the jury should be enlightened regarding the honesty and truthworthiness of a man exercising this power in directing their verdict?

No fear of the witness asking unskillful or irrelevant questions; he would be instructed and prompted by the counsel on the side in behalf of which he was put upon the stand—by whom, indeed, this counter-examination might with advantage be altogether conducted. That would have at least this good effect: if it did not compel lawyers to reform their loose lives, it would make them so guarded in their professional and social intercourse with one another that we should have no more of that commonly veiled, but frequently obvious, unanimity of action between opposing counsel which might justly be dignified by the name of collusion.

Wasp, 1881

POLITICS AND POLITICIANS

Of all the spectacles presented for the bittersweet amusement of mankind, politics would be the richest and most hilarious if we didn't possess so many different means of destroying our planet.

For Bierce, politics was a shooting gallery to which he had a free lifetime pass; its bounty was so rich that he sometimes used a shotgun instead of a rifle: "If nonsense were black, Sacramento would need gas lamps at noonday; if selfishness were audible, the most leathern-lunged orator of the lot would appear a deaf mute flinging silly ideas from his finger tips amid the thunder of innumerable drums. So scurvy a crew I do not remember to have discovered in vermiculose conspiracy outside the carcass of a dead horse—at least not since they adjourned."

With the right target, however, he was a sharpshooter. When the demagogic orator William Jennings Bryan became a presidential candidate, Bierce wrote: "To the dizzy elevation of his candidacy he was hoisted out of the shadow by his own tongue, the longest and liveliest in Christendom. Had he held it—which he could not have done with both hands—there had been no Bryan. His creation was the unstudied act of his own larynx."

The subjects of some of Bierce's satire may have faded in relevance; if only politicians were among them . . .

A Rational Anthem

My country, 'tis of thee,
Sweet land of felony,
 Of thee I sing—
Land where my fathers fried
Young witches and applied
Whips to the Quaker's hide
 And made him spring.

My knavish country, thee,
Land where the thief is free,

Thy laws I love;
I love thy thieving bills
That tap the people's tills;
I love thy mob whose will's
 All laws above.

Let Federal employees
And rings rob all they please,
 The whole year long.
Let office-holders make
Their piles and judges rake
Our coin. For Jesus' sake,
 Let's *all* go wrong!

An Intrusion

Morality put her toe into international politics and it was promptly chopped off.

"A thousand thanks," said Diplomacy, with an engaging bow; "we will keep it in memory of a most distinguished honor."

And Morality has limped a little ever since.

The Moral Principle and the Material Interest

A Moral Principle met a Material Interest on a bridge wide enough for but one.

"Down, you base thing!" thundered the Moral Principle, "and let me pass over you!"

The Material Interest merely looked in the other's eyes without saying anything.

"Ah," said the Moral Principle, hesitatingly, "let us draw lots to see which shall retire till the other has crossed."

The Material Interest maintained an unbroken silence and an unwavering stare.

"In order to avoid a conflict," the Moral Principle resumed, somewhat uneasily, "I shall myself lie down and let you walk over me."

Then the Material Interest found a tongue, and by a strange coincidence it was its own tongue. "I don't think you are very good walking," it said. "I am a little particular about what I have underfoot. Suppose you get off into the water."

It occurred that way.

Congress and the People

Successive Congresses having greatly impoverished the People, they were discouraged and wept copiously.

"Why do you weep?" inquired an Angel who had perched upon a fence near by.

"They have taken all we have," replied the People—"excepting," they added, noting the suggestive visitant—"excepting our hope in Heaven. Thank God, they cannot deprive us of that!"

But at last came the Congress of 1889.

Alarm and Pride

"Good-morning, my friend," said Alarm to Pride; "how are you this morning?"

"Very tired," replied Pride, seating himself on a stone by the wayside and mopping his steaming brow. "The politicians are wearing me out by pointing to their dirty records with *me,* when they could as well use a stick."

Alarm sighed sympathetically, and said:

"It is pretty much the same way here. Instead of using an opera-glass they view the acts of their opponents with *me!*"

As these patient drudges were mingling their tears, they were notified that they must go on duty again, for one of the political parties had nominated a thief and was about to hold a gratification meeting.

Orderly Progression

Somebody has attempted to rob the safe in the office of the City and County Treasurer. This is rushing matters; the impatient scoundrel ought to try his hand at being a Supervisor first. From Supervisor to Thief the transition is natural and easy.

News Letter, 1869

The Boys and the Frogs

Some editors of newspapers were engaged in diffusing general intelligence and elevating the moral sentiment of the public. They had been doing this for some time, when an Eminent Statesman stuck his head out of the pool of politics, and, speaking for the members of his profession, said:

"My friends, I beg you will desist. I know you make a great deal of money by this kind of thing, but consider the damage you inflict upon the business of others!"

Cause and Effect

A thirteen-inch gun having uttered a projectile relapsed into silence. Then sounded a Far, Faint Voice from beyond the earth's curvature: "Did you damage anything?"

"Did I damage anything?" echoed the portentous tube right scornfully. "If you are envious enough about that to investigate you will find a wide and ragged hole in the public treasury."

"Ah, permit me to introduce myself," said the Far, Faint Voice: "I am that hole. It is a wise child that knows its father—I had supposed myself due to the annual salary warrant of a Rear-Admiral."

Six and One

The Committee on Gerrymander worked late, drawing intricate lines on a map of the State, and being weary sought repose in a game of poker. At the close of the game the six Republican members were bankrupt and the single Democrat had all the money. On the next day, when the Committee was called to order for business, one of the luckless six mounted his legs, and said:

"Mr. Chairman, before we bend to our noble task of purifying politics, in the interest of good government I wish to say a word of the untoward events of last evening. If my memory serves me the disasters which overtook the Majority of this honourable body always befell when it was the Minority's deal. It is my solemn conviction, Mr. Chairman, and to its affirmation I pledge my life, my fortune, and my sacred honour, that that wicked and unscrupulous Minority redistricted the cards!"

The Politicians

An Old Politician and a Young Politician were travelling through a beautiful country, by the dusty highway which leads to the City of Prosperous Obscurity. Lured by the flowers and the shade and charmed by the songs of birds which invited to woodland paths and green fields, his imagination fired by glimpses of golden domes and glittering palaces in the distance on either hand, the Young Politician said:

"Let us, I beseech thee, turn aside from this comfortless road

leading, thou knowest whither, but not I. Let us turn our backs upon duty and abandon ourselves to the delights and advantages which beckon from every grove and call to us from every shining hill. Let us, if so thou wilt, follow this beautiful path, which, as thou seest, hath a guide-board saying, 'Turn in here all ye who seek the Palace of Political Distinction.'"

"It is a beautiful path, my son," said the Old Politician, without either slackening his pace or turning his head, "and it leadeth among pleasant scenes. But the search for the Palace of Political Distinction is beset with one mighty peril."

"What is that?" said the Young Politician.

"The peril of finding it," the Old Politician replied, pushing on.

The Treasury and the Arms

A Public Treasury, feeling Two Arms lifting out its contents, exclaimed:

"Mr. Shareman, I move for a division."

"You seem to know something about parliamentary forms of speech," said the Two Arms.

"Yes," replied the Public Treasury, "I am familiar with the hauls of legislation."

Art

For Gladstone's portrait five thousand pounds
 Were paid, 'tis said, to Sir John Millais.
 I cannot help thinking that such fine pay
Transcended reason's uttermost bounds.

For it seems to me uncommonly queer
 That a painted British statesman's price
 Exceeds the established value thrice
Of a living statesman over here.

The Legislator and the Citizen

An ex-Legislator asked a Most Respectable Citizen for a letter to the Governor recommending him for appointment as Commissioner of Shrimps and Crabs.

"Sir," said the Most Respectable Citizen, austerely, "were you not once in the State Senate?"

"Not so bad as that, sir, I assure you," was the reply. "I was a member of the Slower House. I was expelled for selling my influence for money."

"And you dare to ask for mine!" shouted the Most Respectable Citizen. "You have the impudence? A man who will accept bribes will probably offer them. Do you mean to————"

"I should not think of making a corrupt proposal to you, sir; but if I were Commissioner of Shrimps and Crabs, I might have some influence with the waterfront population, and be able to help you make your fight for Coroner."

"In that case I do not feel justified in denying you the letter."

So he took his pen, and, some demon guiding his hand, he wrote, greatly to his astonishment:

> *Who sells his influence should stop it,*
> *An honest man will only swap it.*

The Member and the Soap

A member of the Kansas Legislature meeting a Cake of Soap was passing it by without recognition, but the Cake of Soap insisted on stopping and shaking hands. Thinking it might possibly be in the enjoyment of the elective franchise, he gave it a cordial and earnest grasp. On letting it go he observed that a portion of it adhered to his fingers, and running to a brook in great alarm he proceeded to wash it off. In doing so he necessarily got some on the other hand, and when he had finished washing, both were so white that he went to bed and sent for a physician.

A Statesman

A Statesman who attended a meeting of a Chamber of Commerce rose to speak, but was objected to on the ground that he had nothing to do with commerce.

"Mr. Chairman," said an Aged Member, rising, "I conceive that the objection is not well taken; the gentleman's connection with commerce is close and intimate. He is a Commodity."

The Farmer's Friend

A Great Philanthropist who had thought of himself in connection with the Presidency and had introduced a bill into Congress requiring the Government to loan every voter all the money that he needed, on his

personal security, was explaining to a Sunday-school at a railway station how much he had done for the country, when an angel looked down from Heaven and wept.

"For example," said the Great Philanthropist, watching the teardrops pattering in the dust, "these early rains are of incalculable advantage to the farmer."

The Hares and the Frogs

The Members of a Legislature, being told that they were the meanest thieves in the world, resolved to commit suicide. So they bought shrouds, and laying them in a convenient place prepared to cut their throats. While they were grinding their razors some Tramps passing that way stole the shrouds.

"Let us live, my friends," said one of the Legislators to the others; "the world is better than we thought. It contains meaner thieves than we."

Differences Resolved

A correspondent of a city contemporary wishes to know the exact difference between a Democrat and a Republican. A Democrat is a progressive individual, who believes in regenerating the National Government by inaugurating a system of wholesale plunder in place of the policy which now obtains. A Republican is a conservative person, who favors leaving matters as they are. Of the two policies, that of the Democrat is safer and the more economical, but that of the Republican is the more practicable at present.

News Letter, 1869

Republicans All

On the walls of the San Quentin State Prison, the one at Folsom and the lunatic asylums at Stockton and Napa, the following lines might appropriately be set in letters of gold:

> Here lies the body of the Republican party—
> Corrupt, and, generally speaking, hearty.

Wasp, 1882

The Right to Rule

I have been asked a few hundred times why I wrote altogether, last week, in disparagement of American civilization. It was because I had a thing to say which nobody else would say, and it was necessary to be said. One of the disadvantages of our social system, which is the child of our political, is the tyranny of public opinion, forbidding the utterance of wholesome but unpalatable truth. In a republic we are so accustomed to the rule of majorities that it seldom occurs to us to examine their title to dominion; and as the ideas of might and right are, by our innate sense of justice, linked together, we come to consider public opinion infallible and almost sacred.

Now, majorities rule, not because they are right, but because they are able to rule. In event of collision they would conquer, so it is expedient for minorities to submit beforehand to save trouble. In fact, majorities, embracing as they do the most ignorant, seldom think rightly; public opinion being the opinion of mediocrity is commonly a mistake and a mischief. But it is to nobody's interest—it is against the interest of most—to dispute with it. Public writer and public speaker alike find their account in confirming the masses in their brainless errors and brutish prejudices—in glutting their omnivorous vanity and in-flaming their implacable race and national hatreds.

I thought it seasonable to say a word or two of a different sort, and I shall say a good many more, please God, if I am spared.

Argonaut, 1878

The Citizen and the Snakes

A Public-spirited Citizen who had failed miserably in trying to secure a National political convention for his city suffered acutely from dejection. While in that frame of mind he leaned thoughtlessly against a druggist's show-window, wherein were one hundred and fifty kinds of assorted snakes. The glass breaking, the reptiles all escaped into the street.

"When you can't do what you wish," said the Public-spirited Citizen, "it is worth while to do what you can."

Rascals Rule

I hold that under our political system it is very rarely that a man of brains, honor and good manners gets into public life. In most instances the man who holds an office is a rogue, a vulgarian or an ignoramus;

commonly he is all three. When we see our State represented in the national Senate by such dullards as Farley, and in the House by such hoodlums as Budd; when such headless nobodies as Perkins are pitchforked into the office of Governor, John McComb thrust into a State prison as Warden and Sam Backus shoved into the Postoffice, which would have been more intelligently conducted by the warm spot on the leather cushion of his predecessor; when we reflect that these instances are not exceptional but typical, I say that it is impossible for any observer whose eyes are not servitors of his prejudices to draw any other conclusion than that our political activity is mainly directed to the bestowal of high preferment upon rascals and dunces.

Reform is apparently impossible, but shall we therefore grip our noses and avert our eyes? Not I, for one. When I see an idiot in high station I will add such terrors to his elevation as I can. I will put as many thorns in his crown as the leisure that I can snatch from the pressure of other pleasures will permit me to weave in; and neither the deprecation of his friends nor his own retaliatory lies shall stop the good work.

Wasp, 1883

The Penitent Thief

A Boy who had been taught by his Mother to steal grew to be a man and was a professional public official. One day he was taken in the act and condemned to die. While going to the place of execution he passed his Mother and said to her:

"Behold your work! If you had not taught me to steal, I should not have come to this."

"Indeed!" said the Mother. "And who, pray, taught you to be detected?"

The Electoral Process

Men may bawl themselves hoarse about the advantages of our form of government, but so long as it has the demerit of making us a nation of liars and defamers I, for one, shall not raise my voice in its praise. If the conflict that ends in an election has in it something to engender such reasonless passions, monstrous prejudices and bitter antipathies as find suitable expression in dishonest argument and personal defamation, the system of government requiring its constant recurrence is, in my judgment, undesirable. Men can afford to live under almost any kind of government, but they cannot afford to become fools and rogues.

It may be urged that the partisan strife in which the people of

the country are permitted periodically to engage does not tend to the development of ugly traits of character, but merely discloses such as preexist. If this is true; if the men of this country are by nature as foolish and vicious as every meaningless and unimportant political contest appears to make them; if they cheat in debate, not because of the temptation but because of the opportunity; if they lie for their party, not for love of party but for lust of lying; if they defame one another, not with hot heads but with cold hearts—why, then, indeed our system of elections should be abolished and popular liberty abolished along with it; men by nature so depraved are both unfit and unworthy to govern themselves, and need nothing so much as a despotism strong enough to defend and stern enough to punish.

Wasp, 1884

Honest Differences

Judge Bradley says of the electoral commission: "I firmly believe that the differences of opinion were honest, and arose from the different standpoints of individuals." Not a doubt of it; seven members of the commission looked at the question from a standpoint of self-interest, and eight considered it from one of personal advantage.

Argonaut, 1877

The Kangaroo and the Zebra

A Kangaroo hopping awkwardly along with some bulky object concealed in her pouch met a Zebra, and desirous of keeping his attention upon himself, said:

"Your costume looks as if you might have come out of the penitentiary."

"Appearances are deceitful," replied the Zebra, smiling in the consciousness of a more insupportable wit, "or I should have to think that you had come out of the Legislature."

On Socialism

The wrongs that the poor and feeble suffer from the rich and powerful transcend expression. The sufferers are themselves but dimly aware of them: "tyranny," "plunder" and "insult" are mild terms to describe them. But redress there is none—there is only escape: the victims must emancipate themselves by acquisition of wealth and power. They cannot

hope successfully to fight. They are a minority, and have neither the intelligence nor the means to cope with the formidable energies and exhaustless resources of the system that is to them an engine of oppression. Nine men in ten have in them the potencies and possibilities of rascality, which need but opportunity to develop. Let Socialists make the laws to-day and they would break them to-morrow. No sooner do the poor become rich than they harden their hearts to the miseries of the poor. In so far as it proposes to correct the evils of unequal fortune, Socialism aims to repeal the laws of nature.

Wasp, 1884

Enlightened Self-Interest

By the way, what naked and unabashed bosh we all talk about our political convictions. Pennsylvania produces iron, and it is the political conviction of a Pennsylvanian that the needs of this country require a protective duty on iron. New England manufactures woolen goods, and is convinced that a protective duty on iron is disastrous, but prohibitive duties on manufactured woolen goods are required by every true consideration of statesmanship. But the city of Philadelphia would like to import winter clothing for nothing. The Western and Southern States, which have neither iron, nor cloth factories, believe in their inmost souls that what this nation most suffers from are the high duties on iron and woolen goods.

And the people who have evolved these views from their selfish local interest have the tranquil effrontery to call them opinions—political opinions! Among the voters of the whole country there is not one in ten thousand who has any convictions with regard to questions of national importance; what, with regard to those matters, they think thinking is is a mere convening and perception of old sympathies and prejudices, and attempt to apply "the sense of this meeting" to the broader topic— an expansion of the intellect that is nothing but a dispersal of the faculties. In these excellent people the brain takes advice of the belly, and the tongue speaks from the pocket.

Argonaut, 1878

Sheep and Lion

"You are a beast of war," said the Sheep to the Lion, "yet men go gunning for you. Me, a believer in non-resistance, they do not hunt."

"They do not need to," replied the son of the desert; "they can breed you."

The City of Political Distinction

Jamrach the Rich, being anxious to reach the City of Political Distinction before nightfall, arrived at a fork of the road and was undecided which branch to follow; so he consulted a Wise-Looking Person who sat by the wayside.

"Take *that* road," said the Wise-Looking Person, pointing it out; "it is known as the Political Highway."

"Thank you," said Jamrach, and was about to proceed.

"About how much do you thank me?" was the reply. "Do you suppose I am here for my health?"

As Jamrach had not become rich by stupidity, he handed something to his guide and hastened on, and soon came to a toll-gate kept by a Benevolent Gentleman, to whom he gave something, and was suffered to pass. A little farther along he came to a bridge across an imaginary stream, where a Civil Engineer (who had built the bridge) demanded something for interest on his investment, and it was forthcoming. It was growing late when Jamrach came to the margin of what appeared to be a lake of black ink, and there the road terminated. Seeing a Ferryman in his boat he paid something for his passage and was about to embark.

"No," said the Ferryman. "Put your neck in this noose, and I will tow you over. It is the only way," he added, seeing that the passenger was about to complain of the accommodations.

In due time he was dragged across, half strangled, and dreadfully beslubbered by the feculent waters. "There," said the Ferryman, hauling him ashore and disengaging him, "you are now in the City of Political Distinction. It has fifty millions of inhabitants, and as the colour of the Filthy Pool does not wash off, they all look exactly alike."

"Alas!" exclaimed Jamrach, weeping and bewailing the loss of all his possessions, paid out in tips and tolls; "I will go back with you."

"I don't think you will," said the Ferryman, pushing off; "this city is situated on the Island of the Unreturning."

Metempsychosis

Once with Christ he entered Salem,
Once in Moab bullied Balaam,
Once by Apuleius staged
He the pious much enraged,

And, again, his head, as beaver,
Topped the neck of Nick the Weaver.
Omar saw him (minus tether—
Free and wanton as the weather:
Knowing naught of bit nor spur)
Stamping over Bahram-Gur.
Now, as Altgeld, see him joy
As Governor of Illinois!

Another Aspirant

George Dewey, dear, I did not think that you—
So very married and so happy, too—
Would go philandering with another girl
And give your gay mustache a fetching curl
And set your cap—I should say your cocked hat—
At Miss Columbia the like o' that.
Pray what can you expect to get by throwing
Sheep's eyes at one so very, very knowing?

See how she served McKinley! All his life
He wooed her for his morganatic wife,
Swore that he loved her better than his soul
(I'm half inclined to think, upon the whole,
She better did deserve his love), then vowed
He'd marry her alive, or even aloud!
What did she? Ere his breath he could recover
She heartlessly accepted that poor lover!

There's William Bryan of the silver tongue,
Old in ambition, in discretion young—
He courts her with the song, the dance, the lute,
But knows how suitors feel who do not suit.
And Teddy Roosevelt, plucking from its sheath
The weapon that he wears behind his teeth,
Endeavors in his simple, soldier fashion,
But all in vain, to touch her heart by slashin'.

Beware, my web-foot friend, beware her wiles:
Fly from her sighs and disregard her smiles.

She's no fool mermaid with a comb and glass,
But Satan's daughter with a breast of brass.
Put out your prow to sea again—but hold!
If Bryan and McKinley, all too bold,
Show up along the beach with little Teddy—
Well, Dewey, you may fire when you are ready.

Philosopher Bimm

Republicans think Jonas Bimm
 A Democrat gone mad,
And Democrats consider him
 Republican and bad.

The Lout reviles him as a Dude
 And gives it him right hot;
The Dude condemns his crassitude
 And calls him *sans-culottes*.

Derided as an Anglophile
 By Anglophobes, forsooth,
As Anglophobe he feels, the while,
 The Anglophilic tooth.

The Churchman calls him Atheist;
 The Atheists, rough-shod,
Have ridden o'er him long and hissed:
 "The wretch believes in God!"

The Saints whom clergymen we call
 Would kill him if they could;
The Sinners (scientists and all)
 Complain that he is good.

All men deplore the difference
 Between themselves and him,
And all devise expedients
 For paining Jonas Bimm.

I too, with wild demoniac glee,
 Would put out both his eyes;
For Mr. Bimm appears to me
 Insufferably wise!

Detected

In Congress once great Mowther shone,
 Debating weighty matters;
Now into an asylum thrown,
 He vacuously chatters.

If in that legislative hall
 His wisdom still he'd vented,
It never had been known at all
 That Mowther was demented.

The Bumbo of Jiam

The Pahdour of Patagascar and the Gookul of Madagonia were disputing about an island which both claimed. Finally, at the suggestion of the International League of Cannon Founders, which had important branches in both countries, they decided to refer their claims to the Bumbo of Jiam, and abide by his judgment. In settling the preliminaries of the arbitration they had, however, the misfortune to disagree, and appealed to arms. At the end of a long and disastrous war, when both sides were exhausted and bankrupt, the Bumbo of Jiam intervened in the interest of peace.

"My great and good friends," he said to his brother sovereigns, "it will be advantageous to you to learn that some questions are more complex and perilous than others, presenting a greater number of points upon which it is possible to differ. For four generations your royal predecessors disputed about possession of that island, without falling out. Beware, oh, beware the perils of international arbitration!— against which I feel it my duty to protect you henceforth."

So saying, he annexed both countries, and after a long, peaceful, and happy reign was poisoned by his Prime Minister.

The Hesitating Veteran

When I was young and full of faith
 And other fads that youngsters cherish
A cry rose as of one that saith
 With emphasis: "Help or I perish!"
'Twas heard in all the land, and men
 The sound were each to each repeating.
It made my heart beat faster then
 Than any heart can now be beating.

For the world is old and the world is gray—
 Grown prudent and, I think, more witty.
She's cut her wisdom teeth, they say,
 And doesn't now go in for Pity.
Besides, the melancholy cry
 Was that of one, 'tis now conceded,
Whose plight no one beneath the sky
 Felt half so poignantly as he did.

Moreover, he was black. And yet
 That sentimental generation
With an austere compassion set
 Its face and faith to the occasion.
Then there were hate and strife to spare,
 And various hard knocks a-plenty;
And I ('twas more than my true share,
 I must confess) took five-and-twenty.

That all is over now—the reign
 Of love and trade stills all dissensions,
And the clear heavens arch again
 Above a land of peace and pensions.
The black chap—at the last we gave
 Him everything that he had cried for,
Though many white chaps in the grave
 'Twould puzzle to say what they died for.

I hope he's better off—I trust
 That his society and his master's

Are worth the price we paid, and must
 Continue paying, in disasters;
But sometimes doubts press thronging round
 ('Tis mostly when my hurts are aching)
If war for Union was a sound
 And profitable undertaking.

'Tis said they mean to take away
 The Negro's vote for he's unlettered.
'Tis true he sits in darkness day
 And night, as formerly, when fettered;
But pray observe—howe'er he vote
 To whatsoever party turning,
He'll be with gentlemen of note
 And wealth and consequence and learning.

With saints and sages on each side,
 How could a fool through lack of knowledge,
Vote wrong? If learning is no guide
 Why ought one to have been in college?
O Son of Day, O Son of Night!
 What are your preferences made of?
I know not which of you is right,
 Nor which to be the more afraid of.

The world is old and the world is bad,
 And creaks and grinds upon its axis;
And man's an ape and the gods are mad!—
 There's nothing sure, not even our taxes.
No mortal man can Truth restore,
 Or say where she is to be sought for.
I know what uniform I wore—
 O, that I knew which side I fought for!

Mourning Glories

There appears to be but little doubt of General Grant's death at an early day. I confess that I look forward to that event with a regret that is largely apprehension. Already I seem to hear the faint far murmur of the advancing tide of bosh that will submerge the land. We shall have newspapers

in "mourning" eulogiums galore, a copious outpush of slavering and lachrymose sentimentality. Busy pens, inspired by commercial thrift, are to-day fashioning the horrible editorial, the sickening resolution, the turgid panegyric, the memorial sermon and the cold-drawn "poem" that are to commemorate the sad mischance. The forethoughtful politician is charging himself to the neck with sentimental slime "appropriate to the occasion." Industriously the unpleasant parson collates his platitudes to wring the Christian heart. The "talented" sub-editor feels his bosom heave with pride as he contemplates the first few sheets of his whole-page article of biographical butter; the detailed reporter exults as he sees growing beneath his hand the harrowing accounts of "a nation plunged in gloom," and of "how the sad news was received in this city." Again the town will be made hideous with lank strips of black and white inter-twisted, and star-spangled banners six inches long, costing ten cents the dozen and inked all around the edges. Again the dirging of brass bands will afflict and the march of the bullion-bedaubed whiskey-soldier make ill. The dummy funeral with its "catafalque" and "casket" will drag its slow length along through shoreless oceans of unhatted heads, destitute of sense. O Father of Mercies, if it be thy will, let this cup pass from our lips. Spare to us yet awhile thy servant, the hero and statesman—the object of a nation's long economy. Take Arthur.

Wasp, 1885

Peace on Earth

Two European governments have recently ordered from an American company enough cartridges to kill one hundred and fifty million men. It is from little incidents of that kind that we get occasional glimpses of the progress of Christian civilization, and obtain a just notion of what has been done in only eighteen centuries by the gospel of peace on earth and goodwill toward men. Stored today in the arsenals of the most en-lightened Christian nations are enough bullets to kill every man, woman and child on earth. Let us prate of peace, my brethren—let us exalt our tails, level our ears, drop our jaws, and warble a superior quality of pious bosh about the humanizing influence of our blessed religion. Why, there are more Christians killed by Christians in one decade than heathens by heathens in ten. And it is growing worse all the time. The last century was the bloodiest century, but it was beaten by the first half of the present one, which in its terror was outdone by the first twenty-five years of the remaining half. You may bible the world a foot deep and unsettle the braces of your lungs "hailing the dawn of a new era." You may unsocket

your arms compounding quack remedies for war. You may cherish whatever delusions you prefer, and utter your own make of holy fudge. As for me, I shall continue to salute every new-born Christian male and address it as Colonel.

Wasp, 1885

On Deterrence

I am sorry to observe so sensible a man as the writer of *The Wave's* editorial articles affected by the absurd popular delusion that an increase in the destructive power of arms tends to "abolition of warfare." It is astonishing how persistently this fallacy crops out in our popular literature of the day. In all the history of warfare, from the time when hordes of our shaggy ancestors fought one another with clubs and stone hatchets to the present era of electricity and dynamite, this belief has not a single fact to found its clumsy feet on. Between tribes weaponed with firearms wars are as cheerfully and lightly undertaken as ever they were, and now are, between tribes equipped with bows and spears. The small nations of today fall foul of one another with as engaging an alacrity as did those of a thousand years ago; and amongst the great Powers there is no more reluctance to begin hostilities than when the vast armies of antiquity fought with an arm whose extreme range was five feet, the short sword. By the way, that primitive weapon was far and away more destructive than the costliest and most ingenious of our "arms of precision." It did not kill at as great a distance, but there was no need: the patient came up to get his medicine. It did not kill as many at once but it cut and came again. The battles of antiquity were greatly bloodier than ours; the best lifesaving device known is the Mannlicher rifle.

Examiner, 1892

The Statue at Bumboogle

On a high hill overlooking the ancient city of Bumboogle is a colossal statue, erected by the nation, to the memory of the illustrious Gaaka-Wolwol, "the best and wisest of mankind." A Traveler from a distant country said to the Custodian of the Statue, who is the highest officer of the realm: "The winds of the sea, O Most Exalted, have not blown the fame of your great countryman to my native shores. What did he do?"

"Nothing; that is how we know him to have been good."

"But his wisdom—what did he say?"

"Nothing; that is how we know him to have been wise."

BUSINESS AND OTHER SOCIAL CONTRACTS

Given Bierce's view that most enterprises were dubious, that there was never anything enlightened about self-interest, and that "one of the signal and characteristic qualities of humanity was inhumanity," it is not at all surprising that he would hammer the point home as often and irascibly as possible.

He especially detested the notion, advanced first by Collis P. Huntington, that "every man has his price." When Bierce was leading the fight to have the Central Pacific Railroad (owned by the Big Four—Huntington, Crocker, Stanford, and Hopkins) called to account and forced to repay a $70 million loan to the government they were attempting to extend well into the next century, he was accosted by Huntington one day and asked his price. Bierce roared at the old pirate, "Seventy million dollars!"

Crocker was to some extent the most public of the partners and, through the instrument of his purse, a great friend of politicians—as Bierce duly and gleefully noted in a bit of doggerel about their favors:

> The friendship of Crocker I tenderly prize—
> I wear many kinds of his collars.
> He's endeared to my heart by the sacred ties
> Of a thousand accessible dollars.

Business

> Two villains of the highest rank
> Set out one night to rob a bank.
> They found the building, looked it o'er,
> Each window noted, tried each door,
> Scanned carefully the lidded hole
> For minstrels to cascade the coal—
> In short, examined five-and-twenty
> Short cuts from poverty to plenty.
> But all were sealed, they saw full soon,

Against the minions of the moon.
"Enough," said one: "I'm satisfied."
The other, smiling fair and wide,
Said: "I'm as highly pleased as you:
No burglar ever can get through.
Fate surely prospers our design—
The booty all is yours and mine."
So, full of hope, the following day
To the exchange they took their way
And bought, with manner free and frank,
Some stock of that devoted bank;
And they became, inside the year,
One President and one Cashier.
Their crime I can no further trace—
The means of safety to embrace,
I overdrew and left the place.

A Prophet of Evil

An Undertaker Who Was a Member of a Trust saw a Man Leaning on a Spade, and asked him why he was not at work.

"Because," said the Man Leaning on a Spade, "I belong to the Gravediggers' National Extortion Society, and we have decided to limit the production of graves and get more money for the reduced output. We have a corner in graves and propose to work it to the best advantage."

"My friend," said the Undertaker Who Was a Member of a Trust, "this is a most hateful and injurious scheme. If people cannot be assured of graves, I fear they will no longer die, and the best interests of civilisation will wither like a frosted leaf."

And blowing his eyes upon his handkerchief, he walked away lamenting.

The Compassionate Physician

A Kind-hearted Physician sitting at the bedside of a patient afflicted with an incurable and painful disease, heard a noise behind him, and turning saw a cat laughing at the feeble efforts of a wounded mouse to drag itself out of the room.

"You cruel beast!" cried he. "Why don't you kill it at once, like a lady?"

Rising, he kicked the cat out of the door, and picking up the mouse compassionately put it out of its misery by pulling off its head.

Recalled to the bedside by the moans of his patient, the Kind-hearted Physician administered a stimulant, a tonic, and a nutrient, and went away.

The Ingenious Patriot

Having obtained an audience of the King an Ingenious Patriot pulled a paper from his pocket, saying:

"May it please your Majesty, I have here a formula for constructing armour-plating which no gun can pierce. If these plates are adopted in the Royal Navy our warships will be invulnerable, and therefore invincible. Here, also, are reports of your Majesty's Ministers, attesting the value of the invention. I will part with my right in it for a million tumtums."

After examining the papers, the King put them away and promised him an order on the Lord High Treasurer of the Extortion Department for a million tumtums.

"And here," said the Ingenious Patriot, pulling another paper from another pocket, "are the working plans of a gun that I have invented, which will pierce that armour. Your Majesty's Royal Brother, the Emperor of Bang, is anxious to purchase it, but loyalty to your Majesty's throne and person constrains me to offer it first to your Majesty. The price is one million tumtums."

Having received the promise of another check, he thrust his hand into still another pocket, remarking:

"The price of the irresistible gun would have been much greater, your Majesty, but for the fact that its missiles can be so effectively averted by my peculiar method of treating the armour plates with a new—"

The King signed to the Great Head Factotum to approach.

"Search this man," he said, "and report how many pockets he has."

"Forty-three, Sire," said the Great Head Factotum, completing the scrutiny.

"May it please your Majesty," cried the Ingenious Patriot, in terror, "one of them contains tobacco."

"Hold him up by the ankles and shake him," said the King; "then give him a check for forty-two million tumtums and put him to death. Let a decree issue declaring ingenuity a capital offence."

The Belly and the Members

Some Workingmen employed in a shoe factory went on a strike, saying: "Why should we continue to work to feed and clothe our employer when we have none too much to eat and wear ourselves?"

The Manufacturer, seeing that he could get no labour for a long time and finding the times pretty hard anyhow, burned down his shoe factory for the insurance, and when the strikers wanted to resume work there was no work to resume. So they boycotted a tanner.

The Wolf and the Lamb

A Lamb, pursued by a Wolf, fled into the temple.

"The priest will catch you and sacrifice you," said the Wolf, "if you remain there."

"It is just as well to be sacrificed by the priest as to be eaten by you," said the Lamb.

"My friend," said the Wolf, "it pains me to see you considering so great a question from a purely selfish point of view. It is not just as well for me."

Financial News

Says Rockefeller: "Money is not tight,"
And, faith, I'm thinking that the man is right.
If it were not, at least in morals, loose
He hardly could command it for his use.

Compliance

Said Rockefeller, senior, to his boy:
"Be good and you shall have eternal joy."
Said Rockefeller, junior, to his dad:
"I never do a single thing that's bad."
Said Rockefeller, senior—long gone gray
In service at the altar: "Ever pray."
And Rockefeller, junior, being bid,
Upon his knees and neighbors ever did.

A Needless Labour

After waiting many a weary day to revenge himself upon a Lion for some unconsidered manifestation of contempt, a Skunk finally saw him coming, and posting himself in the path ahead uttered the inaudible discord of his race. Observing that the Lion gave no attention to the matter, the Skunk, keeping carefully out of reach, said:

"Sir, I beg leave to point out that I have set on foot an implacable odour."

"My dear fellow," the Lion replied, "you have taken a needless trouble; I already knew that you were a Skunk."

The Man and the Bird

A Man with a Shotgun said to a Bird:

"It is all nonsense, you know, about shooting being a cruel sport. I put my skill against your cunning—that is all there is of it. It is a fair game."

"True," said the Bird, "but I don't wish to play."

"Why not?" inquired the Man with a Shotgun.

"The game," the Bird replied, "is fair as you say; the chances are about even; but consider the stake. I am in it for you, but what is there in it for me?"

Not being prepared with an answer to the question, the Man with a Shotgun sagaciously removed the propounder.

A Matter of Method

A Philosopher seeing a Fool beating his Donkey, said:

"Abstain, my son, abstain, I implore. Those who resort to violence shall suffer from violence."

"That," said the Fool, diligently belabouring the animal, "is what I'm trying to teach this beast—which has kicked me."

"Doubtless," said the Philosopher to himself, as he walked away, "the wisdom of fools is no deeper nor truer than ours, but they really do seem to have a more impressive way of imparting it."

The Lion and the Mouse

A Lion who had caught a Mouse was about to kill him, when the Mouse said:

"If you will spare my life, I will do as much for you some day."

The Lion good-naturedly let him go. It happened shortly afterwards that the Lion was caught by some hunters and bound with cords. The Mouse, passing that way, and seeing that his benefactor was helpless, gnawed off his tail.

The Overlooked Factor

A Man that owned a fine Dog, and by a careful selection of its mate had bred a number of animals but a little lower than the angels, fell in love with his washer-woman, married her, and reared a family of dolts.

"Alas!" he exclaimed, contemplating the melancholy result, "had I but chosen a mate for myself with half the care that I did for my Dog I should now be a proud and happy father."

"I'm not so sure of that," said the Dog, overhearing the lament. "There's a difference, certainly, between your whelps and mine, but I venture to flatter myself that it is not due altogether to the mothers. You and I are not entirely alike ourselves."

The Sportsman and the Squirrel

A Sportsman who had wounded a Squirrel, which was making desperate efforts to drag itself away, ran after it with a stick, exclaiming:

"Poor thing! I will put it out of its misery."

At that moment the Squirrel stopped from exhaustion, and looking up at its enemy, said:

"I don't venture to doubt the sincerity of your compassion, though it comes rather late, but you seem to lack the faculty of observation. Do you not perceive by my actions that the dearest wish of my heart is to continue in my misery?"

At this exposure of his hypocrisy, the Sportsman was so overcome with shame and remorse that he would not strike the Squirrel, but pointing it out to his dog, walked thoughtfully away.

The Tail of the Sphinx

A Dog of a taciturn disposition said to his Tail:

"Whenever I am angry, you rise and bristle; when I am pleased, you wag; when I am alarmed, you tuck yourself in out of danger. You are too mercurial—you disclose all my emotions. My notion is that tails are given to conceal thought. It is my dearest ambition to be as impassive as the Sphinx."

"My friend, you must recognise the laws and limitations of

your being," replied the Tail, with flexions appropriate to the sentiments uttered, "and try to be great some other way. The Sphinx has one hundred and fifty qualifications for impassiveness which you lack."

"What are they?" the Dog asked.

"One hundred and forty-nine tons of sand on her tail."

"And—?"

"A stone tail."

The Business of Business

The value of the opinions of "business men" as guides in legislation is shown in a lambent light by the action of our Chamber of Commerce the other day. Last May the Chamber recorded its approval of the proposed commercial treaty with France, whereby it was intended to materially reduce the duties on imported wines. But on Tuesday last, at the instance of the California Vinicultural Association, they unanimously recalled their approval and earnestly implored Congress to continue the present tariff.

Now it so happens (that's the word for it) that a large number of the members of the Chamber of Commerce are opposed to protective duties—where local or personal interests are not concerned. They are sturdy free-traders—in Pennsylvania and Massachusetts. It would not surprise if now, by way of atonement for their latest action in this matter, they would demand the abolition of duties all over the continent of Europe. When your man of affairs, looking over the accounts of his political conscience, finds himself debited with a selfish opinion on a matter affecting his own interests, he immediately balances the books by crediting himself with a liberal one on a matter affecting the interests of others.

Argonaut, 1878

Prosperous Penitents

First it was "poor Best!" and now it is "poor Broadhead!" Wherein are these thieves "poor"? In what consist their claims to compassion? Why should honest men be asked to flood an eye when a clumsy rogue, falling over his own feet, unloads his broken back of his neighbor's chattels? I am myself indisposed of this kind of gabble; and I wish to say to the many gentlemen who in recent conversation with me have implied their belief that Best and Broadhead are no worse than themselves, that I think themselves no better than Best and Broadhead.

After all, I suppose these gentlemen are in a sense right; it is not a question of morals, it is a matter of brains. A criminal is merely a fool who has had an opportunity. Every felony affords a fresh illustration. Take Broadhead's. This genius was so scrupulously honest that he committed forgery in order to pay a debt! He did it by raising a check—to one-tenth the sum that he might as easily and securely have obtained! And then, with detection absolutely assured, he remained in the city rather than cloud his name by flight! These are simply the acts of a fool— a man who has not the capacity and habit of clear and effective thought. There are rogues who are not fools (except in the folly of being rogues) but they are even more rare than the dunces who are not rascals, and their distinction is so much the greater. Indeed, it is so so great that they are commonly worshiped.

A friend has directed my attention to another recent instance illustrative of the great truth that a rascal is but a practicing dunce— that of Baldwin, the New Jersey defaulting banker. This luckless lout knew that a pending examination would disclose his theft of millions. He could think of no better expedient than to go and disclose it himself. Then, like Mary's little lamb, he "lingered near" until arrested. He was now utterly and hopelessly disgraced—had nothing but his liberty and money to lose. With the former he could have made a fight for the latter, with every hope of success. He chose to be "manly"—to pose as a penitent; pleaded guilty and got a longer sentence than he would have got on conviction after exhausting all the law's expedients. What mattered it to this dishonored blockhead whether the public regarded his "expiation" as "manly" or not? For years he had been leaving the traces of his villainy everywhere, and finally when the dogs of the law got upon his scent he could think of nothing better to do than lie down and let them chew his throat. Clearly, if the devil would secure good talent he must raise his rate of wages.

All this has its "lesson to parents": stop this senseless and purposeless cultivation of your children's "moral natures," developing their intellects instead. Repress their emotional tendencies and teach them to think. Only the person who has been trained to think can be trusted to feel. Shut up your Sunday-schools, abolish your Bible-classes and found more "godless colleges." I don't quarrel with religion; I am told by those who make a living by teaching it that it is a good preparation for another world. In this world its professors are overmuch given to theft—wherefore the trained logicians of the secular sort clap them into jail.

Wasp, 1882

Disintroductions

The devil is a citizen of every country, but only in our own are we in constant peril of an introduction to him. That is democracy. All men are equal; the devil is a man; therefore, the devil is equal. If that is not a good and sufficient syllogism I should be pleased to know what is the matter with it.

To write in riddles when one is not prophesying is too much trouble; what I am affirming is the horror of the characteristic American custom of promiscuous, unsought and unauthorized introductions.

You incautiously meet your friend Smith in the street; if you had been prudent you would have remained indoors. Your helplessness makes you desperate and you plunge into conversation with him, knowing entirely well the disaster that is in cold storage for you.

The expected occurs: another man comes along and is promptly halted by Smith and you are introduced! Now, you have not given to the Smith the right to enlarge your circle of acquaintance and select the addition himself; why did he do this thing? The person whom he has condemned you to shake hands with may be an admirable person, though there is a strong numerical presumption against it; but for all that the Smith knows he may be your bitterest enemy. The Smith has never thought of that. Or you may have evidence (independent of the fact of the introduction) that he is some kind of thief—there are one thousand and fifty kinds of thieves. But the Smith has never thought of that. In short, the Smith has never thought. In a Smithocracy all men, as aforesaid, being equal, all are equally agreeable to one another.

That is a logical extension of the Declaration of American Independence. If it is erroneous the assumption that a man will be pleasing to me because he is pleasing to another is erroneous too, and to introduce me to one that I have not asked nor consented to know is an invasion of my rights—a denial and limitation of my liberty to a voice in my own affairs. It is like determining what kind of clothing I shall wear, what books I shall read, or what my dinner shall be.

In calling promiscuous introducing an American custom I am not unaware that it obtains in other countries than ours. The difference is that in those it is mostly confined to persons of no consequence and no pretensions to respectability; here it is so nearly universal that there is no escaping it. Democracies are naturally and necessarily gregarious. Even the French of to-day are becoming so, and the time is apparently not distant when they will lose that fine distinctive social sense that has made them the most punctilious, because the most considerate, of all nations excepting the Spanish and the Japanese. By those who have lived in Paris since I did I am told that the chance introduction is beginning to

devastate the social situation, and men of sense who wish to know as few persons as possible can no longer depend on the discretion of their friends.

To say so is not the same thing as to say "Down with the republic!" The republic has its advantages. Among these is the liberty to say, "Down with the republic!"

It is to be wished that some great social force, say a billionaire, would set up a system of disintroductions. It should work somewhat like this:

MR. WHITE—Mr. Black, knowing the low esteem in which you hold each other, I have the honor to disintroduce you from Mr. Green.

MR. BLACK (*bowing*)—Sir, I have long desired the advantage of your unacquaintance.

MR. GREEN (*bowing*)—Charmed to unmeet you, sir. Our acquaintance (the work of a most inconsiderate and unworthy person) has distressed me beyond expression. We are greatly indebted to our good friend here for his tact in repairing the mischance.

MR. WHITE—Thank you. I'm sure you will become very good strangers.

This is only the ghost of a suggestion; of course the plan is capable of an infinite elaboration. Its capital defect is that the persons who are now so liberal with their unwelcome introductions, will be equally lavish with their disintroductions, and will estrange the best of friends with as little ceremony as they now observe in their more fiendish work.

STORIES OF THE SUPERNATURAL

With Poe and Lovecraft, Bierce was often considered a master of the macabre, but time has settled things, and the reputations of both Bierce and the hothouse esthete Lovecraft have slipped a few notches. Though Bierce was a conscientious craftsman, he could not resist injecting grotesquerie and ghoulish humor into many of his stories— manifestations of his misanthropy and his desire to shock or even outrage his readers. Several of his works are, however, minor master-pieces of the genre.

He was accused of being a heartless writer, relying often on coincidence, and responded with a defense which, given the presence of so many grisly deaths in his stories, is somewhat curious: "Fiction has nothing to say to probability; the capable writer gives it not a moment's attention, except to make what is related seem probable in the reading—seem true. Suppose he relates the impossible; what then? Why, he has but passed over the line into the realm of romance, the kingdom of Scott, Defoe, Hawthorne, Beckford and the authors of Arabian Nights—the land of the poets, the home of all that is lasting and good in the literature of the imagination."

It was not the best defense, but it sufficed to quiet the critics at the time, and the collections of his stories went on to be his only really successful books.

A WATCHER BY THE DEAD

In an upper room of an unoccupied dwelling in the part of San Francisco known as North Beach lay the body of a man, under a sheet. The hour was near nine in the evening; the room was dimly lighted by a single candle. Although the weather was warm, the two windows, contrary to the custom which gives the dead plenty of air, were closed and the blinds drawn down. The furniture of the room consisted of but three pieces— an arm-chair, a small reading-stand supporting the candle, and a long kitchen table, supporting the body of the man. All these, as also the corpse, seemed to have been recently brought in, for an observer, had there been one, would have seen that all were free from dust, whereas

everything else in the room was pretty thickly coated with it, and there were cobwebs in the angles of the walls.

Under the sheet the outlines of the body could be traced, even the features, these having that unnaturally sharp definition which seems to belong to faces of the dead, but is really characteristic of those only that have been wasted by disease. From the silence of the room one would rightly have inferred that it was not in the front of the house, facing a street. It really faced nothing but a high breast of rock, the rear of the building being set into a hill.

As a neighboring church clock was striking nine with an indolence which seemed to imply such an indifference to the flight of time that one could hardly help wondering why it took the trouble to strike at all, the single door of the room was opened and a man entered, advancing toward the body. As he did so the door closed, apparently of its own volition; there was a grating, as of a key turned with difficulty, and the snap of a lock bolt as it shot into its socket. A sound of retiring footsteps in the passage outside ensued, and the man was to all appearance a prisoner. Advancing to the table, he stood a moment looking down at the body; then with a slight shrug of the shoulders walked over to one of the windows and hoisted the blind. The darkness outside was absolute, the panes were covered with dust, but by wiping this away he could see that the window was fortified with strong iron bars crossing it within a few inches of the glass and imbedded in the masonry on each side. He examined the other window. It was the same. He manifested no great curiosity in the matter, did not even so much as raise the sash. If he was a prisoner he was apparently a tractable one. Having completed his examination of the room, he seated himself in the arm-chair, took a book from his pocket, drew the stand with its candle alongside and began to read.

The man was young—not more than thirty—dark in complexion, smooth-shaven, with brown hair. His face was thin and high-nosed, with a broad forehead and a "firmness" of the chin and jaw which is said by those having it to denote resolution. The eyes were gray and steadfast, not moving except with definitive purpose. They were now for the greater part of the time fixed upon his book, but he occasionally withdrew them and turned them to the body on the table, not, apparently, from any dismal fascination which under such circumstances it might be supposed to exercise upon even a courageous person, nor with a conscious rebellion against the contrary influence which might dominate a timid one. He looked at it as if in reading he had come upon something recalling him to a sense of his surroundings. Clearly this watcher by the dead was discharging his trust with intelligence and composure, as became him.

After reading for perhaps a half-hour he seemed to come to the

end of a chapter and quietly laid away the book. He then rose and taking the reading-stand from the floor carried it into a corner of the room near one of the windows, lifted the candle from it and returned to the empty fireplace before which he had been sitting.

A moment later he walked over to the body on the table, lifted the sheet and turned it back from the head, exposing a mass of dark hair and a thin face-cloth, beneath which the features showed with even sharper definition than before. Shading his eyes by interposing his free hand between them and the candle, he stood looking at his motionless companion with a serious and tranquil regard. Satisfied with his inspection, he pulled the sheet over the face again and returning to the chair, took some matches off the candlestick, put them in the side pocket of his sack-coat and sat down. He then lifted the candle from its socket and looked at it critically, as if calculating how long it would last. It was barely two inches long; in another hour he would be in darkness. He replaced it in the candlestick and blew it out.

■

In a physician's office in Kearny Street three men sat about a table, drinking punch and smoking. It was late in the evening, almost midnight, indeed, and there had been no lack of punch. The gravest of the three, Dr. Helberson, was the host—it was in his rooms they sat. He was about thirty years of age; the others were even younger; all were physicians.

"The superstitious awe with which the living regard the dead," said Dr. Helberson, "is hereditary and incurable. One needs no more be ashamed of it than of the fact that he inherits, for example, an incapacity for mathematics, or a tendency to lie."

The others laughed. "Oughtn't a man to be ashamed to lie?" asked the youngest of the three, who was in fact a medical student not yet graduated.

"My dear Harper, I said nothing about that. The tendency to lie is one thing; lying is another."

"But do you think," said the third man, "that this superstitious feeling, this fear of the dead, reasonless as we know it to be, is universal? I am myself not conscious of it."

"Oh, but it is 'in your system' for all that," replied Helberson; "it needs only the right conditions—what Shakespeare calls the 'confederate season'—to manifest itself in some very disagreeable way that will open your eyes. Physicians and soldiers are of course more nearly free from it than others."

"Physicians and soldiers!—why don't you add hangmen and headsmen? Let us have in all the assassin classes."

"No, my dear Mancher; the juries will not let the public

executioners acquire sufficient familiarity with death to be altogether unmoved by it."

Young Harper, who had been helping himself to a fresh cigar at the sideboard, resumed his seat. "What would you consider conditions under which any man of woman born would become insupportably conscious of his share of our common weakness in this regard?" he asked, rather verbosely.

"Well, I should say that if a man were locked up all night with a corpse—alone—in a dark room—of a vacant house—with no bed covers to pull over his head—and lived through it without going altogether mad, he might justly boast himself not of woman born, nor yet, like Macduff, a product of Caesarean section."

"I thought you never would finish piling up conditions," said Harper, "but I know a man who is neither a physician nor a soldier who will accept them all, for any stake you like to name."

"Who is he?"

"His name is Jarette—a stranger here; comes from my town in New York. I have no money to back him, but he will back himself with loads of it."

"How do you know that?"

"He would rather bet than eat. As for fear—I dare say he thinks it some cutaneous disorder, or possibly a particular kind of religious heresy."

"What does he look like?" Helberson was evidently becoming interested.

"Like Mancher, here—might be his twin brother."

"I accept the challenge," said Helberson, promptly.

"Awfully obliged to you for the compliment, I'm sure," drawled Mancher, who was growing sleepy. "Can't I get into this?"

"Not against me," Helberson said. "I don't want *your* money."

"All right," said Mancher; "I'll be the corpse."

The others laughed.

The outcome of this crazy conversation we have seen.

■

In extinguishing his meagre allowance of candle Mr. Jarette's object was to preserve it against some unforeseen need. He may have thought, too, or half thought, that the darkness would be no worse at one time than another, and if the situation became insupportable it would be better to have a means of relief, or even release. At any rate it was wise to have a little reserve of light, even if only to enable him to look at his watch.

No sooner had he blown out the candle and set it on the floor at his side than he settled himself comfortably in the arm-chair, leaned

back and closed his eyes, hoping and expecting to sleep. In this he was disappointed; he had never in his life felt less sleepy, and in a few minutes he gave up the attempt. But what could he do? He could not go groping about in absolute darkness at the risk of bruising himself—at the risk, too, of blundering against the table and rudely disturbing the dead. We all recognize their right to lie at rest, with immunity from all that is harsh and violent. Jarette almost succeeded in making himself believe that considerations of this kind restrained him from risking the collision and fixed him to the chair.

While thinking of this matter he fancied that he heard a faint sound in the direction of the table—what kind of sound he could hardly have explained. He did not turn his head. Why should he—in the darkness? But he listened—why should he not? And listening he grew giddy and grasped the arms of the chair for support. There was a strange ringing in his ears; his head seemed bursting; his chest was oppressed by the constriction of his clothing. He wondered why it was so, and whether these were symptoms of fear. Then, with a long and strong expiration, his chest appeared to collapse, and with the great gasp with which he refilled his exhausted lungs the vertigo left him and he knew that so intently had he listened that he had held his breath almost to suffocation. The revelation was vexatious; he arose, pushed away the chair with his foot and strode to the centre of the room. But one does not stride far in darkness; he began to grope, and finding the wall followed it to an angle, turned, followed it past the two windows and there in another corner came into violent contact with the reading-stand, overturning it. It made a clatter that startled him. He was annoyed. "How the devil could I have forgotten where it was?" he muttered, and groped his way along the third wall to the fireplace. "I must put things to rights," said he, feeling the floor for the candle.

Having recovered that, he lighted it and instantly turned his eyes to the table, where, naturally, nothing had undergone any change. The reading-stand lay unobserved upon the floor: he had forgotten to "put it to rights." He looked all about the room, dispersing the deeper shadows by movements of the candle in his hand, and crossing over to the door tested it by turning and pulling the knob with all his strength. It did not yield and this seemed to afford him a certain satisfaction; indeed, he secured it more firmly by a bolt which he had not before observed. Returning to his chair, he looked at his watch; it was half-past nine. With a start of surprise he held the watch at his ear. It had not stopped. The candle was now visibly shorter. He again extinguished it, placing it on the floor at his side as before.

Mr. Jarette was not at his ease; he was distinctly dissatisfied with his surroundings, and with himself for being so. "What have I to fear?" he thought. "This is ridiculous and disgraceful; I will not be so great a fool." But courage does not come of saying, "I will be courageous," nor of recognizing its appropriateness to the occasion. The more Jarette condemned himself, the more reason he gave himself for condemnation; the greater the number of variations which he played upon the simple theme of the harmlessness of the dead, the more insupportable grew the discord of his emotions. "What!" he cried aloud in the anguish of his spirit, "what! shall I, who have not a shade of superstition in my nature—I, who have no belief in immortality—I, who know (and never more clearly than now) that the after-life is the dream of a desire—shall I lose at once my bet, my honor and my self-respect, perhaps my reason, because certain savage ancestors dwelling in caves and burrows conceived the monstrous notion that the dead walk by night?—that—" Distinctly, unmistakably, Mr. Jarette heard behind him a light, soft sound of footfalls, deliberate, regular, successively nearer!

■

Just before daybreak the next morning Dr. Helberson and his young friend Harper were driving slowly through the streets of North Beach in the doctor's coupé.

"Have you still the confidence of youth in the courage or stolidity of your friend?" said the elder man. "Do you believe that I have lost this wager?"

"I *know* you have," replied the other, with enfeebling emphasis.

"Well, upon my soul, I hope so."

It was spoken earnestly, almost solemnly. There was a silence for a few moments.

"Harper," the doctor resumed, looking very serious in the shifting half-lights that entered the carriage as they passed the street lamps, "I don't feel altogether comfortable about this business. If your friend had not irritated me by the contemptuous manner in which he treated my doubt of his endurance—a purely physical quality—and by the cool incivility of his suggestion that the corpse be that of a physician, I should not have gone on with it. If anything should happen we are ruined, as I fear we deserve to be."

"What can happen? Even if the matter should be taking a serious turn, of which I am not at all afraid, Mancher has only to 'resurrect' himself and explain matters. With a genuine 'subject' from the dissecting room, or one of your late patients, it might be different."

Dr. Mancher, then, had been as good as his promise; he was the "corpse."

Dr. Helberson was silent for a long time, as the carriage, at a snail's pace, crept along the same street it had traveled two or three times already. Presently he spoke: "Well, let us hope that Mancher, if he has had to rise from the dead, has been discreet about it. A mistake in that might make matters worse instead of better."

"Yes," said Harper, "Jarette would kill him. But, Doctor"—looking at his watch as the carriage passed a gas lamp—"It is nearly four o'clock at last."

A moment later the two had quitted the vehicle and were walking briskly toward the long-unoccupied house belonging to the doctor in which they had immured Mr. Jarette in accordance with the terms of the mad wager. As they neared it they met a man running. "Can you tell me," he cried, suddenly checking his speed, "where I can find a doctor?"

"What's the matter?" Helberson asked, non-committal.

"Go and see for yourself," said the man, resuming his running.

They hastened on. Arrived at the house, they saw several persons entering in haste and excitement. In some of the dwellings near by and across the way the chamber windows were thrown up, showing a protrusion of heads. All heads were asking questions, none heeding the questions of the others. A few of the windows with closed blinds were illuminated; the inmates of those rooms were dressing to come down. Exactly opposite the door of the house that they sought a street lamp threw a yellow, insufficient light upon the scene, seeming to say that it could disclose a good deal more if it wished. Harper paused at the door and laid a hand upon his companion's arm. "It is all up with us, Doctor," he said in extreme agitation, which contrasted strangely with his free-and-easy words; "the game has gone against us all. Let's not go in there; I'm for lying low."

"I'm a physician," said Dr. Helberson, calmly; "there may be need of one."

They mounted the doorsteps and were about to enter. The door was open; the street lamp opposite lighted the passage into which it opened. It was full of men. Some had ascended the stairs at the farther end, and, denied admittance above, waited for better fortune. All were talking, none listening. Suddenly, on the upper landing there was a great commotion; a man had sprung out of a door and was breaking away from those endeavoring to detain him. Down through the mass of affrighted idlers he came, pushing them aside, flattening them against the wall on one side, or compelling them to cling to the rail on the other, clutching them by the throat, striking them savagely, thrusting them back down the stairs and walking over the fallen. His clothing was in disorder, he

was without a hat. His eyes, wild and restless, had in them something more terrifying than his apparently superhuman strength. His face, smooth-shaven, was bloodless, his hair frost-white.

As the crowd at the foot of the stairs, having more freedom, fell away to let him pass Harper sprang forward. "Jarette! Jarette!" he cried.

Dr. Helberson seized Harper by the collar and dragged him back. The man looked into their faces without seeming to see them and sprang through the door, down the steps, into the street, and away. A stout policeman, who had had inferior success in conquering his way down the stairway, followed a moment later and started in pursuit, all the heads in the windows—those of women and children now—screaming in guidance.

The stairway being now partly cleared, most of the crowd having rushed down to the street to observe the flight and pursuit, Dr. Helberson mounted to the landing, followed by Harper. At a door in the upper passage an officer denied them admittance. "We are physicians," said the doctor, and they passed in. The room was full of men, dimly seen, crowded about a table. The newcomers edged their way forward and looked over the shoulders of those in the front rank. Upon the table, the lower limbs covered with a sheet, lay the body of a man, brilliantly illuminated by the beam of a bull's-eye lantern held by a policeman standing at the feet. The others, excepting those near the head—the officer himself—all were in darkness. The face of the body showed yellow, repulsive, horrible! The eyes were partly open and upturned and the jaw fallen; traces of froth defiled the lips, the chin, the cheeks. A tall man, evidently a doctor, bent over the body with his hand thrust under the shirt front. He withdrew it and placed two fingers in the open mouth. "This man has been about six hours dead," said he. "It is a case for the coroner."

He drew a card from his pocket, handed it to the officer and made his way toward the door.

"Clear the room—out, all!" said the officer, sharply, and the body disappeared as if it had been snatched away, as shifting the lantern he flashed its beam of light here and there against the faces of the crowd. The effect was amazing! The men, blinded, confused, almost terrified, made a tumultuous rush for the door, pushing, crowding, and tumbling over one another as they fled, like the hosts of Night before the shafts of Apollo. Upon the struggling, trampling mass the officer poured his light without pity and without cessation. Caught in the current, Helberson and Harper were swept out of the room and cascaded down the stairs into the street.

"Good God, Doctor! did I not tell you that Jarette would kill him?" said Harper, as soon as they were clear of the crowd.

"I believe you did," replied the other, without apparent emotion.

They walked on in silence, block after block. Against the graying east the dwellings of the hill tribes showed in silhouette. The familiar milk wagon was already astir in the streets; the baker's man would soon come upon the scene; the newspaper carrier was abroad in the land.

"It strikes me, youngster," said Helberson, "that you and I have been having too much of the morning air lately. It is unwholesome; we need a change. What do you say to a tour in Europe?"

"When?"

"I'm not particular. I should suppose that four o'clock this afternoon would be early enough."

"I'll meet you at the boat," said Harper.

■

Seven years afterward these two men sat upon a bench in Madison Square, New York, in familiar conversation. Another man, who had been observing them for some time, himself unobserved, approached and, courteously lifting his hat from locks as white as frost, said: "I beg your pardon, gentlemen, but when you have killed a man by coming to life, it is best to change clothes with him, and at the first opportunity make a break for liberty."

Helberson and Harper exchanged significant glances. They were obviously amused. The former then looked the stranger kindly in the eye and replied:

"That has always been my plan. I entirely agree with you as to its advant—"

He stopped suddenly, rose and went white. He stared at the man, open-mouthed; he trembled visibly.

"Ah!" said the stranger, "I see that you are indisposed, Doctor. If you cannot treat yourself Dr. Harper can do something for you, I am sure."

"Who the devil are you?" said Harper, bluntly.

The stranger came nearer and, bending toward them, said in a whisper: "I call myself Jarette sometimes, but I don't mind telling you, for old friendship, that I am Dr. William Mancher."

The revelation brought Harper to his feet. "Mancher!" he cried; and Helberson added: "It is true, by God!"

"Yes," said the stranger, smiling vaguely, "it is true enough, no doubt."

He hesitated and seemed to be trying to recall something, then began humming a popular air. He had apparently forgotten their presence.

"Look here, Mancher," said the elder of the two, "tell us just what occurred that night—to Jarette, you know."

"Oh, yes, about Jarette," said the other. "It's odd I should have neglected to tell you—I tell it so often. You see I knew, by overhearing him talking to himself, that he was pretty badly frightened. So I couldn't resist the temptation to come to life and have a bit of fun out of him—I couldn't really. That was all right, though certainly I did not think he would take it so seriously; I did not, truly. And afterward—well, it was a tough job changing places with him, and then—damn you! you didn't let me out!"

Nothing could exceed the ferocity with which these last words were delivered. Both men stepped back in alarm.

"We?—why—why," Helberson stammered, losing his self-possession utterly, "we had nothing to do with it."

"Didn't I say you were Drs. Hell-born and Sharper?" inquired the man, laughing.

"My name is Helberson, yes; and this gentleman is Mr. Harper," replied the former, reassured by the laugh. "But we are not physicians now; we are—well, hang it, old man, we are gamblers."

And that was the truth.

"A very good profession—very good, indeed; and, by the way, I hope Sharper here paid over Jarette's money like an honest stakeholder. A very good and honorable profession," he repeated, thoughtfully, moving carelessly away; "but I stick to the old one. I am High Supreme Medical Officer of the Bloomingdale Asylum; it is my duty to cure the superintendent."

The Man and the Snake

It is of veritabyll report, and attested of so many that there be nowe of wyse and learned none to gaynsaye it, that ye serpente hys eye hath a magnetick propertie that whosoe falleth into its svasion is drawn forwards in despyte of his wille, and perisheth miserabyll by ye creature hys byte.

Stretched at ease upon a sofa, in gown and slippers, Harker Brayton smiled as he read the foregoing sentence in old Morryster's *Marvells of Science*. "The only marvel in the matter," he said to himself, "is that the wise and learned in Morryster's day should have believed such nonsense as is rejected by most of even the ignorant in ours."

A train of reflection followed—for Brayton was a man of thought—and he unconsciously lowered his book without altering the

direction of his eyes. As soon as the volume had gone below the line of sight, something in an obscure corner of the room recalled his attention to his surroundings. What he saw, in the shadow under his bed, was too small points of light, apparently about an inch apart. They might have been reflections of the gas jet above him, in metal nail heads; he gave them but little thought and resumed his reading. A moment later something—some impulse which it did not occur to him to analyze— impelled him to lower the book again and seek for what he saw before. The points of light were still there. They seemed to have become brighter than before, shining with a greenish lustre that he had not at first observed. He thought, too, that they might have moved a trifle— were somewhat nearer. They were still too much in shadow, however, to reveal their nature and origin to an indolent attention, and again he resumed his reading. Suddenly something in the text suggested a thought that made him start and drop the book for the third time to the side of the sofa, whence, escaping from his hand, it fell sprawling to the floor, back upward. Brayton, half-risen, was staring intently into the obscurity beneath the bed, where the points of light shone with, it seemed to him, an added fire. His attention was now fully aroused, his gaze eager and imperative. It disclosed, almost directly under the foot-rail of the bed, the coils of a large serpent—the points of light were its eyes! Its horrible head, thrust flatly forth from the innermost coil and resting upon the outermost, was directed straight toward him, the definition of the wide, brutal jaw and the idiot-like forehead serving to show the direction of its malevolent gaze. The eyes were no longer merely luminous points; they looked into his own with a meaning, a malign significance.

■

A snake in a bedroom of a modern city dwelling of the better sort is, happily, not so common a phenomenon as to make explanation altogether needless. Harker Brayton, a bachelor of thirty-five, a scholar, idler and something of an athlete, rich, popular and of sound health, had returned to San Francisco from all manner of remote and unfamiliar countries. His tastes, always a trifle luxurious, had taken on an added exuberance from long privation; and the resources of even the Castle Hotel being inadequate to their perfect gratification, he had gladly accepted the hospitality of his friend, Dr. Druring, the distinguished scientist. Dr. Druring's house, a large, old-fashioned one in what is now an obscure quarter of the city, had an outer and visible aspect of proud reserve. It plainly would not associate with the contiguous elements of its altered environment, and appeared to have developed some of the eccentricities which come of isolation. One of these was a "wing," conspicuously irrelevant in point of architecture, and no less rebellious

in matter of purpose; for it was a combination of laboratory, menagerie and museum. It was here that the doctor indulged the scientific side of his nature in the study of such forms of animal life as engaged his interest and comforted his taste—which, it must be confessed, ran rather to the lower types. For one of the higher nimbly and sweetly to recommend itself unto his gentle senses it had at least to retain certain rudimentary characteristics allying it to such "dragons of the prime" as toads and snakes. His scientific sympathies were distinctly reptilian; he loved nature's vulgarians and described himself as the Zola of zoölogy. His wife and daughters not having the advantage to share his enlightened curiosity regarding the works and ways of our ill-starred fellow-creatures, were with needless austerity excluded from what he called the Snakery and doomed to companionship with their own kind, though to soften the rigors of their lot he had permitted them out of his great wealth to outdo the reptiles in the gorgeousness of their surroundings and to shine with a superior splendor.

Architecturally and in point of "furnishing" the Snakery had a severe simplicity befitting the humble circumstances of its occupants, many of whom, indeed, could not safely have been intrusted with the liberty that is necessary to the full enjoyment of luxury, for they had the troublesome peculiarity of being alive. In their own apartments, however, they were under as little personal restraint as was compatible with their protection from the baneful habit of swallowing one another; and, as Brayton had thoughtfully been apprised, it was more than a tradition that some of them had at divers times been found in parts of the premises where it would have embarrassed them to explain their presence. Despite the Snakery and its uncanny associations—to which, indeed, he gave little attention—Brayton found life at the Druring mansion very much to his mind.

■

Beyond a smart shock of surprise and a shudder of mere loathing Mr. Brayton was not greatly affected. His first thought was to ring the call bell and bring a servant; but although the bell cord dangled within easy reach he made no movement toward it; it had occurred to his mind that the act might subject him to the suspicion of fear, which he certainly did not feel. He was more keenly conscious of the incongruous nature of the situation than affected by its perils; it was revolting, but absurd.

The reptile was of a species with which Brayton was unfamiliar. Its length he could only conjecture; the body at the largest visible part seemed about as thick as his forearm. In what way was it dangerous, if in any way? Was it venomous? Was it a constrictor? His knowledge of

nature's danger signals did not enable him to say; he had never deciphered the code.

If not dangerous the creature was at least offensive. It was *de trop*—"matter out of place"—an impertinence. The gem was unworthy of the setting. Even the barbarous taste of our time and country, which had loaded the walls of the room with pictures, the floor with furniture and the furniture with bric-a-brac, had not quite fitted the place for this bit of the savage life of the jungle. Besides—insupportable thought!— the exhalations of its breath mingled with the atmosphere which he himself was breathing.

These thoughts shaped themselves with greater or less definition in Brayton's mind and begot action. The process is what we call consideration and decision. It is thus that we are wise and unwise. It is thus that the withered leaf in an autumn breeze shows greater or less intelligence than its fellows, falling upon the land or upon the lake. The secret of human action is an open one: something contracts our muscles. Does it matter if we give to the preparatory molecular changes the name of will?

Brayton rose to his feet and prepared to back softly away from the snake, without disturbing it if possible, and through the door. Men retire so from the presence of the great, for greatness is power and power is a menace. He knew that he could walk backward without error. Should the monster follow, the taste which had plastered the walls with paintings had consistently supplied a rack of murderous Oriental weapons from which he could snatch one to suit the occasion. In the mean time the snake's eyes burned with a more pitiless malevolence than before.

Brayton lifted his right foot free of the floor to step backward. That moment he felt a strong aversion to doing so.

"I am accounted brave," he thought; "is bravery, then, no more than pride? Because there are none to witness the shame shall I retreat?"

He was steadying himself with his right hand upon the back of a chair, his foot suspended.

"Nonsense!" he said aloud; "I am not so great a coward as to fear to seem to myself afraid."

He lifted the foot a little higher by slightly bending the knee and thrust it sharply to the floor—an inch in front of the other! He could not think how that occurred. A trial with the left foot had the same result; it was again in advance of the right. The hand upon the chair back was grasping it; the arm was straight, reaching somewhat backward. One might have said that he was reluctant to lose his hold. The snake's malignant head was still thrust forth from the inner coil as before, the

neck level. It had not moved, but its eyes were now electric sparks, radiating an infinity of luminous needles.

The man had an ashy pallor. Again he took a step forward, and another, partly dragging the chair, which when finally released fell upon the floor with a crash. The man groaned; the snake made neither sound nor motion, but its eyes were two dazzling suns. The reptile itself was wholly concealed by them. They gave off enlarging rings of rich and vivid colors, which at their greatest expansion successively vanished like soap-bubbles; they seemed to approach his very face, and anon were an immeasurable distance away. He heard, somewhere, the continuous throbbing of a great drum, with desultory bursts of far music, inconceivably sweet, like the tones of an æolian harp. He knew it for the sunrise melody of Memnon's statue, and thought he stood in the Nileside reeds hearing with exalted sense that immortal anthem through the silence of the centuries.

The music ceased; rather, it became by insensible degrees the distant roll of a retreating thunder-storm. A landscape, glittering with sun and rain, stretched before him, arched with a vivid rainbow framing in its giant curve a hundred visible cities. In the middle distance a vast serpent, wearing a crown, reared its head out of its voluminous convolutions and looked at him with his dead mother's eyes. Suddenly this enchanting landscape seemed to rise swiftly upward like the drop scene at a theatre, and vanished in a blank. Something struck him a hard blow upon the face and breast. He had fallen to the floor, the blood ran from his broken nose and his bruised lips. For a time he was dazed and stunned, and lay with closed eyes, his face against the floor. In a few moments he had recovered, and then knew that this fall, by withdrawing his eyes, had broken the spell that held him. He felt that now, by keeping his gaze averted, he would be able to retreat. But the thought of the serpent within a few feet of his head, yet unseen—perhaps in the very act of springing upon him and throwing its coils about his throat—was too horrible! He lifted his head, stared again into those baleful eyes and was again in bondage.

The snake had not moved and appeared somewhat to have lost its power upon the imagination; the gorgeous illusions of a few moments before were not repeated. Beneath that flat and brainless brow its black, beady eyes simply glittered as at first with an expression unspeakably malignant. It was as if the creature, assured of its triumph, had determined to practise no more alluring wiles.

Now ensued a fearful scene. The man, prone upon the floor, within a yard of his enemy, raised the upper part of his body upon his elbows, his head thrown back, his legs extended to their full length. His face was white between its stains of blood; his eyes were strained open to

their uttermost expansion. There was froth upon his lips; it dropped off in flakes. Strong convulsions ran through his body, making almost serpentile undulations. He bent himself at the waist, shifting his legs from side to side. And every movement left him a little nearer to the snake. He thrust his hands forward to brace himself back, yet constantly advanced upon his elbows.

■

Dr. Druring and his wife sat in the library. The scientist was in rare good humor.

"I have just obtained by exchange with another collector," he said, "a splendid specimen of the *ophiophagus*."

"And what may that be?" the lady inquired with a somewhat languid interest.

"Why, bless my soul, what profound ignorance! My dear, a man who ascertains after marriage that his wife does not know Greek is entitled to a divorce. The *ophiophagus* is a snake that eats other snakes."

"I hope it will eat all yours," she said, absently shifting the lamp. "But how does it get the other snakes? By charming them, I suppose."

"That is just like you, dear," said the doctor, with an affectation of petulance. "You know how irritating to me is any allusion to that vulgar superstition about a snake's power of fascination."

The conversation was interrupted by a mighty cry, which rang through the silent house like the voice of a demon shouting in a tomb! Again and yet again it sounded, with terrible distinctness. They sprang to their feet, the man confused, the lady pale and speechless with fright. Almost before the echoes of the last cry had died away the doctor was out of the room, springing up the stairs two steps at a time. In the corridor in front of Brayton's chamber he met some servants who had come from the upper floor. Together they rushed at the door without knocking. It was unfastened and gave way. Brayton lay upon his stomach on the floor, dead. His head and arms were partly concealed under the foot rail of the bed. They pulled the body away, turning it upon the back. The face was daubed with blood and froth, the eyes were wide open, staring—a dreadful sight!

"Died in a fit," said the scientist, bending his knee and placing his hand upon the heart. While in that position, he chanced to look under the bed. "Good God!" he added, "how did this thing get in here?"

He reached under the bed, pulled out the snake and flung it, still coiled, to the center of the room, whence with a harsh, shuffling sound it slid across the polished floor till stopped by the wall, where it lay without motion. It was a stuffed snake; its eyes were two shoe buttons.

THE DEATH OF HALPIN FRAYSER

For by death is wrought greater change than hath
been shown. Whereas in general the spirit that
removed cometh back upon occasion, and is some-
times seen of those in flesh (appearing in the form of
the body it bore) yet it hath happened that the
veritable body without the spirit hath walked.
And it is attested of those encountering who have
lived to speak thereon that a lich so raised up hath
no natural affection, nor remembrance thereof,
but only hate. Also, it is known that some spirits
which in life were benign become by death evil
altogether.—*Hali*.

One dark night in midsummer a man waking from a dreamless sleep in a
forest lifted his head from the earth, and staring a few moments into the
blackness, said: "Catherine Larue." He said nothing more; no reason was
known to him why he should have said so much.

The man was Halpin Frayser. He lived in St. Helena, but
where he lives now is uncertain, for he is dead. One who practices
sleeping in the woods with nothing under him but the dry leaves and the
damp earth, and nothing over him but the branches from which the
leaves have fallen and the sky from which the earth has fallen, cannot
hope for great longevity, and Frayser had already attained the age of
thirty-two. There are persons in this world, millions of persons, and far
and away the best persons, who regard that as a very advanced age. They
are the children. To those who view the voyage of life from the port of
departure the bark that has accomplished any considerable distance
appears already in close approach to the farther shore. However, it is not
certain that Halpin Frayser came to his death by exposure.

He had been all day in the hills west of the Napa Valley, looking
for doves and such small game as was in season. Late in the afternoon it
had come on to be cloudy, and he had lost his bearings; and although he
had only to go always downhill—everywhere the way to safety when one
is lost—the absence of trails had so impeded him that he was overtaken
by night while still in the forest. Unable in the darkness to penetrate the
thickets of manzanita and other undergrowth, utterly bewildered and
overcome with fatigue, he had lain down near the root of a large
madroño and fallen into a dreamless sleep. It was hours later, in the very
middle of the night, that one of God's mysterious messengers, gliding
ahead of the incalculable host of his companions sweeping westward

with the dawn line, pronounced the awakening word in the ear of the sleeper, who sat upright and spoke, he knew not why, a name, he knew not whose.

Halpin Frayser was not much of a philosopher, nor a scientist. The circumstance that, waking from a deep sleep at night in the midst of a forest, he had spoken aloud a name that he had not in memory and hardly had in mind did not arouse an enlightened curiosity to investigate the phenomenon. He thought it odd, and with a little perfunctory shiver, as if in deference to a seasonal presumption that the night was chill, he lay down again and went to sleep. But his sleep was no longer dreamless.

He thought he was walking along a dusty road that showed white in the gathering darkness of a summer night. Whence and whither it led, and why he traveled it, he did not know, though all seemed simple and natural, as is the way in dreams; for in the Land Beyond the Bed surprises cease from troubling and the judgment is at rest. Soon he came to a parting of the ways; leading from the highway was a road less traveled, having the appearance, indeed, of having been long abandoned, because, he thought, it led to something evil; yet he turned into it without hesitation, impelled by some imperious necessity.

As he pressed forward he became conscious that his way was haunted by invisible existences whom he could not definitely figure to his mind. From among the trees on either side he caught broken and incoherent whispers in a strange tongue which yet he partly understood. They seemed to him fragmentary utterances of a monstrous conspiracy against his body and soul.

It was now long after nightfall, yet the interminable forest through which he journeyed was lit with a wan glimmer having no point of diffusion, for in its mysterious lumination nothing cast a shadow. A shallow pool in the guttered depression of an old wheel rut, as from a recent rain, met his eye with a crimson gleam. He stooped and plunged his hand into it. It stained his fingers; it was blood! Blood, he then observed, was about him everywhere. The weeds growing rankly by the roadside showed it in blots and splashes on their big, broad leaves. Patches of dry dust between the wheelways were pitted and spattered as with a red rain. Defiling the trunks of the trees were broad maculations of crimson, and blood dripped like dew from their foliage.

All this he observed with a terror which seemed not incompatible with the fulfillment of a natural expectation. It seemed to him that it was all in expiation of some crime which, though conscious of his guilt, he could not rightly remember. To the menaces and mysteries of his surroundings the consciousness was an added horror. Vainly he sought by tracing life backward in memory, to reproduce the moment of

his sin; scenes and incidents came crowding tumultuously into his mind, one picture effacing another, or commingling with it in confusion and obscurity, but nowhere could he catch a glimpse of what he sought. The failure augmented his terror; he felt as one who has murdered in the dark, not knowing whom nor why. So frightful was the situation—the mysterious light burned with so silent and awful a menace; the noxious plants, the trees that by common consent are invested with a melancholy or baleful character, so openly in his sight conspired against his peace; from overhead and all about came so audible and startling whispers and the sighs of creatures so obviously not of earth—that he could endure it no longer, and with a great effort to break some malign spell that bound his faculties to silence and inaction, he shouted with the full strength of his lungs! His voice broken, it seemed, into an infinite multitude of unfamiliar sounds, went babbling and stammering away into the distant reaches of the forest, died into silence, and all was as before. But he had made a beginning at resistance and was encouraged. He said:

"I will not submit unheard. There may be powers that are not malignant traveling this accursed road. I shall leave them a record and an appeal. I shall relate my wrongs, the persecutions that I endure—I, a helpless mortal, a penitent, an unoffending poet!" Halpin Frayser was a poet only as he was a penitent: in his dream.

Taking from his clothing a small red-leather pocketbook, one-half of which was leaved for memoranda, he discovered that he was without a pencil. He broke a twig from a bush, dipped it into a pool of blood and wrote rapidly. He had hardly touched the paper with the point of his twig when a low, wild peal of laughter broke out at a measureless distance away, and growing ever louder, seemed approaching ever nearer; a soulless, heartless, and unjoyous laugh, like that of the loon, solitary by the lakeside at midnight; a laugh which culminated in an unearthly shout close at hand, then died away by slow gradations, as if the accursed being that uttered it had withdrawn over the verge of the world whence it had come. But the man felt that this was not so—that it was near by and had not moved.

A strange sensation began slowly to take possession of his body and his mind. He could not have said which, if any, of his senses was affected; he felt it rather as a consciousness—a mysterious mental assurance of some overpowering presence—some supernatural malevolence different in kind from the invisible existences that swarmed about him, and superior to them in power. He knew that it had uttered that hideous laugh. And now it seemed to be approaching him; from what direction he did not know—dared not conjecture. All his former fears were forgotten or merged in the gigantic terror that now held him in thrall. Apart from that, he had but one thought: to complete his written

appeal to the benign powers who, traversing the haunted wood, might some time rescue him if he should be denied the blessing of annihilation. He wrote with terrible rapidity, the twig in his fingers rilling blood without renewal; but in the middle of a sentence his hands denied their service to his will, his arms fell to his sides, the book to the earth; and powerless to move or cry out, he found himself staring into the sharply drawn face and blank, dead eyes of his own mother, standing white and silent in the garments of the grave!

■

In his youth Halpin Frayser had lived with his parents in Nashville, Tennessee. The Fraysers were well-to-do, having a good position in such society as had survived the wreck wrought by civil war. Their children had the social and educational opportunities of their time and place, and had responded to good associations and instruction with agreeable manners and cultivated minds. Halpin being the youngest and not over robust was perhaps a trifle "spoiled." He had the double disadvantage of a mother's assiduity and a father's neglect. Frayser *père* was what no Southern man of means is not—a politician. His country, or rather his section and State, made demands upon his time and attention so exacting that to those of his family he was compelled to turn an ear partly deafened by the thunder of the political captains and the shouting, his own included.

Young Halpin was of a dreamy, indolent and rather romantic turn, somewhat more addicted to literature than law, the profession to which he was bred. Among those of his relations who professed the modern faith of heredity it was well understood that in him the character of the late Myron Bayne, a maternal great-grandfather, had revisited the glimpses of the moon—by which orb Bayne had in his lifetime been sufficiently affected to be a poet of no small Colonial distinction. If not specially observed, it was observable that while a Frayser who was not the proud possessor of a sumptuous copy of the ancestral "poetical works" (printed at the family expense, and long ago withdrawn from an inhospitable market) was a rare Frayser indeed, there was an illogical indisposition to honor the great deceased in the person of his spiritual successor. Halpin was pretty generally deprecated as an intellectual black sheep who was likely at any moment to disgrace the flock by bleating in meter. The Tennessee Fraysers were a practical folk—not practical in the popular sense of devotion to sordid pursuits, but having a robust contempt for any qualities unfitting a man for the wholesome vocation of politics.

In justice to young Halpin it should be said that while in him were pretty faithfully reproduced most of the mental and moral characteristics ascribed by history and family tradition to the famous Colonial

bard, his succession to the gift and faculty divine was purely inferential. Not only had he never been known to court the muse, but in truth he could not have written correctly a line of verse to save himself from the Killer of the Wise. Still, there was no knowing when the dormant faculty might wake and smite the lyre.

In the meantime the young man was rather a loose fish, anyhow. Between him and his mother was the most perfect sympathy, for secretly the lady was herself a devout disciple of the late and great Myron Bayne, though with the tact so generally and justly admired in her sex (despite the hardy calumniators who insist that it is essentially the same thing as cunning) she had always taken care to conceal her weakness from all eyes but those of him who shared it. Their common guilt in respect of that was an added tie between them. If in Halpin's youth his mother had "spoiled" him, he had assuredly done his part toward being spoiled. As he grew to such manhood as is attainable by a Southerner who does not care which way elections go the attachment between him and his beautiful mother—whom from early childhood he called Katy—became yearly stronger and more tender. In these two romantic natures was manifest in a signal way that neglected phenomenon, the dominance of the sexual element in all the relations of life, strengthening, softening, and beautifying even those of consanguinity. The two were nearly inseparable, and by strangers observing their manner were not infrequently mistaken for lovers.

Entering his mother's boudoir one day Halpin Frayser kissed her upon the forehead, toyed for a moment with a lock of her dark hair which had escaped from its confining pins, and said, with an obvious effort at calmness:

"Would you greatly mind, Katy, if I were called away to California for a few weeks?"

It was hardly needful for Katy to answer with her lips a question to which her telltale cheeks had made instant reply. Evidently she would greatly mind; and the tears, too, sprang into her large brown eyes as corroborative testimony.

"Ah, my son," she said, looking up into his face with infinite tenderness, "I should have known that this was coming. Did I not lie awake a half of the night weeping because, during the other half, Grandfather Bayne had come to me in a dream, and standing by his portrait—young, too, and handsome as that—pointed to yours on the same wall? And when I looked it seemed that I could not see the features; you had been painted with a face cloth, such as we put upon the dead. Your father has laughed at me, but you and I, dear, know that such things are not for nothing. And I saw below the edge of the cloth the marks of hands on your throat—forgive me, but we have not been used to keep

such things from each other. Perhaps you have another interpretation. Perhaps it does not mean that you will go to California. Or maybe you will take me with you?"

It must be confessed that this ingenious interpretation of the dream in the light of newly discovered evidence did not wholly commend itself to the son's more logical mind; he had, for the moment at least, a conviction that it foreshadowed a more simple and immediate, if less tragic, disaster than a visit to the Pacific Coast. It was Halpin Frayser's impression that he was to be garroted on his native heath.

"Are there not medical springs in California?" Mrs. Frayser resumed before he had time to give her the true reading of the dream— "places where one recovers from rheumatism and neuralgia? Look—my fingers feel so stiff; and I am almost sure they have been giving me great pain while I slept."

She held out her hands for his inspection. What diagnosis of her case the young man may have thought it best to conceal with a smile the historian is unable to state, but for himself he feels bound to say that fingers looking less stiff, and showing fewer evidences of even insensible pain, have seldom been submitted for medical inspection by even the fairest patient desiring a prescription of unfamiliar scenes.

The outcome of it was that of these two odd persons having equally odd notions of duty, the one went to California, as the interest of his client required, and the other remained at home in compliance with a wish that her husband was scarcely conscious of entertaining.

While in San Francisco Halpin Frayser was walking one dark night along the water front of the city, when, with a suddenness that surprised and disconcerted him, he became a sailor. He was in fact "shanghaied" aboard a gallant, gallant ship, and sailed for a far countree. Nor did his misfortunes end with the voyage; for the ship was cast ashore on an island of the South Pacific, and it was six years afterward when the survivors were taken off by a venturesome trading schooner and brought back to San Francisco.

Though poor in purse, Frayser was no less proud in spirit than he had been in the years that seemed ages and ages ago. He would accept no assistance from strangers, and it was while living with a fellow survivor near the town of St. Helena, awaiting news and remittances from home, that he had gone gunning and dreaming.

■

The apparition confronting the dreamer in the haunted wood— the thing so like, yet so unlike his mother—was horrible! It stirred no love nor longing in his heart; it came unattended with pleasant memories of a golden past—inspired no sentiment of any kind; all the finer emotions were swallowed up in fear. He tried to turn and run from before

it, but his legs were as lead; he was unable to lift his feet from the ground. His arms hung helpless at his sides; of his eyes only he retained control, and these he dared not remove from the lusterless orbs of the apparition, which he knew was not a soul without a body, but that most dreadful of all existences infesting that haunted wood—a body without a soul! In its blank stare was neither love, nor pity, nor intelligence—nothing to which to address an appeal for mercy. "An appeal will not lie," he thought, with an absurd reversion to professional slang, making the situation more horrible, as the fire of a cigar might light up a tomb.

For a time, which seemed so long that the world grew gray with age and sin, and the haunted forest, having fulfilled its purpose in this monstrous culmination of its terrors, vanished out of his consciousness with all its sights and sounds, the apparition stood within a pace, regarding him with the mindless malevolence of a wild brute; then thrust its hands forward and sprang upon him with appalling ferocity! The act released his physical energies without unfettering his will; his mind was still spellbound, but his powerful body and agile limbs, endowed with a blind, insensate life of their own, resisted stoutly and well. For an instant he seemed to see this unnatural contest between a dead intelligence and a breathing mechanism only as a spectator—such fancies are in dreams; then he regained his identity almost as if by a leap forward into his body, and the straining automaton had a directing will as alert and fierce as that of its hideous antagonist.

But what mortal can cope with a creature of his dream? The imagination creating the enemy is already vanquished; the combat's result is the combat's cause. Despite his struggles—despite his strength and activity, which seemed wasted in a void, he felt the cold fingers close upon his throat. Borne backward to the earth, he saw above him the dead and drawn face within a hand's breadth of his own, and then all was black. A sound as of the beating of distant drums—a murmur of swarming voices, a sharp, far cry signing all to silence, and Halpin Frayser dreamed that he was dead.

■

A warm, clear night had been followed by a morning of drenching fog. At about the middle of the afternoon of the preceding day a little whiff of light vapor—a mere thickening of the atmosphere, the ghost of a cloud—had been observed clinging to the western side of Mount St. Helena, away up along the barren altitudes near the summit. It was so thin, so diaphanous, so like a fancy made visible, that one would have said: "Look quickly! in a moment it will be gone."

In a moment it was visibly larger and denser. While with one edge it clung to the mountain, with the other it reached farther and farther out into the air above the lower slopes. At the same time it

extended itself to north and south, joining small patches of mist that appeared to come out of the mountainside on exactly the same level, with an intelligent design to be absorbed. And so it grew and grew until the summit was shut out of view from the valley, and over the valley itself was an ever-extending canopy, opaque and gray. At Calistoga, which lies near the head of the valley and the foot of the mountain, there were a starless night and a sunless morning. The fog, sinking into the valley, had reached southward, swallowing up ranch after ranch, until it had blotted out the town of St. Helena, nine miles away. The dust in the road was laid; trees were adrip with moisture; birds sat silent in their coverts; the morning light was wan and ghastly, with neither color nor fire.

Two men left the town of St. Helena at the first glimmer of dawn, and walked along the road northward up the valley toward Calistoga. They carried guns on their shoulders, yet no one having knowledge of such matters could have mistaken them for hunters of bird or beast. They were a deputy sheriff from Napa and a detective from San Francisco—Holker and Jaralson, respectively. Their business was man-hunting.

"How far is it?" inquired Holker, as they strode along, their feet stirring white the dust beneath the damp surface of the road.

"The White Church? Only a half mile farther," the other answered. "By the way," he added, "it is neither white nor a church; it is an abandoned schoolhouse, gray with age and neglect. Religious services were once held in it—when it was white, and there is a graveyard that would delight a poet. Can you guess why I sent for you, and told you to come heeled?"

"Oh, I never bothered you about things of that kind. I've always found you communicative when the time came. But if I may hazard a guess, you want me to help you arrest one of the corpses in the graveyard."

"You remember Branscom?" said Jaralson, treating his companion's wit with the inattention that it deserved.

"The chap who cut his wife's throat? I ought; I wasted a week's work on him and had my expenses for my trouble. There is a reward of five hundred dollars, but none of us ever got a sight of him. You don't mean to say—"

"Yes, I do. He has been under the noses of you fellows all the time. He comes by night to the old graveyard at the White Church."

"The devil! That's where they buried his wife."

"Well, you fellows might have had sense enough to suspect that he would return to her grave some time."

"The very last place that anyone would have expected him to return to."

"But you had exhausted all the other places. Learning your failure at them, I 'laid for him' there."

"And you found him?"

"Damn it! he found *me*. The rascal got the drop on me—regularly held me up and made me travel. It's God's mercy that he didn't go through me. Oh, he's a good one, and I fancy the half of that reward is enough for me if you're needy."

Holker laughed good humoredly, and explained that his creditors were never more importunate.

"I wanted merely to show you the ground, and arrange a plan with you," the detective explained. "I thought it as well for us to be heeled, even in daylight."

"The man must be insane," said the deputy sheriff. "The reward is for his capture and conviction. If he's mad he won't be convicted."

Mr. Holker was so profoundly affected by that possible failure of justice that he involuntarily stopped in the middle of the road, then resumed his walk with abated zeal.

"Well, he looks it," assented Jaralson. "I'm bound to admit that a more unshaven, unshorn, unkempt, and uneverything wretch I never saw outside the ancient and honorable order of tramps. But I've gone in for him, and can't make up my mind to let go. There's glory in it for us, anyhow. Not another soul knows that he is this side of the Mountains of the Moon."

"All right," Holker said; "we will go and view the ground" and he added, in the words of a once favorite inscription for tombstones: "'where you must shortly lie'—I mean, if old Branscom ever gets tired of you and your impertinent intrusion. By the way, I heard the other day that 'Branscom' was not his real name."

"What is?"

"I can't recall it. I had lost all interest in the wretch, and it did not fix itself in my memory— something like Pardee. The woman whose throat he had the bad taste to cut was a widow when he met her. She had come to California to look up some relatives—there are persons who will do that sometimes. But you know all that."

"Naturally."

"But not knowing the right name, by what happy inspiration did you find the right grave? The man who told me what the name was said it had been cut on the headboard."

"I don't know the right grave." Jaralson was apparently a trifle reluctant to admit his ignorance of so important a point of his plan. "I have been watching about the place generally. A part of our work this morning will be to identify that grave. Here is the White Church."

For a long distance the road had been bordered by fields on

both sides, but now on the left there was a forest of oaks, madroños, and gigantic spruces whose lower parts only could be seen, dim and ghostly in the fog. The undergrowth was, in places, thick, but nowhere impenetrable. For some moments Holker saw nothing of the building, but as they turned into the woods it revealed itself in faint gray outline through the fog, looking huge and far away. A few steps more, and it was within an arm's length, distinct, dark with moisture, and insignificant in size. It had the usual country-schoolhouse form—belonged to the packingbox order of architecture; had an underpinning of stones, a moss-grown roof, and blank window spaces, whence both glass and sash had long departed. It was ruined, but not a ruin—a typical Californian substitute for what are known to guide-bookers abroad as "monuments of the past." With scarcely a glance at this uninteresting structure Jaralson moved on into the dripping undergrowth beyond.

"I will show you where he held me up," he said. "This is the graveyard."

Here and there among the bushes were small inclosures containing graves, sometimes no more than one. They were recognized as graves by the discolored stones or rotting boards at head and foot, leaning at all angles, some prostrate; by the ruined picket fences surrounding them; or, infrequently, by the mound itself showing its gravel through the fallen leaves. In many instances nothing marked the spot where lay the vestiges of some poor mortal—who, leaving "a large circle of sorrowing friends," had been left by them in turn—except a depression in the earth, more lasting than that in the spirits of the mourners. The paths, if any paths had been, were long obliterated; trees of a considerable size had been permitted to grow up from the graves and thrust aside with root or branch the inclosing fences. Over all was that air of abandonment and decay which seems nowhere so fit and significant as in a village of the forgotten dead.

As the two men, Jaralson leading, pushed their way through the growth of young trees, that enterprising man suddenly stopped and brought up his shotgun to the height of his breast, uttered a low note of warning, and stood motionless, his eyes fixed upon something ahead. As well as he could, obstructed by brush, his companion, though seeing nothing, imitated the posture and so stood, prepared for what might ensue. A moment later Jaralson moved cautiously forward, the other following.

Under the branches of an enormous spruce lay the dead body of a man. Standing silent above it they noted such particulars as first strike the attention—the face, the attitude, the clothing; whatever most promptly and plainly answers the unspoken question of a sympathetic curiosity.

The body lay upon its back, the legs wide apart. One arm was thrust upward, the other outward; but the latter was bent acutely, and the hand was near the throat. Both hands were tightly clenched. The whole attitude was that of desperate but ineffectual resistance to—what?

Near by lay a shotgun and a game bag through the meshes of which was seen the plumage of shot birds. All about were evidences of a furious struggle; small sprouts of poison-oak were bent and denuded of leaf and bark; dead and rotting leaves had been pushed into heaps and ridges on both sides of the legs by the action of other feet than theirs; alongside the hips were unmistakable impressions of human knees.

The nature of the struggle was made clear by a glance at the dead man's throat and face. While breast and hands were white, those were purple—almost black. The shoulders lay upon a low mound, and the head was turned back at an angle otherwise impossible, the expanded eyes staring blankly backward in a direction opposite to that of the feet. From the froth filling the open mouth the tongue protruded, black and swollen. The throat showed horrible contusions; not mere fingermarks, but bruises and lacerations wrought by two strong hands that must have buried themselves in the yielding flesh, maintaining their terrible grasp until long after death. Breast, throat, face, were wet; the clothing was saturated; drops of water, condensed from the fog, studded the hair and mustache.

All this the two men observed without speaking—almost at a glance. Then Holker said:

"Poor devil! he had a rough deal."

Jaralson was making a vigilant circumspection of the forest, his shotgun held in both hands and at full cock, his finger upon the trigger.

"The work of a maniac," he said, without withdrawing his eyes from the inclosing wood. "It was done by Branscom—Pardee."

Something half hidden by the disturbed leaves on the earth caught Holker's attention. It was a red-leather pocketbook. He picked it up and opened it. It contained leaves of white paper for memoranda, and upon the first leaf was the name Halpin Frayser." Written in red on several succeeding leaves—scrawled as if in haste and barely legible—were the following lines, which Holker read aloud, while his companion continued scanning the dim gray confines of their narrow world and hearing matter of apprehension in the drip of water from every burdened branch:

"Enthralled by some mysterious spell, I stood
In the lit gloom of an enchanted wood.

The cypress there and myrtle twined their
 boughs,
Significant, in baleful brotherhood.

"The brooding willow whispered to the yew;
Beneath, the deadly nightshade and the rue,
 With immortelles self-woven into strange
Funereal shapes, and horrid nettles grew.

"No song of bird nor any drone of bees,
Nor light leaf lifted by the wholesome breeze:
 The air was stagnant all, and Silence was
A living thing that breathed among the trees.

"Conspiring spirits whispered in the gloom,
Half-heard, the stilly secrets of the tomb.
 With blood the trees were all adrip; the leaves
Shone in the witch-light with a ruddy bloom.

"I cried aloud!—the spell, unbroken still,
Rested upon my spirit and my will.
 Unsouled, unhearted, hopeless and forlorn,
I strove with monstrous presages of ill!

"At last the viewless—"

Holker ceased reading; there was no more to read. The manu-
script broke off in the middle of a line.

"That sounds like Bayne," said Jaralson, who was something of
a scholar in his way. He had abated his vigilance and stood looking down
at the body.

"Who's Bayne?" Holker asked rather incuriously.

"Myron Bayne, a chap who flourished in the early years of the
nation—more than a century ago. Wrote mighty dismal stuff; I have his
collected works. That poem is not among them, but it must have been
omitted by mistake."

"It is cold," said Holker; "let us leave here; we must have up
the coroner from Napa."

Jaralson said nothing, but made a movement in compliance.
Passing the end of the slight elevation of earth upon which the dead man's

head and shoulders lay, his foot struck some hard substance under the rotting forest leaves, and he took the trouble to kick it into view. It was a fallen headboard, and painted on it were the hardly decipherable words, "Catherine Larue."

"Larue, Larue!" exclaimed Holker, with sudden animation. "Why, that is the real name of Branscom—not Pardee. And—bless my soul! how it all comes to me—the murdered woman's name had been Frayser!"

"There is some rascally mystery here," said Detective Jaralson. "I hate anything of that kind."

There came to them out of the fog—seemingly from a great distance—the sound of a laugh, a low, deliberate, soulless laugh, which had no more of joy than that of a hyena night-prowling in the desert; a laugh that rose by slow gradation, louder and louder, clearer, more distinct and terrible, until it seemed barely outside the narrow circle of their vision; a laugh so unnatural, so unhuman, so devilish, that it filled those hardy man-hunters with a sense of dread unspeakable! They did not move their weapons nor think of them; the menace of that horrible sound was not of the kind to be met with arms. As it had grown out of silence, so now it died away; from a culminating shout which had seemed almost in their ears, it drew itself away into the distance, until its failing notes, joyless and mechanical to the last, sank to silence at a measureless remove.

ONE SUMMER NIGHT

The fact that Henry Armstrong was buried did not seem to him to prove that he was dead; he had always been a hard man to convince. That he really was buried, the testimony of his senses compelled him to admit. His posture—flat upon his back, with his hands crossed upon his stomach and tied with something that he easily broke without profitably altering the situation—the strict confinement of his entire person, the black darkness and profound silence, made a body of evidence impossible to controvert and he accepted it without cavil.

But dead—no; he was only very, very ill. He had, withal, the invalid's apathy and did not greatly concern himself about the uncommon fate that had been allotted to him. No philosopher was he—just a plain, commonplace person gifted, for the time being, with a pathological indifference: the organ that he feared consequences with was torpid. So, with no particular apprehension for his immediate future, he fell asleep and all was peace with Henry Armstrong.

But something was going on overhead. It was a dark summer night, shot through with infrequent shimmers of lightning silently

firing a cloud lying low in the west and portending a storm. These brief, stammering illuminations brought out with ghastly distinctness the monuments and headstones of the cemetery and seemed to set them dancing. It was not a night in which any credible witness was likely to be straying about a cemetery, so the three men who were there, digging into the grave of Henry Armstrong, felt reasonably secure.

Two of them were young students from a medical college a few miles away; the third was a gigantic Negro known as Jess. For many years Jess had been employed about the cemetery as a man-of-all-work and it was his favorite pleasantry that he knew "every soul in the place." From the nature of what he was now doing it was inferable that the place was not so populous as its register may have shown it to be.

Outside the wall, at the part of the grounds farthest from the public road, were a horse and a light wagon, waiting.

The work of excavation was not difficult: the earth with which the grave had been loosely filled a few hours before offered little resistance and was soon thrown out. Removal of the casket from its box was less easy, but it was taken out, for it was a perquisite of Jess, who carefully unscrewed the cover and laid it aside, exposing the body in black trousers and white shirt. At that instant the air sprang to flame, a cracking shock of thunder shook the stunned world and Henry Armstrong tranquilly sat up. With inarticulate cries the men fled in terror, each in a different direction. For nothing on earth could two of them have been persuaded to return. But Jess was of another breed.

In the gray of the morning the two students, pallid and haggard from anxiety and with the terror of their adventure still beating tumultuously in their blood, met at the medical college.

"You saw it?" cried one.

"God! yes—what are we to do?"

They went around to the rear of the building, where they saw a horse, attached to a light wagon, hitched to a gatepost near the door of the dissecting-room. Mechanically they entered the room. On a bench in the obscurity sat the Negro Jess. He rose, grinning, all eyes and teeth.

"I'm waiting for my pay," he said.

Stretched naked on a long table lay the body of Henry Armstrong, the head defiled with blood and clay from a blow with a spade.

THE MOONLIT ROAD

Statement of Joel Hetman, Jr.

I am the most unfortunate of men. Rich, respected, fairly well educated and of sound health—with many other advantages usually valued by

those having them and coveted by those who have them not—I some-
times think that I should be less unhappy if they had been denied me, for
then the contrast between my outer and my inner life would not be
continually demanding a painful attention. In the stress of privation and
the need of effort I might sometimes forget the somber secret ever
baffling the conjecture that it compels.

I am the only child of Joel and Julia Hetman. The one was a
well-to-do country gentleman, the other a beautiful and accomplished
woman to whom he was passionately attached with what I now know to
have been a jealous and exacting devotion. The family home was a few
miles from Nashville, Tennessee, a large, irregularly built dwelling of no
particular order of architecture, a little way off the road, in a park of trees
and shrubbery.

At the time of which I write I was nineteen years old, a student
at Yale. One day I received a telegram from my father of such urgency
that in compliance with its unexplained demand I left at once for home.
At the railway station in Nashville a distant relative awaited me to
apprise me of the reason for my recall: my mother had been barbarously
murdered—why and by whom none could conjecture, but the circum-
stances were these:

My father had gone to Nashville, intending to return the next
afternoon. Something prevented his accomplishing the business in
hand, so he returned on the same night, arriving just before the dawn. In
his testimony before the coroner he explained that having no latchkey
and not caring to disturb the sleeping servants, he had, with no clearly
defined intention, gone round to the rear of the house. As he turned an
angle of the building, he heard a sound as of a door gently closed, and saw
in the darkness, indistinctly, the figure of a man, which instantly disap-
peared among the trees of the lawn. A hasty pursuit and brief search of
the grounds in the belief that the trespasser was some one secretly
visiting a servant proving fruitless, he entered at the unlocked door and
mounted the stairs to my mother's chamber. Its door was open, and
stepping into black darkness he fell headlong over some heavy object on
the floor. I may spare myself the details; it was my poor mother, dead of
strangulation by human hands!

Nothing had been taken from the house, the servants had
heard no sound, and excepting those terrible finger-marks upon the dead
woman's throat—dear God! that I might forget them!—no trace of the
assassin was ever found.

I gave up my studies and remained with my father, who,
naturally, was greatly changed. Always of a sedate, taciturn disposition,
he now fell into so deep a dejection that nothing could hold his atten-
tion, yet anything—a footfall, the sudden closing of a door—aroused in

him a fitful interest; one might have called it an apprehension. At any small surprise of the senses he would start visibly and sometimes turn pale, then relapse into a melancholy apathy deeper than before. I suppose he was what is called a "nervous wreck." As to me, I was younger then than now—there is much in that. Youth is Gilead, in which is balm for every wound. Ah, that I might again dwell in that enchanted land! Unacquainted with grief, I knew not how to appraise my bereavement; I could not rightly estimate the strength of the stroke.

One night, a few months after the dreadful event, my father and I walked home from the city. The full moon was about three hours above the eastern horizon; the entire countryside had the solemn stillness of a summer night; our footfalls and the ceaseless song of the katydids were the only sound aloof. Black shadows of bordering trees lay athwart the road, which, in the short reaches between, gleamed a ghostly white. As we approached the gate to our dwelling, whose front was in shadow, and in which no light shone, my father suddenly stopped and clutched my arm, saying, hardly above his breath:

"God! God! what is that?"

"I hear nothing," I replied.

"But see—see!" he said, pointing along the road, directly ahead.

I said: "Nothing is there. Come, father, let us go in—you are ill."

He had released my arm and was standing rigid and motionless in the center of the illuminated roadway, staring like one bereft of sense. His face in the moonlight showed a pallor and fixity inexpressibly distressing. I pulled gently at his sleeve, but he had forgotten my existence. Presently he began to retire backward, step by step, never for an instant removing his eyes from what he saw, or thought he saw. I turned half round to follow, but stood irresolute. I do not recall any feeling of fear, unless a sudden chill was its physical manifestation. It seemed as if an icy wind had touched my face and enfolded my body from head to foot; I could feel the stir of it in my hair.

At that moment my attention was drawn to a light that suddenly streamed from an upper window of the house: one of the servants, awakened by what mysterious premonition of evil who can say, and in obedience to an impulse that she was never able to name, had lit a lamp. When I turned to look for my father he was gone, and in all the years that have passed no whisper of his fate has come across the borderland of conjecture from the realm of the unknown.

Statement of Caspar Grattan

To-day I am said to live; to-morrow, here in this room, will lie a senseless shape of clay that all too long was I. If anyone lift the cloth from the face of that unpleasant thing it will be in gratification of a mere morbid curiosity. Some, doubtless, will go further and inquire, "Who was he?" In this writing I supply the only answer that I am able to make—Caspar Grattan. Surely, that should be enough. The name has served my small need for more than twenty years of a life of unknown length. True, I gave it to myself, but lacking another I had the right. In this world one must have a name; it prevents confusion, even when it does not establish identity. Some, though, are known by numbers, which also seem inadequate distinctions.

One day, for illustration, I was passing along a street of a city, far from here, when I met two men in uniform, one of whom, half pausing and looking curiously into my face, said to his companion, "That man looks like 767." Something in the number seemed familiar and horrible. Moved by an uncontrollable impulse, I sprang into a side street and ran until I fell exhausted in a country lane.

I have never forgotten that number, and always it comes to memory attended by gibbering obscenity, peals of joyless laughter, the clang of iron doors. So I say a name, even if self-bestowed, is better than a number. In the register of the potter's field I shall soon have both. What wealth!

Of him who shall find this paper I must beg a little consideration. It is not the history of my life; the knowledge to write that is denied me. This is only a record of broken and apparently unrelated memories, some of them as distinct and sequent as brilliant beads upon a thread, others remote and strange, having the character of crimson dreams with interspaces blank and black—witch-fires glowing still and red in a great desolation.

Standing upon the shore of eternity, I turn for a last look landward over the course by which I came. There are twenty years of footprints fairly distinct, the impressions of bleeding feet. They lead through poverty and pain, devious and unsure, as of one staggering beneath a burden—

Remote, unfriended, melancholy, slow.

Ah, the poet's prophecy of Me—how admirable, how dreadfully admirable!

Backward beyond the beginning of this *via dolorosa*—this epic

of suffering with episodes of sin—I see nothing clearly; it comes out of a cloud. I know that it spans only twenty years, yet I am an old man.

One does not remember one's birth—one has to be told. But with me it was different; life came to me full-handed and dowered me with all my faculties and powers. Of a previous existence I know no more than others, for all have stammering intimations that may be memories and may be dreams. I know only that my first consciousness was of maturity in body and mind—a consciousness accepted without surprise or conjecture. I merely found myself walking in a forest, half-clad, foot-sore, unutterably weary and hungry. Seeing a farmhouse, I approached and asked for food, which was given me by one who inquired my name. I did not know, yet knew that all had names. Greatly embarrassed, I retreated, and night coming on, lay down in the forest and slept.

The next day I entered a large town which I shall not name. Nor shall I recount further incidents of the life that is now to end—a life of wandering, always and everywhere haunted by an overmastering sense of crime in punishment of wrong and of terror in punishment of crime. Let me see if I can reduce it to narrative.

I seem once to have lived near a great city, a prosperous planter, married to a woman whom I loved and distrusted. We had, it sometimes seems, one child, a youth of brilliant parts and promise. He is at all times a vague figure, never clearly drawn, frequently altogether out of the picture.

One luckless evening it occurred to me to test my wife's fidelity in a vulgar, commonplace way familiar to everyone who has acquaint-ance with the literature of fact and fiction. I went to the city, telling my wife that I should be absent until the following afternoon. But I returned before daybreak and went to the rear of the house, purposing to enter by a door with which I had secretly so tampered that it would seem to lock, yet not actually fasten. As I approached it, I heard it gently open and close, and saw a man steal away into the darkness. With murder in my heart, I sprang after him, but he had vanished without even the bad luck of identification. Sometimes now I cannot even persuade myself that it was a human being.

Crazed with jealousy and rage, blind and bestial with all the elemental passions of insulted manhood, I entered the house and sprang up the stairs to the door of my wife's chamber. It was closed, but having tampered with its lock also, I easily entered and despite the black darkness soon stood by the side of her bed. My groping hands told me that although disarranged it was unoccupied.

"She is below," I thought, "and terrified by my entrance has evaded me in the darkness of the hall."

With the purpose of seeking her I turned to leave the room, but took a wrong direction—the right one! My foot struck her, cowering in a corner of the room. Instantly my hands were at her throat, stifling a shriek, my knees were upon her struggling body; and there in the darkness, without a word of accusation or reproach, I strangled her till she died!

There ends the dream. I have related it in the past tense, but the present would be the fitter form, for again and again the somber tragedy reenacts itself in my consciousness—over and over I lay the plan, I suffer the confirmation, I redress the wrong. Then all is blank; and afterward the rains beat against the grimy window-panes, or the snows fall upon my scant attire, the wheels rattle in the squalid streets where my life lies in poverty and mean employment. If there is ever sunshine I do not recall it; if there are birds they do not sing.

There is another dream, another vision of the night. I stand among the shadows in a moonlit road. I am aware of another presence, but whose I cannot rightly determine. In the shadow of a great dwelling I catch the gleam of white garments; then the figure of a woman confronts me in the road—my murdered wife! There is death in the face; there are marks upon the throat. The eyes are fixed on mine with an infinite gravity which is not reproach, nor hate, nor menace, nor anything less terrible than recognition. Before this awful apparition I retreat in terror—a terror that is upon me as I write. I can no longer rightly shape the words. See! they—

Now I am calm, but truly there is no more to tell: the incident ends where it began—in darkness and in doubt.

Yes, I am again in control of myself: "the captain of my soul." But that is not respite; it is another stage and phase of expiation. My penance, constant in degree, is mutable in kind: one of its variants is tranquillity. After all, it is only a life-sentence. "To Hell for life"—that is a foolish penalty: the culprit chooses the duration of his punishment. To-day my term expires.

To each and all, the peace that was not mine.

Statement of the Late Julia Hetman, Through the Medium Bayrolles

I had retired early and fallen almost immediately into a peaceful sleep, from which I awoke with that indefinable sense of peril which is, I think, a common experience in that other, earlier life. Of its unmeaning character, too, I was entirely persuaded, yet that did not banish it. My hus-

band, Joel Hetman, was away from home; the servants slept in another part of the house. But these were familiar conditions; they had never before distressed me. Nevertheless, the strange terror grew so insupportable that conquering my reluctance to move I sat up and lit the lamp at my bedside. Contrary to my expectation this gave me no relief; the light seemed rather an added danger, for I reflected that it would shine out under the door, disclosing my presence to whatever evil thing might lurk outside. You that are still in the flesh, subject to horrors of the imagination, think what a monstrous fear that must be which seeks in darkness security from malevolent existences of the night. That is to spring to close quarters with an unseen enemy—the strategy of despair!

Extinguishing the lamp I pulled the bedclothing about my head and lay trembling and silent, unable to shriek, forgetful to pray. In this pitiable state I must have lain for what you call hours—with us there are no hours, there is no time.

At last it came—a soft, irregular sound of footfalls on the stairs! They were slow, hesitant, uncertain, as of something that did not see its way; to my disordered reason all the more terrifying for that, as the approach of some blind and mindless malevolence to which is no appeal. I even thought that I must have left the hall lamp burning and the groping of this creature proved it a monster of the night. This was foolish and inconsistent with my previous dread of the light, but what would you have? Fear has no brains; it is an idiot. The dismal witness that it bears and the cowardly counsel that it whispers are unrelated. We know this well, we who have passed into the Realm of Terror, who skulk in eternal dusk among the scenes of our former lives, invisible even to ourselves and one another, yet hiding forlorn in lonely places; yearning for speech with our loved ones, yet dumb, and as fearful of them as they of us. Sometimes the disability is removed, the law suspended: by the deathless power of love or hate we break the spell—we are seen by those whom we would warn, console, or punish. What form we seem to them to bear we know not; we know only that we terrify even those whom we most wish to comfort, and from whom we most crave tenderness and sympathy.

Forgive, I pray you, this inconsequent digression by what was once a woman. You who consult us in this imperfect way—you do not understand. You ask foolish questions about things unknown and things forbidden. Much that we know and could impart in our speech is meaningless in yours. We must communicate with you through a stammering intelligence in that small fraction of our language that you yourselves can speak. You think that we are of another world. No, we have knowledge of no world but yours, though for us it holds no sun-

light, no warmth, no music, no laughter, no song of birds, nor any companionship. O God! what a thing it is to be a ghost, cowering and shivering in an altered world, a prey to apprehension and despair!

No, I did not die of fright: the Thing turned and went away. I heard it go down the stairs, hurriedly, I thought, as if itself in sudden fear. Then I rose to call for help. Hardly had my shaking hand found the doorknob when—merciful heaven!—I heard it returning. Its footfalls as it remounted the stairs were rapid, heavy and loud; they shook the house. I fled to an angle of the wall and crouched upon the floor. I tried to pray. I tried to call the name of my dear husband. Then I heard the door thrown open. There was an interval of unconsciousness, and when I revived I felt a strangling clutch upon my throat—felt my arms feebly beating against something that bore me backward—felt my tongue thrusting itself from between my teeth! And then I passed into this life.

No, I have no knowledge of what it was. The sum of what we knew at death is the measure of what we know afterward of all that went before. Of this existence we know many things, but no new light falls upon any page of that; in memory is written all of it that we can read. Here are no heights of truth overlooking the confused landscape of that dubitable domain. We still dwell in the Valley of the Shadow, lurk in its desolate places, peering from brambles and thickets at its mad, malign inhabitants. How should we have new knowledge of that fading past?

What I am about to relate happened on a night. We know when it is night, for then you retire to your houses and we can venture from our places of concealment to move unafraid about our old homes, to look in at the windows, even to enter and gaze upon your faces as you sleep. I had lingered long near the dwelling where I had been so cruelly changed to what I am, as we do while any that we love or hate remain. Vainly I had sought some method of manifestation, some way to make my continued existence and my great love and poignant pity understood by my husband and son. Always if they slept they would wake, or if in my desperation I dared approach them when they were awake, would turn toward me the terrible eyes of the living, frightening me by the glances that I sought from the purpose that I held.

On this night I had searched for them without success, fearing to find them; they were nowhere in the house, nor about the moonlit lawn. For, although the sun is lost to us forever, the moon, full-orbed or slender, remains to us. Sometimes it shines by night, sometimes by day, but always it rises and sets, as in that other life.

I left the lawn and moved in the white light and silence along the road, aimless and sorrowing. Suddenly I heard the voice of my poor husband in exclamations of astonishment, with that of my son in reassurance and dissuasion; and there by the shadow of a group of trees they

stood—near, so near! Their faces were toward me, the eyes of the elder man fixed upon mine. He saw me—at last, at last, he saw me! In the consciousness of that, my terror fled as a cruel dream. The deathspell was broken: Love had conquered Law! Mad with exultation I shouted—I *must* have shouted, "He sees, he sees: he will understand!" Then, controlling myself, I moved forward, smiling and consciously beautiful, to offer myself to his arms, to comfort him with endearments, and, with my son's hand in mine, to speak words that should restore the broken bonds between the living and the dead.

Alas! alas! his face went white with fear, his eyes were as those of a hunted animal. He backed away from me, as I advanced, and at last turned and fled into the wood—whither, it is not given to me to know.

To my poor boy, left doubly desolate, I have never been able to impart a sense of my presence. Soon he, too, must pass to this Life Invisible and be lost to me forever.

MOXON'S MASTER

"Are you serious?—do you really believe that a machine thinks?"

I got no immediate reply; Moxon was apparently intent upon the coals in the grate, touching them deftly here and there with the firepoker till they signified a sense of his attention by a brighter glow. For several weeks I had been observing in him a growing habit of delay in answering even the most trivial of commonplace questions. His air, however, was that of preoccupation rather than deliberation: one might have said that he had "something on his mind."

Presently he said:

"What is a 'machine'? The word has been variously defined. Here is one definition from a popular dictionary: 'Any instrument or organization by which power is applied and made effective, or a desired effect produced.' Well, then, is not a man a machine? And you will admit that he thinks—or thinks he thinks."

"If you do not wish to answer my question," I said, rather testily, "why not say so?—all that you say is mere evasion. You know well enough that when I say 'machine' I do not mean a man, but something that man has made and controls."

"When it does not control him," he said, rising abruptly and looking out of a window, whence nothing was visible in the blackness of a stormy night. A moment later he turned about and with a smile said: "I beg your pardon; I had no thought of evasion. I considered the dictionary man's unconscious testimony suggestive and worth something in the discussion. I can give your question a direct answer easily enough: I do believe that a machine thinks about the work that it is doing."

That was direct enough, certainly. It was not altogether pleasing, for it tended to confirm a sad suspicion that Moxon's devotion to study and work in his machine-shop had not been good for him. I knew, for one thing, that he suffered from insomnia, and that is no light affliction. Had it affected his mind? His reply to my question seemed to me then evidence that it had; perhaps I should think differently about it now. I was younger then, and among the blessings that are not denied to youth is ignorance. Incited by that great stimulant to controversy, I said:

"And what, pray, does it think with—in the absence of a brain?"

The reply, coming with less than his customary delay, took his favorite form of counter-interrogation:

"With what does a plant think—in the absence of a brain?"

"Ah, plants also belong to the philosopher class! I should be pleased to know some of their conclusions; you may omit the premises."

"Perhaps," he replied, apparently unaffected by my foolish irony, "you may be able to infer their convictions from their acts. I will spare you the familiar examples of the sensitive mimosa, the several insectivorous flowers and those whose stamens bend down and shake their pollen upon the entering bee in order that he may fertilize their distant mates. But observe this. In an open spot in my garden I planted a climbing vine. When it was barely above the surface I set a stake into the soil a yard away. The vine at once made for it, but as it was about to reach it after several days I removed it a few feet. The vine at once altered its course, making an acute angle, and again made for the stake. This manœuvre was repeated several times, but finally, as if discouraged, the vine abandoned the pursuit and ignoring further attempts to divert it traveled to a small tree, farther away, which it climbed.

"Roots of the eucalyptus will prolong themselves incredibly in search of moisture. A well-known horticulturist relates that one entered an old drain pipe and followed it until it came to a break, where a section of the pipe had been removed to make way for a stone wall that had been built across its course. The root left the drain and followed the wall until it found an opening where a stone had fallen out. It crept through and following the other side of the wall back to the drain, entered the unexplored part and resumed its journey."

"And all this?"

"Can you miss the significance of it? It shows the consciousness of plants. It proves that they think."

"Even if it did—what then? We were speaking, not of plants, but of machines. They may be composed partly of wood—wood that has no longer vitality—or wholly of metal. Is thought an attribute also of the mineral kingdom?"

"How else do you explain the phenomena, for example, of crystallization?"

"I do not explain them."

"Because you cannot without affirming what you wish to deny, namely, intelligent co-operation among the constituent elements of the crystals. When soldiers form lines, or hollow squares, you call it reason. When wild geese in flight take the form of a letter V you say instinct. When the homogeneous atoms of a mineral, moving freely in solution, arrange themselves into shapes mathematically perfect, or particles of frozen moisture into the symmetrical and beautiful forms of snowflakes, you have nothing to say. You have not even invented a name to conceal your heroic unreason."

Moxon was speaking with unusual animation and earnestness. As he paused I heard in an adjoining room known to me as his "machineshop," which no one but himself was permitted to enter, a singular thumping sound, as of some one pounding upon a table with an open hand. Moxon heard it at the same moment and, visibly agitated, rose and hurriedly passed into the room whence it came. I thought it odd that any one else should be in there, and my interest in my friend—with doubtless a touch of unwarrantable curiosity—led me to listen intently, though, I am happy to say, not at the keyhole. There were confused sounds, as of a struggle or scuffle; the floor shook. I distinctly heard hard breathing and a hoarse whisper which said "Damn you!" Then all was silent, and presently Moxon reappeared and said, with a rather sorry smile:

"Pardon me for leaving you so abruptly. I have a machine in there that lost its temper and cut up rough."

Fixing my eyes steadily upon his left cheek, which was traversed by four parallel excoriations showing blood, I said:

"How would it do to trim its nails?"

I could have spared myself the jest; he gave it no attention, but seated himself in the chair that he had left and resumed the interrupted monologue as if nothing had occurred:

"Doubtless you do not hold with those (I need not name them to a man of your reading) who have taught that all matter is sentient, that every atom is a living, feeling, conscious being. I do. There is no such thing as dead, inert matter: it is all alive; all instinct with force, actual and potential; all sensitive to the same forces in its environment and susceptible to the contagion of higher and subtler ones residing in such superior organisms as it may be brought into relation with. It absorbs something of his intelligence and purpose—more of them in proportion to the complexity of the resulting machine and that of its work.

"Do you happen to recall Herbert Spencer's definition of 'Life'?

I read it thirty years ago. He may have altered it afterward, for anything I know, but in all that time I have been unable to think of a single word that could profitably be changed or added or removed. It seems to me not only the best definition, but the only possible one.

"'Life,' he says, 'is a definite combination of heterogeneous changes, both simultaneous and successive, in correspondence with external coexistences and sequences.'"

"That defines the phenomenon," I said, "but gives no hint of its cause."

"That," he replied, "is all that any definition can do. As Mill points out, we know nothing of cause except as an antecedent—nothing of effect except as a consequent. Of certain phenomena, one never occurs without another, which is dissimilar: the first in point of time we call cause, the second, effect. One who had many times seen a rabbit pursued by a dog, and had never seen rabbits and dogs otherwise, would think the rabbit the cause of the dog.

"But I fear," he added, laughing naturally enough, "that my rabbit is leading me a long way from the track of my legitimate quarry: I'm indulging in the pleasure of the chase for its own sake. What I want you to observe is that in Herbert Spencer's definition of 'life' the activity of a machine is included—there is nothing in the definition that is not applicable to it. According to this sharpest of observers and deepest of thinkers, if a man during his period of activity is alive, so is a machine when in operation. As an inventor and constructor of machines I know that to be true."

Moxon was silent for a long time, gazing absently into the fire. It was growing late and I thought it time to be going, but somehow I did not like the notion of leaving him in that isolated house, all alone except for the presence of some person of whose nature my conjectures could go no further than that it was unfriendly, perhaps malign. Leaning toward him and looking earnestly into his eyes while making a motion with my hand through the door of his workshop, I said:

"Moxon, whom have you in there?"

Somewhat to my surprise he laughed lightly and answered without hesitation:

"Nobody; the incident that you have in mind was caused by my folly in leaving a machine in action with nothing to act upon, while I undertook the interminable task of enlightening your understanding. Do you happen to know that Consciousness is the creature of Rhythm?"

"O bother them both!" I replied, rising and laying hold of my overcoat. "I'm going to wish you good night; and I'll add the hope that the machine which you inadvertently left in action will have her gloves on the next time you think it needful to stop her."

Without waiting to observe the effect of my shot I left the house.

Rain was falling, and the darkness was intense. In the sky beyond the crest of a hill toward which I groped my way along precarious plank sidewalks and across miry, unpaved streets I could see the faint glow of the city's lights, but behind me nothing was visible but a single window of Moxon's house. It glowed with what seemed to me a mysterious and fateful meaning. I knew it was an uncurtained aperture in my friend's "machine-shop," and I had little doubt that he had resumed the studies interrupted by his duties as my instructor in mechanical consciousness and the fatherhood of Rhythm. Odd, and in some degree humorous, as his convictions seemed to me at that time, I could not wholly divest myself of the feeling that they had some tragic relation to his life and character—perhaps to his destiny—although I no longer entertained the notion that they were the vagaries of a disordered mind. Whatever might be thought of his views, his exposition of them was too logical for that. Over and over, his last words came back to me: "Consciousness is the creature of Rhythm." Bald and terse as the statement was, I now found it infinitely alluring. At each recurrence it broadened in meaning and deepened in suggestion. Why, here, (I thought) is something upon which to found a philosophy. If consciousness is the product of rhythm all things *are* conscious, for all have motion, and all motion is rhythmic. I wondered if Moxon knew the significance and breadth of his thought—the scope of this momentous generalization; or had he arrived at his philosophic faith by the tortuous and uncertain road of observation?

That faith was then new to me, and all Moxon's expounding had failed to make me a convert; but now it seemed as if a great light shone about me, like that which fell upon Saul of Tarsus; and out there in the storm and darkness and solitude I experienced what Lewes calls "the endless variety and excitement of philosophic thought." I exulted in a new sense of knowledge, a new pride of reason. My feet seemed hardly to touch the earth; it was as if I were uplifted and borne through the air by invisible wings.

Yielding to an impulse to seek further light from him whom I now recognized as my master and guide, I had unconsciously turned about, and almost before I was aware of having done so found myself again at Moxon's door. I was drenched with rain, but felt no discomfort. Unable in my excitement to find the doorbell I instinctively tried the knob. It turned and, entering, I mounted the stairs to the room that I had so recently left. All was dark and silent; Moxon, as I had supposed, was in the adjoining room—the "machine-shop." Groping along the wall until I found the communicating door I knocked loudly several

times, but got no response, which I attributed to the uproar outside, for the wind was blowing a gale and dashing the rain against the thin walls in sheets. The drumming upon the shingle roof spanning the unceiled room was loud and incessant.

I had never been invited into the machine-shop—had, indeed, been denied admittance, as had all others, with one exception, a skilled metal worker, of whom no one knew anything except that his name was Haley and his habit silence. But in my spiritual exaltation, discretion and civility were alike forgotten and I opened the door. What I saw took all philosophical speculation out of me in short order.

Moxon sat facing me at the farther side of a small table upon which a single candle made all the light that was in the room. Opposite him, his back toward me, sat another person. On the table between the two was a chess-board; the men were playing. I knew little of chess, but as only a few pieces were on the board it was obvious that the game was near its close. Moxon was intensely interested—not so much, it seemed to me, in the game as in his antagonist, upon whom he had fixed so intent a look that, standing though I did directly in the line of his vision, I was altogether unobserved. His face was ghastly white, and his eyes glittered like diamonds. Of his antagonist I had only a back view, but that was sufficient; I should not have cared to see his face.

He was apparently not more than five feet in height, with proportions suggesting those of a gorilla—a tremendous breadth of shoulders, thick, short neck and broad, squat head, which had a tangled growth of black hair and was topped with a crimson fez. A tunic of the same color, belted tightly to the waist, reached the seat—apparently a box—upon which he sat; his legs and feet were not seen. His left forearm appeared to rest in his lap; he moved his pieces with his right hand, which seemed disproportionately long.

I had shrunk back and now stood a little to one side of the doorway and in shadow. If Moxon had looked farther than the face of his opponent he could have observed nothing now, except that the door was open. Something forbade me either to enter or to retire, a feeling—I know not how it came—that I was in the presence of an imminent tragedy and might serve my friend by remaining. With a scarcely conscious rebellion against the indelicacy of the act I remained.

The play was rapid. Moxon hardly glanced at the board before making his moves, and to my unskilled eye seemed to move the piece most convenient to his hand, his motions in doing so being quick, nervous and lacking in precision. The response of his antagonist, while equally prompt in the inception, was made with a slow, uniform, mechanical and, I thought, somewhat theatrical movement of the arm, that

was a sore trial to my patience. There was something unearthly about it all, and I caught myself shuddering. But I was wet and cold.

Two or three times after moving a piece the stranger slightly inclined his head, and each time I observed that Moxon shifted his king. All at once the thought came to me that the man was dumb. And then that he was a machine—an automaton chess-player! Then I remembered that Moxon had once spoken to me of having invented such a piece of mechanism, though I did not understand that it had actually been constructed. Was all his talk about the consciousness and intelligence of machines merely a prelude to eventual exhibition of this device—only a trick to intensify the effect of its mechanical action upon me in my ignorance of its secret?

A fine end, this, of all my intellectual transports—my "endless variety and excitement of philosophic thought!" I was about to retire in disgust when something occurred to hold my curiosity. I observed a shrug of the thing's great shoulders, as if it were irritated: and so natural was this—so entirely human—that in my new view of the matter it startled me. Nor was that all, for a moment later it struck the table sharply with its clenched hand. At that gesture Moxon seemed even more startled than I: he pushed his chair a little backward, as in alarm.

Presently Moxon, whose play it was, raised his hand high above the board, pounced upon one of his pieces like a sparrow-hawk and with the exclamation "checkmate!" rose quickly to his feet and stepped behind his chair. The automaton sat motionless.

The wind had now gone down, but I heard, at lessening intervals and progressively louder, the rumble and roll of thunder. In the pauses between I now became conscious of a low humming or buzzing which, like the thunder, grew momentarily louder and more distinct. It seemed to come from the body of the automaton, and was unmistakably a whirring of wheels. It gave me the impression of a disordered mechanism which had escaped the repressive and regulating action of some controlling part—an effect such as might be expected if a pawl should be jostled from the teeth of a ratchet-wheel. But before I had time for much conjecture as to its nature my attention was taken by the strange motions of the automaton itself. A slight but continuous convulsion appeared to have possession of it. In body and head it shook like a man with palsy or an ague chill, and the motion augmented every moment until the entire figure was in violent agitation. Suddenly it sprang to its feet and with a movement almost too quick for the eye to follow shot forward across table and chair, with both arms thrust forth to their full length—the posture and lunge of a diver. Moxon tried to throw himself backward out of reach, but he was too late: I saw the horrible thing's hands close upon

his throat, his own clutch its wrists. Then the table was overturned, the candle thrown to the floor and extinguished, and all was black dark. But the noise of the struggle was dreadfully distinct, and most terrible of all were the raucous, squawking sounds made by the strangled man's efforts to breathe. Guided by the infernal hubbub, I sprang to the rescue of my friend, but had hardly taken a stride in the darkness when the whole room blazed with a blinding white light that burned into my brain and heart and memory a vivid picture of the combatants on the floor, Moxon underneath, his throat still in the clutch of those iron hands, his head forced backward, his eyes protruding, his mouth wide open and his tongue thrust out; and—horrible contrast!—upon the painted face of his assassin an expression of tranquil and profound thought, as in the solution of a problem in chess! This I observed, then all was blackness and silence.

Three days later I recovered consciousness in a hospital. As the memory of that tragic night slowly evolved in my ailing brain I recognized in my attendant Moxon's confidential workman, Haley. Responding to a look he approached, smiling.

"Tell me about it," I managed to say, faintly—"all about it."

"Certainly," he said; "you were carried unconscious from a burning house—Moxon's. Nobody knows how you came to be there. You may have to do a little explaining. The origin of the fire is a bit mysterious, too. My own notion is that the house was struck by lightning."

"And Moxon?"

"Buried yesterday—what was left of him."

Apparently this reticent person could unfold himself on occasion. When imparting shocking intelligence to the sick he was affable enough. After some moments of the keenest mental suffering I ventured to ask another question:

"Who rescued me?"

"Well, if that interests you—I did."

"Thank you, Mr. Haley, and may God bless you for it. Did you rescue, also, that charming product of your skill, the automaton chess-player that murdered its inventor?"

The man was silent a long time, looking away from me. Presently he turned and gravely said:

"Do you know that?"

"I do," I replied; "I saw it done."

That was many years ago. If asked to-day I should answer less confidently.

THE DAMNED THING
One Does Not Always Eat What Is on the Table

By the light of a tallow candle which had been placed on one end of a rough table a man was reading something written in a book. It was an old account book, greatly worn; and the writing was not, apparently, very legible, for the man sometimes held the page close to the flame of the candle to get a stronger light on it. The shadow of the book would then throw into obscurity a half of the room, darkening a number of faces and figures; for besides the reader, eight other men were present. Seven of them sat against the rough log walls, silent, motionless, and the room being small, not very far from the table. By extending an arm any one of them could have touched the eighth man, who lay on the table, face upward, partly covered by a sheet, his arms at his sides. He was dead.

The man with the book was not reading aloud, and no one spoke; all seemed to be waiting for something to occur; the dead man only was without expectation. From the blank darkness outside came in, through the aperture that served for a window, all the ever unfamiliar noises of night in the wilderness—the long nameless note of a distant coyote; the stilly pulsing thrill of tireless insects in trees; strange cries of night birds, so different from those of the birds of day; the drone of great blundering beetles, and all that mysterious chorus of small sounds that seem always to have been but half heard when they have suddenly ceased, as if conscious of an indiscretion. But nothing of all this was noted in that company; its members were not overmuch addicted to idle interest in matters of no practical importance; that was obvious in every line of their rugged faces—obvious even in the dim light of the single candle. They were evidently men of the vicinity—farmers and woodsmen.

The person reading was a trifle different; one would have said of him that he was of the world, worldly, albeit there was that in his attire which attested a certain fellowship with the organisms of his environment. His coat would hardly have passed muster in San Francisco; his foot-gear was not of urban origin, and the hat that lay by him on the floor (he was the only one uncovered) was such that if one had considered it as an article of mere personal adornment he would have missed its meaning. In countenance the man was rather prepossessing, with just a hint of sternness; though that he may have assumed or cultivated, as appropriate to one in authority. For he was a coroner. It was by virtue of his office that he had possession of the book in which he was reading; it had been found among the dead man's effects—in his cabin, where the inquest was now taking place.

When the coroner had finished reading he put the book into his

breast pocket. At that moment the door was pushed open and a young man entered. He, clearly, was not of mountain birth and breeding: he was clad as those who dwell in cities. His clothing was dusty, however, as from travel. He had, in fact, been riding hard to attend the inquest.

The coroner nodded; no one else greeted him.

"We have waited for you," said the coroner. "It is necessary to have done with this business to-night."

The young man smiled. "I am sorry to have kept you," he said. "I went away, not to evade your summons, but to post to my newspaper an account of what I suppose I am called back to relate."

The coroner smiled.

"The account that you posted to your newspaper," he said, "differs, probably, from that which you will give here under oath."

"That," replied the other, rather hotly and with a visible flush, "is as you please. I used manifold paper and have a copy of what I sent. It was not written as news, for it is incredible, but as fiction. It may go as a part of my testimony under oath."

"But you say it is incredible."

"That is nothing to you, sir, if I also swear that it is true."

The coroner was silent for a time, his eyes upon the floor. The men about the sides of the cabin talked in whispers, but seldom withdrew their gaze from the face of the corpse. Presently the coroner lifted his eyes and said: "We will resume the inquest."

The men removed their hats. The witness was sworn.

"What is your name?" the coroner asked.

"William Harker."

"Age?"

"Twenty-seven."

"You knew the deceased, Hugh Morgan?"

"Yes."

"You were with him when he died?"

"Near him."

"How did that happen—your presence, I mean?"

"I was visiting him at this place to shoot and fish. A part of my purpose, however, was to study him and his odd, solitary way of life. He seemed a good model for a character in fiction. I sometimes write stories."

"I sometimes read them."

"Thank you."

"Stories in general—not yours."

Some of the jurors laughed. Against a sombre background humor shows high lights. Soldiers in the intervals of battle laugh easily, and a jest in the death chamber conquers by surprise.

"Relate the circumstances of this man's death," said the coroner. "You may use any notes or memoranda that you please."

The witness understood. Pulling a manuscript from his breast pocket he held it near the candle and turning the leaves until he found the passage that he wanted began to read.

What May Happen in a Field of Wild Oats

". . . The sun had hardly risen when we left the house. We were looking for quail, each with a shotgun, but we had only one dog. Morgan said that our best ground was beyond a certain ridge that he pointed out, and we crossed it by a trail through the *chaparral.* On the other side was comparatively level ground, thickly covered with wild oats. As we emerged from the *chaparral* Morgan was but a few yards in advance. Suddenly we heard, at a little distance to our right and partly in front, a noise as of some animal thrashing about in the bushes, which we could see were violently agitated.

"'We've started a deer,' I said. 'I wish we had brought a rifle.'

"Morgan, who had stopped and was intently watching the agitated *chaparral,* said nothing, but had cocked both barrels of his gun and was holding it in readiness to aim. I thought him a trifle excited, which surprised me, for he had a reputation for exceptional coolness, even in moments of sudden and imminent peril.

"'O, come,' I said. 'You are not going to fill up a deer with quail-shot, are you?'

"Still he did not reply; but catching a sight of his face as he turned it slightly toward me I was struck by the intensity of his look. Then I understood that we had serious business in hand and my first conjecture was that we had 'jumped' a grizzly. I advanced to Morgan's side, cocking my piece as I moved.

"The bushes were now quiet and the sounds had ceased, but Morgan was as attentive to the place as before.

"'What is it? What the devil is it?' I asked.

"'That Damned Thing!' he replied, without turning his head. His voice was husky and unnatural. He trembled visibly.

"I was about to speak further, when I observed the wild oats near the place of the disturbance moving in the most inexplicable way. I can hardly describe it. It seemed as if stirred by a streak of wind, which not only bent it, but pressed it down—crushed it so that it did not rise; and this movement was slowly prolonging itself directly toward us.

"Nothing that I had ever seen had affected me so strangely as this unfamiliar and unaccountable phenomenon, yet I am unable to recall any sense of fear. I remember—and tell it here because, singularly

enough, I recollected it then—that once in looking carelessly out of an open window I momentarily mistook a small tree close at hand for one of a group of larger trees at a little distance away. It looked the same size as the others, but being more distinctly and sharply defined in mass and detail seemed out of harmony with them. It was a mere falsification of the law of aërial perspective, but it startled, almost terrified me. We so rely upon the orderly operation of familiar natural laws that any seeming suspension of them is noted as a menace to our safety, a warning of unthinkable calamity. So now the apparently causeless movement of the herbage and the slow, undeviating approach of the line of disturbance were distinctly disquieting. My companion appeared actually frightened, and I could hardly credit my senses when I saw 'him suddenly throw his gun to his shoulder and fire both barrels at the agitated grain! Before the smoke of the discharge had cleared away I heard a loud savage cry—a scream like that of a wild animal—and flinging his gun upon the ground Morgan sprang away and ran swiftly from the spot. At the same instant I was thrown violently to the ground by the impact of something unseen in the smoke—some soft, heavy substance that seemed thrown against me with great force.

"Before I could get upon my feet and recover my gun, which seemed to have been struck from my hands, I heard Morgan crying out as if in mortal agony, and mingling with his cries were such hoarse, savage sounds as one hears from fighting dogs. Inexpressibly terrified, I struggled to my feet and looked in the direction of Morgan's retreat; and may Heaven in mercy spare me from another sight like that! At a distance of less than thirty yards was my friend, down upon one knee, his head thrown back at a frightful angle, hatless, his long hair in disorder and his whole body in violent movement from side to side, backward and forward. His right arm was lifted and seemed to lack the hand—at least, I could see none. The other arm was invisible. At times, as my memory now reports this extraordinary scene, I could discern but a part of his body; it was as if he had been partly blotted out—I cannot otherwise express it—then a shifting of his position would bring it all into view again.

"All this must have occurred within a few seconds, yet in that time Morgan assumed all the postures of a determined wrestler vanquished by superior weight and strength. I saw nothing but him, and him not always distinctly. During the entire incident his shouts and curses were heard, as if through an enveloping uproar of such sounds of rage and fury as I had never heard from the throat of man or brute!

"For a moment only I stood irresolute, then throwing down my gun I ran forward to my friend's assistance. I had a vague belief that he was suffering from a fit, or some form of convulsion. Before I could

reach his side he was down and quiet. All sounds had ceased, but with a feeling of such terror as even these awful events had not inspired I now saw again the mysterious movement of the wild oats, prolonging itself from the trampled area about the prostrate man toward the edge of a wood. It was only when it had reached the wood that I was able to withdraw my eyes and look at my companion. He was dead."

A Man Though Naked May Be In Rags

The coroner rose from his seat and stood beside the dead man. Lifting an edge of the sheet he pulled it away, exposing the entire body, altogether naked and showing in the candle-light a claylike yellow. It had, however, broad maculations of bluish black, obviously caused by extravasated blood from contusions. The chest and sides looked as if they had been beaten with a bludgeon. There were dreadful lacerations; the skin was torn in strips and shreds.

The coroner moved round to the end of the table and undid a silk handkerchief which had been passed under the chin and knotted on the top of the head. When the handkerchief was drawn away it exposed what had been the throat. Some of the jurors who had risen to get a better view repented their curiosity and turned away their faces. Witness Harker went to the open window and leaned out across the sill, faint and sick. Dropping the handkerchief upon the dead man's neck the coroner stepped to an angle of the room and from a pile of clothing produced one garment after another, each of which he held up a moment for inspection. All were torn, and stiff with blood. The jurors did not make a closer inspection. They seemed rather uninterested. They had, in truth, seen all this before; the only thing that was new to them being Harker's testimony.

"Gentlemen," the coroner said, "we have no more evidence, I think. Your duty has been already explained to you; if there is nothing you wish to ask you may go outside and consider your verdict."

The foreman rose—a tall, bearded man of sixty, coarsely clad.

"I should like to ask one question, Mr. Coroner," he said. "What asylum did this yer last witness escape from?"

"Mr. Harker," said the coroner, gravely and tranquilly, "from what asylum did you last escape?"

Harker flushed crimson again, but said nothing, and the seven jurors rose and solemnly filed out of the cabin.

"If you have done insulting me, sir," said Harker, as soon as he and the officer were left alone with the dead man, "I suppose I am at liberty to go?"

"Yes."

Harker started to leave, but paused, with his hand on the door latch. The habit of his profession was strong in him—stronger than his sense of personal dignity. He turned about and said:

"The book that you have there—I recognize it as Morgan's diary. You seemed greatly interested in it; you read in it while I was testifying. May I see it? The public would like—"

"The book will cut no figure in this matter," replied the official, slipping it into his coat pocket; "all the entries in it were made before the writer's death."

As Harker passed out of the house the jury reëntered and stood about the table, on which the now covered corpse showed under the sheet with sharp definition. The foreman seated himself near the candle, produced from his breast pocket a pencil and scrap of paper and wrote rather laboriously the following verdict, which with various degrees of effort all signed:

"We, the jury, do find that the remains come to their death at the hands of a mountain lion, but some of us thinks, all the same, they had fits."

An Explanation from the Tomb

In the diary of the late Hugh Morgan are certain interesting entries having, possibly, a scientific value as suggestions. At the inquest upon his body the book was not put in evidence; possibly the coroner thought it not worth while to confuse the jury. The date of the first of the entries mentioned cannot be ascertained; the upper part of the leaf is torn away; the part of the entry remaining follows:

". . . would run in a half-circle, keeping his head turned always toward the centre, and again he would stand still, barking furiously. At last he ran away into the brush as fast as he could go. I thought at first that he had gone mad, but on returning to the house found no other alteration in his manner than what was obviously due to fear of punishment.

"Can a dog see with his nose? Do odors impress some cerebral centre with images of the thing that emitted them? . . .

"Sept. 2.—Looking at the stars last night as they rose above the crest of the ridge east of the house, I observed them successively disappear—from left to right. Each was eclipsed but an instant, and only a few at the same time, but along the entire length of the ridge all that were within a degree or two of the crest were blotted out. It was as if something had passed along between me and them; but I could not see

it, and the stars were not thick enough to define its outline. Ugh! I don't like this."

Several weeks' entries are missing, three leaves being torn from the book

"Sept. 27.—It has been about here again—I find evidence of its presence every day. I watched again all last night in the same cover, gun in hand, double-charged with buckshot. In the morning the fresh footprints were there, as before. Yet I would have sworn that I did not sleep—indeed, I hardly sleep at all. It is terrible, insupportable! If these amazing experiences are real I shall go mad; if they are fanciful I am mad already.

"Oct. 3.—I shall not go—it shall not drive me away. No, this is *my* house, *my* land. God hates a coward. . . .

"Oct. 5.—I can stand it no longer; I have invited Harker to pass a few weeks with me—he has a level head. I can judge from his manner if he thinks me mad.

"Oct. 7.—I have the solution of the mystery; it came to me last night—suddenly, as by revelation. How simple—how terribly simple!

"There are sounds that we cannot hear. At either end of the scale are notes that stir no chord of that imperfect instrument, the human ear. They are too high or too grave. I have observed a flock of blackbirds occupying an entire tree-top—the tops of several trees—and all in full song. Suddenly—in a moment—at absolutely the same instant—all spring into the air and fly away. How? They could not all see one another—whole tree-tops intervened. At no point could a leader have been visible to all. There must have been a signal of warning or command, high and shrill above the din, but by me unheard. I have observed, too, the same simultaneous flight when all were silent, among not only blackbirds, but other birds—quail, for example, widely separated by bushes—even on opposite sides of a hill.

"It is known to seamen that a school of whales basking or sporting on the surface of the ocean, miles apart, with the convexity of the earth between, will sometimes dive at the same instant—all gone out of sight in a moment. The signal has been sounded—too grave for the ear of the sailor at the masthead and his comrades on the deck—who nevertheless feel its vibrations in the ship as the stones of a cathedral are stirred by the bass of the organ.

"As with sounds, so with colors. At each end of the solar spectrum the chemist can detect the presence of what are known as 'actinic' rays. They represent colors—integral colors in the composition of light—which we are unable to discern. The human eye is an imperfect

instrument; its range is but a few octaves of the real 'chromatic scale.' I am not mad; there are colors that we cannot see.

"And, God help me! the Damned Thing is of such a color!"

HAïTI THE SHEPHERD

In the heart of Haïti the illusions of youth had not been supplanted by those of age and experience. His thoughts were pure and pleasant, for his life was simple and his soul devoid of ambition. He rose with the sun and went forth to pray at the shrine of Hastur, the god of shepherds, who heard and was pleased. After performance of this pious rite Haïti unbarred the gate of the fold and with a cheerful mind drove his flock afield, eating his morning meal of curds and oat cake as he went, occasionally pausing to add a few berries, cold with dew, or to drink of the waters that came away from the hills to join the stream in the middle of the valley and be borne along with it, he knew not whither.

During the long summer day, as his sheep cropped the good grass which the gods had made to grow for them, or lay with their forelegs doubled under their breasts and chewed the cud, Haïti, reclining in the shadow of a tree, or sitting upon a rock, played so sweet music upon his reed pipe that sometimes from the corner of his eye he got accidental glimpses of the minor sylvan deities, leaning forward out of the copse to hear; but if he looked at them directly they vanished. From this—for he must be thinking if he would not turn into one of his own sheep—he drew the solemn inference that happiness may come if not sought, but if looked for will never be seen; for next to the favor of Hastur, who never disclosed himself, Haïti most valued the friendly interest of his neighbors, the shy immortals of the wood and stream. At nightfall he drove his flock back to the fold, saw that the gate was secure and retired to his cave for refreshment and for dreams.

So passed his life, one day like another, save when the storms uttered the wrath of an offended god. Then Haïti cowered in his cave, his face hidden in his hands, and prayed that he alone might be punished for his sins and the world saved from destruction. Sometimes when there was a great rain, and the stream came out of its banks, compelling him to urge his terrified flock to the uplands, he interceded for the people in the cities which he had been told lay in the plain beyond the two blue hills forming the gateway of his valley.

"It is kind of thee, O Hastur," so he prayed, "to give me mountains so near to my dwelling and my fold that I and my sheep can escape the angry torrents; but the rest of the world thou must thyself deliver in some way that I know not of, or I will no longer worship thee."

And Hastur, knowing that Haïti was a youth who kept his word, spared the cities and turned the waters into the sea.

So he had lived since he could remember. He could not rightly conceive any other mode of existence. The holy hermit who dwelt at the head of the valley, a full hour's journey away, from whom he had heard the tale of the great cities where dwelt people—poor souls!—who had no sheep, gave him no knowledge of that early time, when, so he reasoned, he must have been small and helpless like a lamb.

It was through thinking on these mysteries and marvels, and on that horrible change to silence and decay which he felt sure must some time come to him, as he had seen it come to many of his flock—as it came to all living things except the birds—that Haïti first became conscious how miserable and hopeless was his lot.

"It is necessary," he said, "that I know whence and how I came; for how can one perform his duties unless able to judge what they are by the way in which he was intrusted with them? And what contentment can I have when I know not how long it is going to last? Perhaps before another sun I may be changed, and then what will become of the sheep? What, indeed, will have become of me?"

Pondering these things Haïti became melancholy and morose. He no longer spoke cheerfully to his flock, nor ran with alacrity to the shrine of Hastur. In every breeze he heard whispers of malign deities whose existence he now first observed. Every cloud was a portent signifying disaster, and the darkness was full of terrors. His reed pipe when applied to his lips gave out no melody, but a dismal wail; the sylvan and riparian intelligences no longer thronged to the thicket-side to listen, but fled from the sound, as he knew by the stirred leaves and bent flowers. He relaxed his vigilance and many of his sheep strayed away into the hills and were lost. Those that remained became lean and ill for lack of good pasturage, for he would not seek it for them, but conducted them day after day to the same spot, through mere abstraction, while puzzling about life and death—of immortality he knew not.

One day while indulging in the gloomiest reflections he suddenly sprang from the rock upon which he sat, and with a determined gesture exclaimed: "I will no longer be a suppliant for knowledge which the gods withhold. Let them look to it that they do me no wrong. I will do my duty as best I can and if I err upon their own heads be it!"

Suddenly, as he spoke, a great brightness fell about him, causing him to look upward, thinking the sun had burst through a rift in the clouds; but there were no clouds. No more than an arm's length away stood a beautiful maiden. So beautiful she was that the flowers about her feet folded their petals in despair and bent their heads in token of

submission; so sweet her look that the humming birds thronged her eyes, thrusting their thirsty bills almost into them, and the wild bees were about her lips. And such was her brightness that the shadows of all objects lay divergent from her feet, turning as she moved.

Haïti was entranced. Rising, he knelt before her in adoration, and she laid her hand upon his head.

"Come," she said in a voice that had the music of all the bells of his flock—"come, thou art not to worship me, who am no goddess, but if thou art truthful and dutiful I will abide with thee."

Haïti seized her hand, and stammering his joy and gratitude arose, and hand in hand they stood and smiled into each other's eyes. He gazed on her with reverence and rapture. He said: "I pray thee, lovely maid, tell me thy name and whence and why thou comest."

At this she laid a warning finger on her lip and began to withdraw. Her beauty underwent a visible alteration that made him shudder, he knew not why, for still she was beautiful. The landscape was darkened by a giant shadow sweeping across the valley with the speed of a vulture. In the obscurity the maiden's figure grew dim and indistinct and her voice seemed to come from a distance, as she said, in a tone of sorrowful reproach: "Presumptuous and ungrateful youth! must I then so soon leave thee? Would nothing do but thou must at once break the eternal compact?"

Inexpressibly grieved, Haïti fell upon his knees and implored her to remain—rose and sought her in the deepening darkness—ran in circles, calling to her aloud, but all in vain. She was no longer visible, but out of the gloom he heard her voice saying: "Nay, thou shalt not have me by seeking. Go to thy duty, faithless shepherd, or we shall never meet again."

Night had fallen; the wolves were howling in the hills and the terrified sheep crowding about Haïti's feet. In the demands of the hour he forgot his disappointment, drove his sheep to the fold and repairing to the place of worship poured out his heart in gratitude to Hastur for permitting him to save his flock, then retired to his cave and slept.

When Haïti awoke the sun was high and shone in at the cave, illuminating it with a great glory. And there, beside him, sat the maiden. She smiled upon him with a smile that seemed the visible music of his pipe of reeds. He dared not speak, fearing to offend her as before, for he knew not what he could venture to say.

"Because," she said, "thou didst thy duty by the flock, and didst not forget to thank Hastur for staying the wolves of the night, I am come to thee again. Wilt thou have me for a companion?"

"Who would not have thee forever?" replied Haïti. "Oh!

never again leave me until—until I—change and become silent and motionless."

Haïti had no word for death.

"I wish, indeed," he continued, "that thou wert of my own sex, that we might wrestle and run races and so never tire of being together."

At these words the maiden arose and passed out of the cave, and Haïti, springing from his couch of fragrant boughs to overtake and detain her, observed to his astonishment that the rain was falling and the stream in the middle of the valley had come out of its banks. The sheep were bleating in terror, for the rising waters had invaded their fold. And there was danger for the unknown cities of the distant plain.

It was many days before Haïti saw the maiden again. One day he was returning from the head of the valley, where he had gone with ewe's milk and oat cakes and berries for the holy hermit, who was too old and feeble to provide himself with food.

"Poor old man!" he said aloud, as he trudged along homeward. "I will return to-morrow and bear him on my back to my own dwelling, where I can care for him. Doubtless it is for this that Hastur has reared me all these many years, and gives me health and strength."

As he spoke, the maiden, clad in glittering garments, met him in the path with a smile that took away his breath.

"I am come again," she said, "to dwell with thee if thou wilt now have me, for none else will. Thou mayest have learned wisdom, and art willing to take me as I am, nor care to know."

Haïti threw himself at her feet. "Beautiful being," he cried, "if thou wilt but deign to accept all the devotion of my heart and soul—after Hastur be served—it is thine forever. But, alas! thou are capricious and wayward. Before to-morrow's sun I may lose thee again. Promise, I beseech thee, that however in my ignorance I may offend, thou wilt forgive and remain always with me."

Scarcely had he finished speaking when a troop of bears came out of the hills, racing toward him with crimson mouths and fiery eyes. The maiden again vanished, and he turned and fled for his life. Nor did he stop until he was in the cot of the holy hermit, whence he had set out. Hastily barring the door against the bears he cast himself upon the ground and wept.

"My son," said the hermit from his couch of straw, freshly gathered that morning by Haïti's hands, "it is not like thee to weep for bears—tell me what sorrow hath befallen thee, that age may minister to the hurts of youth with such balms as it hath of its wisdom."

Haïti told him all; how thrice he had met the radiant maid,

and thrice she had left him forlorn. He related minutely all that had passed between them, omitting no word of what had been said.

When he had ended, the holy hermit was a moment silent, then said: "My son, I have attended to thy story, and I know the maiden. I have myself seen her, as have many. Know, then, that her name, which she would not even permit thee to inquire, is Happiness. Thou saidst the truth to her, that she is capricious for she imposeth conditions that man can not fulfill, and delinquency is punished by desertion. She cometh only when unsought, and will not be questioned. One manifestation of curiosity, one sign of doubt, one expression of misgiving, and she is away! How long didst thou have her at any time before she fled?"

"Only a single instant," answered Haïti, blushing with shame at the confession. "Each time I drove her away in one moment."

"Unfortunate youth!" said the holy hermit, "but for thine indiscretion thou mightst have had her for two."

MY FAVORITE MURDER

Having murdered my mother under circumstances of singular atrocity, I was arrested and put upon my trial, which lasted seven years. In charging the jury, the judge of the Court of Acquittal remarked that it was one of the most ghastly crimes that he had ever been called upon to explain away.

At this, my attorney rose and said:

"May it please your Honor, crimes are ghastly or agreeable only by comparison. If you were familiar with the details of my client's previous murder of his uncle you would discern in his later offense (if offense it may be called) something in the nature of tender forbearance and filial consideration for the feelings of the victim. The appalling ferocity of the former assassination was indeed inconsistent with any hypothesis but that of guilt; and had it not been for the fact that the honorable judge before whom he was tried was the president of a life insurance company that took risks on hanging, and in which my client held a policy, it is hard to see how he could decently have been acquitted. If your Honor would like to hear about it for instruction and guidance of your Honor's mind, this unfortunate man, my client, will consent to give himself the pain of relating it under oath."

The district attorney said: "Your Honor, I object. Such a statement would be in the nature of evidence, and the testimony in this case is closed. The prisoner's statement should have been introduced three years ago, in the spring of 1881."

"In a statutory sense," said the judge, "you are right, and in

the Court of Objections and Technicalities you would get a ruling in your favor. But not in a Court of Acquittal. The objection is overruled."

"I except," said the district attorney.

"You cannot do that," the judge said. "I must remind you that in order to take an exception you must first get this case transferred for a time to the Court of Exceptions on a formal motion duly supported by affidavits. A motion to that effect by your predecessor in office was denied by me during the first year of this trial. Mr. Clerk, swear the prisoner."

The customary oath having been administered, I made the following statement, which impressed the judge with so strong a sense of the comparative triviality of the offense for which I was on trial that he made no further search for mitigating circumstances, but simply instructed the jury to acquit, and I left the court, without a stain upon my reputation:

"I was born in 1856 in Kalamakee, Mich., of honest and reputable parents, one of whom Heaven has mercifully spared to comfort me in my later years. In 1867 the family came to California and settled near Nigger Head, where my father opened a road agency and prospered beyond the dreams of avarice. He was a reticent, saturnine man then, though his increasing years have now somewhat relaxed the austerity of his disposition, and I believe that nothing but his memory of the sad event for which I am now on trial prevents him from manifesting a genuine hilarity.

"Four years after we had set up the road agency an itinerant preacher came along, and having no other way to pay for the night's lodging that we gave him, favored us with an exhortation of such power that, praise God, we were all converted to religion. My father at once sent for his brother, the Hon. William Ridley of Stockton, and on his arrival turned over the agency to him, charging him nothing for the franchise nor plant—the latter consisting of a Winchester rifle, a sawed-off shotgun, and an assortment of masks made out of flour sacks. The family then moved to Ghost Rock and opened a dance house. It was called 'The Saints' Rest Hurdy-Gurdy,' and the proceedings each night began with prayer. It was there that my now sainted mother, by her grace in the dance, acquired the *sobriquet* of 'The Bucking Walrus.'

"In the fall of '75 I had occasion to visit Coyote, on the road to Mahala, and took the stage at Ghost Rock. There were four other passengers. About three miles beyond Nigger Head, persons whom I identified as my Uncle William and his two sons held up the stage. Finding nothing in the express box, they went through the passengers. I acted a most honorable part in the affair, placing myself in line with the others, holding up my hands and permitting myself to be deprived of forty

dollars and a gold watch. From my behavior no one could have suspected that I knew the gentlemen who gave the entertainment. A few days later, when I went to Nigger Head and asked for the return of my money and watch my uncle and cousins swore they knew nothing of the matter, and they affected a belief that my father and I had done the job ourselves in dishonest violation of commercial good faith. Uncle William even threatened to retaliate by starting an opposition dance house at Ghost Rock. As 'The Saints' Rest' had become rather unpopular, I saw this would assuredly ruin it and prove a paying enterprise, so I told my uncle that I was willing to overlook the past if he would take me into the scheme and keep the partnership a secret from my father. This fair offer he rejected, and I then perceived that it would be better and more satisfactory if he were dead.

"My plans to that end were soon perfected, and communicating them to my dear parents I had the gratification of receiving their approval. My father said he was proud of me, and my mother promised that although her religion forbade her to assist in taking human life I should have the advantage of her prayers for my success. As a preliminary measure looking to my security in case of detection I made an application for membership in that powerful order, the Knights of Murder, and in due course was received as a member of the Ghost Rock commandery. On the day that my probation ended I was for the first time permitted to inspect the records of the order and learn who belonged to it—all rites of initiation having been conducted in masks. Fancy my delight when, in looking over the roll of membership, I found the third name to be that of my uncle, who indeed was junior vice-chancellor of the order! Here was an opportunity exceeding my wildest dreams—to murder I could add insubordination and treachery. It was what my good mother would have called 'a special Providence.'

"At about this time something occurred which caused my cup of joy, already full, to overflow on all sides, a circular cataract of bliss. Three men, strangers in that locality, were arrested for the stage robbery in which I had lost my money and watch. They were brought to trial and, despite my efforts to clear them and fasten the guilt upon three of the most respectable and worthy citizens of Ghost Rock, convicted on the clearest proof. The murder would now be as wanton and reasonless as I could wish.

"One morning I shouldered my Winchester rifle, and going over to my uncle's house, near Nigger Head, asked my Aunt Mary, his wife, if he were at home, adding that I had come to kill him. My aunt replied with her peculiar smile that so many gentlemen called on that errand and were afterward carried away without having performed it that

I must excuse her for doubting my good faith in the matter. She said I did not look as if I would kill anybody, so, as a proof of good faith I leveled my rifle and wounded a Chinaman who happened to be passing the house. She said she knew whole families that could do a thing of that kind, but Bill Ridley was a horse of another color. She said, however, that I would find him over on the other side of the creek in the sheep lot; and she added that she hoped the best man would win.

"My Aunt Mary was one of the most fair-minded women that I have ever met.

"I found my uncle down on his knees engaged in skinning a sheep. Seeing that he had neither gun nor pistol handy I had not the heart to shoot him, so I approached him, greeted him pleasantly and struck him a powerful blow on the head with the butt of my rifle. I have a very good delivery and Uncle William lay down on his side, then rolled over on his back, spread out his fingers and shivered. Before he could recover the use of his limbs I seized the knife that he had been using and cut his hamstrings. You know, doubtless, that when you sever the *tendo Achillis* the patient has no further use of his leg; it is just the same as if he had no leg. Well, I parted them both, and when he revived he was at my service. As soon as he comprehended the situation, he said:

"'Samuel, you have got the drop on me and can afford to be generous. I have only one thing to ask of you, and that is that you carry me to the house and finish me in the bosom of my family.'

"I told him I thought that a pretty reasonable request and I would do so if he would let me put him into a wheat sack; he would be easier to carry that way and if we were seen by the neighbors *en route* it would cause less remark. He agreed to that, and going to the barn I got a sack. This, however, did not fit him; it was too short and much wider than he; so I bent his legs, forced his knees up against his breast and got him into it that way, tying the sack above his head. He was a heavy man and I had all that I could do to get him on my back, but I staggered along for some distance until I came to a swing that some of the children had suspended to the branch of an oak. Here I laid him down and sat upon him to rest, and the sight of the rope gave me a happy inspiration. In twenty minutes my uncle, still in the sack, swung free to the sport of the wind.

"I had taken down the rope, tied one end tightly about the mouth of the bag, thrown the other across the limb and hauled him up about five feet from the ground. Fastening the other end of the rope also about the mouth of the sack, I had the satisfaction to see my uncle converted into a large, fine pendulum. I must add that he was not himself entirely aware of the nature of the change that he had undergone

in his relation to the exterior world, though in justice to a good man's memory I ought to say that I do not think he would in any case have wasted much of my time in vain remonstrance.

"Uncle William had a ram that was famous in all that region as a fighter. It was in a state of chronic constitutional indignation. Some deep disappointment in early life had soured its disposition and it had declared war upon the whole world. To say that it would butt anything accessible is but faintly to express the nature and scope of its military activity: the universe was its antagonist; its methods that of a projectile. It fought like the angels and devils, in mid-air, cleaving the atmosphere like a bird, describing a parabolic curve and descending upon its victim at just the exact angle of incidence to make the most of its velocity and weight. Its momentum, calculated in foot-tons, was something incredible. It had been seen to destroy a four year old bull by a single impact upon that animal's gnarly forehead. No stone wall had ever been known to resist its downward swoop; there were no trees tough enough to stay it; it would splinter them into matchwood and defile their leafy honors in the dust. This irascible and implacable brute—this incarnate thunderbolt—this monster of the upper deep, I had seen reposing in the shade of an adjacent tree, dreaming dreams of conquest and glory. It was with a view to summoning it forth to the field of honor that I suspended its master in the manner described.

"Having completed my preparations, I imparted to the avuncular pendulum a gentle oscillation, and retiring to cover behind a contiguous rock, lifted up my voice in a long rasping cry whose diminishing final note was drowned in a noise like that of a swearing cat, which emanated from the sack. Instantly that formidable sheep was upon its feet and had taken in the military situation at a glance. In a few moments it had approached, stamping, to within fifty yards of the swinging foeman, who, now retreating and anon advancing, seemed to invite the fray. Suddenly I saw the beast's head drop earthward as if depressed by the weight of its enormous horns; then a dim, white, wavy streak of sheep prolonged itself from that spot in a generally horizontal direction to within about four yards of a point immediately beneath the enemy. There it struck sharply upward, and before it had faded from my gaze at the place whence it had set out I heard a horrid thump and a piercing scream, and my poor uncle shot forward, with a slack rope higher than the limb to which he was attached. Here the rope tautened with a jerk, arresting his flight, and back he swung in a breathless curve to the other end of his arc. The ram had fallen, a heap of indistinguishable legs, wool and horns, but pulling itself together and dodging as its antagonist swept downward it retired at random, alternately shaking its head and stamping its fore-feet. When it had backed about the same distance as that

from which it had delivered the assault it paused again, bowed its head as if in prayer for victory and again shot forward, dimly visible as before—a prolonging white streak with monstrous undulations, ending with a sharp ascension. Its course this time was at a right angle to its former one, and its impatience so great that it struck the enemy before he had nearly reached the lowest point of his arc. In consequence he went flying round and round in a horizontal circle whose radius was about equal to half the length of the rope, which I forgot to say was nearly twenty feet long. His shrieks, *crescendo* in approach and *diminuendo* in recession, made the rapidity of his revolution more obvious to the ear than to the eye. He had evidently not yet been struck in a vital spot. His posture in the sack and the distance from the ground at which he hung compelled the ram to operate upon his lower extremities and the end of his back. Like a plant that has struck its root into some poisonous mineral, my poor uncle was dying slowly upward.

"After delivering its second blow the ram had not again retired. The fever of battle burned hot in its heart; its brain was intoxicated with the wine of strife. Like a pugilist who in his rage forgets his skill and fights ineffectively at half-arm's length, the angry beast endeavored to reach its fleeting foe by awkward vertical leaps as he passed overhead, sometimes, indeed, succeeding in striking him feebly, but more frequently overthrown by its own misguided eagerness. But as the impetus was exhausted and the man's circles narrowed in scope and diminished in speed, bringing him nearer to the ground, these tactics produced better results, eliciting a superior quality of screams, which I greatly enjoyed.

"Suddenly, as if the bugles had sung truce, the ram suspended hostilities and walked away, thoughtfully wrinkling and smoothing its great aquiline nose, and occasionally cropping a bunch of grass and slowly munching it. It seemed to have tired of war's alarms and resolved to beat the sword into a plowshare and cultivate the arts of peace. Steadily it held its course away from the field of fame until it had gained a distance of nearly a quarter of a mile. There it stopped and stood with its rear to the foe, chewing its cud and apparently half asleep. I observed, however, an occasional slight turn of its head, as if its apathy were more affected than real.

"Meanwhile Uncle William's shrieks had abated with his motion, and nothing was heard from him but long, low moans, and at long intervals my name, uttered in pleading tones exceedingly grateful to my ear. Evidently the man had not the faintest notion of what was being done to him, and was inexpressibly terrified. When Death comes cloaked in mystery he is terrible indeed. Little by little my uncle's oscillations diminished, and finally he hung motionless. I went to him and was about to give him the *coup de grâce,* when I heard and felt a

succession of smart shocks which shook the ground like a series of light earthquakes, and turning in the direction of the ram, saw a long cloud of dust approaching me with inconceivable rapidity and alarming effect! At a distance of some thirty yards away it stopped short, and from the near end of it rose into the air what I at first thought a great white bird. Its ascent was so smooth and easy and regular that I could not realize its extraordinary celerity, and was lost in admiration of its grace. To this day the impression remains that it was a slow, deliberate movement, the ram—for it was that animal—being upborne by some power other than its own impetus, and supported through the successive stages of its flight with infinite tenderness and care. My eyes followed its progress through the air with unspeakable pleasure, all the greater by contrast with my former terror of its approach by land. Onward and upward the noble animal sailed, its head bent down almost between its knees, its fore-feet thrown back, its hinder legs trailing to rear like the legs of a soaring heron.

"At a height of forty or fifty feet, as fond recollection presents it to view, it attained its zenith and appeared to remain an instant stationary; then, tilting suddenly forward without altering the relative position of its parts, it shot downward on a steeper and steeper course with augmenting velocity, passed immediately above me with a noise like the rush of a cannon shot and struck my poor uncle almost squarely on the top of the head! So frightful was the impact that not only the man's neck was broken, but the rope too; and the body of the deceased, forced against the earth, was crushed to pulp beneath the awful front of that meteoric sheep! The concussion stopped all the clocks between Lone Hand and Dutch Dan's, and Professor Davidson, a distinguished authority in matters seismic, who happened to be in the vicinity, promptly explained that the vibrations were from north to southwest."

"Altogether, I cannot help thinking that in point of artistic atrocity my murder of Uncle William has seldom been excelled."

OIL OF DOG

My name is Boffer Bings. I was born of honest parents in one of the humbler walks of life, my father being a manufacturer of dog-oil and my mother having a small studio in the shadow of the village church, where she disposed of unwelcome babes. In my boyhood I was trained to habits of industry; I not only assisted my father in procuring dogs for his vats, but was frequently employed by my mother to carry away the débris of her work in the studio. In performance of this duty I sometimes had need of all my natural intelligence for all the law officers of the vicinity were opposed to my mother's business. They were not elected on an opposition

ticket, and the matter had never been made a political issue; it just happened so. My father's business of making dog-oil was, naturally, less unpopular, though the owners of missing dogs sometimes regarded him with suspicion, which was reflected, to some extent, upon me. My father had, as silent partners, all the physicians of the town, who seldom wrote a prescription which did not contain what they were pleased to designate as *Ol. can.* It is really the most valuable medicine ever discovered. But most persons are unwilling to make personal sacrifices for the afflicted, and it was evident that many of the fattest dogs in town had been forbidden to play with me—a fact which pained my young sensibilities, and at one time came near driving me to become a pirate.

Looking back upon those days, I cannot but regret, at times, that by indirectly bringing my beloved parents to their death I was the author of misfortunes profoundly affecting my future.

One evening while passing my father's oil factory with the body of a foundling from my mother's studio I saw a constable who seemed to be closely watching my movements. Young as I was, I had learned that a constable's acts, of whatever apparent character, are prompted by the most reprehensible motives, and I avoided him by dodging into the oilery by a side door which happened to stand ajar. I locked it at once and was alone with my dead. My father had retired for the night. The only light in the place came from the furnace, which glowed a deep, rich crimson under one of the vats, casting ruddy reflections on the walls. Within the cauldron the oil still rolled in indolent ebullition, occasionally pushing to the surface a piece of dog. Seating myself to wait for the constable to go away, I held the naked body of the foundling in my lap and tenderly stroked its short, silken hair. Ah, how beautiful it was! Even at that early age I was passionately fond of children, and as I looked upon this cherub I could almost find it in my heart to wish that the small, red wound upon its breast—the work of my dear mother—had not been mortal.

It had been my custom to throw the babes into the river which nature had thoughtfully provided for the purpose, but that night I did not dare to leave the oilery for fear of the constable. "After all," I said to myself, "it cannot greatly matter if I put it into this cauldron. My father will never know the bones from those of a puppy, and the few deaths which may result from administering another kind of oil for the incomparable *ol. can.* are not important in a population which increases so rapidly." In short, I took the first step in crime and brought myself untold sorrow by casting the babe into the cauldron.

The next day, somewhat to my surprise, my father, rubbing his hands with satisfaction, informed me and my mother that he had obtained the finest quality of oil that was ever seen; that the physicians to

whom he had shown samples had so pronounced it. He added that he had no knowledge as to how the result was obtained; the dogs had been treated in all respects as usual, and were of an ordinary breed. I deemed it my duty to explain—which I did, though palsied would have been my tongue if I could have foreseen the consequences. Bewailing their previous ignorance of the advantages of combining their industries, my parents at once took measures to repair the error. My mother removed her studio to a wing of the factory building and my duties in connection with the business ceased; I was no longer required to dispose of the bodies of the small superfluous, and there was no need of alluring dogs to their doom, for my father discarded them altogether, though they still had an honorable place in the name of the oil. So suddenly thrown into idleness, I might naturally have been expected to become vicious and dissolute, but I did not. The holy influence of my dear mother was ever about me to protect me from the temptations which beset youth, and my father was a deacon in a church. Alas, that through my fault these estimable persons should have come to so bad an end!

Finding a double profit in her business, my mother now devoted herself to it with a new assiduity. She removed not only superfluous and unwelcome babes to order, but went out into the highways and byways, gathering in children of a larger growth, and even such adults as she could entice to the oilery. My father, too, enamored of the superior quality of oil produced, purveyed for his vats with diligence and zeal. The conversion of their neighbors into dog-oil became, in short, the one passion of their lives—an absorbing and overwhelming greed took possession of their souls and served them in place of a hope in Heaven—by which, also, they were inspired.

So enterprising had they now become that a public meeting was held and resolutions passed severely censuring them. It was intimated by the chairman that any further raids upon the population would be met in a spirit of hostility. My poor parents left the meeting brokenhearted, desperate and, I believe, not altogether sane. Anyhow, I deemed it prudent not to enter the oilery with them that night, but slept outside in a stable.

At about midnight some mysterious impulse caused me to rise and peer through a window into the furnace-room, where I knew my father now slept. The fires were burning as brightly as if the following day's harvest had been expected to be abundant. One of the large cauldrons was slowly "walloping" with a mysterious appearance to self-restraint, as if it bided its time to put forth its full energy. My father was not in bed; he had risen in his nightclothes and was preparing a noose in a strong cord. From the looks which he cast at the door of my mother's bedroom I knew too well the purpose that he had in mind. Speechless

and motionless with terror, I could do nothing in prevention or warning. Suddenly the door of my mother's apartment was opened, noiselessly, and the two confronted each other, both apparently surprised. The lady, also, was in her nightclothes, and she held in her right hand the tool of her trade, a long, narrow-bladed dagger.

She, too, had been unable to deny herself the last profit which the unfriendly action of the citizens and my absence had left her. For one instant they looked into each other's blazing eyes and then sprang together with indescribable fury. Round and round the room they struggled, the man cursing, the woman shrieking, both fighting like demons—she to strike him with the dagger, he to strangle her with his great bare hands. I know not how long I had the unhappiness to observe this disagreeable instance of domestic infelicity, but at last, after a more than usually vigorous struggle, the combatants suddenly moved apart.

My father's breast and my mother's weapon showed evidences of contact. For another instant they glared at each other in the most un-amiable way; then my poor, wounded father, feeling the hand of death upon him, leaped forward, unmindful of resistance, grasped my dear mother in his arms, dragged her to the side of the boiling cauldron, collected all his failing energies, and sprang in with her! In a moment, both had disappeared and were adding their oil to that of the committee of citizens who had called the day before with an invitation to the public meeting.

Convinced that these unhappy events closed to me every avenue to an honorable career in that town, I removed to the famous city of Otumwee where these memoirs are written with a heart full of remorse for a heedless act entailing so dismal a commercial disaster.

WRITE IT RIGHT

In 1909, while preparing his collected works, Bierce took the time to dash off a handbook of proper English usage, a crotchety work conservative to the point of austerity. He could not turn the tide—much of what he railed against had been evolving since Shakespeare—but he made many of his points with wit and precision, and those have been preserved here.

The only writer allowed to make fun of Bierce was Bierce, and in compiling this book, as well as *The Devil's Dictionary,* he indulged in some of his usual tomfoolery: An early definition, dropped from the final version of that volume, read "Gent, n. The vulgarian's ideal of a gentleman. The male of the genus Hoodlum." This was followed by a nice bit of doggerel:

> Observe with care, my son, the distinction I reveal:
> A gentleman is gentle and a gent genteel.
> Heed not the definitions your "Unabridged" presents,
> For dictionary makers are generally gents.

WRITE IT RIGHT

A LITTLE BLACKLIST OF LITERARY FAULTS

Aims and the Plan

The author's main purpose in this book is to teach precision in writing; and of good writing (which, essentially, is clear thinking made visible) precision is the point of capital concern. It is attained by choice of the word that accurately and adequately expresses what the writer has in mind, and by exclusion of that which either denotes or connotes something else. As Quintilian puts it, the writer should so write that his reader not only may, but must, understand.

Few words have more than one literal and serviceable meaning, however many metaphorical, derivative, related, or even unrelated, meanings lexicographers may think it worth while to gather from all sorts and conditions of men, with which to bloat their absurd and misleading dictionaries. This actual and serviceable meaning—not always determined by derivation, and seldom by popular usage—is the one affirmed, according to his light, by the author of this little manual of solecisms. Narrow etymons of the mere scholar and loose locutions of the ignorant are alike denied a standing.

The plan of the book is more illustrative than expository, the aim being to use the terms of etymology and syntax as little as is compatible with clarity, familiar example being more easily apprehended than technical precept. When both are employed the precept is commonly given after the example has prepared the student to apply it, not only to the matter in mind, but to similar matters not mentioned. Everything in quotation marks is to be understood as disapproved.

THE BLACKLIST

Action for Act. "In wrestling, a blow is a reprehensible action." A blow is not an action but an act. An action may consist of many acts.

Admission for **Admittance.** "The price of admission is one dollar."

Admit for **Confess.** To admit is to concede something affirmed. An unaccused offender cannot admit his guilt.

Adopt. "He adopted a disguise." One may adopt a child, or an opinion, but a disguise is assumed.

Advisedly for **Advertently, Intentionally.** "It was done advisedly" should mean that it was done after advice.

Afford. It is not well to say "the fact affords a reasonable presumption"; "the house afforded ample accommodation." The fact supplies a reasonable presumption. The house offered, or gave, ample accommodation.

Aggravate for **Irritate.** "He aggravated me by his insolence." To aggravate is to augment the disagreeableness of something already disagreeable, or the badness of something bad. But a person cannot be aggravated, even if disagreeable or bad. Women are singularly prone to misuse of this word.

All of. "He gave all of his property." The words are contradictory: an entire thing cannot be of itself. Omit the preposition.

Alleged. "The alleged murderer." One can allege a murder, but not a murderer; a crime, but not a criminal. A man that is merely suspected of crime would not, in any case, be an alleged criminal, for an allegation is a definite and positive statement. In their tiresome addiction to this use of alleged, the newspapers, though having mainly in mind the danger of libel suits, can urge in further justification the lack of any other single word that exactly expresses their meaning; but the fact that a mud-puddle supplies the shortest route is not a compelling reason for walking through it. One can go around.

Allow for **Permit.** "I allow you to go." Precision is better attained by saying permit, for allow has other meanings.

Anticipate for **Expect.** "I anticipate trouble." To anticipate is to act on an expectation in a way to promote or forestall the event expected.

Anxious for **Eager.** "I was anxious to go." Anxious should not be followed by an infinitive. Anxiety is contemplative; eagerness, alert for action.

Appreciate for **Highly Value.** In the sense of value, it means value justly, not highly. In another and preferable sense it means to increase in value.

Appropriated for *Took.* "He appropriated his neighbor's horse to his own use." To appropriate is to set apart, as a sum of money, for a special purpose."

Apt for *Likely.* "One is apt to be mistaken." Apt means facile, felicitous, ready, and the like; but even the dictionary-makers cannot persuade a person of discriminating taste to accept it as synonymous with likely.

Around for *About.* "The débris of battle lay around them." "The huckster went around, crying his wares." Around carries the concept of circularity.

At for *By.* "She was shocked at his conduct." This very common solecism is without excuse.

Attain for *Accomplish.* "By diligence we attain our purpose." A purpose is accomplished; success is attained.

Authoress. A needless word—as needless as "poetess."

Avocation for *Vocation.* A vocation is, literally, a calling; that is, a trade or profession. An avocation is something that calls one away from it. If I say that farming is some one's avocation I mean that he practises it, not regularly, but at odd times.

Avoid for *Avert.* "By displaying a light the skipper avoided a collision." To avoid is to shun; the skipper could have avoided a collision only by getting out of the way.

Badly for *Bad.* "I feel badly." "He looks badly." The former sentence implies defective nerves of sensation, the latter, imperfect vision. Use the adjective.

Both alike. "They are both alike." Say, they are alike. One of them could not be alike.

Brainy. Pure slang, and singularly disagreeable.

Bug for *Beetle,* or for anything. Do not use it.

Business for *Right.* "He has no business to go there."

Build for *Make.* "Build a fire." "Build a canal." Even "build a tunnel" is not unknown, and probably if the woodchuck is skilled in the American tongue he speaks of building a hole.

By for *Of.* "A man by the name of Brown." Say, of the name. Better than either form is: a man named Brown.

Calculated for *Likely.* "The bad weather is calculated to produce sickness." Calculated implies calculation, design.

Candidate for *Aspirant.* In American politics, one is not a candidate for an office until formally named (nominated) for it by a convention, or otherwise, as provided by law or custom. So when a man who is moving Heaven and Earth to procure the nomination protests that he is "not a candidate" he tells the truth in order to deceive.

Capable. "Men are capable of being flattered." Say, susceptible to flattery. "Capable of being refuted." Vulnerable to refutation. Unlike capacity, capability is not passive, but active. We are capable of doing, not of having something done to us.

Capacity for *Ability.* "A great capacity for work." Capacity is receptive; ability, potential. A sponge has capacity for water; the hand, ability to squeeze it out.

Casket for *Coffin.* A needless euphemism affected by undertakers.

Casualties for *Losses* in Battle. The essence of casualty is accident, absence of design. Death and wounds in battle are produced otherwise, are expectable and expected, and, by the enemy, intentional.

Chance for *Opportunity.* "He had a good chance to succeed."

Chivalrous. The word is popularly used in the Southern States only, and commonly has reference to men's manner toward women. Archaic, stilted and fantastic.

Claim for *Affirm.* "I claim that he is elected." To claim is to assert ownership.

Climb down. In climbing one ascends.

Coat for *Coating.* "A coat of paint, or varnish." If we coat something we produce a coating, not a coat.

Colonel, Judge, Governor, etc., for *Mister.* Give a man a title only if it belongs to him, and only while it belongs to him.

Commencement for *Termination.* A contribution to our noble tongue by its scholastic conservators, "commencement day" being their name for the last day of the collegiate year. It is ingeniously defended on the ground that on that day those on whom degrees are bestowed commence to hold them. Lovely!

Commit Suicide. Instead of "He committed suicide," say, He killed himself, or, He took his life. For married we do not say "committed matrimony." Unfortunately most of us do say, "got married," which is almost as bad. For lack of a suitable verb we just sometimes say

committed this or that, as in the instance of bigamy, for the verb to bigam is a blessing that is still in store for us.

Compare with for Compare to. "He had the immodesty to compare himself with Shakespeare." Nothing necessarily immodest in that. Comparison with may be for observing a difference; comparison to affirms a similarity.

Complected. Anticipatory past participle of the verb "to complect." Let us wait for that.

Conscious for Aware. "The King was conscious of the conspiracy." We are conscious of what we feel; aware of what we know.

Consent for Assent. "He consented to that opinion." To consent is to agree to a proposal; to assent is to agree with a proposition.

Conservative for Moderate. "A conservative estimate"; "a conservative forecast"; "a conservative statement," and so on. These and many other abuses of the word are of recent growth in the newspapers and "halls of legislation." Having been found to have several meanings, conservative seems to be thought to mean everything.

Continually and Continuously. It seems that these words should have the same meaning, but in their use by good writers there is a difference. What is done continually is not done all the time, but continuous action is without interruption. A loquacious fellow, who nevertheless finds time to eat and sleep, is continually talking; but a great river flows continuously.

Couple for Two. For two things to be a couple they must be of one general kind, and their number unimportant to the statement made of them. It would be weak to say, "He gave me only one, although he took a couple for himself." Couple expresses indifference to the exact number, as does several. That is true, even in the phrase, a married couple, for the number is carried in the adjective and needs no emphasis.

Created for First Performed. Stage slang. "Burbage created the part of Hamlet." What was it that its author did to it?

Critically for Seriously. "He has long been critically ill." A patient is critically ill only at the crisis of his disease.

Criticise for Condemn, or Disparage. Criticism is not necessarily censorious; it may approve.

Custom for Habit. Communities have customs; individuals, habits—commonly bad ones.

Declared for Said. To a newspaper reporter no one seems ever to

say anything; all "declare." Like "alleged" (which see) the word is tiresome exceedingly.

Deliver. "He delivered an oration," or "delivered a lecture." Say, He made an oration, or gave a lecture.

Demean for *Debase* or *Degrade.* "He demeaned himself by accepting charity." The word relates, not to meanness, but to demeanor, conduct, behavior. One may demean oneself with dignity and credit.

Demise for *Death.* Usually said of a person of note. Demise means the lapse, as by death, of some authority, distinction or privilege, which passes to another than the one that held it; as the demise of the Crown.

Deprivation for *Privation.* "The mendicant showed the effects of deprivation." Deprivation refers to the act of depriving, taking away from; privation is the state of destitution, of not having.

Distinctly for *Distinctively.* "The custom is distinctly Oriental." Distinctly is plainly; distinctively, in a way to distinguish one thing from others.

Essential for *Necessary.* This solecism is common among the best writers of this country and England. "It is essential to go early"; "Irrigation is essential to cultivation of arid lands," and so forth. One thing is essential to another thing only if it is of the essence of it—an important and indispensable part of it, determining its nature; the soul of it.

Even for *Exact.* "An even dozen."

Every for *Ever.* "Every now and then." This is nonsense: there can be no such thing as a now and then, nor, of course, a number of now and thens. Now and then is itself bad enough, reversing as it does the sequence of things, but it is idiomatic and there is no quarreling with it. But "every" is here a corruption of ever, meaning repeatedly, continually.

Excessively for *Exceedingly.* "The disease is excessively painful." "The weather is excessively cold." Anything that is painful at all is excessively so. Even a slight degree or small amount of what is disagreeable or injurious is excessive—that is to say, redundant, superfluous, not required.

Executed. "The condemned man was executed." He was hanged, or otherwise put to death; it is the sentence that is executed.

Fail. "He failed to note the hour." That implies that he tried to note it, but did not succeed. Failure carries always the sense of endeavor; when

there has been no endeavor there is no failure. A falling stone cannot fail to strike you, for it does not try; but a marksman firing at you may fail to hit you; and I hope he always will.

Favor for *Resemble.* "The child favors its father."

Fetch for *Bring.* Fetching includes, not only bringing, but going to get—going for and returning with. You may bring what you did not go for.

Forebears for *Ancestors.* The word is sometimes spelled forbears, a worse spelling than the other, but not much. If used at all it should be spelled *forebeers,* for it means those who have *been* before. A forebe-er is one who fore-was. Considered in any way, it is a senseless word.

Forecasted. For this abominable word we are indebted to the weather bureau—at least it was not sent upon us until that affliction was with us. Let us hope that it may some day be losted from the language.

Funds for *Money.* "He was out of funds." Funds are not money in general, but sums of money or credit available for particular purposes.

Furnish for *Provide, or Supply.* "Taxation furnished the money." A pauper may furnish a house if some one will provide the furniture, or the money to buy it. "His flight furnishes a presumption of guilt." It supplies it.

Generally for *Usually.* "The winds are generally high." "A fool is generally vain." This misuse of the word appears to come of abbreviating: Generally speaking, the weather is bad. A fool, to speak generally, is vain.

Gentleman. It is not possible to teach the correct use of this overworked word: one must be bred to it. Everybody knows that it is not synonymous with man, but among the "genteel" and those ambitious to be thought "genteel" it is commonly so used in discourse too formal for the word "gent." To use the word gentleman correctly, be one.

Got Married for *Married.* If this is correct we should say, also, "got dead" for died; one expression is as good as the other.

Gratuitous for *Unwarranted.* "A gratuitous assertion." Gratuitous means without cost.

Gubernatorial. Eschew it; it is not English, is needless and bombastic. Leave it to those who call a political office a "chair." "Gubernatorial chair" is good enough for them. So is hanging.

Hail for *Come.* "He hails from Chicago." This is sea speech, and

comes from the custom of hailing passing ships. It will not do for serious discourse.

Have Got for *Have.* "I have got a good horse" directs attention rather to the act of getting than to the state of having, and represents the capture as recently completed.

Hereafter for *Henceforth.* Hereafter means at some time in the future; henceforth, always in the future. The penitent who promises to be good hereafter commits himself to the performance of a single good act, not to a course of good conduct.

Horseflesh for *Horses.* A singularly senseless and disagreeable word which, when used, as it commonly is, with reference to hippophilism, savors rather more of the spit than of the spirit.

Humans as a Noun. We have no single word having the general yet limited meaning that this is sometimes used to express—a meaning corresponding to that of the word animals, as the word men would if it included women and children. But there is time enough to use two words.

Hurry for *Haste* and *Hasten.* To hurry is to hasten in a more or less disorderly manner. Hurry is misused, also, in another sense: "There is no hurry"—meaning, There is no reason for haste.

Imaginary Line. The adjective is needless. Geometrically, every line is imaginary; its graphic representation is a mark. True the textbooks say, draw a line, but in a mathematical sense the line already exists; the drawing only makes its course visible.

Inaugurate for *Begin, Establish,* etc. Inauguration implies some degree of formality and ceremony.

Insignificant for *Trivial, or Small.* Insignificant means not signifying anything, and should be used only in contrast, expressed or implied, with something that is important for what it implies. The bear's tail may be insignificant to a naturalist tracing the animal's descent from an earlier species, but to the rest of us, not concerned with the matter, it is merely small.

Integrity for *Honesty.* The word means entireness, wholeness. It may be rightly used to affirm possession of all the virtues, that is, unity of moral character.

Item for *Brief Article.* Commonly used of a narrative in a newspaper. Item connotes an aggregate of which it is a unit—one thing of many. Hence it suggests more than we may wish to direct attention to.

Juncture. Juncture means a joining, a junction; its use to signify a time, however critical a time, is absurd. "At this juncture the woman screamed." In reading that account of it we scream too.

Just Exactly. Nothing is gained in strength nor precision by this kind of pleonasm. Omit just.

Juvenile for *Child.* This needless use of the adjective for the noun is probably supposed to be humorous, like "canine" for dog, "optic" for eye, "anatomy" for body, and the like. Happily the offense is not very common.

Last and *Past.* "Last week." "The past week." Neither is accurate: a week cannot be the last if another is already begun; and all weeks except this one are past. Here two wrongs seem to make a right: we can say the week last past. But will we? I trow not.

Laundry. Meaning a place where clothing is washed, this word cannot mean, also, clothing sent there to be washed.

Lease. To say of a man that he leases certain premises leaves it doubtful whether he is lessor or lessee. Being ambiguous, the word should be used with caution.

Leave for *Let.* "Leave it alone." By this many persons mean, not that it is to be left in solitude, but that it is to be untouched, or unmolested.

Lengthy. Usually said in disparagement of some wearisome discourse. It is no better than breadthy, or thicknessy.

Liable for *Likely.* "Man is liable to err." Man is not liable to err, but to error. Liable should be followed, not by an infinitive, but by a preposition.

Likely for *Probably.* "He will likely be elected." If likely is thought the better word (and in most cases it is) put it this way: "It is likely that he will be elected," or, "He is likely to be elected."

Limited for *Small, Inadequate,* etc. "The army's operations were confined to a limited area." "We had a limited supply of food." A large area and an adequate supply would also be limited. Everything that we know about is limited.

Literally for *Figuratively.* "The stream was literally alive with fish." "His eloquence literally swept the audience from its feet." It is bad enough to exaggerate, but to affirm the truth of the exaggeration is intolerable.

Locate. "After many removals the family located at Smithville." Some dictionaries give locate as an intransitive verb having that meaning, but—well, dictionaries are funny.

Maintain for *Contend.* "The senator maintained that the tariff was iniquitous." He maintained it only if he proved it.

Majority for *Plurality.* Concerning votes cast in an election, a majority is more than half the total; a plurality is the excess of one candidate's votes over another's. Commonly the votes compared are those for the successful candidate and those for his most nearly successful competitor.

Mend for *Repair.* "They mended the road." To mend is to repair, but to repair is not always to mend. A stocking is mended, a road repaired.

Militate. "Negligence militates against success." If "militate" meant anything it would mean fight, but there is no such word.

Moneyed for *Wealthy.* "The moneyed men of New York." One might as sensibly say, "The cattled men of Texas," or, "The lobstered men of the fish market."

Mutual. By this word we express a reciprocal relation. It implies exchange, a giving and taking, not a mere possessing in common. There can be a mutual affection, or a mutual hatred, but not a mutual friend, nor a mutual horse.

Negotiate. From the Latin *negotium.* It means, as we all know, to fix the terms for a transaction, to bargain. But when we say, "The driver negotiated a difficult turn of the road," or, "The chauffeur negotiated a hill," we speak nonsense.

Occasion for *Induce,* or *Cause.* "His arrival occasioned a great tumult." As a verb, the word is needless and unpleasing.

Opposite for *Contrary.* "I hold the opposite opinion." "The opposite practice."

Ovation. In ancient Rome an ovation was an inferior triumph accorded to victors in minor wars or unimportant battle. Its character and limitations, like those of the triumph, were strictly defined by law and custom. An enthusiastic demonstration in honor of an American civilian is nothing like that, and should not be called by its name.

Over for *More than.* "A sum of over ten thousand dollars." "Upward of ten thousand dollars" is equally objectionable.

Over for *On.* "The policeman struck him over the head." If the blow was over the head it did not hit him.

Partially for *Partly.* A dictionary word, to swell the book.

Patron for *Customer.*

Pay for *Give, Make, etc.* "He pays attention." "She paid a visit to Niagara." It is conceivable that one may owe attention or a visit to another person, but one cannot be indebted to a place.

Pay. "Laziness does not pay." "It does not pay to be uncivil." This use of the word is grossly commercial. Say, Indolence is unprofitable. There is no advantage in incivility.

Peculiar for *Odd, or Unusual.* Also sometimes used to denote distinction, or particularity. Properly a thing is peculiar only to another thing, of which it is characteristic, nothing else having it; as knowledge of the use of fire is peculiar to Man.

Phenomenal for *Extraordinary, or Surprising.* Everything that occurs is phenomenal, for all that we know about is phenomena, appearances. Of realities, noumena, we are ignorant.

Poetry for *Verse.* Not all verse is poetry; not all poetry is verse. Few persons can know, or hope to know, the one from the other, but he who has the humility to doubt (if such a one there be) should say verse if the composition is metrical.

Point Blank. "He fired at him point blank." This usually is intended to mean directly, or at short range. But point blank means the point at which the line of sight is crossed downward by the trajectory—the curve described by the missile.

Poisonous for *Venomous.* Hemlock is poisonous, but a rattlesnake is venomous.

Practically for *Virtually.* This error is very common. "It is practically conceded." "The decision was practically unanimous." "The panther and the cougar are practically the same animal." These and similar misapplications of the word are virtually without excuse.

Preparedness for *Readiness.* An awkward and needless word much used in discussion of national armaments, as, "Our preparedness for war."

Pretend for *Profess.* "I do not pretend to be infallible." Of course not; one does not care to confess oneself a pretender. To pretend is to try to deceive; one may profess quite honestly.

Preventative for *Preventive.* No such word as preventative.

Propose for *Purpose,* or *Intend.* "I propose to go to Europe." A mere intention is not a proposal.

Proportions for *Dimensions.* "A rock of vast proportions." Proportions relate to form; dimensions to magnitude.

Raise for *Bring up, Grow, Breed,* etc. In this country a word-of-all-work: "raise children," "raise wheat," "raise cattle." Children are brought up, grain, hay and vegetables are grown, animals and poultry are bred.

Recollect for *Remember.* To remember is to have in memory; to recollect is to recall what has escaped from memory. We remember automatically; in recollecting we make a conscious effort.

Refused. "He was refused a crown." It is the crown that was refused to him.

Reliable for *Trusty,* or *Trustworthy.* A word not yet admitted to the vocabulary of the fastidious, but with a strong backing for the place.

Rendition for *Interpretation,* or *Performance.* "The actor's rendition of the part was good." Rendition means a surrender, or a giving back.

Reportorial. A vile word, improperly made. It assumes the Latinized spelling, "reportor." The Romans had not the word, for they were, fortunately for them, without the thing.

Respect for *Way,* or *Matter.* "They were alike in that respect." The misuse comes of abbreviating: the sentence properly written might be, They were alike in respect of that—*i.e.,* with regard to that. The word in the bad sense has even been pluralized: "In many respects it is admirable."

Respective. "They went to their respective homes." The adjective here (if an adjective is thought necessary) should be several. In the adverbial form the word is properly used in the sentence following: John and James are bright and dull, respectively. That is, John is bright and James dull.

Responsible. "The bad weather is responsible for much sickness." "His intemperance was responsible for his crime." Responsibility is not an attribute of anything but human beings, and few of these can respond, in damages or otherwise. Responsible is nearly synonymous with accountable and answerable, which, also, are frequently misused.

Roomer for *Lodger.* See *Bedder* and *Mealer*—if you can find them.

Ruination for *Ruin.* Questionably derived and problematically needful.

Scholar for *Student,* or *Pupil.* A scholar is a person who is learned, not a person who is learning.

Secure for *Procure.* "He secured a position as book-keeper." "The dwarf secured a stick and guarded the jewels that he had found." Then it was the jewels that were secured.

Self-confessed. "A self-confessed assassin." Self is superfluous: one's sins cannot be confessed by another.

Sensation for *Emotion.* "The play caused a great sensation." "A sensational newspaper." A sensation is a physical feeling; an emotion, a mental. Doubtless the one usually accompanies the other, but the good writer will name the one that he has in mind, not the other. There are few errors more common than the one here noted.

Smart for *Bright,* or *Able.* An Americanism that is dying out. But "smart" has recently come into use for fashionable, which is almost as bad.

Snap for *Period* (of time) or *Spell.* "A cold snap." This is a word of incomprehensible origin in that sense; we can know only that its parents were not respectable. "Spell" is itself not very well-born.

Spend for *Pass.* "We shall spend the summer in Europe." Spend denotes a voluntary relinquishment, but time goes from us against our will.

State for *Say.* "He stated that he came from Chicago." "It is stated that the president is angry." We state a proposition, or a principle, but say that we are well. And we say our prayers—some of us.

Still Continue. "The rain still continues." Omit still; it is contained in the other word.

Stock. "I take no stock in it." Disagreeably commercial. Say, I have no faith in it. Many such metaphorical expressions were unobjectionable, even pleasing, in the mouth of him who first used them, but by constant repetition by others have become mere slang, with all the offensiveness of plagiarism. The prime objectionableness of slang is its hideous lack of originality. Until mouthworn it is not slang.

Stop for *Stay.* "Prayer will not stop the ravages of cholera." Stop is frequently misused for stay in another sense of the latter word: "He is

stopping at the hotel." Stopping is not a continuing act; one cannot be stopping who has already stopped.

Substantiate for *Prove.* Why?

Such Another for *Another Such.* There is illustrious authority for this—in poetry. Poets are a lawless folk, and may do as they please so long as they do please.

Such for *So.* "He had such weak legs that he could not stand." The absurdity of this is made obvious by changing the form of the statement: "His legs were such weak that he could not stand." If the word is an adverb in the one sentence it is in the other. "He is such a great bore that none can endure him." Say, so great a bore.

Survive for *Live,* or *Persist.* Survival is an outliving, or outlasting of something else. "The custom survives" is wrong, but a custom may survive its utility. Survive is a transitive verb.

Sustain for *Incur.* "He sustained an injury." "He sustained a broken neck." That means that although his neck was broken he did not yield to the mischance.

The Following. "Washington wrote the following." The following what? Put in the noun. "The following animals are ruminants." It is not the animals that follow, but their names.

Then as an Adjective. "The then governor of the colony." Say, the governor of the colony at that time.

To. As part of an infinitive it should not be separated from the other part by an adverb, as, "to hastily think," for hastily to think, or, to think hastily. Condemnation of the split infinitive is now pretty general, but it is only recently that any one seems to have thought of it. Our forefathers and we elder writers of this generation used it freely and without shame—perhaps because it had not a name, and our crime could not be pointed out without too much explanation.

Transaction for *Action,* or *Incident.* "The policeman struck the man with his club, but the transaction was not reported." "The picking of a pocket is a criminal transaction." In a transaction two or more persons must have an active or assenting part; as, a business transaction, Transactions of the Geographical Society, etc. The Society's action would be better called Proceedings.

Transpire for *Occur, Happen,* etc. "This event transpired in 1906." Transpire (*trans,* through, and *spirare,* to breathe) means leak out, that is, become known. What transpired in 1906 may have occurred long before.

Try an Experiment. An experiment is a trial; we cannot try a trial. Say, make.

Try and for *Try to.* "I will try and see him." This plainly says that my effort to see him will succeed—which I cannot know and do not wish to affirm. "Please try and come." This colloquial slovenliness of speech is almost universal in this country, but freedom of speech is one of our most precious possessions.

Ugly for *Ill-natured, Quarrelsome.* What is ugly is the temper, or disposition, not the person having it.

Unique. "This is very unique." "The most unique house in the city." There are no degrees of uniqueness: a thing is unique if there is not another like it. The word has nothing to do with oddity, strangeness, nor picturesqueness.

Unkempt for *Disordered, Untidy,* etc. Unkempt means uncombed, and can properly be said of nothing but the hair.

Utter for *Absolute, Entire,* etc. Utter has a damnatory signification and is to be used of evil things only. It is correct to say utter misery, but not "utter happiness;" utterly bad, but not "utterly good."

Various for *Several.* "Various kinds of men." Kinds are various of course, for they vary—that is what makes them kinds. Use various only when, in speaking of a number of things, you wish to direct attention to their variety—their difference, one from another. "The dividend was distributed among the various stockholders." The stockholders vary, as do all persons, but that is irrelevant and was not in mind. "Various persons have spoken to me of you." Their variation is unimportant; what is meant is that there was a small indefinite number of them; that is, several.

Ventilate for *Express, Disclose,* etc. "The statesman ventilated his views." A disagreeable and dog-eared figure of speech.

Wed for *Wedded.* "They were wed at noon." "He wed her in Boston." The word wed in all its forms as a substitute for marry, is pretty hard to bear.

Well. As a mere meaningless prelude to a sentence this word is overtasked.

Win out. Like its antithesis, "lose out," this reasonless phrase is of sport, "sporty."

Witness for *See.* To witness is more than merely to see, or observe; it is to observe, and to tell afterward.

Would-be. "The would-be assassin was arrested." The word doubt-less supplies a want, but we can better endure the want than the word. In the instance of the assassin, it is needless, for he who attempts to murder is an assassin, whether he succeeds or not.

THE
DEVIL'S
DICTIONARY

This book has a curious history. Bierce had occasionally run items containing definitions in the *News Letter* and had generally credited them to "The Idiots' Unabridged Dictionary." He eventually abandoned the idea until 1881, when he revived the format in *Wasp* as "The Devil's Dictionary" and ran items as a regular feature. Oddly enough, he began with the letter *P* and moved forward from there before circling back to *A*. The pieces were quite popular, but he discontinued them when he went to work for the *San Francisco Examiner*.

In 1906, the definitions were collected into a book with the bowdlerized title *The Cynic's Word-Book*. It contained only definitions from *A* to *L*. While preparing his collected works in 1911, when he was living in Washington, D.C., he added as much of the remainder as he could lay his hands upon and wrote many new definitions. He also appended a great deal of doggerel, some published other places, not always entirely germane. This has been cut, along with some definitions neither relevant to today nor to "enlightened souls who prefer dry wines to sweet, sense to sentiment, wit to humor and clean English to slang."

A

Abasement, n. A decent and customary mental attitude in the presence of wealth or power. Peculiarly appropriate in an employee when addressing an employer.

Abdication, n. An act whereby a sovereign attests his sense of the high temperature of the throne.

Abdomen, n. The temple of the god Stomach, in whose worship, with sacrificial rights, all true men engage. From women this ancient faith commands but a stammering assent. They sometimes minister at the altar in a half-hearted and ineffective way, but true reverence for the one deity that men really adore they know not. If women had a free hand in the world's marketing the race would become graminivorous.

Aberration, n. Any deviation in another from one's own habit of thought, not sufficient in itself to constitute insanity.

Abet, v.t. To encourage in crime, as to aid poverty with pennies.

Ability, n. The natural equipment to accomplish some small part of the meaner ambitions distinguishing able men from dead ones. In the last analysis ability is commonly found to consist mainly in a high degree of solemnity. Perhaps, however, this impressive quality is rightly appraised; it is no easy task to be solemn.

Abnormal, adj. Not conforming to standard. In matters of thought and conduct, to be independent is to be abnormal, to be abnormal is to be detested. Wherefore the lexicographer adviseth a striving toward a straiter resemblance to the Average Man than he hath to himself. Whoso attaineth thereto shall have peace, the prospect of death and the hope of Hell.

Aborigines, n. Persons of little worth found cumbering the soil of a newly discovered country. They soon cease to cumber; they fertilize.

Abroad, adj. At war with savages and idiots. To be a Frenchman abroad is to be miserable; to be an American abroad is to make others miserable.

Abrupt, adj. Sudden, without ceremony, like the arrival of a cannon-shot and the departure of the soldier whose interests are most affected by it. Dr. Samuel Johnson beautifully said of another author's ideas that they were "concatenated without abruption."

Abscond, v. i. To "move in a mysterious way," commonly with the property of another.

Absence, n. That which "makes the heart grow fonder"—of absence. Absence of mind is the cerebral condition essential to success in popular preaching. It is sometimes termed lack of sense.

Absent, adj. Peculiarly exposed to the tooth of detraction; vilified; hopelessly in the wrong; superseded in the consideration and affection of another.

Absentee, n. A person with an income who has had the forethought to remove himself from the sphere of exaction.

Absolute, adj. Independent, irresponsible. An absolute monarchy is one in which the sovereign does as he pleases so long as he pleases the assassins. Not many absolute monarchies are left, most of them having been replaced by limited monarchies, where the sovereign's power for evil (and for good) is greatly curtailed, and by republics, which are governed by chance.

Abstainer, n. A weak person who yields to the temptation of

denying himself a pleasure. A total abstainer is one who abstains from everything but abstention, and especially from inactivity in the affairs of others.

Absurdity, *n.* A statement or belief manifestly inconsistent with one's own opinion.

Abuse, *n.* Unanswerable wit.

Academe, *n.* An ancient school where morality and philosophy were taught.

Academy, *n. (from academe).* A modern school where football is taught.

Accident, *n.* An inevitable occurrence due to the action of immutable natural laws.

Accomplice, *n.* One associated with another in a crime, having guilty knowledge and complicity, as an attorney who defends a criminal, knowing him guilty. This view of the attorney's position in the matter has not hitherto commanded the assent of attorneys, no one having offered them a fee for assenting.

Accord, *n.* Harmony.

Accordion, *n.* An instrument in harmony with the sentiments of an assassin.

Accountability, *n.* The mother of caution.

Achievement, *n.* The death of endeavor and the birth of disgust.

Acknowledge, *v. t.* To confess. Acknowledgment of one another's faults is the highest duty imposed by our love of truth.

Acquaintance, *n.* A person whom we know well enough to borrow from, but not well enough to lend to. A degree of friendship called slight when its object is poor or obscure, and intimate when he is rich or famous.

Acquit, *v. t.* To render judgment in a murder case in San Francisco.

Actually, *adv.* Perhaps; possibly.

Adage, *n.* Boned wisdom for weak teeth.

Adamant, *n.* A mineral frequently found beneath a corset. Soluble in solicitate of gold.

Adder, *n.* A species of snake. So called from its habit of adding funeral outlays to the others expenses of living.

Adherent, n. A follower who has not yet obtained all that he expects to get.

Administration, n. An ingenious abstraction in politics, designed to receive the kicks and cuffs due to the premier or president. A man of straw, proof against bad-egging and dead-catting.

Admiral, n. That part of a war-ship which does the talking while the figure-head does the thinking.

Admiration, n. Our polite recognition of another's resemblance to ourselves.

Adore, v. t. To venerate expectantly.

Advice, n. The smallest current coin.

Aesthetics, n. The most unpleasant ticks afflicting the race. Worse than wood-ticks.

Affection, n. In morals, a sentiment; in medicine, a disease. To a young woman an affection of the heart means love; to a doctor it may mean fatty degeneration. The difference is one of nomenclature merely.

Affectionate, adj. Addicted to being a nuisance. The most affectionate creature in the world is a wet dog.

Affianced, pp. Fitted with an ankle-ring for the ball-and-chain.

Affliction, n. An acclimatizing process preparing the soul for another and bitter world.

Affirm, v. t. To declare with suspicious gravity when one is not compelled to wholly discredit himself with an oath.

Age, n. That period of life in which we compound for the vices that we still cherish by reviling those that we have no longer the enterprise to commit.

Agitator, n. A statesman who shakes the fruit trees of his neighbors—to dislodge the worms.

Agrarian, n. A politician who carries his real estate under his nails. A son of the soil who, like Aeneas, carries his father on his person.

Air, n. A nutritious substance supplied by a bountiful Providence for the fattening of the poor.

Alderman, n. An ingenious criminal who covers his secret thieving with a pretence of open marauding.

Alien, n. An American sovereign in his probationary state.

Allegiance, n. The traditional bond of duty between the taxer and the taxee. It is not reversible.

Alliance, n. In international politics, the union of two thieves who have their hands so deeply inserted in each other's pocket that they cannot separately plunder a third.

Alone, adj. In bad company.

Amateur, n. A public nuisance who mistakes taste for skill, and confounds his ambition with his ability.

Amazon, n. One of an ancient race who do not appear to have been much concerned about woman's rights and the equality of the sexes. Their thoughtless habit of twisting the necks of the males has unfortunately resulted in the extinction of their kind.

Ambidextrous, adj. Able to pick with equal skill a right-hand pocket or a left.

Ambition, n. An overmastering desire to be vilified by enemies while living and made ridiculous by friends when dead.

Amnesty, n. The state's magnanimity to those offenders whom it would be too expensive to punish.

Anoint, v. t. To grease a king or other great functionary already sufficiently slippery.

Antipathy, n. The sentiment inspired by one's friend's friend.

Aphorism, n. Predigested wisdom.

Apologize, v. i. To lay the foundation for a future offence.

Apostate, n. A leech who, having penetrated the shell of a turtle only to find that the creature has long been dead, deems it expedient to form a new attachment to a fresh turtle.

Apothecary, n. The physician's accomplice, undertaker's benefactor and grave worm's provider.

Appeal, v. t. In law, to put the dice into the box for another throw.

Appetite, n. An instinct thoughtfully implanted by Providence as a solution to the labor question.

Applause, n. The echo of a platitude.

Architect, n. One who drafts a plan of your house, and plans a draft of your money.

Ardor, n. The quality that distinguishes love without knowledge.

Arena, n. In politics, an imaginary rat-pit in which the statesman wrestles with his record.

Aristocracy, n. Government by the best men. (In this sense the word is obsolete; so is that kind of government.) Fellows that wear downy hats and clean shirts—guilty of education and suspected of bank accounts.

Armor, n. The kind of clothing worn by a man whose tailor is a blacksmith.

Arrayed, pp. Drawn up and given an orderly disposition, as a rioter hanged to a lamppost.

Arrest, v. t. Formally to detain one accused of unusualness.

God made the world in six days and was arrested on the seventh.—*The Unauthorized Version.*

Arsenic, n. A kind of cosmetic greatly affected by the ladies, whom it greatly affects in turn.

Art, n. This word has no definition. Its origin is related as follows by the ingenious Father Gassalasca Jape, S.J.

> One day a wag—what would the wretch be at?—
> Shifted a letter of the cipher RAT,
> And said it was a god's name! Straight arose
> Fantastic priests and postulants (with shows,
> And mysteries, and mummeries, and hymns,
> And disputations dire that lamed their limbs)
> To serve his temple and maintain the fires,
> Expound the law, manipulate the wires.
> Amazed, the populace the rites attend,
> Believe whate'er they cannot comprehend,
> And, inly edified to learn that two
> Half-hairs joined so and so (as Art can do)
> Have sweeter values and a grace more fit
> Than Nature's hairs that never have been split,
> Bring cates and wines for sacrificial feasts,
> And sell their garments to support the priests.

Artlessness, n. A certain engaging quality to which women attain by long study and severe practice upon the admiring male, who is pleased to fancy it resembles the candid simplicity of his young.

Asperse, v. t. Maliciously to ascribe to another vicious actions which one has not had the temptation and opportunity to commit.

Ass, n. A public singer with a good voice but no ear. In Virginia City, Nevada, he is called the Washoe Canary, in Dakota, the Senator, and everywhere the Donkey. The animal is widely and variously celebrated in the literature, art and religion of every age and country; no other so engages and fires the human imagination as this noble vertebrate. Indeed, it is doubted by some (Ramasilus, *lib. II., De Clem.,* and C. Stantatus, *De Temperamente*) if it is not a god; and as such we know it was worshipped by the Etruscans, and, if we may believe Macrobious, by the Cupasians also. Of the only two animals admitted into the Mahometan Paradise along with the souls of men, the ass that carried Balaam is one, the dog of the Seven Sleepers the other. This is no small distinction. From what has been written about this beast might be compiled a library of great splendor and magnitude, rivaling that of the Shakspearean cult, and that which clusters about the Bible. It may be said, generally, that all literature is more or less Asinine.

Astrology, n. The science of making the dupe see stars. Astrology is by some held in high respect as the precursor of astronomy. Similarly, the night-howling tomcat has a just claim to reverential consideration as the precursor to the hurtling bootjack.

Attorney, n. A person legally appointed to mismanage one's affairs which one has not himself the skill to rightly mismanage.

Auctioneer, n. The man who proclaims with a hammer that he has picked a pocket with his tongue.

Australia, n. A country lying in the South Sea, whose industrial and commercial development has been unspeakably retarded by an unfortunate dispute among geographers as to whether it is a continent or an island.

Authentic, adj. Indubitably true—in someone's opinion.

B

Babe or Baby, n. A misshapen creature of no particular age, sex, or condition, chiefly remarkable for the violence of the sympathies and antipathies it excites in others, itself without sentiment or emotion. There have been famous babes; for example, little Moses, from whose adventure in the bulrushes the Egyptian hierophants of seven centuries before doubtless derived their idle tale of the child Osiris being preserved on a floating lotus leaf.

Bacchus, n. A convenient deity invented by the ancients as an excuse for getting drunk.

Back, *n.* That part of your friend which it is your privilege to contemplate in your adversity.

Backbite, *v. t.* To speak of a man as you find him when he can't find you.

Bait, *n.* A preparation that renders the hook more palatable. The best kind is beauty.

Bang, *n.* The cry of a gun. That arrangement of a woman's hair which suggests the thought of shooting her; hence the name.

Barometer, *n.* An ingenious instrument which indicates what kind of weather we are having.

Barrack, *n.* A house in which soldiers enjoy a portion of that of which it is their business to deprive others.

Bastinado, *n.* The act of walking on wood without exertion.

Bath, *n.* A kind of mystic ceremony substituted for religious worship, with what spiritual efficacy has not been determined.

Battle, *n.* A method of untying with the teeth a political knot that would not yield to the tongue.

Beard, *n.* The hair that is commonly cut off by those who justly execrate the absurd Chinese custom of shaving the head.

Beauty, *n.* The power by which a woman charms a lover and terrifies a husband.

Befriend, *v. t.* To make an ingrate.

Beg, *v.* To ask for something with an earnestness proportioned to the belief that it will not be given.

Beggar, *n.* One who has relied on the assistance of his friends.

Belladonna, *n.* In Italian a beautiful lady; in English a deadly poison. A striking example of the essential identity of the two tongues.

Benefactor, *n.* One who makes heavy purchases of ingratitude, without, however, materially affecting the price, which is still within the means of all.

Betrothed, *p.p.* The condition of a man and a woman who, pleasing to one another and objectionable to their friends, are anxious to propitiate society by becoming unendurable to each other.

Bigamy, *n.* A mistake in taste for which the wisdom of the future will adjudge a punishment called trigamy.

Bigot, n. One who is obstinately and zealously attached to an opinion that you do not entertain.

Billingsgate, n. The invective of an opponent.

Birth, n. The first and direst of all disasters. As to the nature of it there appears to be no uniformity. Castor and Pollux were born from the egg. Pallas came out of a skull. Galatea was once a block of stone. Peresilis, who wrote in the tenth century, avers that he grew up out of the ground where a priest had spilled holy water. It is known that Arimaxus was derived from a hole in the earth, made by a stroke of lightning. Leucomedon was the son of a cavern in Mount Ætna, and I have myself seen a man come out of a wine cellar.

Blackguard, n. A man whose qualities, prepared for display like a box of berries in a market—the fine ones on top—have been opened on the wrong side. An inverted gentleman.

Blank-verse, n. Unrhymed iambic pentameters—the most difficult kind of English verse to write acceptably; a kind, therefore, much affected by those who cannot acceptably write any kind.

Body-snatcher, n. A robber of grave-worms. One who supplies the young physicians with that with which the old physicians have supplied the undertaker.

Bondsman, n. A fool who, having property of his own, undertakes to become responsible for that entrusted by another to a third.

 Philippe of Orleans wishing to appoint one of his favorites, a dissolute nobleman, to a high office, asked him what security he would be able to give. "I need no bondsmen," he replied, "for I can give you my word of honor." "And pray what may be the value of that?" inquired the amused Regent. "Monsieur, it is worth its weight in gold."

Bore, n. A person who talks when you wish him to listen.

Botany, n. The science of vegetables—those that are not good to eat, as well as those that are. It deals largely with their flowers, which are commonly badly designed, inartistic in color, and ill-smelling.

Bottle-nosed, adj. Having a nose created in the image of its maker.

Boundary, n. In political geography, an imaginary line between two nations, separating the imaginary rights of one from the imaginary rights of the other.

Brain, n. An apparatus with which we think that we think. That which distinguishes the man who is content to *be* something from the

man who wishes to *do* something. A man of great wealth, or one who has been pitchforked into high station, has commonly such a headful of brain that his neighbors cannot keep their hats on. In our civilization, and under our republican form of government, brain is so highly honored that it is rewarded by exemption from the cares of office.

Brandy, n. A cordial composed of one part thunder-and-lightning, one part remorse, two parts bloody murder, one part death-hell-and-the-grave and four parts clarified Satan. Dose, a headful all the time. Brandy is said by Dr. Johnson to be the drink of heroes. Only a hero will venture to drink it.

Bride, n. A woman with a fine prospect of happiness behind her.

Brute, n. See HUSBAND.

C

Caaba, n. A large stone presented by the archangel Gabriel to the patriarch Abraham, and preserved at Mecca. The patriarch had perhaps asked the archangel for bread.

Cabbage, n. A familiar kitchen-garden vegetable about as large and wise as a man's head.

The cabbage is so called from Cabagius, a prince who on ascending the throne issued a decree appointing a High Council of Empire consisting of the members of his predecessor's Ministry and the cabbages in the royal garden. When any of his Majesty's measures of state policy miscarried conspicuously it was gravely announced that several members of the High Council had been beheaded, and his murmuring subjects were appeased.

Calamity, n. A more than commonly plain and unmistakable reminder that the affairs of this life are not of our own ordering. Calamities are of two kinds: misfortune to ourselves, and good fortune to others.

Callous, adj. Gifted with great fortitude to bear the evils afflicting another.

When Zeno was told that one of his enemies was no more he was observed to be deeply moved. "What!" said one of his disciples, "you weep at the death of an enemy?" "Ah, 'tis true," replied the great Stoic; "but you should see me smile at the death of a friend."

Cannibal, n. A gastronome of the old school who preserves the simple tastes and adheres to the natural diet of the pre-pork period.

Cannon, _n._ An instrument employed in the rectification of national boundaries.

Capital, _n._ The seat of misgovernment. That which provides the fire, the pot, the dinner, the table and the knife and fork for the anarchist; the part of the repast that himself supplies is the disgrace before meat. _Capital Punishment,_ a penalty regarding the justice and expediency of which many worthy persons—including all the assassins—entertain grave misgivings.

Carnivorous, _adj._ Addicted to the cruelty of devouring the timorous vegetarian, his heirs and assigns.

Carouse, _v. i._ To celebrate with appropriate ceremonies the birth of a noble headache.

Cartesian, _adj._ Relating to Descartes, a famous philosopher, author of the celebrated dictum, _Cogito ero sum_—whereby he was pleased to suppose he demonstrated the reality of human existence. The dictum might be improved, however, thus: _Cogito cogito ergo cogito sum_—"I think that I think, therefore I think that I am;" as close an approach to certainty as any philosopher has yet made.

Cat, _n._ A soft, indestructible automaton provided by nature to be kicked when things go wrong in the domestic circle.

Caviler, _n._ A critic of our own work.

Cemetery, _n._ An isolated suburban spot where mourners match lies, poets write at a target and stone-cutters spell for a wager. The inscription following will serve to illustrate the success attained in these Olympian games:

> His virtues were so conspicious that his enemies, unable to overlook them, denied them, and his friends, to whose loose lives they were a rebuke, represented them as vices. They are here commemorated by his family, who shared them.

Censor, _n._ An officer of certain governments, employed to suppress the works of genius. Among the Romans the censor was an inspector of public morals, but the public morals of modern nations will not bear inspection.

Cerberus, _n._ The watch-dog of Hades, whose duty it was to guard the entrance—against whom or what does not clearly appear; everybody, sooner or later, had to go there, and nobody wanted to carry off the entrance.

Childhood, _n._ The period of human life intermediate between the

idiocy of infancy and the folly of youth—two removes from the sin of manhood and three from the remorse of old age.

Chinaman, *n.* A working man whose faults are docility, skill, industry, frugality and temperance, and whom we clamor to be forbidden by law to employ; whose labor opens countless avenues of employment to the whites and cheapens the necessities of life to the poor; to whom the squalor of poverty is imputed to be a congenial vice, exciting not compassion but resentment.

Chorus, *n.* In opera, a band of howling dervishes who terrify the audience while the singers are taking breath.

Christen, *v. t.* To ceremoniously afflict a helpless child with a name.

Christian, *n.* One who believes that the New Testament is a divinely inspired book admirably suited to the spiritual needs of his neighbor. One who follows the teachings of Christ in so far as they are not inconsistent with a life of sin.

Circumlocution, *n.* A literary trick whereby the writer who has nothing to say breaks it gently to the reader.

Circus, *n.* A place where horses, ponies and elephants are permitted to see men, women and children acting the fool.

Clairvoyant, *n.* A person, commonly a woman, who has the power of seeing that which is invisible to her patron—namely, that he is a blockhead.

Clarionet, *n.* An instrument of torture operated by a person with cotton in his ears. There are two instruments that are worse than a clarionet—two clarionets.

Clergyman, *n.* A man who undertakes the management of our spiritual affairs as a method of bettering his temporal ones.

Clock, *n.* A machine of great moral value to man, allaying his concern for the future by reminding him what a lot of time remains to him.

Close-fisted, *adj.* Unduly desirous of keeping that which many meritorious persons wish to obtain.

Club, *n.* An association of men for purposes of drunkenness, gluttony, unholy hilarity, murder, sacrilege and the slandering of mothers, wives and sisters.

For this definition I am indebted to several estimable ladies

who have the best means of information, their husbands being members of several clubs.

Comfort, _n._ A state of mind produced by contemplation of a neighbor's uneasiness.

Commendation, _n._ The tribute that we pay to achievements that resemble, but do not equal, our own.

Commerce, _n._ A kind of transaction in which A plunders from B the goods of C, and for compensation B picks the pocket of D of money belonging to E.

Compromise, _n._ Such an adjustment of conflicting interests as gives each adversary the satisfaction of thinking he has got what he ought not to have, and is deprived of nothing except what was justly his due.

Compulsion, _n._ The eloquence of power.

Conceit, _n._ Self-respect in one whom we dislike.

Confidant, Confidante, _n._ One entrusted by A with the secrets of B, confided by _him_ to C.

Congratulation, _n._ The civility of envy.

Congress, _n._ A body of men who meet to repeal laws.

Conjugal, _adj._ (Latin, _con,_ mutual, and _jugum,_ a yoke.) Relating to a popular kind of penal servitude—the yoking together of two fools by a parson.

Connoisseur, _n._ A specialist who knows everything about something and nothing about anything else.

An old wine-bibber having been smashed in a railway collision, some wine was poured upon his lips to revive him. "Pauillac, 1873," he murmured and died.

Conservative, _n._ A statesman who is enamored of existing evils, as distinguished from the Liberal, who wishes to replace them with others.

Consolation, _n._ The knowledge that a better man is more unfortunate than yourself.

Consul, _n._ In American politics, a person who having failed to secure an office from the people is given one by the Administration on condition that he leave the country.

Consult, _v. t._ To seek another's approval of a course already decided on.

Contempt, n. The feeling of a prudent man for an enemy who is too formidable safely to be opposed.

Controversy, n. A battle in which spittle or ink replaces the injurious cannon-ball and the inconsiderate bayonet.

Convent, n. A place of retirement for women who wish for leisure to meditate upon the vice of idleness.

Conversation, n. A fair for the display of the minor mental commodities, each exhibitor being too intent upon the arrangement of his own wares to observe those of his neighbor.

Coronation, n. The ceremony of investing a sovereign with the outward and visible signs of his divine right to be blown skyhigh with a dynamite bomb.

Corporation, n. An ingenious device for obtaining individual profit without individual responsibility.

Corsair, n. A politician of the seas.

Court Fool, n. The plaintiff.

Courtship, n. The timid sipping of two thirsty souls from a goblet which both can easily drain but neither replenish.

Coward, n. One who in a perilous emergency thinks with his legs.

Cowlick, n. A tuft of hair which persists in lying the wrong way. In the case of a married man it usually points toward the side that his wife commonly walks on.

Creditor, n. One of a tribe of savages dwelling beyond the Financial Straits and dreaded for their desolating incursions.

Critic, n. A person who boasts himself hard to please because nobody tries to please him.

Cunning, n. The faculty that distinguishes a weak animal or person from a strong one. It brings its possessor much mental satisfaction and great material adversity. An Italian proverb says: "The furrier gets the skins of more foxes than asses."

Cupid, n. The so-called god of love. This bastard creation of a barbarous fancy was no doubt inflicted upon mythology for the sins of its deities. Of all unbeautiful and inappropriate conceptions this is the most reasonless and offensive. The notion of symbolizing sexual love by a semisexless babe, and comparing the pains of passion to the wounds of an arrow—of introducing this pudgy homunculus into art grossly to materialize the subtle spirit and suggestion of the work—this is eminently

worthy of the age that, giving it birth, laid it on the doorstep of posterity.

Curiosity, n. An objectionable quality of the female mind. The desire to know whether or not a woman is cursed with curiosity is one of the most active and insatiable passions of the masculine soul.

Curse, v. t. Energetically to belabor with a verbal slap-stick. This is an operation which in literature, particularly in the drama, is commonly fatal to the victim. Nevertheless, the liability to a cursing is a risk that cuts but a small figure in fixing the rates of life insurance.

Custard, n. A detestable substance produced by a malevolent conspiracy of the hen, the cow and the cook.

Cynic, n. A blackguard whose faulty vision sees things as they are, not as they ought to be. Hence the custom among the Scythians of plucking out a cynic's eyes to improve his vision.

D

Damn, v. A word formerly much used by the Paphlagonians, the meaning of which is lost. By the learned Dr. Dolabelly Gak it is believed to have been a term of satisfaction, implying the highest possible degree of mental tranquillity. Professor Groke, on the contrary, thinks it expressed an emotion of tumultuous delight, because it so frequently occurs in combination with the word *jod* or *god,* meaning "joy." It would be with great diffidence that I should advance an opinion conflicting with that of either of these formidable authorities.

Dance, v. i. To leap about to the sound of tittering music, preferably with arms about your neighbor's wife or daughter. There are many kinds of dances, but all those requiring the participation of the two sexes have two characteristics in common: they are conspicuously innocent, and warmly loved by the vicious.

Dawn, n. The time when men of reason go to bed. Certain old men prefer to rise at about that time, taking a cold bath and a long walk with an empty stomach, and otherwise mortifying the flesh. They then point with pride to these practices as the cause of their sturdy health and ripe years; the truth being that they are hearty and old, not because of their habits, but in spite of them. The reason we find only robust persons doing this thing is that it has killed all the others who have tried it.

Day, n. A period of twenty-four hours, mostly misspent. This period is divided into two parts, the day proper and the night, or day

improper—the former devoted to sins of business, the latter consecrated to the other sort. These two kinds of social activity overlap.

Debauchee, n. One who has so earnestly pursued pleasure that he has had the misfortune to overtake it.

Debt, n. An ingenious substitute for the chain and whip of the slave-driver.

Decalogue, n. A series of commandments, ten in number—just enough to permit an intelligent selection for observance, but not enough to embarrass the choice. Following is the revised edition of the Decalogue, calculated for this meridian.

> Thou shalt no God but me adore:
> 'Twere too expensive to have more.
>
> No images nor idols make
> For Robert Ingersoll to break.
>
> Take not God's name in vain; select
> A time when it will have effect.
>
> Work not on Sabbath days at all,
> But go to see the teams play ball.
>
> Honor thy parents. That creates
> For life insurance lower rates.
>
> Kill not, abet not those who kill;
> Thou shalt not pay thy butcher's bill.
>
> Kiss not thy neighbor's wife, unless
> Thine own thy neighbor doth caress.
>
> Don't steal; thou'lt never thus compete
> Successfully in business. Cheat.
>
> Bear not false witness—that is low—
> But "hear 'tis rumored so and so."
>
> Covet thou naught that thou hast not
> By hook or crook, or somehow, got.

Decide, *v. i.* To succumb to the preponderance of one set of influences over another set.

Defame, *v. t.* To lie about another. To tell the truth about another.

Defenceless, *adj.* Unable to attack.

Defendant, *n.* In law, an obliging person who devotes his time and character to preserving property for his lawyer.

Defraud, *v. t.* To impart instruction and experience to the confiding.

Degradation, *n.* One of the stages of moral and social progress from private station to political preferment.

Delegation, *n.* In American politics, an article of merchandise that comes in sets.

Deliberation, *n.* The act of examining one's bread to determine which side it is buttered on.

Deluge, *n.* A notable first experiment in baptism which washed away the sins (and sinners) of the world.

Delusion, *n.* The father of a most respectable family, comprising Enthusiasm, Affection, Self-denial, Faith, Hope, Charity and many other goodly sons and daughters.

Demagogue, *n.* A political opponent.

Demure, *adj.* Grave and modest-mannered, like a particularly unscrupulous woman.

Dentist, *n.* A prestidigitator, who puts metal into your mouth and pulls coins out of your pocket.

Deny, *v. t.* See HURL BACK THE ALLEGATION.

Dependent, *adj.* Reliant upon another's generosity for the support which you are not in a position to exact from his fears.

Deportment, *n.* An invention of the devil, to assist his followers into good society.

Deputy, *n.* A male relative of an officeholder, or of his bondsman. The deputy is commonly a beautiful young man, with a red necktie and an intricate system of cobwebs extending from his nose to his desk. When accidentally struck by the janitor's broom, he gives off a cloud of dust.

Desertion, *n.* An aversion to fighting, as exhibited by abandoning an army or a wife.

Deshabille, n. A reception costume for intimate friends varying according to locality, e.g., in Borriboola Gha, a streak of red and yellow paint across the thorax. In San Francisco, pearl earrings and a smile.

Destiny, n. A tyrant's authority for crime and a fool's excuse for failure.

Diagnosis, n. A physician's forecast of disease by the patient's pulse and purse.

Diaphragm, n. A muscular partition separating disorders of the chest from disorders of the bowels.

Diary, n. A daily record of that part of one's life, which he can relate to himself without blushing.

Dice, n. Small polka-dotted cubes of ivory, constructed like a lawyer to lie on any side, but commonly on the wrong one.

Dictator, n. The chief of a nation that prefers the pestilence of despotism to the plague of anarchy.

Dictionary, n. A malevolent literary device for cramping the growth of a language and making it hard and inelastic. This dictionary, however, is a most useful work.

Digestion, n. The conversion of victuals into virtues. When the process is imperfect, vices are evolved instead—a circumstance from which that wicked writer, Dr. Jeremiah Blenn, infers that the ladies are the greater sufferers from dyspepsia.

Diplomacy, n. The patriotic art of lying for one's country.

Disabuse, v. t. To present your neighbor with another and better error than the one which he has deemed it advantageous to embrace.

Discriminate, v. i. To note the particulars in which one person or thing is, if possible, more objectionable than another.

Discussion, n. A method of confirming others in their errors.

Disobedience, n. The silver lining to the cloud of servitude.

Disobey, v. t. To celebrate with an appropriate ceremony the maturity of a command.

Dissemble, v. i. To put a clean shirt upon the character.

Distance, n. The only thing that the rich are willing for the poor to call theirs, and keep.

Distress, n. A disease incurred by exposure to the prosperity of a friend.

Divination, *n.* The art of nosing out the occult. Divination is of as many kinds as there are fruit-bearing varieties of the flowering dunce and the early fool.

Divine, *n.* A bird of pray.

Divorce, *n.* A resumption of diplomatic relations and rectification of boundaries.

Doctrinaire, *n.* One whose doctrine has the demerit of antagonizing your own.

Dog, *n.* A kind of additional or subsidiary Deity designed to catch the overflow and surplus of the world's worship. This Divine Being in some of his smaller and silkier incarnations takes, in the affection of Woman, the place to which there is no human male aspirant. The Dog is a survival—an anachronism. He toils not, neither does he spin, yet Solomon in all his glory never lay upon a door-mat all day long, sun-soaked and fly-fed and fat, while his master worked for the means wherewith to purchase an idle wag of the Solomonic tail, seasoned with a look of tolerant recognition.

Dragoon, *n.* A soldier who combines dash and steadiness in so equal measure that he makes his advances on foot and his retreats on horseback.

Dramatist, *n.* One who adapts plays from the French.

Drowsy, *adj.* Profoundly affected by a play adapted from the French.

Dullard, *n.* A member of the reigning dynasty in letters and life. The Dullards came in with Adam, and being both numerous and sturdy have overrun the habitable world. The secret of their power is their insensibility to blows; tickle them with a bludgeon and they laugh with a platitude. The Dullards came originally from Bœotia, whence they were driven by stress of starvation, their dulness having blighted the crops. For some centuries they infested Philistia, and many of them are called Philistines to this day. In the turbulent times of the Crusades they withdrew thence and gradually overspread all Europe, occupying most of the high places in politics, art, literature, science and theology. Since a detachment of Dullards came over with the Pilgrims in the *Mayflower* and made a favorable report of the country, their increase by birth, immigration, and conversion has been rapid and steady. According to the most trustworthy statistics the number of adult Dullards in the United States is but little short of thirty millions, including the statisticians. The intellectual centre of the race is somewhere about Peoria, Illinois, but the New England Dullard is the most shockingly moral.

Duty, n. That which sternly impels us in the direction of profit, along the line of desire.

E

Eat, v. i. To perform successively (and successfully) the functions of mastication, humectation, and deglutition.

"I was in the drawing-room, enjoying my dinner," said Brillat-Savarin, beginning an anecdote. "What!" interrupted Rochebriant; "eating dinner in a drawing-room?" "I must beg you to observe, monsieur," explained the great gastronome, "that I did not say I was eating my dinner, but enjoying it. I had dined an hour before."

Eavesdrop, v. i. Secretly to overhear a catalogue of the crimes and vices of another or yourself.

Eccentricity, n. A method of distinction so cheap that fools employ it to accentuate their incapacity.

Economy, n. Purchasing the barrel of whiskey that you do not need for the price of the cow that you cannot afford.

Edible, adj. Good to eat, and wholesome to digest, as a worm to a toad, a toad to a snake, a snake to a pig, a pig to a man, and a man to a worm.

Editor, n. A person who combines the judicial functions of Minos, Rhadamanthus and Æacus, but is placable with an obolus; a severely virtuous censor, but so charitable withal that he tolerates the virtues of others and the vices of himself; who flings about him the splintering lightning and sturdy thunders of admonition till he resembles a bunch of firecrackers petulantly uttering its mind at the tail of a dog; then straightway murmurs a mild, melodious lay, soft as the cooing of a donkey intoning its prayer to the evening star. Master of mysteries and lord of law, high-pinnacled upon the throne of thought, his face suffused with the dim splendors of the Transfiguration, his legs intertwisted and his tongue a-cheek, the editor spills his will along the paper and cuts it off in lengths to suit. And at intervals from behind the veil of the temple is heard the voice of the foreman demanding three inches of wit and six lines of religious meditation, or bidding him turn off the wisdom and whack up some pathos.

Education, n. That which discloses to the wise and disguises from the foolish their lack of understanding.

Effect, n. The second of two phenomena which always occur together in the same order. The first, called a Cause, is said to generate the

other—which is no more sensible than it would be for one who has never seen a dog except in pursuit of a rabbit to declare the rabbit the cause of the dog.

Egotist, n. A person of low taste, more interested in himself than in me.

Ejection, n. An approved remedy for the disease of garrulity. It is also much used in cases of extreme poverty.

Elector, n. One who enjoys the sacred privilege of voting for the man of another man's choice.

Elegy, n. A composition in verse, in which, without employing any of the methods of humor, the writer aims to produce in the reader's mind the dampest kind of dejection. The most famous English example begins somewhat like this:

> The cur foretells the knell of parting day;
>> The loafing herd winds slowly o'er the lea;
> The wise man homeward plods; I only stay
>> To fiddle-faddle in a minor key.

Eloquence, n. The art of orally persuading fools that white is the color that it appears to be. It includes the gift of making any color appear white.

Elysium, n. An imaginary delightful country which the ancients foolishly believed to be inhabited by the spirits of the good. This ridiculous and mischievous fable was swept off the face of the earth by the early Christians—may their souls be happy in Heaven!

Emancipation, n. A bondman's change from the tyranny of another to the despotism of himself.

Embalm, v. t. To cheat vegetation by locking up the gases upon which it feeds. By embalming their dead and thereby deranging the natural balance between animal and vegetable life, the Egyptians made their once fertile and populous country barren and incapable of supporting more than a meagre crew. The modern metallic burial casket is a step in the same direction, and many a dead man who ought now to be ornamenting his neighbor's lawn as a tree, or enriching his table as a bunch of radishes, is doomed to a long inutility. We shall get him after awhile if we are spared, but in the meantime the violet and rose are languishing for a nibble at his *glutœus maximus*.

Emotion, n. A prostrating disease caused by a determination of the heart to the head. It is sometimes accompanied by a copious discharge of hydrated chloride of sodium from the eyes.

Enthusiasm, n. A distemper of youth, curable by small doses of repentance in connection with outward applications of experience.

Envelope, n. The coffin of a document; the scabbard of a bill; the husk of a remittance; the bed-gown of a love-letter.

Envy, n. Emulation adapted to the meanest capacity.

Epaulet, n. An ornamented badge, serving to distinguish a military officer from the enemy—that is to say, from the officer of lower rank to whom his death would give promotion.

Epicure, n. An opponent of Epicurus, an abstemious philosopher who, holding that pleasure should be the chief aim of man, wasted no time in gratification of the senses.

Epidemic, n. A disease having a sociable turn and few prejudices.

Epigram, n. A short, sharp saying in prose or verse, frequently characterized by acidity or acerbity and sometimes by wisdom. Following are some of the more notable epigrams of the learned and ingenious Dr. Jamrach Holobom:

> We know better the needs of ourselves than of others. To serve oneself is economy of administration.

> In each human heart are a tiger, a pig, an ass and a nightingale. Diversity of character is due to their unequal activity.

> There are three sexes; males, females and girls.

> Beauty in women and distinction in men are alike in this: they seem to the unthinking a kind of credibility.

> Women in love are less ashamed than men. They have less to be ashamed of.

> While your friend holds you affectionately by both your hands you are safe, for you can watch both his.

Epitaph, n. An inscription on a tomb, showing that virtues acquired by death have a retroactive effect. Following is a touching example:

> Here lie the bones of Parson Platt,
> Wise, pious, humble and all that,
> Who showed us life as all should live it;
> Let that be said—and God forgive it!

Erudition, n. Dust shaken out of a book into an empty skull.

Esoteric, adj. Very particularly abstruse and consummately occult. The ancient philosophies were of two kinds,—*exoteric,* those that the philosophers themselves could partly understand, and *esoteric,* those that nobody could understand. It is the latter that have most profoundly affected modern thought and found greatest acceptance in our time.

Essential, adj. Pertaining to the *essence,* or that which determines the distinctive character of a thing. People, who, because they do not know the English language are driven to the unprofitable vocation of writing for American newspapers, commonly use this word in the sense of *necessary,* as "April rains are essential to June harvests."

Ethnology, n. The science that treats of the various tribes of Man, as robbers, thieves, swindlers, dunces, lunatics, idiots and ethnologists.

Eucharist, n. A sacred feast of the religious sect of Theophagi.

A dispute once unhappily arose among the members of this sect as to what it was that they ate. In this controversy some five hundred thousand have already been slain, and the question is still unsettled.

Eulogy, n. Praise of a person who has either the advantages of wealth and power, or the consideration to be dead.

Euphemism, n. In rhetoric, a figure by which the severe asperity of truth is mitigated by the use of a softer expression than the facts would warrant—as, to call Mr. Charles Crocker ninety-nine kinds of a knave.

Evangelist, n. A bearer of good tidings, particularly (in a religious sense) such as assure us of our own salvation and the damnation of our neighbors.

Exception, n. A thing which takes the liberty to differ from other things of its class, as an honest man, a truthful woman, etc. "The exception proves the rule" is an expression constantly upon the lips of the ignorant, who parrot it from one another with never a thought of its absurdity. In the Latin, *"Exceptio probat regulam"* means that the exception *tests* the rule, puts it to the proof, not *confirms* it. The malefactor who drew the meaning from this excellent dictum and substituted a contrary one of his own exerted an evil power which appears to be immortal.

Excess, n. In morals, an indulgence that enforces by appropriate penalties the law of moderation.

Excursion, n. An expedition of so disagreeable a character that steamboat and railroad fares are compassionately mitigated to the miserable sufferers.

Executive, n. An officer of the Government, whose duty it is to

enforce the wishes of the legislative power until such time as the judicial department shall be pleased to pronounce them invalid and of no effect.

Exhort, v. t. In religious affairs, to put the conscience of another upon the spit and roast it to a nut-brown discomfort.

Exile, n. One who serves his country by residing abroad, yet is not an ambassador.

Experience, n. The wisdom that enables us to recognize as an undesirable old acquaintance the folly that we have already embraced.

F

Faith, n. Belief without evidence in what is told by one who speaks without knowledge, of things without parallel.

Famous, adj. Conspicuously miserable.

Fashion, n. A despot whom the wise ridicule and obey.

Feast, n. A festival. A religious celebration usually signalized by gluttony and drunkenness, frequently in honor of some holy person distinguished for abstemiousness. In the Roman Catholic Church feasts are "movable" and "immovable," but the celebrants are uniformly immovable until they are full.

Felon, n. A person of greater enterprise than discretion, who in embracing an opportunity has formed an unfortunate attachment.

Female, n. One of the opposing, or unfair, sex.

Fib, n. A lie that has not cut its teeth. An habitual liar's nearest approach to truth: the perigee of his eccentric orbit.

Fickleness, n. The iterated satiety of an enterprising affection.

Fiddle, n. An instrument to tickle human ears by friction of a horse's tail on the entrails of a cat.

Fidelity, n. A virtue peculiar to those who are about to be betrayed.

Filial, adj. In such a manner as to placate the parental Purse.

Finance, n. The art or science of managing revenues and resources for the best advantage of the manager. The pronunciation of this word with the i long and the accent on the first syllable is one of America's most precious discoveries and possessions.

Flag, n. A colored rag borne above troops and hoisted on forts and

ships. It appears to serve the same purpose as certain signs that one sees on vacant lots in London—"Rubbish may be shot here."

Flint, n. A substance much in use as a material for hearts. Its composition is silica, 98.00; oxide of iron, 0.25; alumina, 0.25; water, 1.50. When an editor's heart is made, the water is commonly left out; in a lawyer's more water is added—and frozen.

Flirtation, n. A game in which you do not want the other player's stake but stand to lose your own.

Flunkey, n. Properly, a servant in livery, the application of the word to a member of a uniformed political club being a monstrous degradation of language and a needless insult to a worthy class of menials.

Fool, n. A person who pervades the domain of intellectual speculation and diffuses himself through the channels of moral activity. He is omnific, omniform, omnipercipient, omniscient, omnipotent. He it was who invented letters, printing, the railroad, the steamboat, the telegraph, the platitude and the circle of the sciences. He created patriotism and taught the nations war—founded theology, philosophy, law, medicine and Chicago. He established monarchical and republican government. He is from everlasting to everlasting—such as creation's dawn beheld he fooleth now. In the morning of time he sang upon primitive hills, and in the noonday of existence headed the procession of being. His grandmotherly hand has warmly tucked-in the set sun of civilization, and in the twilight he prepares Man's evening meal of milk-and-morality and turns down the covers of the universal grave. And after the rest of us shall have retired for the night of eternal oblivion he will sit up to write a history of human civilization.

Forbidden, p.p. Invested with a new and irresistible charm.

Force, n.

> "Force is but might," the teacher said—
> "That definition's just."
> The boy said naught but thought instead,
> Remembering his pounded head:
> "Force is not might but must!"

Forefinger, n. The finger commonly used in pointing out two malefactors.

Foreordination, n. This looks like an easy word to define, but when I consider that pious and learned theologians have spent long lives

in explaining it, and written libraries to explain their explanations; when I remember that nations have been divided and bloody battles caused by the difference between foreordination and predestination, and that millions of treasure have been expended in the effort to prove and disprove its compatibility with freedom of the will and the efficacy of prayer, praise, and a religious life,—recalling these awful facts in the history of the word, I stand appalled before the mighty problem of its signification, abase my spiritual eyes, fearing to contemplate its portentous magnitude, reverently uncover and humbly refer it to His Eminence Cardinal Gibbons and His Grace Bishop Potter.

Forgetfulness, n. A gift of God bestowed upon debtors in compensation for their destitution of conscience.

Forgiveness, n. A stratagem to throw an offender off his guard and catch him red-handed in his next offense.

Fork, n. An instrument used chiefly for the purpose of putting dead animals into the mouth. Formerly the knife was employed for this purpose, and by many worthy persons is still thought to have many advantages over the other tool, which, however, they do not altogether reject, but use to assist in charging the knife. The immunity of these persons from swift and awful death is one of the most striking proofs of God's mercy to those that hate Him.

Forma Pauperis (Latin). In the character of a poor person—a method by which a litigant without money for lawyers is considerately permitted to lose his case.

Fortune-Hunter, n. A man without wealth whom a rich woman catches and marries within an inch of his life.

Freebooter, n. A conqueror in a small way of business, whose annexations lack the sanctifying merit of magnitude.

Freedom, n. Exemption from the stress of authority in a beggarly half dozen of restraint's infinite multitude of methods. A political condition that every nation supposes itself to enjoy in virtual monopoly. Liberty. The distinction between freedom and liberty is not accurately known; naturalists have never been able to find a living specimen of either.

Freemasons, n. An order with secret rites, grotesque ceremonies and fantastic costumes, which, originating in the reign of Charles II, among working artisans of London, has been joined successively by the dead of past centuries in unbroken retrogression until now it embraces all the generations of man on the hither side of Adam and is drumming up distinguished recruits among the pre–Creational inhabitants of

Chaos and the Formless Void. The order was founded at different times by Charlemagne, Julius Cæsar, Cyrus, Solomon, Zoroaster, Confucius, Thothmes, and Buddha. Its emblems and symbols have been found in the Catacombs of Paris and Rome, on the stones of the Parthenon and the Chinese Great Wall, among the temples of Karnak and Palmyra and in the Egyptian Pyramids—always by a Freemason.

Friendless, adj. Having no favors to bestow. Destitute of fortune. Addicted to utterance of truth and common sense.

Friendship, n. A ship big enough to carry two in fair weather, but only one in foul.

Frog, n. A reptile with edible legs. The first mention of frogs in profane literature is in Homer's narrative of the war between them and the mice. Skeptical persons have doubted Homer's authorship of the work, but the learned, ingenious and industrious Dr. Schliemann has set the question forever at rest by uncovering the bones of the slain frogs. One of the forms of moral suasion by which Pharaoh was besought to favor the Israelites was a plague of frogs, but Pharaoh, who liked them *fricasées,* remarked, with truly oriental stoicism, that he could stand it as long as the frogs and the Jews could; so the programme was changed. The frog is a diligent songster, having a good voice but no ear. The libretto of his favorite opera, as written by Aristophanes, is brief, simple and effective—"brekekex-koäx"; the music is apparently by that eminent composer, Richard Wagner. Horses have a frog in each hoof—a thoughtful provision of nature, enabling them to shine in a hurdle race.

Frying-Pan, n. One part of the penal apparatus employed in that punitive institution, a woman's kitchen. The frying-pan was invented by Calvin, and by him used in cooking span-long infants that had died without baptism; and observing one day the horrible torment of a tramp who had incautiously pulled a fried babe from the waste-dump and devoured it, it occurred to the great divine to rob death of its terrors by introducing the frying-pan into every household in Geneva. Thence it spread to all corners of the world, and has been of invaluable assistance in the propagation of his sombre faith. The following lines (said to be from the pen of his Grace Bishop Potter) seem to imply that the usefulness of this utensil is not limited to this world; but as the consequences of its employment in this life reach over into the life to come, so also itself may be found on the other side, rewarding its devotees:

> Old Nick was summoned to the skies.
> Said Peter: "Your intentions
> Are good, but you lack enterprise
> Concerning new inventions.

"Now, broiling is an ancient plan
 Of torment, but I hear it
Reported that the frying-pan
 Sears best the wicked spirit.

"Go get one—fill it up with fat—
 Fry sinners brown and good in't."
"I know a trick worth two o' that,"
 Said Nick—"I'll cook their food in't."

Funeral, _n._ A pageant whereby we attest our respect for the dead by enriching the undertaker, and strengthen our grief by an expenditure that deepens our groans and doubles our tears.

Future, _n._ That period of time in which our affairs prosper, our friends are true and our happiness is assured.

G

Gallows, _n._ A stage for the performance of miracle plays, in which the leading actor is translated to heaven. In this country the gallows is chiefly remarkable for the number of persons who escape it.

Gargoyle, _n._ A rain-spout projecting from the eaves of mediæval buildings, commonly fashioned into a grotesque caricature of some personal enemy of the architect or owner of the building. This was especially the case in churches and ecclesiastical structures generally, in which the gargoyles presented a perfect rogues' gallery of local heretics and controversialists. Sometimes when a new dean and chapter were installed the old gargoyles were removed and others substituted having a closer relation to the private animosities of the new incumbents.

Garter, _n._ An elastic band intended to keep a woman from coming out of her stockings and desolating the country.

Geese, _n._ The plural of "Prohibitionist."

Generous, _adj._ Originally this word meant noble by birth and was rightly applied to a great multitude of persons. It now means noble by nature and is taking a bit of a rest.

Genealogy, _n._ An account of one's descent from an ancestor who did not particularly care to trace his own.

Genteel, _adj._ Refined, after the fashion of a gent.

Observe with care, my son, the distinction I reveal:
A gentleman is gentle and a gent genteel.
Heed not the definitions your "Unabridged"
 presents,
For dictionary makers are generally gents.

Geology, n. The science of the earth's crust—to which, doubtless, will be added that of its interior whenever a man shall come up garrulous out of a well. The geological formations of the globe already noted are catalogued thus: The Primary, or lower one, consists of rocks, bones of mired mules, gas-pipes, miners' tools, antique statues minus the nose, Spanish doubloons and ancestors. The Secondary is largely made up of red worms and moles. The Tertiary comprises railway tracks, patent pavements, grass, snakes, mouldy boots, beer bottles, tomato cans, intoxicated citizens, garbage, anarchists, snap-dogs and fools.

Ghost, n. The outward and visible sign of an inward fear.

Good, adj. Sensible, madam, to the worth of this present writer. Alive, sir, to the advantages of letting him alone.

Goose, n. A bird that supplies quills for writing. These, by some occult process of nature, are penetrated and suffused with various degrees of the bird's intellectual energies and emotional character, so that when inked and drawn mechanically across paper by a person called an "author," there results a very fair and accurate transcript of the fowl's thought and feeling. The difference in geese, as discovered by this ingenious method, is considerable: many are found to have only trivial and insignificant powers, but some are seen to be very great geese indeed.

Gout, n. A physician's name for the rheumatism of a rich patient.

Grammar, n. A system of pitfalls thoughtfully prepared for the feet of the self-made man, along the path by which he advances to distinction.

Grape, n.

Hail noble fruit!—by Homer sung,
 Anacreon and Khayyam;
Thy praise is ever on the tongue
 Of better men than I am.

The lyre my hand has never swept,
 The song I cannot offer:

My humbler service pray accept—
 I'll help to kill the scoffer.

The water-drinkers and the cranks
 Who load their skins with liquor—
I'll gladly bare their belly-tanks
 And tap them with my sticker.

Fill up, fill up, for wisdom cools
 When e'er we let the wine rest.
Here's death to Prohibition's fools,
 And every kind of vine-pest!

Grapeshot, n. An argument which the future is preparing in answer to the demands of American Socialism.

Grave, n. A place in which the dead are laid to await the coming of the medical student.

Gravitation, n. The tendency of all bodies to approach one another with a strength proportioned to the quantity of matter they contain—the quantity of matter they contain being ascertained by the strength of their tendency to approach one another. This is a lovely and edifying illustration of how science, having made A the proof of B, makes B the proof of A.

Guillotine, n. A machine which makes a Frenchman shrug his shoulders with good reason.

 In his great work on *Divergent Lines of Racial Evolution,* the learned Professor Brayfugle argues from the prevalence of this gesture— the shrug—among Frenchmen, that they are descended from turtles and it is simply a survival of the habit of retracting the head inside the shell. It is with reluctance that I differ with so eminent an authority, but in my judgment (as more elaborately set forth and enforced in my work entitled *Hereditary Emotions*—lib. II, c. XI) the shrug is a poor foundation upon which to build so important a theory, for previously to the Revolution the gesture was unknown. I have not a doubt that it is directly referable to the terror inspired by the guillotine during the period of that instrument's activity.

Gunpowder, n. An agency employed by civilized nations for the settlement of disputes which might become troublesome if left unadjusted. By most writers the invention of gunpowder is ascribed to the Chinese, but not upon very convincing evidence. Milton says it was

invented by the devil to dispel angels with, and this opinion seems to derive some support from the scarcity of angels.

H

Habeas Corpus. A writ by which a man may be taken out of jail when confined for the wrong crime.

Habit, n. A shackle for the free.

Hades, n. The lower world; the residence of departed spirits; the place where the dead live.

Among the ancients the idea of Hades was not synonymous with our Hell, many of the most respectable men of antiquity residing there in a very comfortable kind of way. Indeed, the Elysian Fields themselves were a part of Hades, though they have since been removed to Paris. When the Jacobean version of the New Testament was in process of evolution the pious and learned men engaged in the work insisted by a majority vote on translating the Greek word "Ἀιδης" as "Hell"; but a conscientious minority member secretly possessed himself of the record and struck out the objectionable word whenever he could find it. At the next meeting, the Bishop of Salisbury, looking over the work, suddenly sprang to his feet and said with considerable excitement: "Gentlemen, somebody has been razing 'Hell' here!" Years afterward the good prelate's death was made sweet by the reflection that he had been the means (under Providence) of making an important, serviceable and immortal addition to the phraseology of the English tongue.

Hag, n. An elderly lady whom you do not happen to like; sometimes called, also, a hen, or cat. Old witches, sorceresses, etc., were called hags from the belief that their heads were surrounded by a kind of baleful lumination or nimbus—hag being the popular name of that peculiar electrical light sometimes observed in the hair. At one time hag was not a word of reproach: Drayton speaks of a "beautiful hag, all smiles," much as Shakespeare said, "sweet wench." It would not now be proper to call your sweetheart a hag—that compliment is reserved for the use of her grandchildren.

Half, n. One of two equal parts into which a thing may be divided, or considered as divided. In the fourteenth century a heated discussion arose among theologists and philosophers as to whether Omniscience could part an object into three halves; and the pious Father Aldrovinus publicly prayed in the cathedral at Rouen that God would demonstrate the affirmative of the proposition in some signal and unmistakable way, and particularly (if it should please Him) upon the body of that hardy

blasphemer, Manutius Procinus, who maintained the negative. Procinus, however, was spared to die of the bite of a viper.

Halo, n. Properly, a luminous ring encircling an astronomical body, but not infrequently confounded with "aureola," or "nimbus," a somewhat similar phenomenon worn as a head-dress by divinities and saints. The halo is a purely optical illusion, produced by moisture in the air, in the manner of a rainbow; but the aureola is conferred as a sign of superior sanctity, in the same way as a bishop's mitre, or the Pope's tiara. In the painting of the Nativity, by Szedgkin, a pious artist of Pesth, not only do the Virgin and the Child wear the nimbus, but as ass nibbling hay from the sacred manger is similarly decorated and, to his lasting honor be it said, appears to bear his unaccustomed dignity with a truly saintly grace.

Hand, n. A singular instrument worn at the end of the human arm and commonly thrust into somebody's pocket.

Handkerchief, n. A small square of silk or linen, used in various ignoble offices about the face and especially serviceable at funerals to conceal the lack of tears. The handkerchief is of recent invention; our ancestors knew nothing of it and intrusted its duties to the sleeve. Shakespeare's introducing it into the play of "Othello" is an anachronism: Desdemona dried her nose with her skirt, as Dr. Mary Walker and other reformers have done with their coattails in our own day—an evidence that revolutions sometimes go backward.

Hangman, n. An officer of the law charged with duties of the highest dignity and utmost gravity, and held in hereditary disesteem by a populace having a criminal ancestry. In some of the American States his functions are now performed by an electrician, as in New Jersey, where executions by electricity have recently been ordered—the first instance known to this lexicographer of anybody questioning the expediency of hanging Jerseymen.

Happiness, n. An agreeable sensation arising from contemplating the misery of another.

Harangue, n. A speech by an opponent, who is known as an harangue-outang.

Harbor, n. A place where ships taking shelter from storms are exposed to the fury of the customs.

Hash, x. There is no definition for this word—nobody knows what hash is.

Hatred, n. A sentiment appropriate to the occasion of another's superiority.

Hearse, n. Death's baby-carriage.

Heart, n. An automatic, muscular bloodpump. Figuratively, this useful organ is said to be the seat of emotions and sentiments—a very pretty fancy which, however, is nothing but a survival of a once universal belief. It is now known that the sentiments and emotions reside in the stomach, being evolved from food by chemical action of the gastric fluid. The exact process by which a beefsteak becomes a feeling—tender or not, according to the age of the animal from which it was cut; the successive stages of elaboration through which a caviar sandwich is transmuted to a quaint fancy and reappears as a pungent epigram; the marvelous functional methods of converting a hard-boiled egg into religious contrition, or a cream-puff into a sigh of sensibility—these things have been patiently ascertained by M. Pasteur, and by him expounded with convincing lucidity. (See, also, my monograph, *The Essential Identity of the Spiritual Affections and Certain Intestinal Gases Freed in Digestion*—4to, 687 pp.) In a scientific work entitled, I believe, *Delectatio Demonorum* (John Camden Hotton, London, 1873) this view of the sentiments receives a striking illustration; and for further light consult Professor Dam's famous treatise on *Love as a Product of Alimentary Maceration*.

Heathen, n. A benighted creature who has the folly to worship something that he can see and feel.

Heaven, n. A place where the wicked cease from troubling you with talk of their personal affairs, and the good listen with attention while you expound your own.

Helpmate, n. A wife, or bitter half.

Hemp, n. A plant from whose fibrous bark is made an article of neckwear which is frequently put on after public speaking in the open air and prevents the wearer from taking cold.

Hermit, n. A person whose vices and follies are not sociable.

Hibernate, v. i. To pass the winter season in domestic seclusion. There have been many singular popular notions about the hibernation of various animals. Many believe that the bear hibernates during the whole winter and subsists by mechanically sucking its paws. It is admitted that it comes out of its retirement in the spring so lean that it has to try twice before it can cast a shadow. Three or four centuries ago, in England, no fact was better attested than that swallows passed the winter months in the mud at the bottoms of the brooks, clinging together in globular masses. They have apparently been compelled to give up the custom on account of the foulness of the brooks. Sotus Escobius discovered in Central Asia a whole nation of people who hibernate. By some inves-

tigators, the fasting of Lent is supposed to have been originally a modified form of hibernation, to which the Church gave a religious significance; but this view was strenuously opposed by that eminent authority, Bishop Kip, who did not wish any honors denied to the memory of the Founder of his family.

Hippogriff, n. An animal (now extinct) which was half horse and half griffin. The griffin was itself a compound creature, half lion and half eagle. The hippogriff was actually, therefore, only one-quarter eagle, which is two dollars and fifty cents in gold. The study of zoology is full of surprises.

Historian, n. A broad-gauge gossip.

History, n. An account mostly false, of events mostly unimportant, which are brought about by rulers mostly knaves, and soldiers mostly fools.

Hog, n. A bird remarkable for the catholicity of its appetite and serving to illustrate that of ours. Among the Mahometans and Jews, the hog is not in favor as an article of diet, but is respected for the delicacy of its habits, the beauty of its plumage and the melody of its voice. It is chiefly as a songster that the fowl is esteemed; a cage of him in full chorus has been known to draw tears from two persons at once. The scientific name of this dicky-bird is *Porcus Rockefelleri*. Mr. Rockefeller did not discover the hog, but it is considered his by right of resemblance.

Home, n. The place of last resort—open all night.

Homesick, adj. Dead broke abroad.

Homœopathist, n. The humorist of the medical profession.

Homœopathy, n. A school of medicine midway between Allopathy and Christian Science. To the last both the others are distinctly inferior, for Christian Science will cure imaginary diseases, and they can not.

Homicide, n. The slaying of one human being by another. There are four kinds of homicide: felonious, excusable, justifiable and praiseworthy, but it makes no great difference to the person slain whether he fell by one kind or another—the classification is for advantage of the lawyers.

Honorable, adj. Afflicted with an impediment in one's reach. In legislative bodies it is customary to mention all members as honorable; as, "the honorable gentleman is a scurvy cur."

Hope, n. Desire and expectation rolled into one.

> Delicious Hope! when naught to man is left—
> Of fortune destitute, of friends bereft;
> When even his dog deserts him, and his goat
> With tranquil disaffection chews his coat
> While yet it hangs upon his back; then thou,
> The star far-flaming on thine angel brow,
> Descendest, radiant, from the skies to hint
> The promise of a clerkship in the Mint.

Horrid, adj. In English, hideous, frightful, appalling. In Young-womanese, mildly objectionable.

Hospitality, n. The virtue which induces us to feed and lodge certain persons who are not in need of food and lodging.

Hostility, n. A peculiarly sharp and specially applied sense of the earth's overpopulation. Hostility is classed as active and passive; as (respectively) the feeling of a woman for her female friends, and that which she entertains for all the rest of her sex.

Houri, n. A comely female inhabiting the Mohammedan Paradise to make things cheery for the good Mussulman, whose belief in her existence marks a noble discontent with his earthly spouse, whom he denies a soul. By that good lady the Houris are said to be held in deficient esteem.

House, n. A hollow edifice erected for the habitation of man, rat, mouse, beetle, cockroach, fly, mosquito, flea, bacillus and microbe. *House of Correction,* a place of reward for political and personal service, and for the detention of offenders and appropriations. *House of God,* a building with a steeple and a mortgage on it. *House-dog,* a pestilent beast kept on domestic premises to insult persons passing by and appal the hardy visitor. *House-maid,* a youngerly person of the opposing sex employed to be variously disagreeable and ingeniously unclean in the station in which it has pleased God to place her.

Houseless, adj. Having paid all taxes on household goods.

Humanity, n. The human race, collectively, exclusive of the anthropoid poets.

Hurricane, n. An atmospheric demonstration once very common but now generally abandoned for the tornado and cyclone. The hurricane is still in popular use in the West Indies and is preferred by certain old-

fashioned sea-captains. It is also used in the construction of the upper decks of steamboats, but generally speaking, the hurricane's usefulness has outlasted it.

Hurry, n. The dispatch of bunglers.

Husband, n. One who, having dined, is charged with the care of the plate.

Hydra, n. A kind of animal that the ancients catalogued under many heads.

Hyena, n. A beast held in reverence by some oriental nations from its habit of frequenting at night the burial-places of the dead. But the medical student does that.

Hypocrite, n. One who, professing virtues that he does not respect, secures the advantage of seeming to be what he despises.

I

I is the first letter of the alphabet, the first word of the language, the first thought of the mind, the first object of affection. In grammar it is a pronoun of the first person and singular number. Its plural is said to be *We,* but how there can be more than one myself is doubtless clearer to the grammarians than it is to the author of this incomparable dictionary. Conception of two myselves is difficult, but fine. The frank yet graceful use of "I" distinguishes a good writer from a bad; the latter carries it with the manner of a thief trying to cloak his loot.

Idiot, n. A member of a large and powerful tribe whose influence in human affairs has always been dominant and controlling. The Idiot's activity is not confined to any special field of thought or action, but "pervades and regulates the whole." He has the last word in everything; his decision is unappealable. He sets the fashions of opinion and taste, dictates the limitations of speech and circumscribes conduct with a dead-line.

Idleness, n. A model farm where the devil experiments with seeds of new sins and promotes the growth of staple vices.

Ignoramus, n. A person unacquainted with certain kinds of knowledge familiar to yourself, and having certain other kinds that you know nothing about.

Illustrious, adj. Suitably placed for the shafts of malice, envy and detraction.

Imagination, n. A warehouse of facts, with poet and liar in joint ownership.

Imbecility, n. A kind of divine inspiration, or sacred fire affecting censorious critics of this dictionary.

Immigrant, n. An unenlightened person who thinks one country better than another.

Immodest, adj. Having a strong sense of one's own merit, coupled with a feeble conception of worth in others.

Immoral, adj. Inexpedient. Whatever in the long run and with regard to the greater number of instances men find to be generally inexpedient comes to be considered wrong, wicked, immoral. If man's notions of right and wrong have any other basis than this of expediency; if they originated, or could have originated, in any other way; if actions have in themselves a moral character apart from, and nowise dependent on, their consequences—then all philosophy is a lie and reason a disorder of the mind.

Impale, v. t. In popular usage to pierce with any weapon which remains fixed in the wound. This, however, is inaccurate; to impale is, properly, to put to death by thrusting an upright sharp stake into the body, the victim being left in a sitting posture. This was a common mode of punishment among many of the nations of antiquity, and is still in high favor in China and other parts of Asia. Down to the beginning of the fifteenth century it was widely employed in "churching" heretics and schismatics. Wolecraft calls it the "stoole of repentynge," and among the common people it was jocularly known as "riding the one legged horse." Ludwig Salzmann informs us that in Thibet impalement is considered the most appropriate punishment for crimes against religion; and although in China it is sometimes awarded for secular offences, it is most frequently adjudged in cases of sacrilege. To the person in actual experience of impalement it must be a matter of minor importance by what kind of civil or religious dissent he was made acquainted with its discomforts; but doubtless he would feel a certain satisfaction if able to contemplate himself in the character of a weather-cock on the spire of the True Church.

Impartial, adj. Unable to perceive any promise of personal advantage from espousing either side of a controversy or adopting either of two conflicting opinions.

Impenitence, n. A state of mind intermediate in point of time between sin and punishment.

Impiety, n. Your irreverence toward my deity.

Imposition, n. The act of blessing or consecrating by the laying on of hands—a ceremony common to many ecclesiastical systems, but performed with the frankest sincerity by the sect known as Thieves.

Imposter, n. A rival aspirant to public honors.

Improvidence, n. Provision for the needs of to-day from the revenues of to-morrow.

Impunity, n. Wealth.

Inadmissible, adj. Not competent to be considered. Said of certain kinds of testimony which juries are supposed to be unfit to be entrusted with, and which judges, therefore, rule out, even of proceedings before themselves alone. Heresay evidence is inadmissible because the person quoted was unsworn and is not before the court for examination; yet most momentous actions, military, political, commercial and of every other kind, are daily undertaken on hearsay evidence. There is no religion in the world that has any other basis than hearsay evidence. Revelation is hearsay evidence; that the Scriptures are the word of God we have only the testimony of men long dead whose identity is not clearly established and who are not known to have been sworn in any sense. Under the rules of evidence as they now exist in this country, no single assertion in the Bible has in its support any evidence admissible in a court of law. It cannot be proved that the battle of Blenheim ever was fought, that there was such a person as Julius Cæsar, such an empire as Assyria.

But as records of courts of justice are admissible, it can easily be proved that powerful and malevolent magicians once existed and were a scourge to mankind. The evidence (including confession) upon which certain women were convicted of witchcraft and executed was without a flaw; it is still unimpeachable. The judges' decisions based on it were sound in logic and in law. Nothing in any existing court was ever more thoroughly proved than the charges of witchcraft and sorcery for which so many suffered death. If there were no witches, human testimony and human reason are alike destitute of value.

Inauspiciously, adv. In an unpromising manner, the auspices being unfavorable. Among the Romans it was customary before undertaking any important action or enterprise to obtain from the augurs, or state prophets, some hint of its probable outcome; and one of their favorite and most trustworthy modes of divination consisted in observing the flight of birds—the omens thence derived being called *auspices.* Newspaper reporters and certain miscreant lexicographers have decided

that the word—always in the plural—shall mean "patronage" or "management"; as, "The festivities were under the auspices of the Ancient and Honorable Order of Body-Snatchers"; or, "The hilarities were auspicated by the Knights of Hunger."

Income, n. The natural and rational gauge and measure of respectability, the commonly accepted standards being artificial, arbitrary and fallacious; for, as "Sir Sycophas Chrysolater" in the play has justly remarked, "the true use and function of property (in whatsoever it consisteth—coins, or land, or houses, or merchant-stuff, or anything which may be named as holden of right to one's own subservience) as also of honors, titles, preferments and place, and all favor and acquaintance of persons of quality or ableness, are but to get money. Hence it followeth that all things are truly to be rated as of worth in measure of their serviceableness to that end; and their possessors should take rank in agreement thereto, neither the lord of an unproducing manor, howsoever broad and ancient, nor he who bears an unremunerate dignity, nor yet the pauper favorite of a king, being esteemed to level excellency with him whose riches are of daily accretion; and hardly should they whose wealth is barren claim and rightly take more honor than the poor and unworthy."

Incompatibility, n. In matrimony a similarity of tastes, particularly the taste for domination. Incompatibility may, however, consist of a meek-eyed matron living just around the corner. It has even been known to wear a moustache.

Incompossible, adj. Unable to exist if something else exists. Two things are incompossible when the world of being has scope enough for one of them, but not enough for both—as Walt Whitman's poetry and God's mercy to man. Incompossibility, it will be seen, is only incompatibility let loose. Instead of such low language as "Go heel yourself—I mean to kill you on sight," the words, "Sir, we are incompossible," would convey an equally significant intimation and in stately courtesy are altogether superior.

Incorporation, n. The act of uniting several persons into one fiction called a corporation, in order that they may be no longer responsible for their actions. A, B, and C are a corporation. A robs, B steals and C (it is necessary that there be one gentleman in the concern) cheats. It is a plundering, thieving, swindling corporation. But A, B, and C, who have jointly determined and severally executed every crime of the corporation, are blameless. It is wrong to mention them by name when censuring their acts as a corporation, but right when praising. Incorporation is somewhat like the ring of Gyges: it bestows the blessing of

invisibility—comfortable to knaves. The scoundrel who invented incorporation is dead—he has disincorporated.

Incumbent, n. A person of the liveliest interest to the outcumbents.

Indecision, n. The chief element of success; "for whereas," saith Sir Thomas Brewbold, "there is but one way to do nothing and divers ways to do something, whereof, to a surety, only one is the right way, it followeth that he who from indecision standeth still hath not so many chances of going astray as he who pusheth forwards"—a most clear and satisfactory exposition of the matter.

Indifferent, adj. Imperfectly sensible to distinctions among things.

Indigestion, n. A disease which the patient and his friends frequently mistake for deep religious conviction and concern for the salvation of mankind. As the simple Red Man of the western wild put it, with, it must be confessed, a certain force: "Plenty well, no pray; big bellyache, heap God."

Indiscretion, n. The guilt of woman.

Inexpedient, adj. Not calculated to advance one's interests.

Infancy, n. The period of our lives when, according to Wordsworth, "Heaven lies about us." The world begins lying about us pretty soon afterward.

Infidel, n. In New York, one who does not believe in the Christian religion; in Constantinople, one who does.

Influence, n. In politics, a visionary *quo* given in exchange for a substantial *quid*.

Ingrate, n. One who receives a benefit from another, or is otherwise an object of charity.

Inhumanity, n. One of the signal and characteristic qualities of humanity.

Injury, n. An offense next in degree of enormity to a slight.

Injustice, n. A burden which of all those that we load upon others and carry ourselves is lightest in the hands and heaviest upon the back.

Ink, n. A villainous compound of tannogallate of iron, gum-arabic and water, chiefly used to facilitate the infection of idiocy and promote intellectual crime. The properties of ink are peculiar and contradictory: it may be used to make reputations and unmake them; to blacken them

and to make them white; but it is most generally and acceptably employed as a mortar to bind together the stones in an edifice of fame, and as a whitewash to conceal afterward the rascal quality of the material. There are men called journalists who have established ink baths which some persons pay money to get into, others to get out of. Not infrequently it occurs that a person who has paid to get in pays twice as much to get out.

Innate, adj. Natural, inherent—as innate ideas, that is to say, ideas that we are born with, having had them previously imparted to us. The doctrine of innate ideas is one of the most admirable faiths of philosophy, being itself an innate idea and therefore inaccessible to disproof, though Locke foolishly supposed himself to have given it "a black eye." Among innate ideas may be mentioned the belief in one's ability to conduct a newspaper, in the greatest of one's country, in the superiority of one's civilization, in the importance of one's personal affairs and in the interesting nature of one's diseases.

In'ards, n. The stomach, heart, soul and other bowels. Many eminent investigators do not class the soul as an in'ard, but that acute observer and renowned authority, Dr. Gunsaulus, is persuaded that the mysterious organ known as the spleen is nothing less than our immortal part. To the contrary, Professor Garrett P. Servis holds that man's soul is that prolongation of his spinal marrow which forms the pith of his no tail; and for demonstration of his faith points confidently to the fact that tailed animals have no souls. Concerning these two theories, it is best to suspend judgment by believing both.

Inscription, n. Something written on another thing. Inscriptions are of many kinds, but mostly memorial, intended to commemorate the fame of some illustrious person and hand down to distant ages the record of his services and virtues. To this class of inscriptions belongs the name of John Smith, penciled on the Washington monument.

Inspiration, n. Literally, the act of breathing into, as a prophet is inspired by the Spirit, and a flute by an enemy of mankind.

Insurance, n. An ingenious modern game of chance in which the player is permitted to enjoy the comfortable conviction that he is beating the man who keeps the table.

Insurrection, n. An unsuccessful revolution. Disaffection's failure to substitute misrule for bad government.

Intention, n. The mind's sense of the prevalence of one set of influences over another set; an effect whose cause is the imminence, immediate or remote, of the performance of an involuntary act.

Interpreter, n. One who enables two persons of different languages to understand each other by repeating to each what it would have been to the interpreter's advantage for the other to have said.

Interregnum, n. The period during which a monarchical country is governed by a warm spot on the cushion of the throne. The experiment of letting the spot grow cold has commonly been attended by most unhappy results from the zeal of many worthy persons to make it warm again.

Intimacy, n. A relation into which fools are providentially drawn for their mutual destruction.

Introduction, n. A social ceremony invented by the devil for the gratification of his servants and the plaguing of his enemies. The introduction attains its most malevolent development in this country, being, indeed, closely related to our political system. Every American being the equal of every other American, it follows that everybody has the right to know everybody else, which implies the right to introduce without request or permission. The Declaration of Independence should have read thus:

"We hold those truths to be self-evident: that all men are created equal; that they are endowed by their Creator with certain inalienable rights; that among these are life, and the right to make that of another miserable by thrusting upon him an incalculable quantity of acquaintances; liberty, particularly the liberty to introduce persons to one another without first ascertaining if they are not already acquainted as enemies; and the pursuit of another's happiness with a running pack of strangers."

Inventor, n. A person who makes an ingenious arrangement of wheels, levers and springs, and believes it civilization.

Irreligion, n. The principal one of the great faiths of the world.

Itch, n. The patriotism of a Scotchman.

J

Jealous, adj. Unduly concerned about the preservation of that which can be lost only if not worth keeping.

Jester, n. An officer formerly attached to a king's household, whose business it was to amuse the court by ludicrous actions and utterances, the absurdity being attested by his motley costume. The king himself being attired with dignity, it took the world some centuries to discover

that his own conduct and decrees were sufficiently ridiculous for the amusement not only of his court but of all mankind.

Jews-harp, n. An unmusical instrument, played by holding it fast with the teeth and trying to brush it away with the finger.

Joss-sticks, n. Small sticks burned by the Chinese in their pagan tomfoolery, in imitation of certain sacred rites of our holy religion.

Jury, n. A number of persons appointed by a court to assist the attorneys in preventing law from degenerating into justice.

Justice, n. A commodity which in a more or less adulterated condition the State sells to the citizen as a reward for his allegiance, taxes and personal service.

K

Kill, v. t. To create a vacancy without nominating a successor.

Kindness, n. A brief preface to ten volumes of exaction.

King, n. A male person commonly known in America as a "crowned head," although he never wears a crown and has usually no head to speak of.

Kiss, n. A word invented by the poets as a rhyme for "bliss." It is supposed to signify, in a general way, some kind of rite or ceremony appertaining to a good understanding; but the manner of its performance is unknown to this lexicographer.

Kleptomaniac, n. A rich thief.

Koran, n. A book which the Mohammedans foolishly believe to have been written by divine inspiration, but which Christians know to be a wicked imposture, contradictory to the Holy Scriptures.

L

Labor, n. One of the processes by which A acquires property for B.

Land, n. A part of the earth's surface, considered as property. The theory that land is property subject to private ownership and control is the foundation of modern society, and is eminently worthy of the super-structure. Carried to its logical conclusion, it means that some have the right to prevent others from living; for the right to own implies the right exclusively to occupy; and in fact laws of trespass are enacted wherever property in land is recognized. It follows that if the whole area of *terra*

firma is owned by A, B and C, there will be no place for D, E, F and G to be born, or, born as trespassers, to exist.

Language, *n*. The music with which we charm the serpents guarding another's treasure.

Laocoon, *n*. A famous piece of antique sculpture representing a priest of that name and his two sons in the folds of two enormous serpents. The skill and diligence with which the old man and lads support the serpents and keep them up to their work have been justly regarded as one of the noblest artistic illustrations of the mastery of human intelligence over brute inertia.

Lap, *n*. One of the most important organs of the female system— an admirable provision of nature for the repose of infancy, but chiefly useful in rural festivities to support plates of cold chicken and heads of adult males. The male of our species has a rudimentary lap, imperfectly developed and in no way contributing to the animal's substantial welfare.

Law, *n*.

> Once Law was sitting on the bench,
> And Mercy knelt a-weeping.
> "Clear out!" he cried, "disordered wench!
> Nor come before me creeping.
> Upon your knees if you appear,
> 'Tis plain your have no standing here."
>
> Then Justice came. His Honor cried:
> "*Your* status?—devil seize you!"
> "*Amica curiae*," she replied—
> "Friend of the court, so please you."
> "Begone!" he shouted—"there's the door—
> I never saw your face before!"

Lawful, *adj*. Compatible with the will of a judge having jurisdiction.

Lawyer, *n*. One skilled in circumvention of the law.

Laziness, *n*. Unwarranted repose of manner in a person of low degree.

Lead, *n*. A heavy blue-gray metal much used in giving stability to light lovers—particularly to those who love not wisely but other men's

wives. Lead is also of great service as a counterpoise to an argument of such weight that it turns the scale of debate the wrong way. An interesting fact in the chemistry of international controversy is that at the point of contact of two patriotisms lead is precipitated in great quantities.

Learning, n. The kind of ignorance distinguishing the studious.

Lecturer, n. One with his hand in your pocket, his tongue in your ear and his faith in your patience.

Legacy, n. A gift from one who is legging it out of this vale of tears.

Legislator, n. A person who goes to the capital of his country to increase his own; one who makes laws and money.

Lettuce, n. An herb of the genus *Lactuca,* "Wherewith," says that pious gastronome, Hengist Pelly, "God has been pleased to reward the good and punish the wicked. For by his inner light the righteous man has discerned a manner of compounding for it a dressing to the appetency whereof a multitude of gustible condiments conspire, being reconciled and ameliorated with profusion of oil, the entire comestible making glad the heart of the godly and causing his face to shine. But the person of spiritual unworth is successfully tempted of the Adversary to eat of lettuce with destitution of oil, mustard, egg, salt and garlic, and with a rascal bath of vinegar polluted with sugar. Wherefore the person of spiritual unworth suffers an intestinal pang of strange complexity and raises the song."

Lexicographer, n. A pestilent fellow who, under the pretense of recording some particular stage in the development of a language, does what he can to arrest its growth, stiffen its flexibility and mechanize its methods. For your lexicographer, having written his dictionary, comes to be considered "as one having authority," whereas his function is only to make a record, not to give a law. The natural servility of the human understanding having invested him with judicial power, surrenders its right of reason and submits itself to a chronicle as if it were a statute. Let the dictionary (for example) mark a good word as "obsolete" or "obsolescent" and few men thereafter venture to use it, whatever their need of it and however desirable its restoration to favor—whereby the process of impoverishment is accelerated and speech decays. On the contrary, the bold and discerning writer who, recognizing the truth that language must grow by innovation if it grow at all, makes new words and uses the old in an unfamiliar sense, has no following and is tartly reminded that "it isn't in the dictionary"—although down to the time of the first lexicographer (Heaven forgive him!) no author ever had used a word that *was* in the dictionary. In the golden prime and high noon of English speech; when from the lips of the great Elizabethans fell words that made

their own meaning and carried it in their very sound; when a Shakespeare and a Bacon were possible, and the language now rapidly perishing at one end and slowly renewed at the other was in vigorous growth and hardy preservation—sweeter than honey and stronger than a lion—the lexicographer was a person unknown, the dictionary a creation which his Creator had not created him to create.

Liar, n. A lawyer with a roving commission.

Liberty, n. One of Imagination's most precious possessions.

Lickspittle, n. A useful functionary, not infrequently found editing a newspaper. In his character of editor he is closely allied to the blackmailer by the tie of occasional identity; for in truth the lickspittle is only the blackmailer under another aspect, though the latter is frequently found as an independent species. Lickspittling is more detestable than blackmailing, precisely as the business of a confidence man is more detestable than that of a highway robber; and the parallel maintains itself throughout, for whereas few robbers will cheat, every sneak will plunder if he dare.

Life, n. A spiritual pickle preserving the body from decay. We live in daily apprehension of its loss; yet when lost it is not missed. The question, "Is life worth living?" has been much discussed; particularly by those who think it is not, many of whom have written at great length in support of their view and by careful observance of the laws of health enjoyed for long terms of years the honors of successful controversy.

Lighthouse, n. A tall building on the seashore in which the government maintains a lamp and the friend of a politician.

Litigant, n. A person about to give up his skin for the hope of retaining his bones.

Litigation, n. A machine which you go into as a pig and come out as a sausage.

Liver, n. A large red organ thoughtfully provided by nature to be bilious with. The sentiments and emotions which every literary anatomist now knows to haunt the heart were anciently believed to infest the liver; and even Gascoygne, speaking of the emotional side of human nature, calls it "our hepaticall parte." It was at one time considered the seat of life; hence its name—liver, the thing we live with. The liver is heaven's best gift to the goose; without it that bird would be unable to supply us with the Strasbourg *pâté.*

Lock-and-key, n. The distinguishing device of civilization and enlightenment.

Lodger, n. A less popular name for the Second Person of that delectable newspaper Trinity, the Roomer, the Bedder and the Mealer.

Logic, n. The art of thinking and reasoning in strict accordance with the limitations and incapacities of the human misunderstanding. The basic of logic is the syllogism, consisting of a major and a minor premise and a conclusion—thus:

Major Premise: Sixty men can do a piece of work sixty times as quickly as one man.

Minor Premise: One man can dig a posthole in sixty seconds; therefore—

Conclusion: Sixty men can dig a posthole in one second.

This may be called the syllogism arithmetical, in which, by combining logic and mathematics, we obtain a double certainty and are twice blessed.

Longevity, n. Uncommon extension of the fear of death.

Loquacity, n. A disorder which renders the sufferer unable to curb his tongue when you wish to talk.

Loss, n. Privation of that which we had, or had not. Thus, in the latter sense, it is said of a defeated candidate that he "lost his election"; and of that eminent man, the poet Gilder, that he has "lost his mind." It is in the former and more legitimate sense, that the word is used in the famous epitaph:

> Here Huntington's ashes long have lain
> Whose loss is our own eternal gain,
> For while he exercised all his powers
> Whatever he gained, the loss was ours.

Love, n. A temporary insanity curable by marriage or by removal of the patient from the influences under which he incurred the disorder. This disease, like *caries* and many other ailments, is prevalent only among civilized races living under artificial conditions; barbarous nations breathing pure air and eating simple food enjoy immunity from its ravages. It is sometimes fatal, but more frequently to the physician than to the patient.

Low-bred, adj. "Raised" instead of brought up.

Luminary, n. One who throws light upon a subject; as an editor by not writing about it.

M

Mace, n. A staff of office signifying authority. Its form, that of a heavy club, indicates its original purpose and use in dissuading from dissent.

Machination, n. The method employed by one's opponents in baffling one's open and honorable efforts to do the right thing.

Mad, adj. Affected with a high degree of intellectual independence; not conforming to standards of thought, speech and action derived by the conformants from study of themselves; at odds with the majority; in short, unusual. It is noteworthy that persons are pronounced mad by officials destitute of evidence that themselves are sane. For illustration, this present (and illustrious) lexicographer is no firmer in the faith of his own sanity than is any inmate of any madhouse in the land; yet for aught he knows to the contrary, instead of the lofty occupation that seems to him to be engaging his powers he may really be beating his hands against the window bars of an asylum and declaring himself Noah Webster, to the innocent delight of many thoughtless spectators.

Magdalene, n. An inhabitant of Magdala. Popularly, a woman found out. This definition of the word has the authority of ignorance, Mary of Magdala being another person than the penitent woman mentioned by St. Luke. It has also the official sanction of the governments of Great Britain and the United States. In England the word is pronounced Maudlin, whence maudlin, adjective, unpleasantly sentimental. With their Maudlin for Magdalene, and their Bedlam for Bethlehem, the English may justly boast themselves the greatest of revisers.

Magic, n. An art of converting superstition into coin. There are other arts serving the same high purpose, but the discreet lexicographer does not name them.

Magnificent, adj. Having a grandeur or splendor superior to that to which the spectator is accustomed, as the ears of an ass, to a rabbit, or the glory of a glowworm, to a maggot.

Magpie, n. A bird whose thievish disposition suggested to some one that it might be taught to talk.

Maiden, n. A young person of the unfair sex addicted to clewless conduct and views that madden to crime. The genus has a wide geographical distribution, being found wherever sought and deplored wherever found. The maiden is not altogether unpleasing to the eye, nor

(without her piano and her views) insupportable to the ear, though in respect to comeliness distinctly inferior to the rainbow, and, with regard to the part of her that is audible, beaten out of the field by the canary—which, also, is more portable.

Majesty, n. The state and title of a king. Regarded with a just contempt by the Most Eminent Grand Masters, Grand Chancellors, Great Incohonees and Imperial Potentates of the ancient and honorable orders of republican America.

Male, n. A member of the unconsidered, or negligible sex. The male of the human race is commonly known (to the female) as Mere Man. The genus has two varieties: good providers and bad providers.

Malefactor, n. The chief factor in the progress of the human race.

Malthusian, adj. Pertaining to Malthus and his doctrines. Malthus believed in artificially limiting population, but found that it could not be done by talking. One of the most practical exponents of the Malthusian idea was Herod of Judea, though all the famous soldiers have been of the same way of thinking.

Mammalia, n. pl. A family of vertebrate animals whose females in a state of nature suckle their young, but when civilized and enlightened put them out to nurse, or use the bottle.

Mammon, n. The god of the world's leading religion. His chief temple is in the holy city of New York.

Man, n. An animal so lost in rapturous contemplation of what he thinks he is as to overlook what he indubitably ought to be. His chief occupation is extermination of other animals and his own species, which, however, multiplies with such insistent rapidity as to infest the whole habitable earth and Canada.

Manicheism, n. The ancient Persian doctrine of an incessant warfare between Good and Evil. When Good gave up the fight the Persians joined the victorious Opposition.

Marriage, n. The state or condition of a community consisting of a master, a mistress and two slaves, making in all, two.

Martyr, n. One who moves along the line of least reluctance to a desired death.

Mausoleum, n. The final and funniest folly of the rich.

Mayonnaise, n. One of the sauces which serve the French in place of a state religion.

Me, pro. The objectionable case of I. The personal pronoun in

English has three cases, the dominative, the objectionable and the oppressive. Each is all three.

Meander, n. To proceed sinuously and aimlessly. The word is the ancient name of a river about one hundred and fifty miles south of Troy, which turned and twisted in the effort to get out of hearing when the Greeks and Trojans boasted of their prowess.

Medicine, n. A stone flung down the Bowery to kill a dog in Broadway.

Meekness, n. Uncommon patience in planning a revenge that is worth while.

Mendacious, adj. Addicted to rhetoric.

Merchant, n. One engaged in a commercial pursuit. A commercial pursuit is one in which the thing pursued is a dollar.

Mercy, n. An attribute beloved of detected offenders.

Mesmerism, n. Hypnotism before it wore good clothes, kept a carriage and asked Incredulity to dinner.

Metropolis, n. A stronghold of provincialism.

Millennium, n. The period of a thousand years when the lid is to be screwed down, with all reformers on the under side.

Mind, n. A mysterious form of matter secreted by the brain. Its chief activity consists in the endeavor to ascertain its own nature, the futility of the attempt being due to the fact that it has nothing but itself to know itself with. From the Latin *mens,* a fact unknown to that honest shoe-seller, who, observing that his learned competitor over the way had displayed the motto *"Mens conscia recti,"* emblazoned his own shop front with the words "Men's, women's and children's conscia recti."

Mine, adj. Belonging to me if I can hold or seize it.

Minister, n. An agent of a higher power with a lower responsibility. In diplomacy an officer sent into a foreign country as the visible embodiment of his sovereign's hostility. His principal qualification is a degree of plausible inveracity next below that of an ambassador.

Miscreant, n. A person of the highest degree of unworth. Etymologically, the word means unbeliever, and its present signification may be regarded as theology's noblest contribution to the development of our language.

Misdemeanor, n. An infraction of the law having less dignity

than a felony and constituting no claim to admittance into the best criminal society.

Misfortune, n. The kind of fortune that never misses.

Miss, n. A title with which we brand unmarried women to indicate that they are in the market. Miss, Missis (Mrs.) and Mister (Mr.) are the three most distinctly disagreeable words in the language, in sound and sense. Two are corruptions of Mistress, the other of Master. In the general abolition of social titles in this our country they miraculously escaped to plague us. If we must have them let us be consistent and give one to the unmarried man. I venture to suggest Mush, abbreviated to Mh.

Monarch, n. A person engaged in reigning. Formerly the monarch ruled, as the derivation of the word attests, and as many subjects have had occasion to learn. In Russia and the Orient the monarch has still a considerable influence in public affairs and in the disposition of the human head, but in western Europe political administration is mostly entrusted to his ministers, he being somewhat preoccupied with reflections relating to the status of his own head.

Monday, n. In Christian countries, the day after the baseball game.

Money, n. A blessing that is of no advantage to us excepting when we part with it. An evidence of culture and a passport to polite society. Supportable property.

Monologue, n. The activity of a tongue that has no ears.

Monsignor, n. A high ecclesiastical title, of which the Founder of our religion overlooked the advantages.

Moral, adj. Conforming to a local and mutable standard of right. Having the quality of general expediency.

More, adj. The comparative degree of too much.

Mouse, n. An animal which strews its path with fainting women. As in Rome Christians were thrown to the lions, so centuries earlier in Otumwee, the most ancient and famous city of the world, female heretics were thrown to the mice. Jakak-Zotp, the historian, the only Otumwump whose writings have descended to us, says that these martyrs met their death with little dignity and much exertion. He even attempts to exculpate the mice (such is the malice of bigotry) by declaring that the unfortunate women perished, some from exhaustion, some of broken necks from falling over their own feet, and some from lack of restoratives. The mice, he avers, enjoyed the pleasures of the chase with

composure. But if "Roman history is nine-tenths lying," we can hardly expect a smaller proportion of that rhetorical figure in the annals of a people capable of so incredible cruelty to lovely woman; for a hard heart has a false tongue.

Mousquetaire, n. A long glove covering a part of the arm. Worn in New Jersey. But "mousquetaire" is a mighty poor way to spell muskeeter.

Mouth, n. In man, the gateway to the soul; in woman, the outlet of the heart.

Mugwump, n. In politics one afflicted with self-respect and addicted to the vice of independence. A term of contempt.

Multitude, n. A crowd; the source of political wisdom and virtue. In a republic, the object of the statesman's adoration. "In a multitude of counsellors there is wisdom," saith the proverb. If many men of equal individual wisdom are wiser than any one of them, it must be that they acquire the excess of wisdom by the mere act of getting together. Whence comes it? Obviously from nowhere—as well say that a range of mountains is higher than the single mountains composing it. A multitude is as wise as its wisest member if it obey him; if not, it is no wiser than its most foolish.

Mythology, n. The body of a primitive people's beliefs concerning its origin, early history, heroes, deities and so forth, as distinguished from the true accounts which it invents later.

N

Nectar, n. A drink served at banquets of the Olympian deities. The secret of its preparation is lost, but the modern Kentuckians believe that they come pretty near to a knowledge of its chief ingredient.

Neighbor, n. One whom we are commanded to love as ourselves, and who does all he knows how to make us disobedient.

Nepotism, n. Appointing your grandmother to office for the good of the party.

Nobleman, n. Nature's provision for wealthy American maids ambitious to incur social distinction and suffer high life.

Noise, n. A stench in the ear. Undomesticated music. The chief product and authenticating sign of civilization.

Nominate, v. To designate for the heaviest political assessment. To

put forward a suitable person to incur the mudgobbing and deadcatting of the opposition.

Nominee, _n._ A modest gentleman shrinking from the distinction of private life and diligently seeking the honorable obscurity of public office.

Non-Combatant, _n._ A dead Quaker.

Nose, _n._ The extreme outpost of the face. From the circumstance that great conquerors have great noses, Getius, whose writings antedate the age of humor, calls the nose the organ of quell. It has been observed that one's nose is never so happy as when thrust into the affairs of another, from which some physiologists have drawn the inference that the nose is devoid of the sense of smell.

Notoriety, _n._ The fame of one's competitor for public honors. The kind of renown most accessible and acceptable to mediocrity. A Jacob's-ladder leading to the vaudeville stage, with angels ascending and descending.

Novel, _n._ A short story padded. A species of composition bearing the same relation to literature that the panorama bears to art. As it is too long to be read at a sitting the impressions made by its successive parts are successively effaced, as in the panorama. Unity, totality of effect, is impossible; for besides the few pages last read all that is carried in mind is the mere plot of what has gone before. To the romance the novel is what photography is to painting. Its distinguishing principle, probability, corresponds to the literal actuality of the photograph and puts it distinctly into the category of reporting; whereas the free wing of the romancer enables him to mount to such altitudes of imagination as he may be fitted to attain; and the first three essentials of the literary art are imagination, imagination and imagination. The art of writing novels, such as it was, is long dead everywhere except in Russia, where it is new. Peace to its ashes—some of which have a large sale.

November, _n._ The eleventh twelfth of a weariness.

O

Oath, _n._ In law, a solemn appeal to the Deity, made binding upon the conscience by a penalty for perjury.

Oblivion, _n._ The state or condition in which the wicked cease from struggling and the dreary are at rest. Fame's eternal dumping ground. Cold storage for high hopes. A place where ambitious authors meet their

works without pride and their betters without envy. A dormitory without an alarm clock.

Observatory, n. A place where astronomers conjecture away the guesses of their predecessors.

Obsolete, adj. No longer used by the timid. Said chiefly of words. A word which some lexicographer has marked obsolete is ever thereafter an object of dread and loathing to the fool writer, but if it is a good word and has no exact modern equivalent equally good, it is good enough for the good writer. Indeed, a writer's attitude toward "obsolete" words is as true a measure of his literary ability as anything except the character of his work. A dictionary of obsolete and obsolescent words would not only be singularly rich in strong and sweet parts of speech; it would add large possessions to the vocabulary of every competent writer who might not happen to be a competent reader.

Obstinate, adj. Inaccessible to the truth as it is manifest in the splendor and stress of our advocacy.

The popular type and exponent of obstinacy is the mule, a most intelligent animal.

Occident, n. The part of the world lying west (or east) of the Orient. It is largely inhabited by Christians, a powerful subtribe of the Hypocrites, whose principal industries are murder and cheating, which they are pleased to call "war" and "commerce." These, also, are the principal industries of the Orient.

Ocean, n. A body of water occupying about two-thirds of a world made for man—who has no gills.

Offensive, adj. Generating disagreeable emotions or sensations, as the advance of an army against its enemy.

"Were the enemy's tactics offensive?" the king asked. "I should say so!" replied the unsuccessful general. "The blackguard wouldn't come out of his works!"

Old, adj. In that stage of usefulness which is not inconsistent with general inefficiency, as an *old man*. Discredited by lapse of time and offensive to the popular taste, as an *old* book.

Oleaginous, adj. Oily, smooth, sleek.

Disraeli once described the manner of Bishop Wilberforce as "unctuous, oleaginous, saponaceous." And the good prelate was ever afterward known as Soapy Sam. For every man there is something in the vocabulary that would stick to him like a second skin. His enemies have only to find it.

Olympian, adj. Relating to a mountain in Thessaly, once inhabited by gods, now a repository of yellowing newspapers, beer bottles and mutilated sardine cans, attesting the presence of the tourist and his appetite.

> His name the smirking tourist scrawls
> Upon Minerva's temple walls,
> Where thundered once Olympian Zeus,
> And marks his appetite's abuse.

Omen, n. A sign that something will happen if nothing happens.

Once, adv. Enough.

Opera, n. A play representing life in another world, whose inhabitants have no speech but song, no motions but gestures and no postures but attitudes. All acting is simulation, and the word *simulation* is from *simia,* an ape; but in opera the actor takes for his model *Simia audibilis* (or *Poithecanthropos stentor*)—the ape that howls.

Opiate, n. An unlocked door in the prison of Identity. It leads into the jail yard.

Opportunity, n. A favorable occasion for grasping a disappointment.

Oppose, v. To assist with obstructions and objections.

Opposition, n. In politics the party that prevents the Government from running amuck by hamstringing it.

Optimism, n. The doctrine, or belief, that everything is beautiful, including what is ugly, everything good, especially the bad, and everything right that is wrong. It is held with greatest tenacity by those most accustomed to the mischance of falling into adversity, and is most acceptably expounded with the grin that apes a smile. Being a blind faith, it is inaccessible to the light of disproof—an intellectual disorder, yielding to no treatment but death. It is hereditary, but fortunately not contagious.

Optimist, n. A proponent of the doctrine that black is white.

A pessimist applied to God for relief.

"Ah, you wish me to restore your hope and cheerfulness," said God.

"No," replied the petitioner, "I wish you to create something that would justify them."

"The world is all created," said God, "but you have overlooked something—the mortality of the optimist."

Oratory, n. A conspiracy between speech and action to cheat the understanding. A tyranny tempered by stenography.

Orphan, n. A living person whom death has deprived of the power of filial ingratitude—a privation appealing with a particular eloquence to all that is sympathetic in human nature. When young the orphan is commonly sent to an asylum, where by careful cultivation of its rudimentary sense of locality it is taught to know its place. It is then instructed in the arts of dependence and servitude and eventually turned loose to prey upon the world as a bootblack or scullery maid.

Orthodox, n. An ox wearing the popular religious yoke.

Ostrich, n. A large bird to which (for its sins, doubtless) nature has denied that hinder toe in which so many pious naturalists have seen a conspicuous evidence of design. The absence of a good working pair of wings is no defect, for, as has been ingeniously pointed out, the ostrich does not fly.

Otherwise, adv. No better.

Outcome, n. A particular type of disappointment. By the kind of intelligence that sees in an exception a proof of the rule the wisdom of an act is judged by the outcome, the result. This is immortal nonsense; the wisdom of an act is to be judged by the light that the doer had when he performed it.

Outdo, v. t. To make an enemy.

Out-of-Doors, n. That part of one's environment upon which no government has been able to collect taxes. Chiefly useful to inspire poets.

Ovation, n. In ancient Rome, a definite, formal pageant in honor of one who had been disserviceable to the enemies of the nation. A lesser "triumph." In modern English the word is improperly used to signify any loose and spontaneous expression of popular homage to the hero of the hour and place.

Overwork, n. A dangerous disorder affecting high public functionaries who want to go fishing.

Owe, v. To have (and to hold) a debt. The word formerly signified not indebtedness, but possession; it meant "own," and in the minds of debtors there is still a good deal of confusion between assets and liabilities.

Oyster, n. A slimy, gobby shellfish which civilization gives men the

hardihood to eat without removing its entrails! The shells are sometimes given to the poor.

P

Pain, *n.* An uncomfortable frame of mind that may have a physical basis in something that is being done to the body, or may be purely mental, caused by the good fortune of another.

Painting, *n.* The art of protecting flat surfaces from the weather and exposing them to the critic.

Formerly, painting and sculpture were combined in the same work: the ancients painted their statues. The only present alliance between the two arts is that the modern painter chisels his patrons.

Palace, *n.* A fine and costly residence, particularly that of a great official. The residence of a high dignitary of the Christian Church is called a palace; that of the Founder of his religion was known as a field, or wayside. There is progress.

Palm, *n.* A species of tree having several varieties, of which the familiar "itching palm" (*Palma hominis*) is most widely distributed and sedulously cultivated. This noble vegetable exudes a kind of invisible gum, which may be detected by applying to the bark a piece of gold or silver. The metal will adhere with remarkable tenacity. The fruit of the itching palm is so bitter and unsatisfying that a considerable percentage of it is sometimes given away in what are known as "benefactions."

Palmistry, *n.* The 947th method (according to Mimbleshaw's classification) of obtaining money by false pretenses. It consists in "reading character" in the wrinkles made by closing the hand. The pretense is not altogether false; character can really be read very accurately in this way, for the wrinkles in every hand submitted plainly spell the word "dupe." The imposture consists in not reading it aloud.

Pandemonium, *n.* Literally, the Place of All the Demons. Most of them have escaped into politics and finance, and the place is now used as a lecture hall by the Audible Reformer. When disturbed by his voice the ancient echoes clamor appropriate responses most gratifying to his pride of distinction.

Pantaloons, *n.* A nether habiliment of the adult civilized male. The garment is tubular and unprovided with hinges at the points of flexion. Supposed to have been invented by a humorist. Called "trousers" by the enlightened and "pants" by the unworthy.

Pantheism, n. The doctrine that everything is God, in contradistinction to the doctrine that God is everything.

Pantomime, n. A play in which the story is told without violence to the language. The least disagreeable form of dramatic action.

Pardon, v. To remit a penalty and restore to a life of crime. To add to the lure of crime the temptation of ingratitude.

Passport, n. A document treacherously inflicted upon a citizen going abroad, exposing him as an alien and pointing him out for special reprobation and outrage.

Past, n. That part of Eternity with some small fraction of which we have a slight and regrettable acquaintance. A moving line called the Present parts it from an imaginary period known as the Future. These two grand division of Eternity, of which the one is continually effacing the other, are entirely unlike. The one is dark with sorrow and disappointment, the other bright with prosperity and joy. The Past is the region of sobs, the Future is the realm of song. In the one crouches Memory, clad in sackcloth and ashes, mumbling penitential prayer; in the sunshine of the other Hope flies with a free wing, beckoning to temples of success and bowers of ease. Yet the Past is the Future of yesterday, the Future is the Past of to-morrow. They are one—the knowledge and the dream.

Pastime, n. A device for promoting dejection. Gentle exercise for intellectual debility.

Patience, n. A minor form of despair, disguised as a virtue.

Patriot, n. One to whom the interests of a part seem superior to those of the whole. The dupe of statesmen and the tool of conquerors.

Patriotism, n. Combustible rubbish ready to the torch of any one ambitious to illuminate his name.

 In Dr. Johnson's famous dictionary patriotism is defined as the last resort of a scoundrel. With all due respect to an enlightened but inferior lexicographer I beg to submit that it is the first.

Peace, n. In international affairs, a period of cheating between two periods of fighting.

Pedestrian, n. The variable (and audible) part of the roadway for an automobile.

Pedigree, n. The known part of the route from an arboreal ancestor with a swim bladder to an urban descendant with a cigarette.

Penitent, adj. Undergoing or awaiting punishment.

Perfection, n. An imaginary state or quality distinguished from the actual by an element known as excellence; an attribute of the critic.

The editor of an English magazine having received a letter pointing out the erroneous nature of his views and style, and signed "Perfection," promptly wrote at the foot of the letter: "I don't agree with you," and mailed it to Matthew Arnold.

Pericardium, n. A sack of membrane covering a multitude of sins.

Peripatetic, adj. Walking about. Relating to the philosophy of Aristotle, who, while expounding it, moved from place to place in order to avoid his pupil's objections. A needless precaution—they knew no more of the matter than he.

Peroration, n. The explosion of an oratorical rocket. It dazzles, but to an observer having the wrong kind of nose its most conspicuous peculiarity is the smell of the several kinds of powder used in preparing it.

Perseverance, n. A lowly virtue whereby mediocrity achieves an inglorious success.

Pessimism, n. A philosophy forced upon the convictions of the observer by the disheartening prevalence of the optimist with his scarecrow hope and his unsightly smile.

Philanthropist, n. A rich (and usually bald) old gentleman who has trained himself to grin while his conscience is picking his pocket.

Philistine, n. One whose mind is the creature of its environment, following the fashion in thought, feeling and sentiment. He is sometimes learned, frequently prosperous, commonly clean and always solemn.

Philosophy, n. A route of many roads leading from nowhere to nothing.

Phrenology, n. The science of picking the pocket through the scalp. It consists in locating and exploiting the organ that one is a dupe with.

Physician, n. One upon whom we set our hopes when ill and our dogs when well.

Physiognomy, n. The art of determining the character of another by the resemblances and differences between his face and our own, which is the standard of excellence.

Piano, n. A parlor utensil for subduing the impenitent visitor. It is

operated by depressing the keys of the machine and the spirits of the audience.

Picture, n. A representation in two dimensions of something wearisome in three.

Pie, n. An advance agent of the reaper whose name is Indigestion.

Piety, n. Reverence for the Supreme Being, based upon His supposed resemblance to man.

Pig, n. An animal (*Porcus omnivorus*) closely allied to the human race by the splendor and vivacity of its appetite, which, however, is inferior in scope, for it sticks at pig.

Pilgrim, n. A traveler that is taken seriously. A Pilgrim Father was one who, leaving Europe in 1620 because not permitted to sing psalms through his nose, followed it to Massachusetts, where he could personate God according to the dictates of his conscience.

Pillory, n. A mechanical device for inflicting personal distinction—prototype of the modern newspaper conducted by persons of austere virtues and blameless lives.

Piracy, n. Commerce without its folly-swaddles, just as God made it.

Pitiful, adj. The state of an enemy or opponent after an imaginary encounter with oneself.

Pity, n. A failing sense of exemption, inspired by contrast.

Plagiarism, n. A literary coincidence compounded of a discreditable priority and an honorable subsequence.

Plagiarize, v. To take the thought or style of another writer whom one has never, never read.

Plague, n. In ancient times a general punishment of the innocent for admonition of their ruler, as in the familiar instance of Pharaoh the Immune. The plague as we of to-day have the happiness to know it is merely Nature's fortuitous manifestation of her purposeless objectionableness.

Plan, v. t. To bother about the best method of accomplishing an accidental result.

Platitude, n. The fundamental element and special glory of popular literature. A thought that snores in words that smoke. The wisdom of a million fools in the diction of a dullard. A fossil sentiment in artificial rock. A moral without the fable. All that is mortal of a departed truth. A

demi-tasse of milk-and-morality. The Pope's-nose of a featherless peacock. A jelly-fish withering on the shore of the sea of thought. The cackle surviving the egg. A desiccated epigram.

Platonic, adj. Pertaining to the philosophy of Socrates. Platonic Love is a fool's name for the affection between a disability and a frost.

Plaudits, n. Coins with which the populace pays those who tickle and devour it.

Please, v. To lay the foundation for a superstructure of imposition.

Pleasure, n. The least hateful form of dejection.

Plebiscite, n. A popular vote to ascertain the will of the sovereign.

Plenipotentiary, adj. Having full power. A Minister Plenipotentiary is a diplomatist possessing absolute authority on condition that he never exert it.

Plow, n. An implement that cries aloud for hands accustomed to the pen.

Plunder, v. To take the property of another without observing the decent and customary reticences of theft. To effect a change of ownership with the candid concomitance of a brass band. To wrest the wealth of A from B and leave C lamenting a vanished opportunity.

Pocket, n. The cradle of motive and the grave of conscience. In woman this organ is lacking; so she acts without motive, and her conscience, denied burial, remains ever alive, confessing the sins of others.

Poetry, n. A form of expression peculiar to the Land beyond the Magazines.

Police, n. An armed force for protection and participation.

Politeness, n. The most acceptable hypocrisy.

Politics, n. A strife of interests masquerading as a contest of principles. The conduct of public affairs for private advantage.

Politician, n. An eel in the fundamental mud upon which the superstructure of organized society is reared. When he wriggles he mistakes the agitation of his tail for the trembling of the edifice. As compared with the statesman, he suffers the disadvantage of being alive.

Polygamy, n. A house of atonement, or expiatory chapel, fitted with several stools of repentance, as distinguished from monogamy, which has but one.

Populist, n. A fossil patriot of the early agricultural period, found

in the old red soapstone underlying Kansas; characterized by an uncommon spread of ear, which some naturalists contend gave him the power of flight, though Professors Morse and Whitney, pursuing independent lines of thought, have ingeniously pointed out that had he possessed it he would have gone elsewhere. In the picturesque speech of his period, some fragments of which have come down to us, he was known as "The Matter with Kansas."

Portable, adj. Exposed to a mutable ownership through vicissitudes of possession.

Positive, adj. Mistaken at the top of one's voice.

Positivism, n. A philosophy that denies our knowledge of the Real and affirms our ignorance of the Apparent. Its longest exponent is Comte, its broadest Mill and its thickest Spencer.

Posterity, n. An appellate court which reverses the judgment of a popular author's contemporaries, the appellant being his obscure competitor.

Potable, n. Suitable for drinking. Water is said to be potable; indeed, some declare it our natural beverage, although even they find it palatable only when suffering from the recurrent disorder known as thirst, for which it is a medicine. Upon nothing has so great and diligent ingenuity been brought to bear in all ages and in all countries, except the most uncivilized, as upon the invention of substitutes for water. To hold that this general aversion to that liquid has no basis in the preservative instinct of the race is to be unscientific—and without science we are as the snakes and toads.

Poverty, n. A file provided for the teeth of the rats of reform. The number of plans for its abolition equals that of the reformers who suffer from it, plus that of the philosophers who know nothing about it. Its victims are distinguished by possession of all the virtues and by their faith in leaders seeking to conduct them into a prosperity where they believe these to be unknown.

Pray, v. To ask that the laws of the universe be annulled in behalf of a single petitioner confessedly unworthy.

Precedent, n. In Law, a previous decision, rule or practice which, in the absence of a definite statute, has whatever force and authority a Judge may choose to give it, thereby greatly simplifying his task of doing as he pleases. As there are precedents for everything, he has only to ignore those that make against his interest and accentuate those in the line of his desire. Invention of the precedent elevates the trial-at-law from the

low estate of a fortuitous ordeal to the noble attitude of a dirigible arbitrament.

Predestination, n. The doctrine that all things occur according to programme. This doctrine should not be confused with that of foreordination, which means that all things are programmed, but does not affirm their occurrence, that being only an implication from other doctrines by which this is entailed. The difference is great enough to have deluged Christendom with ink, to say nothing of the gore. With the distinction of the two doctrines kept well in mind, and a reverent belief in both, one may hope to escape perdition if spared.

Predicament, n. The wage of consistency.

Predilection, n. The preparatory stage of disillusion.

Preference, n. A sentiment, or frame of mind, induced by the erroneous belief that one thing is better than another.

An ancient philosopher, expounding his conviction that life is no better than death, was asked by a disciple why, then, he did not die. "Because," he replied, "death is no better than life."

It is longer.

Prejudice, n. A vagrant opinion without visible means of support.

Prerogative, n. A sovereign's right to do wrong.

Prescription, n. A physician's guess at what will best prolong the situation with least harm to the patient.

Present, n. That part of eternity dividing the domain of disappointment from the realm of hope.

Presentable, adj. Hideously appareled after the manner of the time and place.

In Boorioboola-Gha a man is presentable on occasions of ceremony if he have his abdomen painted a bright blue and wear a cow's tail; in New York he may, if it please him, omit the paint, but after sunset he must wear two tails made of the wool of a sheep and dyed black.

Preside, v. To guide the action of a deliberative body to a desirable result. In Journalese, to perform upon a musical instrument; as, "He presided at the piccolo."

Presidency, n. The greased pig in the field game of American politics.

President, n. The leading figure in a small group of men of whom—and of whom only—it is positively known that immense numbers of their countrymen did not want any of them for President.

Prevaricator, n. A liar in the caterpillar state.

Price, n. Value, plus a reasonable sum for the wear and tear of conscience in demanding it.

Priest, n. A gentleman who claims to own the inside track on the road to Paradise, and wants to charge toll on the same.

Principle, n. A thing which too many people confound with interest.

Prison, n. A place of punishments and rewards. The poet assures us that—

> "Stone walls do not a prison make,"

but a combination of the stone wall, the political parasite and the moral instructor is no garden of sweets.

Private, n. A military gentleman with a field-marshal's baton in his knapsack and an impediment in his hope.

Projectile, n. The final arbiter in international disputes. Formerly these disputes were settled by physical contact of the disputants, with such simple arguments as the rudimentary logic of the times could supply—the sword, the spear, and so forth. With the growth of prudence in military affairs the projectile came more and more into favor, and is now held in high esteem by the most courageous. Its capital defect is that it requires personal attendance at the point of propulsion.

Proof, n. Evidence having a shade more of plausibility than of unlikelihood. The testimony of two credible witnesses as opposed to that of only one.

Proof-reader, n. A malefactor who atones for making your writing nonsense by permitting the compositor to make it unintelligible.

Property, n. Any material thing, having no particular value, that may be held by A against the cupidity of B. Whatever gratifies the passion for possession in one and disappoints it in all others. The object of man's brief rapacity and long indifference.

Prophecy, n. The art and practice of selling one's credibility for future delivery.

Prospect, n. An outlook, usually forbidding. An expectation, usually forbidden.

Providence, n. A Personage whose arrangements, if we believe only half of what we hear, could be improved on by almost anybody.

Providential, adj. Unexpectedly and conspicuously beneficial to the person so describing it.

Prude, n. A bawd hiding behind the back of her demeanor.

Publish, v. In literary affairs, to become the fundamental element in a cone of critics.

Push, n. One of the two things mainly conducive to success, especially in politics. The other is Pull.

Q

Qualification, n. Being a cousin of the President's tailor.

Queen, n. A woman by whom the realm is ruled when there is a king, and through whom it is ruled when there is not.

Quill, n. An implement of torture yielded by a goose and commonly wielded by an ass. This use of the quill is now obsolete, but its modern equivalent, the steel pen, is wielded by the same everlasting Presence.

Quorum, n. A sufficient number of members of a deliberative body to have their own way and their own way of having it. In the United States Senate a quorum consists of the chairman of the Committee on Finance and a messenger from the White House; in the House of Representatives, of the Speaker and the devil.

Quotation, n. The act of repeating erroneously the words of another. The words erroneously repeated.

Quotient, n. A number showing how many times a sum of money belonging to one person is contained in the pocket of another—usually about as many times as it can be got there.

R

Rabble, n. In a republic, those who exercise a supreme authority tempered by fraudulent elections. The rabble is like the sacred Simurgh, of Arabian fable—omnipotent on condition that it do nothing. (The word is Aristocratese, and has no exact equivalent in our tongue, but means, as nearly as may be, "soaring swine.")

Rack, n. An argumentative implement formerly much used in persuading devotees of a false faith to embrace the living truth. As a call to the unconverted the rack never had any particular efficacy, and is now held in light popular esteem.

Radicalism, n. The conservatism of to-morrow injected into the affairs of to-day.

Ranch, n. An undressed farm.

Rank, n. Relative elevation in the scale of human worth.

Ransom, n. The purchase of that which neither belongs to the seller, nor can belong to the buyer. The most unprofitable of investments.

Rapacity, n. Providence without industry. The thrift of power.

Rarebit, n. A Welsh rabbit, in the speech of the humorless, who point out that it is not a rabbit. To whom it may be solemnly explained that the comestible known as toad-in-a-hole is really not a toad, and that *riz-de-veau à la financière* is not the smile of a calf prepared after the recipe of a she banker.

Rascal, n. A fool considered under another aspect.

Rascality, n. Stupidity militant. The activity of a clouded intellect.

Rash, adj. Insensible to the value of our advice.

Rational, adj. Devoid of all delusions save those of observation, experience and reflection.

Reach, n. The radius of action of the human hand. The area within which it is possible (and customary) to gratify directly the propensity to provide.

Reading, n. The general body of what one reads. In our country it consists, as a rule, of Indiana novels, short stories in "dialect" and humor in slang.

Realism, n. The art of depicting nature as it is seen by toads. The charm suffusing a landscape painted by a mole, or a story written by a measuring-worm.

Reality, n. The dream of a mad philosopher.

Really, adv. Apparently.

Rear, n. In American military matters, that exposed part of the army that is nearest to Congress.

Reason, v. i. To weigh probabilities in the scales of desire.

Reason, n. Propensitate of prejudice.

Reasonable, adj. Accessible to the infection of our own opinions. Hospitable to persuasion, dissuasion and evasion.

Rebel, n. A proponent of a new misrule who has failed to establish it.

Recollect, v. To recall with additions something not previously known.

Reconciliation, n. A suspension of hostilities. An armed truce for the purpose of digging up the dead.

Reconsider, v. To seek a justification for a decision already made.

Recount, n. In American politics, another throw of the dice, accorded to the player against whom they are loaded.

Recreation, n. A particular kind of dejection to relieve a general fatigue.

Recruit, n. A person distinguishable from a civilian by his uniform and from a soldier by his gait.

Redemption, n. Deliverance of sinners from the penalty of their sin, through their murder of the deity against whom they sinned. The doctrine of Redemption is the fundamental mystery of our holy religion, and whoso believeth in it shall not perish, but have everlasting life in which to try to understand it.

Redress, n. Reparation without satisfaction.

Among the Anglo-Saxons a subject conceiving himself wronged by the king was permitted, on proving his injury, to beat a brazen image of the royal offender with a switch that was afterward applied to his own naked back. The latter rite was performed by the public hangman, and it assured moderation in the plaintiff's choice of a switch.

Referendum, n. A law for submission of proposed legislation to a popular vote to learn the nonsensus of public opinion.

Reflection, n. An action of the mind whereby we obtain a clearer view of our relation to the things of yesterday and are able to avoid the perils that we shall not again encounter.

Reform, n. A thing that mostly satisfies reformers opposed to reformation.

Refusal, n. Denial of something desired; as an elderly maiden's hand in marriage, to a rich and handsome suitor; a valuable franchise to a rich corporation, by an alderman; absolution to an impenitent king, by a priest, and so forth. Refusals are graded in a descending scale of finality thus: the refusal absolute, the refusal conditional, the refusal tentative and the refusal feminine. The last is called by some casuists the refusal assentive.

Religion, n. A daughter of Hope and Fear, explaining to Ignorance the nature of the Unknowable.

"What is your religion my son?" inquired the Archbishop of Rheims.

"Pardon, monseigneur," replied Rochebriant; "I am ashamed of it."

"Then why do you not become an atheist?"

"Impossible! I should be ashamed of atheism."

"In that case, monsieur, you should join the Protestants."

Reliquary, n. A receptacle for such sacred objects as pieces of the true cross, short-ribs of saints, the ears of Balaam's ass, the lung of the cock that called Peter to repentance and so forth. Reliquaries are commonly of metal, and provided with a lock to prevent the contents from coming out and performing miracles at unseasonable times. A feather from the wing of the Angel of the Annunciation once escaped during a sermon in Saint Peter's and so tickled the noses of the congregation that they woke and sneezed with great vehemence three times each. It is related in the "Gesta Sanctorum" that a sacristan in the Canterbury cathedral surprised the head of Saint Dennis in the library. Reprimanded by its stern custodian, it explained that it was seeking a body of doctrine. This unseemly levity so enraged the diocesan that the offender was publicly anathematized, thrown into the Stour and replaced by another head of Saint Dennis, brought from Rome.

Renown, n. A degree of distinction between notoriety and fame— a little more supportable than the one and a little more intolerable than the other. Sometimes it is conferred by an unfriendly and inconsiderate hand.

Reparation, n. Satisfaction that is made for a wrong and deducted from the satisfaction felt in committing it.

Repartee, n. Prudent insult in retort. Practiced by gentlemen with a constitutional aversion to violence, but a strong disposition to offend. In a war of words, the tactics of the North American Indian.

Repentance, n. The faithful attendant and follower of Punishment. It is usually manifest in a degree of reformation that is not inconsistent with continuity of sin.

Replica, n. A reproduction of a work of art, by the artist that made the original. It is so called to distinguish it from a "copy," which is made by another artist. When the two are made with equal skill the replica is the more valuable, for it is supposed to be more beautiful than it looks.

Reporter, *n.* A writer who guesses his way to the truth and dispels it with a tempest of words.

Repose, *v. i.* To cease from troubling.

Representative, *n.* In national politics, a member of the Lower House in this world, and without discernible hope of promotion in the next.

Reprobation, *n.* In theology, the state of a luckless mortal prenatally damned. The doctrine of reprobation was taught by Calvin, whose joy in it was somewhat marred by the sad sincerity of his conviction that although some are foredoomed to perdition, others are predestined to salvation.

Republic, *n.* A nation in which, the thing governing and the thing governed being the same, there is only a permitted authority to enforce an optional obedience. In a republic the foundation of public order is the ever lessening habit of submission inherited from ancestors who, being truly governed, submitted because they had to. There are as many kinds of republics as there are gradations between the despotism whence they came and the anarchy whither they lead.

Requiem, *n.* A mass for the dead which the minor poets assure us the winds sing o'er the graves of their favorites. Sometimes, by way of providing a varied entertainment, they sing a dirge.

Resident, *adj.* Unable to leave.

Resign, *v. t.* To renounce an honor for an advantage. To renounce an advantage for a greater advantage.

Resolute, *adj.* Obstinate in a course that we approve.

Respectability, *n.* The offspring of a *liaison* between a bald head and a bank account.

Respirator, *n.* An apparatus fitted over the nose and mouth of an inhabitant of London, whereby to filter the visible universe in its passage to the lungs.

Respite, *n.* A suspension of hostilities against a sentenced assassin, to enable the Executive to determine whether the murder may not have been done by the prosecuting attorney. Any break in the continuity of a disagreeable expectation.

Responsibility, *n.* A detachable burden easily shifted to the shoulders of God, Fate, Fortune, Luck or one's neighbor. In the days of astrology it was customary to unload it upon a star.

Restitution, *n.* The founding or endowing of universities and public libraries by gift or bequest.

Retaliation, *n.* The natural rock upon which is reared the Temple of Law.

Retribution, *n.* A rain of fire-and-brimstone that falls alike upon the just and such of the unjust as have not procured shelter by evicting them.

Reveille, *n.* A signal to sleeping soldiers to dream of battlefields no more, but get up and have their blue noses counted. In the American army it is ingeniously called "rev-e-lee," and to that pronunciation our countrymen have pledged their lives, their misfortunes and their sacred dishonor.

Revenge, *n.* Sending your girl's love letters to your rival after he has married her.

Reverence, *n.* The spiritual attitude of a man to a god and a dog to a man.

Review, *v. t.*

> To set your wisdom (holding not a doubt of it,
> Although in truth there's neither bone nor skin
> to it)
> At work upon a book, and so read out of it.
> The qualities that you have first read into it.

Revolution, *n.* In politics, an abrupt change in the form of misgovernment. Specifically, in American history, the substitution of the rule of an Administration for that of a Ministry, whereby the welfare and happiness of the people were advanced a full half-inch. Revolutions are usually accompanied by a considerable effusion of blood, but are accounted worth it—this appraisement being made by beneficiaries whose blood had not the mischance to be shed. The French revolution is of incalculable value to the Socialist of to-day; when he pulls the string actuating its bones its gestures are inexpressibly terrifying to gory tyrants suspected of fomenting law and order.

Ribaldry, *n.* Censorious language by another concerning oneself.

Rich, *adj.* Holding in trust and subject to an accounting the property of the indolent, the incompetent, the unthrifty, the envious and the luckless. That is the view that prevails in the underworld, where the Brotherhood of Man finds its most logical development and candid advocacy. To denizens of the midworld the word means good and wise.

Ridicule, n. Words designed to show that the person of whom they are uttered is devoid of the dignity of character distinguishing him who utters them. It may be graphic, mimetic or merely rident. Shaftesbury is quoted as having pronounced it the test of truth—a ridiculous assertion, for many a solemn fallacy has undergone centuries of ridicule with no abatement of its popular acceptance. What, for example, has been more valorously derided than the doctrine of Infant Respectability?

Right, n. Legitimate authority to be, to do or to have; as the right to be a king, the right to do one's neighbor, the right to have measles, and the like. The first of these rights was once universally believed to be derived directly from the will of God; and this is still sometimes affirmed *in partibus infidelium* outside the enlightened realms of Democracy; as the well known lines of Sir Abednego Bink, following:

> By what right, then, do royal rulers rule?
> > Whose is the sanction of their state and pow'r?
> He surely were as stubborn as a mule
> > Who, God unwilling, could maintain an hour
> His uninvited session on the throne, or air
> His pride securely in the Presidential chair.

> Whatever is is so by Right Divine;
> > Whate'er occurs, God wills it so. Good land!
> It were a wondrous thing if His design
> > A fool could baffle or a rogue withstand!
> If so, then God, I say (intending no offence)
> Is guilty of contributory negligence.

Riot, n. A popular entertainment given to the military by innocent bystanders.

R. I. P. A careless abbreviation of *requiescat in pace,* attesting an indolent goodwill to the dead. According to the learned Dr. Drigge, however, the letters originally meant nothing more than *reductus in pulvis.*

Rite, n. A religious or semi-religious ceremony fixed by law, precept or custom, with the essential oil of sincerity carefully squeezed out of it.

Ritualism, n. A Dutch Garden of God where He may walk in rectilinear freedom, keeping off the grass.

Road, n. A strip of land along which one may pass from where it is too tiresome to be to where it is futile to go.

Romance, n. Fiction that owes no allegiance to the God of Things as They Are. In the novel the writer's thought is tethered to probability, as a domestic horse to the hitching-post, but in romance it ranges at will over the entire region of the imagination—free, lawless, immune to bit and rein. Your novelist is a poor creature, as Carlyle might say—a mere reporter. He may invent his characters and plot, but he must not imagine anything taking place that might not occur, albeit his entire narrative is candidly a lie. Why he imposes this hard condition on himself, and "drags at each remove a lengthening chain" of his own forging he can explain in ten thick volumes without illuminating by so much as a candle's ray the black profound of his own ignorance of the matter. There are great novels, for great writers have "laid waste their powers" to write them, but it remains true that far and away the most fascinating fiction that we have is "The Thousand and One Nights."

Rope, n. An obsolescent appliance for reminding assassins that they too are mortal. It is put about the neck and remains in place one's whole life long. It has been largely superseded by a more complex electrical device worn upon another part of the person; and this is rapidly giving place to an apparatus known as the preachment.

Rostrum, n. In Latin, the beak of a bird or the prow of a ship. In America, a place from which a candidate for office energetically expounds the wisdom, virtue and power of the rabble.

Roundhead, n. A member of the Parliamentarian party in the English civil war—so called from his habit of wearing his hair short, whereas his enemy, the Cavalier, wore his long. There were other points of difference between them, but the fashion in hair was the fundamental cause of quarrel. The Cavaliers were royalists because the king, an indolent fellow, found it more convenient to let his hair grow than to wash his neck. This the Roundheads, who were mostly barbers and soap-boilers, deemed an injury to trade, and the royal neck was therefore the object of their particular indignation. Descendants of the belligerents now wear their hair all alike, but the fires of animosity enkindled in that ancient strife smoulder to this day beneath the snows of British civility.

Ruin, v. To destroy. Specifically, to destroy a maid's belief in the virtue of maids.

Rum, n. Generically, fiery liquors that produce madness in total abstainers.

Rumor, n. A favorite weapon of the assassins of character.

S

Sabbath, n. A weekly festival having its origin in the fact that God made the world in six days and was arrested on the seventh. Among the Jews observance of the day was enforced by a Commandment of which this is the Christian version: "Remember the seventh day to make thy neighbor keep it wholly." To the Creator it seemed fit and expedient that the Sabbath should be the last day of the week, but the Early Fathers of the Church held other views. So great is the sanctity of the day that even where the Lord holds a doubtful and precarious jurisdiction over those who go down to (and down into) the sea it is reverently recognized, as is manifest in the following deepwater version of the Fourth Commandment:

> Six days shalt thou labor and do all thou art able,
> And on the seventh holystone the deck and scrape
> the cable.

Sacrament, n. A solemn religious ceremony to which several degrees of authority and significance are attached. Rome has seven sacraments, but the Protestant churches, being less prosperous, feel that they can afford only two, and these of inferior sanctity. Some of the smaller sects have no sacraments at all—for which mean economy they will indubitably be damned.

Sacred, adj. Dedicated to some religious purpose; having a divine character; inspiring solemn thoughts or emotions; as, the Dalai Lama of Thibet; the Moogum of M'bwango; the temple of Apes in Ceylon; the Cow in India; the Crocodile, the Cat and the Onion of ancient Egypt; the Mufti of Moosh; the hair of the dog that bit Noah, etc.

Sandlotter, n. A vertebrate mammal holding the political views of Denis Kearney, a notorious demagogue of San Francisco, whose audiences gathered in the open spaces (sandlots) of the town. True to the traditions of his species, this leader of the proletariat was finally bought off by his law-and-order enemies, living prosperously silent and dying impenitently rich. But before his treason he imposed upon California a constitution that was a confection of sin in a diction of solecisms. The similarity between the words "sandlotter" and "sansculotte" is problematically significant, but indubitably suggestive.

Saint, n. A dead sinner revised and edited.

The Duchess of Orleans relates that the irreverent old calumniator, Marshal Villeroi, who in his youth had known St. Francis de Sales, said, on hearing him called saint: "I am delighted to hear that

Monsieur de Sales is a saint. He was fond of saying indelicate things, and used to cheat at cards. In other respects he was a perfect gentleman, though a fool."

Salacity, n. A certain literary quality frequently observed in popular novels, especially in those written by women and young girls, who give it another name and think that in introducing it they are occupying a neglected field of letters and reaping an overlooked harvest. If they have the misfortune to live long enough they are tormented with a desire to burn their sheaves.

Satan, n. One of the Creator's lamentable mistakes, repented in sashcloth and axes. Being instated as an archangel, Satan made himself multifariously objectionable and was finally expelled from Heaven. Halfway in his descent he paused, bent his head in thought a moment and at last went back. "There is one favor that I should like to ask," said he.

"Name it."

"Man, I understand, is about to be created. He will need laws."

"What, wretch! you his appointed adversary, charged from the dawn of eternity with hatred of his soul—you ask for the right to make his laws?"

"Pardon; what I have to ask is that he be permitted to make them himself."

It was so ordered.

Satire, n. An obsolete kind of literary composition in which the vices and follies of the author's enemies were expounded with imperfect tenderness. In this country satire never had more than a sickly and uncertain existence, for the soul of it is wit, wherein we are dolefully deficient, the humor that we mistake for it, like all humor, being tolerant and sympathetic. Moreover, although Americans are "endowed by their Creator" with abundant vice and folly, it is not generally known that these are reprehensible qualities, wherefore the satirist is popularly regarded as a sour-spirited knave, and his every victim's outcry for codefendants evokes a national assent.

Sauce, n. The one infallible sign of civilization and enlightenment. A people with no sauces has one thousand vices; a people with one sauce has only nine hundred and ninety-nine. For every sauce invented and accepted a vice is renounced and forgiven.

Saw, n. A trite popular saying, or proverb. (Figurative and colloquial.) So called because it makes its way into a wooden head. Following are examples of old saws fitted with new teeth.

A penny saved is a penny to squander.

A man is known by the company that he organizes.

A bad workman quarrels with the man who calls him that.

A bird in the hand is worth what it will bring.

Better late than before anybody has invited you.

Example is better than following it.

Half a loaf is better than a whole one if there is much else.

Think twice before you speak to a friend in need.

What is worth doing is worth the trouble of asking somebody to do it.

Least said is soonest disavowed.

He laughs best who laughs least.

Speak of the Devil and he will hear about it.

Of two evils choose to be the least.

Strike while your employer has a big contract.

Where there's a will there's a won't.

Scarification, n. A form of penance practised by the mediæval pious. The rite was performed, sometimes with a knife, sometimes with a hot iron, but always, says Arsenius Asceticus, acceptably if the penitent spared himself no pain nor harmless disfigurement. Scarification, with other crude penances, has now been superseded by benefaction. The founding of a library or endowment of a university is said to yield to the penitent a sharper and more lasting pain than is conferred by the knife or iron, and is therefore a surer means of grace. There are, however,

two grave objections to it as a penitential method: the good that it does and the taint of justice.

Scepter, n. A king's staff of office, the sign and symbol of his authority. It was originally a mace with which the sovereign admonished his jester and vetoed ministerial measures by breaking the bones of their proponents.

Scrap-Book, n. A book that is commonly edited by a fool. Many persons of some small distinction compile scrap-books containing whatever they happen to read about themselves or employ others to collect.

Scribbler, n. A professional writer whose views are antagonistic to one's own.

Scriptures, n. The sacred books of our holy religion, as distinguished from the false and profane writings on which all other faiths are based.

Seine, n. A kind of net for effecting an involuntary change of environment. For fish it is made strong and coarse, but women are more easily taken with a singularly delicate fabric weighted with small, cut stones.

Self-esteem, n. An erroneous appraisement.

Self-evident, adj. Evident to one's self and to nobody else.

Selfish, adj. Devoid of consideration for the selfishness of others.

Senate, n. A body of elderly gentlemen charged with high duties and misdemeanors.

Serial, n. A literary work, usually a story that is not true, creeping through several issues of a newspaper or magazine. Frequently appended to each instalment is a "synopsis of preceding chapters" for those who have not read them, but a direr need is a synopsis of succeeding chapters for those who do not intend to read *them*. A synopsis of the entire work would be still better.

Siren, n. One of several musical prodigies famous for a vain attempt to dissuade Odysseus from a life on the ocean wave. Figuratively, any lady of splendid promise, dissembled purpose and disappointing performance.

Slang, n. The grunt of the human hog (*Pignoramus intolerabilis*) with an audible memory. The speech of one who utters with his tongue what he thinks with his ear, and feels the pride of a creator in accomplishing the feat of a parrot. A means (under Providence) of setting up as a wit without a capital of sense.

Sophistry, *n.* The controversial method of an opponent, distinguished from one's own by superior insincerity and fooling. This method is that of the later Sophists, a Grecian sect of philosophers who began by teaching wisdom, prudence, science, art and, in brief, whatever men ought to know, but lost themselves in a maze of quibbles and a fog of words.

Sorcery, *n.* The ancient prototype and forerunner of political influence. It was, however, deemed less respectable and sometimes was punished by torture and death. Augustine Nicholas relates that a poor peasant who had been accused of sorcery was put to the torture to compel a confession. After enduring a few gentle agonies the suffering simpleton admitted his guilt, but naively asked his tormentors if it were not possible to be a sorcerer without knowing it.

Soul, *n.* A spiritual entity concerning which there hath been brave disputation. Plato held that those souls which in a previous state of existence (antedating Athens) had obtained the clearest glimpses of eternal truth entered into the bodies of persons who became philosophers. Plato was himself a philosopher. The souls that had least contemplated divine truth animated the bodies of usurpers and despots. Dionysius I, who had threatened to decapitate the broad-browed philosopher, was a usurper and despot. Plato, doubtless, was not the first to construct a system of philosophy that could be quoted against his enemies; certainly he was not the last.

"Concerning the nature of the soul," saith the renowned author of *Diversiones Sanctorum,* "there hath been hardly more argument than that of its place in the body. Mine own belief is that the soul hath her seat in the abdomen—in which faith we may discern and interpret a truth hitherto unintelligible, namely that the glutton is of all men most devout. He is said in the Scripture to 'make a god of his belly'—why, then, should he not be pious, having ever his Deity with him to freshen his faith? Who so well as he can know the might and majesty that he shrines? Truly and soberly, the soul and the stomach are one Divine Entity; and such was the belief of Promasius, who nevertheless erred in denying it immortality. He had observed that its visible and material substance failed and decayed with the rest of the body after death, but of its immaterial essence he knew nothing. This is what we call the Appetite, and it survives the wreck and reek of mortality, to be rewarded or punished in another world, according to what it hath demanded in the flesh. The Appetite whose coarse clamoring was for the unwholesome viands of the general market and the public refectory shall be cast into eternal famine, whilst that which firmly though civilly insisted on

ortolans, caviare, terrapin, anchovies, *pâtès de foie gras* and all such Christian comestibles shall flesh its spiritual tooth in the souls of them forever and ever, and wreak its divine thirst upon the immortal parts of the rarest and richest wines ever quaffed here below.

Suffrage, n. Expression of opinion by means of a ballot. The right of suffrage (which is held to be both a privilege and a duty) means, as commonly interpreted, the right to vote for the man of another man's choice, and is highly prized. Refusal to do so has the bad name of "incivism." The incivilian, however, cannot be properly arrainged for his crime, for there is no legitimate accuser. If the accuser is himself guilty he has no standing in the court of opinion; if not, he profits by the crime, for A's abstention from voting gives greater weight to the vote of B. By female suffrage is meant the right of a woman to vote as some man tells her to. It is based on female responsibility, which is somewhat limited. The woman most eager to jump out of her petticoat to assert her rights is first to jump back into it when threatened with a switching for misusing them.

Sycophant, n. One who approaches Greatness on his belly so that he may not be commanded to turn and be kicked. He is sometimes an editor.

Sylph, n. An immaterial but visible being that inhabited the air when the air was an element and before it was fatally polluted by factory smoke, sewer gas and similar products of civilization. Sylphs were allied to gnomes, nymphs and salamanders, which dwelt, respectively, in earth, water and fire, all now insalubrious. Sylphs, like fowls of the air, were male and female, to no purpose, apparently, for if they had progeny they must have nested in inaccessible places, none of the chicks having ever been seen.

Symbol, n. Something that is supposed to typify or stand for something else. Many symbols are mere "survivals"—things which having no longer any utility continue to exist because we have inherited the tendency to make them; as funereal urns carved on memorial monuments. They were once real urns holding the ashes of the dead. We cannot stop making them, but we can give them a name that conceals our helplessness.

T

Tail, n. The part of an animal's spine that has transcended its natural limitations to set up an independent existence in a world of its own. Excepting in his fœtal state, Man is without a tail, a privation of

which he attests an hereditary and uneasy consciousness by the coat-skirt of the male and the train of the female, and by a marked tendency to ornament that part of his attire where the tail should be, and indubitably once was. This tendency is most observable in the female of the species, in whom the ancestral sense is strong and persistent. The tailed men described by Lord Monboddo are now generally regarded as a product of an imagination unusually susceptible to influences generated in the golden age of our pithecan past.

Take, v. t. To acquire, frequently by force but preferably by stealth.

Talk, v. t. To commit an indiscretion without temptation, from an impulse without purpose.

Tariff, n. A scale of taxes on imports, designed to protect the domestic producer against the greed of his consumer.

Tedium, n. Ennui, the state or condition of one that is bored. Many fanciful derivations of the word have been affirmed, but so high an authority as Father Jape says that it comes from a very obvious source— the first words of the ancient Latin hymn *Te Deum Laudamus.* In this apparently natural derivation there is something that saddens.

Teetotaler, n. One who abstains from strong drink, sometimes totally, sometimes tolerably totally.

Telephone, n. An invention of the devil which abrogates some of the advantages of making a disagreeable person keep his distance.

Telescope, n. A device having a relation to the eye similar to that of the telephone to the ear, enabling distant objects to plague us with a multitude of needless details. Luckily it is unprovided with a bell summoning us to the sacrifice.

Tenacity, n. A certain quality of the human hand in its relation to the coin of the realm. It attains its highest development in the hand of authority and is considered a serviceable equipment for a career in politics.

Theosophy, n. An ancient faith having all the certitude of religion and all the mystery of science. The modern Theosophist holds, with the Buddhists, that we live an incalculable number of times on this earth, in as many as several bodies, because one life is not long enough for our complete spiritual development; that is, a single lifetime does not suffice for us to become as wise and good as we choose to wish to become. To be absolutely wise and good—that is perfection; and the Theosophist is so keen-sighted as to have observed that everything desirous of improve-

ment eventually attains perfection. Less competent observers are disposed to except cats, which seem neither wiser nor better than they were last year. The greatest and fattest of recent Theosophists was the late Madame Blavatsky, who had no cat.

Tights, n. An habiliment of the stage designed to reinforce the general acclamation of the press agent with a particular publicity. Public attention was once somewhat diverted from this garment to Miss Lillian Russell's refusal to wear it, and many were the conjectures as to her motive, the guess of Miss Pauline Hall showing a high order of ingenuity and sustained reflection. It was Miss Hall's belief that nature had not endowed Miss Russell with beautiful legs. This theory was impossible of acceptance by the male understanding, but the conception of a faulty female leg was of so prodigious originality as to rank among the most brilliant feats of philosophical speculation! It is strange that in all the controversy regarding Miss Russell's aversion to tights no one seems to have thought to ascribe it to what was known among the ancients as "modesty." The nature of that sentiment is now imperfectly understood, and possibly incapable of exposition with the vocabulary that remains to us. The study of lost arts has, however, been recently revived and some of the arts themselves recovered. This is an epoch of *renaissances,* and there is ground for hope that the primitive "blush" may be dragged from its hiding-place amongst the tombs of antiquity and hissed on to the stage.

Tomb, n. The House of Indifference. Tombs are now by common consent invested with a certain sanctity, but when they have been long tenanted it is considered no sin to break them open and rifle them, the famous Egyptologist, Dr. Huggyns, explaining that a tomb may be innocently "glened" as soon as its occupant is done "smellynge," the soul being then all exhaled. This reasonable view is now generally accepted by archæologists, whereby the noble science of Curiosity has been greatly dignified.

Tope, v. To tipple, booze, swill, soak, guzzle, lush, bib, or swig. In the individual, toping is regarded with disesteem, but toping nations are in the forefront of civilization and power. When pitted against the hard-drinking Christians the abstemious Mahometans go down like grass before the scythe. In India one hundred thousand beef-eating and brandy-and-soda guzzling Britons hold in subjection two hundred and fifty million vegetarian abstainers of the same Aryan race. With what an easy grace the whisky-loving American pushed the temperate Spaniard out of his possessions! From the time when the Berserkers ravaged all the coasts of western Europe and lay drunk in every conquered port it has been the same way: everywhere the nations that drink too much are observed to fight rather well and not too righteously. Wherefore the

estimable old ladies who abolished the canteen from the American army may justly boast of having materially augmented the nation's military power.

Tree, n. A tall vegetable intended by nature to serve as a penal apparatus, though through a miscarriage of justice most trees bear only a negligible fruit, or none at all.

Trial, n. A formal inquiry designed to prove and put upon record the blameless characters of judges, advocates and jurors. In order to effect this purpose it is necessary to supply a contrast in the person of one who is called the defendant, the prisoner, or the accused. If the contrast is made sufficiently clear this person is made to undergo such an affliction as will give the virtuous gentlemen a comfortable sense of their immunity, added to that of their worth. In our day the accused is usually a human being, or a socialist, but in mediæval times, animals, fishes, reptiles and insects were brought to trial. A beast that had taken human life, or practiced sorcery, was duly arrested, tried and, if condemned, put to death by the public executioner. Insects ravaging grain fields, orchards or vineyards were cited to appeal by counsel before a civil tribunal, and after testimony, argument and condemnation, if they continued *in contumaciam* the matter was taken to a high ecclesiastical court, where they were solemnly excommunicated and anathematized. In a street of Toledo, some pigs that had wickedly run between the viceroy's legs, upsetting him, were arrested on a warrant, tried and punished. In Naples an ass was condemned to be burned at the stake, but the sentence appears not to have been executed. D'Addosio relates from the court records many trials of pigs, bulls, horses, cocks, dogs, goats, etc., greatly, it is believed, to the betterment of their conduct and morals. In 1451 a suit was brought against the leeches infesting some ponds about Berne, and the Bishop of Lausanne, instructed by the faculty of Heidelberg University, directed that some of "the aquatic worms" be brought before the local magistracy. This was done and the leeches, both present and absent, were ordered to leave the places that they had infested within three days on pain of incurring "the malediction of God." In the voluminous records of this *cause celebre* nothing is found to show whether the offenders braved the punishment, or departed forthwith out of that inhospitable jurisdiction.

Trichinosis, n. The pig's reply to proponents of porcophagy.

Trinity, n. In the multiplex theism of certain Christian churches, three entirely distinct deities consistent with only one. Subordinate deities of the polytheistic faith, such as devils and angels, are not dowered with the power of combination, and must urge individually

their claims to adoration and propitiation. The Trinity is one of the most sublime mysteries of our holy religion. In rejecting it because it is incomprehensible, Unitarians betray their inadequate sense of theological fundamentals. In religion we believe only what we do not understand, except in the instance of an intelligible doctrine that contradicts an incomprehensible one. In that case we believe the former as a part of the latter.

Troglodyte, n. Specifically, a cave-dweller of the paleolithic period, after the Tree and before the Flat. A famous community of troglodytes dwelt with David in the Cave of Adullam. The colony consisted of "every one that was in distress, and every one that was in debt, and every one that was discontented"—in brief, all the Socialists of Judah.

Truce, n. Friendship.

Truth, n. An ingenious compound of desirability and appearance. Discovery of truth is the sole purpose of philosophy, which is the most ancient occupation of the human mind and has a fair prospect of existing with increasing activity to the end of time.

Truthful, adj. Dumb and illiterate.

Trust, n. In American politics, a large corporation composed in greater part of thrifty working men, widows of small means, orphans in the care of guardians and the courts, with many similar malefactors and public enemies.

Turkey, n. A large bird whose flesh when eaten on certain religious anniversaries has the peculiar property of attesting piety and gratitude. Incidentally, it is pretty good eating.

Twice, adv. Once too often.

Type, n. Pestilent bits of metal suspected of destroying civilization and enlightenment, despite their obvious agency in this incomparable dictionary.

Tzetze, (or Tsetse) Fly, n. An African insect (*Glossina morsitans*) whose bite is commonly regarded as nature's most efficacious remedy for insomnia, though some patients prefer that of the American novelist (*Mendax interminabilis.*)

U

Ugliness, n. A gift of the gods to certain women, entailing virtue without humility.

Ultimatum, *n.* In diplomacy, a last demand before resorting to concessions.

Un-American, *adj.* Wicked, intolerable, heathenish.

Unction, *n.* An oiling, or greasing. The rite of extreme unction consists in touching with oil consecrated by a bishop several parts of the body of one engaged in dying. Marbury relates that after the rite had been administered to a certain wicked English nobleman it was discovered that the oil had not been properly consecrated and no other could be obtained. When informed of this the sick man said in anger: "Then I'll be damned if I die!"

"My son," said the priest, "that is what we fear."

Urbanity, *n.* The kind of civility that urban observers ascribe to dwellers in all cities but New York. Its commonest expression is heard in the words, "I beg your pardon," and it is not inconsistent with disregard of the rights of others.

Usage, *n.* The First Person of the literary Trinity, the Second and Third being Custom and Conventionality. Imbued with a decent reverence for this Holy Triad an industrious writer may hope to produce books that will live as long as the fashion.

Uxoriousness, *n.* A perverted affection that has strayed to one's own wife.

V

Valor, *n.* A soldierly compound of vanity, duty and the gambler's hope.

Virtues, *n. pl.* Certain abstentions.

Vituperation, *n.* Satire, as understood by dunces and all such as suffer from an impediment in their wit.

Vote, *n.* The instrument and symbol of a freeman's power to make a fool of himself and a wreck of his country.

W

Wall Street, *n.* A symbol of sin for every devil to rebuke. That Wall Street is a den of thieves is a belief that serves every unsuccessful thief in place of a hope in Heaven.

War, *n.* A by-product of the arts of peace. The most menacing political condition is a period of international amity. The student of

history who has not been taught to expect the unexpected may justly boast himself inaccessible to the light. "In time of peace prepare for war" has a deeper meaning than is commonly discerned; it means, not merely that all things earthly have an end—that change is the one immutable and eternal law—but that the soil of peace is thickly sown with seeds of war and singularly suited to their germination and growth.

Washingtonian, n. A Potomac tribesman who exchanged the privilege of governing himself for the advantage of good government. In justice to him it should be said that he did not want to.

Weaknesses, n. pl. Certain primal powers of Tyrant Woman wherewith she holds dominion over the male of her species, binding him to the service of her will and paralyzing his rebellious energies.

Weather, n. The climate of an hour. A permanent topic of conversation among persons whom it does not interest, but who have inherited the tendency to chatter about it from naked arboreal ancestors whom it keenly concerned. The setting up of official weather bureaus and their maintenance in mendacity prove that even governments are accessible to suasion by the rude forefathers of the jungle.

Wedding, n. A ceremony at which two persons undertake to become one, one undertakes to become nothing, and nothing undertakes to become supportable.

Werewolf, n. A wolf that was once, or is sometimes, a man. All werewolves are of evil disposition, having assumed a bestial form to gratify a bestial appetite, but some, transformed by sorcery, are as humane as is consistent with an acquired taste for human flesh.

Some Bavarian peasants having caught a wolf one evening, tied it to a post by the tail and went to bed. The next morning nothing was there! Greatly perplexed, they consulted the local priest, who told them that their captive was undoubtedly a werewolf and had resumed its human form during the night. "The next time that you take a wolf," the good man said, "see that you chain it by the leg, and in the morning you will find a Lutheran."

Wheat, n. A cereal from which a tolerably good whisky can with some difficulty be made, and which is used also for bread. The French are said to eat more bread *per capita* of population than any other people, which is natural, for only they know how to make the stuff palatable.

Widow, n. A pathetic figure that the Christian world has agreed to take humorously, although Christ's tenderness towards widows was one of the most marked features of his character.

Wine, n. Fermented grape-juice known to the Women's Christian

Union as "liquor," sometimes as "rum." Wine, madam, is God's next best gift to man.

Wit, n. The salt with which the American humorist spoils his intellectual cookery by leaving it out.

Witch, n. (1) An ugly and repulsive old woman, in a wicked league with the devil. (2) A beautiful and attractive young woman, in wickedness a league beyond the devil.

Witticism, n. A sharp and clever remark, usually quoted, and seldom noted; what the Philistine is pleased to call a "joke."

Woman, n. An animal usually living in the vicinity of Man, and having a rudimentary susceptibility to domestication. It is credited by many of the elder zoölogists with a certain vestigial docility acquired in a former state of seclusion, but naturalists of the postsusananthony period, having no knowledge of the seclusion, deny the virtue and declare that such as creation's dawn beheld, it roareth now. The species is the most widely distributed of all beasts of prey, infesting all habitable parts of the globe, from Greenland's spicy mountains to India's moral strand. The popular name (wolfman) is incorrect, for the creature is of the cat kind. The woman is lithe and graceful in its movements, especially the American variety (*Felis pugnans*), is omnivorous and can be taught not to talk. —*Balthasar Pober.*

Worms'-meat, n. The finished product of which we are the raw material. The contents of the Taj Mahal, the Tombeau Napoleon and the Grantarium. Worms'-meat is usually outlasted by the structure that houses it, but "this too must pass away." Probably the silliest work in which a human being can engage is construction of a tomb for himself. The solemn purpose cannot dignify, but only accentuates by contrast the foreknown futility.

Worship, n. Homo Creator's testimony to the sound construction and fine finish of Deus Creatus. A popular form of abjection, having an element of pride.

Wrath, n. Anger of a superior quality and degree, appropriate to exalted characters and momentous occasions; as, "the wrath of God," "the day of wrath," etc. Amongst the ancients the wrath of kings was deemed sacred, for it could usually command the agency of some god for its fit manifestation, as could also that of a priest. The Greeks before Troy were so harried by Apollo that they jumped out of the frying-pan of the wrath of Chryses into the fire of the wrath of Achilles, though Agamemnon, the sole offender, was neither fried nor roasted. A similar noted immunity was that of David when he incurred the wrath of Yahveh by

numbering his people, seventy thousand of whom paid the penalty with their lives. God is now Love, and a director of the census performs his work without apprehension of disaster.

Y

Year, *n.* A period of three hundred and sixty-five disappointments.

Yesterday, *n.* The infancy of youth, the youth of manhood, the entire past of age.

Yoke, *n.* An implement, madam, to whose Latin name, *jugum,* we owe one of the most illuminating words in our language—a word that defines the matrimonial situation with precision, point and poignancy. A thousand apologies for withholding it.

Z

Zany, *n.* A popular character in old Italian plays, who imitated with ludicrous incompetence the *buffone,* or clown, and was therefore the ape of an ape; for the clown himself imitated the serious characters of the play. The zany was progenitor to the specialist in humor, as we to-day have the unhappiness to know him. In the zany we see an example of creation; in the humorist, of transmission. Another excellent specimen of the modern zany is the curate, who apes the rector, who apes the bishop, who apes the archbishop, who apes the devil.

Zeal, *n.* A certain nervous disorder afflicting the young and in- experienced. A passion that goeth before a sprawl.

Zenith, *n.* A point in the heavens directly overhead to a standing man or a growing cabbage. A man in bed or a cabbage in the pot is not considered as having a zenith, though from this view of the matter there was once a considerable dissent among the learned, some holding that the posture of the body was immaterial. These were called Horizon- talists, their opponents, Verticalists. The Horizontalist heresy was fi- nally extinguished by Xanobus, the philosopher-king of Abara, a zeal- ous Verticalist. Entering an assembly of philosophers who were debating the matter, he cast a severed human head at the feet of his opponents and asked them to determine its zenith, explaining that its body was hang- ing by the heels outside. Observing that it was the head of their leader, the Horizontalists hastened to profess themselves converted to whatever opinion the Crown might be pleased to hold, and Horizontalism took its place among *fides defuncti.*

Zigzag, v. t. To move forward uncertainly, from side to side, as one carrying the white man's burden. (From *zed, z,* and *jag,* an Icelandic word of unknown meaning.)

Zoology, n. The science and history of the animal kingdom, including its king, the House Fly (*Musca maledicta*). The father of Zoölogy was Aristotle, as is universally conceded, but the name of its mother has not come down to us. Two of the science's most illustrious expounders were Buffon and Oliver Goldsmith, from both of whom we learn (*L'Histoire générale des animaux* and *A History of Animated Nature*) that the domestic cow sheds its horns every two years.

CODA:
ON SUICIDE

Conventional wisdom has it that Bierce, tired of life, went to Mexico courting death. His comments about being stood up against a wall there and shot seem to confirm the theory. He had withstood the deaths of his wife and sons and many friends (nearly a dozen by their own hand), he had fought many battles with few victories, his collected works had found very few readers, and America was going its own way—which was not his: "Why should I remain in a country that is on the eve of Prohibition and woman's suffrage?"

Years before, he had stirred up a storm with a "Prattle" column on suicide. "The smug, self-righteous modern way of looking upon the act as that of a craven or a lunatic is the creation of priests, philistines and women," he wrote. "No principle is involved in this matter; suicide is justifiable or not, according to the circumstances; each case is to be considered on its own merits and he having the act under advisement is sole judge."

As an epitaph, the following eloquent essay is as good as any other. It might even be the one he would have chosen.

TAKING ONESELF OFF

A person who loses heart and hope through a personal bereavement is like a grain of sand on the seashore complaining that the tide has washed a neighboring grain out of sight. He is worse, for the bereaved grain can not help itself; it has to be a grain of sand and play the game of tide, win or lose; whereas he can quit—by watching his opportunity can "quit a winner." For sometimes we do beat "the man that keeps the table"—never in the long run, but infrequently and out of small stakes. But this is no time to "cash in" and go, for you can not take your little winning with you. The time to quit is when you have lost a big stake, your foolish hope of eventual success, your fortitude and your love of the game. If you stay in the game, which you are not compelled to do, take your losses in good temper and do not whine about them. They are hard to bear, but that is no reason why you should be.

But we are told with tiresome iteration that we are "put here" for some purpose (not disclosed) and have no right to retire until "summoned"—it may be by small-pox, it may be by the bludgeon of a blackguard, it may be by the kick of a cow; the "summoning" Power

(said to be the same as the "putting" Power) has not a nice taste in the choice of messengers. That argument is not worth attention, for it is unsupported by either evidence or anything resembling evidence. "Put here." Indeed! And by the keeper of the table! We were put here by our parents—that is all that anybody knows about it; and they had no authority and probably no intention.

The notion that we have not the right to take our own lives comes of our consciousness that we have not the courage. It is the plea of the coward—his excuse for continuing to live when he has nothing to live for—or his provision against such a time in the future. If he were not egotist as well as coward he would need no excuse. To one who does not regard himself as the center of creation and his sorrows as throes of the universe, life, if not worth living, is also not worth leaving. The ancient philosopher who was asked why he did not die if, as he taught, life was no better than death, replied: "Because death is no better than life." We do not know that either proposition is true, but the matter is not worth considering, for both states are supportable—life despite its pleasures and death despite its repose.

It was Robert G. Ingersoll's opinion that there is rather too little than too much suicide in the world—that people are so cowardly as to live on long after endurance has ceased to be a virtue. This view is but a return to the wisdom of the ancients, in whose splendid civilization suicide had as honorable place as any other courageous, reasonable and unselfish act. Antony, Brutus, Cato, Seneca—these were not of the kind of men to do deeds of cowardice and folly. The smug, self-righteous modern way of looking upon the act as that of a craven or a lunatic is the creation of priests, philistines and women. If courage is manifest in endurance of profitless discomfort it is cowardice to warm oneself when cold, to cure oneself when ill, to drive away mosquitoes, to go in when it rains. The "pursuit of happiness," then, is not an "unalienable right," for it implies avoidance of pain.

No principle is involved in this matter; suicide is justifiable or not, according to circumstances; each case is to be considered on its merits, and he having the act under advisement is sole judge. To his decision, made with whatever light he may chance to have, all honest minds will bow. The appellant has no court to which to take his appeal. Nowhere is a jurisdiction so comprehensive as to embrace the right of condemning the wretched to life.

Suicide is always courageous. We call it courage in a soldier merely to face death—say to lead a forlorn hope—although he has a chance of life and a certainty of "glory." But the suicide does more than face death; he incurs it, and with a certainty, not of glory, but of reproach. If that is not courage we must reform our vocabulary.

True, there may be a higher courage in living than in dying. The courage of the suicide, like that of the pirate, is not incompatible with a selfish disregard of the rights of others—a cruel recreancy to duty and decency. I have been asked: "Do you not think it cowardly for a man to end his life, thereby leaving his family in want?" No, I do not; I think it selfish and cruel. Is not that enough to say of it? Must we distort words from their true meaning in order more effectually to damn the act and cover its author with a greater infamy? A word means something; despite the maunderings of the lexicographers, it does not mean whatever you want it to mean. "Cowardice" means a shrinking from danger, not a shrinking of duty. The writer who allows himself as much liberty in the use of words as he is allowed by the dictionary-maker and by popular consent is a bad writer. He can make no impression on his reader, and would do better service at the ribbon-counter.

The ethics of suicide is not a simple matter; one can not lay down laws of universal application, but each case is to be judged, if judged at all, with a full knowledge of all the circumstances, including the mental and moral make-up of the person taking his own life—an impossible qualification for judgment. One's time, race and religion have much to do with it. Some peoples, like the ancient Romans and the modern Japanese, have considered suicide in certain circumstances honorable and obligatory; among ourselves it is held in disfavor. A man of sense will not give much attention to considerations of this kind, excepting in so far as they affect others, but in judging weak offenders they are to be taken into the account. Speaking generally, I should say that in our time and country the persons here noted (and some others) are justified in removing themselves, and that in some of them it is a duty:

One afflicted with a painful or loathsome and incurable disease.

One who is a heavy burden to his friends, with no prospect of their relief.

One threatened with permanent insanity.

One irreclaimably addicted to drunkenness or some similarly destructive or offensive habit.

One without friends, property, employment or hope.

One who has disgraced himself.

Why do we honor the valiant soldier, sailor, fireman? For obedience to duty? Not at all; that alone—without the peril—seldom elicits remark, never evokes enthusiasm. It is because he faced without flinching the risk of that supreme disaster, or what we feel to be such—death. But look you: the soldier braves the danger of death; the suicide braves death itself! The leader of the forlorn hope may not be struck. The sailor who voluntarily goes down with his ship may be picked up or cast

ashore. It is not certain that the wall will topple until the fireman shall have descended with his precious burden. But the suicide—his is the foeman that has never missed a mark, his the sea that gives nothing back; the wall that he mounts bears no man's weight. And his, at the end of it all, is the dishonored grave where the wild ass of public opinion

Stamps o'er his head but can not break his sleep.